GRAPHIC DESIGN USA: 15

THE ANNUAL OF THE AMERICAN INSTITUTE OF GRAPHIC ARTS

Written by Véronique Vienne, Steven Heller, Eric La Brecque, Dana Bartelt, and Moira Cullen
Designed by Beth Crowell, Cheung/Crowell Design
Computer composition by Mark F. Cheung, Cheung/Crowell Design
Marie Finamore, Managing Editor

Copyright © 1994 by The American Institute of Graphic Arts. First published in 1994 in
New York by The American Institute of Graphic Arts, 164 Fifth Avenue, New York, NY 10010
and Watson-Guptill Publications, a division of BPI Communications, Inc., 1515 Broadway,
New York, NY 10036.

Distributed to the trade by Watson-Guptill Publications, 1515 Broadway, New York, NY 10036.

ISBN 0-8230-6381-X

Printed in Japan by Toppan Printing Co., Ltd.
Typeset by Cheung/Crowell Design, Rowayton, CT.
First printing, 1994.

Distributed outside the U.S. and Canada by Hearst Books International, 1350 Avenue of the
Americas, New York, NY 10019.

CONTENTS

THE AMERICAN INSTITUTE OF GRAPHIC ARTS is the national non-profit organization that promotes excellence in graphic design. Founded in 1914, the AIGA advances graphic design through competitions, exhibitions, publications, professional seminars, educational activities, and projects in the public interest.

Members of the Institute are involved in the design and production of books, magazines, and periodicals as well as corporate, environmental, and promotional graphics. Their contributions of specialized skills and expertise provide the foundation for the Institute's programs. Through the Institute, members form an effective, informal network of professional assistance that is a resource to the profession and the public.

Separately incorporated, the thirty-five AIGA chapters enable designers to represent their profession collectively on a local level. Drawing upon the resources of the national organization, chapters sponsor a wide variety of programs dealing with all areas of graphic design.

By being a part of a national network, bringing in speakers and exhibitions from other parts of the country and abroad, focusing on new ideas and technical advances, and discussing business practice issues, the chapters place the profession of graphic design in an integrated and national context.

The competitive exhibition schedule at the Institute's national gallery in New York includes the annual *Book Show* and *Communication Graphics.* Other exhibitions include *Illustration, Photography, Covers* (book jackets, record albums and compact disks, magazines, and periodicals), *Posters, Signage,* and *Packaging.* The exhibitions travel nationally and are reproduced in *Graphic Design USA.* Acquisitions have been made from AIGA exhibitions by the Popular and Applied Arts Division of the Library of Congress. Each year, the *Book Show* is donated to the Rare Book and Manuscript Library of Columbia University, which houses the AIGA collection of award-winning books dating back to the 1920s. For the past ten years, the *Book Show* has also been exhibited at the Frankfurt Book Fair.

The AIGA sponsors a biennial national design conference, covering such topics as professional practice, education, technology, the creative process, and design history. The 1995 design conference will be held in Seattle. This year, the AIGA also instituted a business conference, to be held biennially. The 1994 business conference was held in New York.

The AIGA also sponsors an active and comprehensive publications program. Publications include *Graphic Design USA*, the annual of the Institute; the *AIGA Journal of Graphic Design,* published quarterly; *Graphic Design: A Career Guide and Education Directory;* the *1994 Salary and Benefits Survey; Graphic Design for Non-Profit Organizations,* second edition; *Symbol Signs,* second edition; and the *Symbol Signs Repro Art Kit* (the book and accompanying portfolio of fifty passenger/pedestrial symbols originally designed for the U.S. Department of Transportation, with guidelines for their use); the *1994 AIGA Membership and Resource Directory;* the *AIGA Standard Form of Agreement* (contract); and a *Graphic Design Education Statement.*

CONTRIBUTORS TO
THE CAPITAL CAMPAIGN

*We would like to thank those individuals
and corporations who have contributed to the
three-year Capital Campaign to support the
renovation and restoration of the AIGA's new
home at 164 Fifth Avenue.*

PATRONS

Champion International Corporation
Crosby Associates Inc.
Drenttel Doyle Partners
Pentagram Design, Inc.

SPONSORS

Chermayeff & Geismar Inc.
James Cross
Fine Arts Engraving
Frankfurt Balkind Partners
Milton Glaser
Steve Liska
Clement Mok
Stan Richards
Anthony Russell
Arnold Saks Associates
Siegel and Gale Inc.
Sussman/Prejza & Co., Inc.
Vignelli Associates
Alina Wheeler

DONORS

Carbone Smolan Associates
Richard Danne & Associates
Diana Graham
Hansen Design Company
Hawthorne/Wolfe
The Hennegan Company
Alexander Isley
Karen Skunta
Weyerhaeuser Paper Company

CONTRIBUTORS

Primo Angeli
Bass/Yeager & Associates
Mark Coleman
Concrete/The Office of Jilly Simons
Michael Cronan
Joe Duffy
Joseph and Susan Feigenbaum
Mark Fox
Hopper Papers
Wendy Richmond

*If you would like more information about the
Capital Campaign, please contact Anne Rehkopf
at (212) 807-1990, extension 230.*

DIRECTOR'S LETTER The AIGA celebrated its eightieth birthday at a new address, 164 Fifth Avenue. Two weeks ago (as of this writing), we made a relatively smooth move into the renovated second floor, which is full of packing boxes while the rest of the building is full of promise and possibilities. The wonderful gallery space on the first floor shows the aftereffects of demolition and is large, dark, and empty; the mezzanine level, which will house the library and audiovisual center, now houses Nathan Gluck, who is computerizing AIGA archival ephemera dating back to 1914.

In years to come, the AIGA will owe a debt of gratitude to the 1992–1993 Board of Directors for their courage in purchasing the building on Fifth Avenue. That decision could not have become a reality without the Capital Campaign Committee—Ivan Chermayeff, chair; Bart Crosby; Jim Cross; Milton Glaser; Kit Hinrichs; and Deborah Sussman. Their initial commitment has been essential. The intelligence and skill of Irene Bareis, Associate Director, made it possible for us to secure an Industrial Development Agency loan, which has stabilized our space costs for the next thirty years. We will be spending the same amount we were spending on our former space, which was a third the size and totally lacking in possibilities. Throughout the acquisition process, Tony Russell, AIGA President 1991–1994, gave his wholehearted support, from fundraising to signing the final documents of purchase in an office high over Wall Street late one night, surrounded by lawyers. In the mix, we discovered our papers of incorporation, undoubtedly signed under similar, formal circumstances in 1927 by, among others, Frederic Goudy and the Commissioner of Education of the State of New York, whose signature puts John Hancock's to shame.

The year was active on other fronts. Living Contradictions, our national design conference in Miami, was preceded by the anxiety caused by random violence in Miami, and followed by a critical barrage in the design press, despite excellent and telling presentations by Neil Postman, Javier Mariscal, and Oliviero Toscani. The criticism attached itself to issues of political correctness, which were in part lightning rods for unrest and uncertainty in the field at large.

In addition to the exhibitions documented in this book, there were twenty-one openings of AIGA exhibitions through our traveling program this year, including *Vive Les Graphistes*, an exhibition of French graphic design that appeared in four cities. We are also planning a joint exhibition with the Dutch government, and, with the Cooper-Hewitt Museum, are discussing joint programs that will take advantage of our new home. *Graphic Design: A Career Guide and Education Directory* was finally published (and well received), and we were awarded an NEA grant to put together a video library, now in progress.

At the end of the letter from the director that appeared in last year's *Graphic Design USA,* there was a wonderfully prescient typo—"these are exiting [exciting] times." Both are true. This is my last year at the AIGA. In the seventeen years since Dick Danne hired me, I've been fortunate to work with intelligent and productive boards and staff, including seven presidents, who were responsible for changing the AIGA from a distinguished New York–based organization to a truly national one with chapters in thirty-six U.S. cities. Membership has grown from 1,200 to 8,500, and we've established the journal, this annual, and a significant national conference. We all have reason to be pleased with our efforts and have much to look forward to.

Caroline Hightower
April 15, 1994

THE AIGA MEDAL

For seventy-four years, the medal of the AIGA
has been awarded to individuals in recognition of
their distinguished achievements, services, or other
contributions within the field of the graphic arts.
Medalists are chosen by the awards committee,
subject to approval by the Board of Directors.

PAST RECIPIENTS

Norman T. A. Munder, 1920
Daniel Berkeley Updike, 1922
John C. Agar, 1924
Stephen H. Horgan, 1924
Bruce Rogers, 1925
Burton Emmett, 1926
Timothy Cole, 1927
Frederic W. Goudy, 1927
William A. Dwiggins, 1929
Henry Watson Kent, 1930
Dard Hunter, 1931
Porter Garnett, 1932
Henry Lewis Bullen, 1934
J. Thompson Willing, 1935
Rudolph Ruzicka, 1936
William A. Kittredge, 1939
Thomas M. Cleland, 1940
Carl Purington Rollins, 1941
Edwin and Robert Grabhorn, 1942

Edward Epstean, 1944
Frederic G. Melcher, 1945
Stanley Morison, 1946
Elmer Adler, 1947
Lawrence C. Wroth, 1948
Earnest Elmo Calkins, 1950
Alfred A. Knopf, 1950
Harry L. Gage, 1951
Joseph Blumenthal, 1952
George Macy, 1953
Will Bradley, 1954
Jan Tschichold, 1954
P. J. Conkwright, 1955
Ray Nash, 1956
Dr. M. F. Agha, 1957
Ben Shahn, 1958
May Massee, 1959
Walter Paepcke, 1960
Paul A. Bennett, 1962
William Sandberg, 1963
Saul Steinberg, 1963
Josef Albers, 1964
Leonard Baskin, 1965
Paul Rand, 1966
Romana Javitz, 1967
Dr. Giovanni Mardersteig, 1968
Dr. Robert R. Leslie, 1969
Herbert Bayer, 1970
Will Burtin, 1971
Milton Glaser, 1972
Richard Avedon, 1973
Allen Hurlburt, 1973
Philip Johnson, 1973
Robert Rauschenberg, 1974
Bradbury Thompson, 1975
Henry Wolf, 1976
Jerome Snyder, 1976
Charles and Ray Eames, 1977
Lou Dorfsman, 1978
Ivan Chermayeff and
Thomas Geismar, 1979
Herb Lubalin, 1980
Saul Bass, 1981
Massimo and Lella Vignelli, 1982
Herbert Matter, 1983
Leo Lionni, 1984
Seymour Chwast, 1985
Walter Herdeg, 1986
Alexey Brodovitch, 1987
Gene Federico, 1987
William Golden, 1988
George Tscherny, 1988
Paul Davis, 1989
Bea Feitler, 1989
Alvin Eisenman, 1990
Frank Zachary, 1990
Colin Forbes, 1991
Rudolph de Harak, 1992

THE DESIGN LEADERSHIP AWARD

The Design Leadership Award has been established to
recognize the role of perceptive and forward-thinking
organizations that have been instrumental in the advance-
ment of design by applying the highest standards, as a
matter of policy. Recipients are chosen by the awards
committee, subject to approval by the Board of Directors.

PAST RECIPIENTS

IBM Corporation, 1980
Massachusetts Institute of
 Technology, 1981
Container Corporation of America, 1982
Cummins Engine Company, Inc., 1983
Herman Miller, Inc., 1984
WGBH Educational Foundation, 1985
Esprit, 1986
Walker Art Center, 1987
The New York Times, 1988
Apple and Adobe Systems, 1989
The National Park Service, 1990
MTV, 1991
Olivetti, 1991
Sesame Street, Children's Television Workshop, 1992

THE LIFETIME ACHIEVEMENT AWARD

The Lifetime Achievement Award, presented in 1991
for the first time, is posthumously awarded to individuals
in recognition of their distinguished achievements,
services, or other contributions within the field of graphic
arts. This award is conclusive and is for special and
historical recognition. This award has been created to
ensure that history, past and present, is integral to the
awards process, is part of the awards presentation,
and is documented in the Annual. Recipients are chosen
by the awards committee, subject to approval by the
Board of Directors.

PAST RECIPIENTS

E. McKnight Kauffer, 1991–1992
George Nelson, 1991–1992
Lester Beall, 1992–1993

THE AIGA AWARDS 1993–1994: A CONTINUUM OF EXCELLENCE The recipients of this year's AIGA Awards are all exemplars of their craft and share a common philosophy: Quality is not something that you try to achieve in certain instances, but is a demanded and accepted part of everyday life and work. The people or institutions granted the AIGA Awards have achieved exceptional status with responsible communicative work, and have contributed to the world's awareness of graphic design.

Tomoko Miho has been awarded the AIGA Medal for her extraordinary contribution to graphic design. She is especially deserving of recognition since her quiet, reserved personality has never led her to self-promotion. Instead, she has allowed her work to speak for her. In particular, the posters she designed, alone or in partnership, for the Air and Space Museum, the city of Chicago, and the Museum of Modern Art are intelligently designed with minimalist reserve.

For his pioneering work in American Modernism, Alvin Lustig has amply earned the posthumous Lifetime Achievement Award for special and historical recognition. In addition to industrial, textile, and interior designs, Lustig created innovative book jackets and covers.

The Design Leadership Award is presented to a company or organization that has sustained the highest standards of design excellence in all aspects of communication or has made a significant contribution to graphic design. Nike Inc. has undeniably qualified with their extraordinary product, advertising, and graphic design programs. They have done for traditional shoe advertising today what Helmut Krone did for Volkswagon and automobile advertising years ago by making what took place in the past forgettable.

I would like to thank the awards committee for their dedication and thoughtful contributions, as well as Natalia Ilyin and Caroline Hightower of the AIGA. The awards committee members included George Tscherny of George Tscherny Inc. and Rudolph de Harak (both past recipients of the AIGA Medal); Meredith Davis, head of Graphic Design at North Carolina State University School of Design; Samina Quraeshi, principal of Shepard Quraeshi Associates; and Kent Hunter, principal executive design director of Frankfurt Balkind.

B. Martin Pedersen
Chairman, Medalist Committee

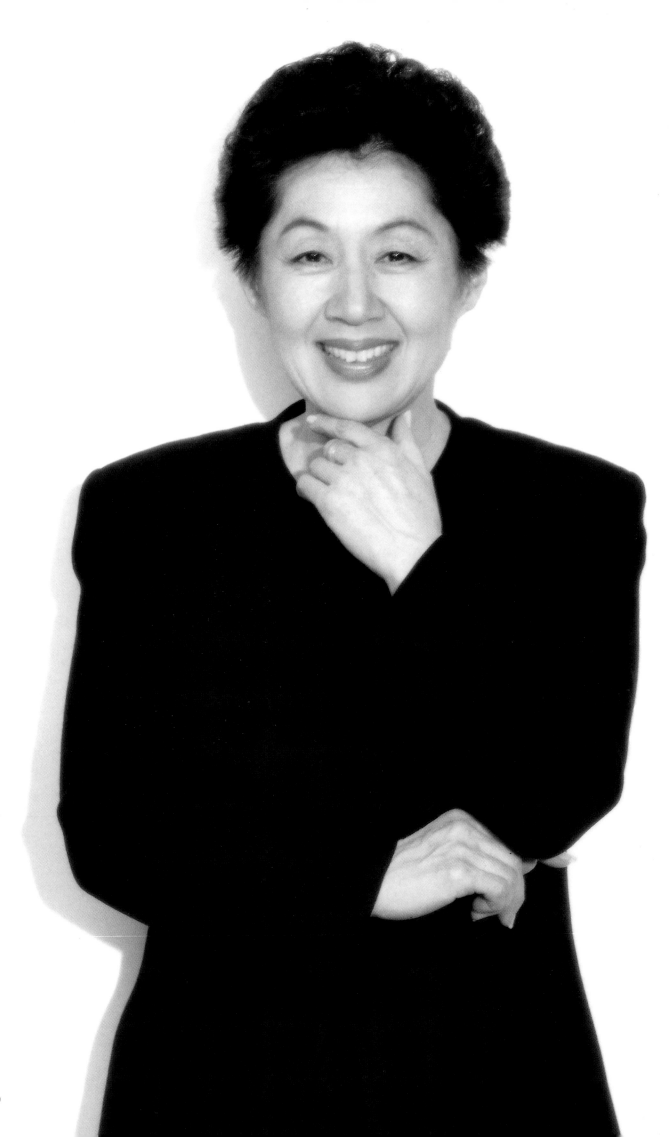

TOMOKO MIHO

A Fearless Dedication to Content

BY VÉRONIQUE VIENNE

Opposite Portrait by Tohru Nakamura.

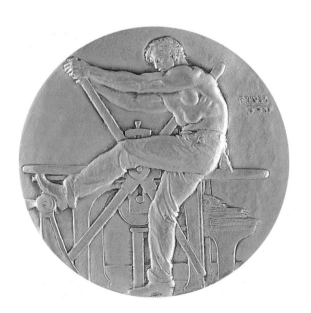

Tomoko Miho is the design world's best-kept secret. A distinctive presence — but a very private person — she has avoided the spotlight. She does not need it, for her designs, endowed with a crystalline clarity, have a luster all their own. She never attempted to make a name for herself, but she has acquired a formidable reputation among her peers: "A minimalist and a Modernist — in the best sense of the term" (George Tscherny). "One of the most perceptive problem-solvers I know" (Rudolph de Harak). "A master of the dramatic understatement" (John Massey).

Reserved and quietly elegant, she is a consensus-builder *par excellence*. When looking back at her career, everyone agrees that her work is an example of the whole being greater than the sum of its parts. Her contribution to graphic design is far greater than the sum of her talents. Her posters, books, catalogs, logos, showrooms, and architectural signage share a common denominator — an internal breadth that comes from the exacting relationship between space and substance, between imagery and information, between concept and details. There is never any sentimentality in her work, yet it elicits a strong emotional response — the gratitude one feels when someone gets it right.

The boldness of her design solutions is not the result of a stylistic choice, but of a fearless dedication to content. Tomoko's unflinching commitment to quality is simply daunting.

One of her gifts is to find potential greatness where others merely see constraints. Born in Los Angeles, Tomoko Kawakami spent part of her early years with her family in an Arizona internment camp. "In order to recover, we had to excel," she says. "The experience forced many Japanese-Americans to seek new horizons." Her new horizons would be defined by fortuitous design opportunities. A summer scholarship from the Minneapolis School of Art (now the Minneapolis College of Art and Design) opened a realm of possibilities. A visit to the Museum of Modern Art during her first trip to Manhattan after high school helped her

Top First trip to Manhattan. *Bottom left* Herman Miller catalog (1964). Design firm: George Nelson & Co. Inc., New York. *Bottom right* Front and back covers of the Herman Miller Action Office 2 brochure and inside pages from the Comprehensive Storage Panel Systems brochure (1969–1970). Design firm: Center for Advanced Research in Design (CARD).

focus her professional ambition. But it was a full scholarship from the Art Center School in Los Angeles (now the Art Center College of Design in Pasadena) that would truly challenge her sense of aesthetics and broaden her field of vision.

With a degree in industrial design from the Art Center School, she moved first to Philadelphia to join her husband, James Miho, and later to Michigan, where she was hired as a packaging designer by Harley Earl Associates Inc. In the early sixties, a lengthy six-month tour of Europe with Jim and another couple, also designers educated at the Art Center, gave her a chance to reevaluate — and consolidate — all her previous design assumptions.

She remembers her exhilaration when she encountered the European artists — painters, sculptors, craftsmen, typographers — who shared a same keen spirit of experimentation. The international typographic style championed by Swiss graphic designers was not an isolated phenomenon, but an expression of a

new concern for the relationship between form and content. This integrated design vision was soon to change the way corporate America viewed itself. Complex identity programs, incorporating various disciplines, would help big companies develop their design philosophy and with it their sense of mission. Europe in the early sixties was seething with an objectifying fervor born from a need to find a consensus after the war. The Swiss graphic approach — multicultural yet rational and neutral — offered everyone an opportunity to start all over again. New sans serif typefaces came to epitomize a burgeoning non-partisan international democratic spirit. Seen as a universal expression of an open class-free rationalism, this simplified European design style was instantly assimilated into the American culture. "To get a design award in those days," recalls Martin Pedersen with a chuckle, "all you had to do was use Helvetica."

The description of Tomoko and Jim's European tour reads like a designer's epic poem. In Milan, they met Olivetti art director

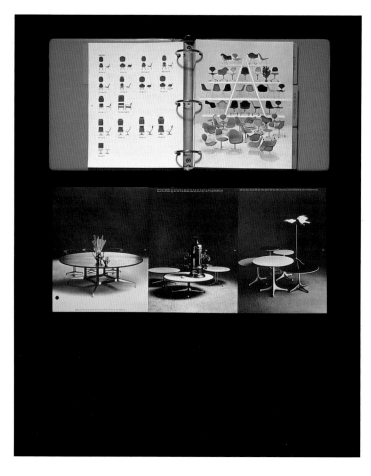

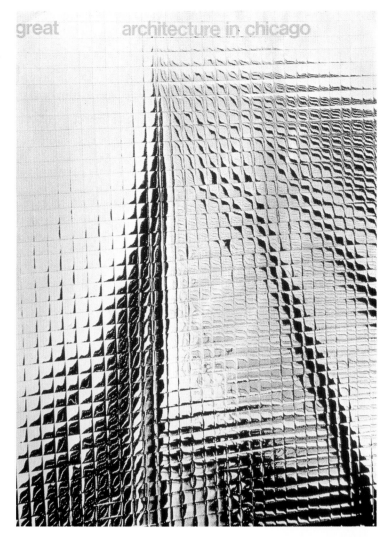

great architecture in chicago

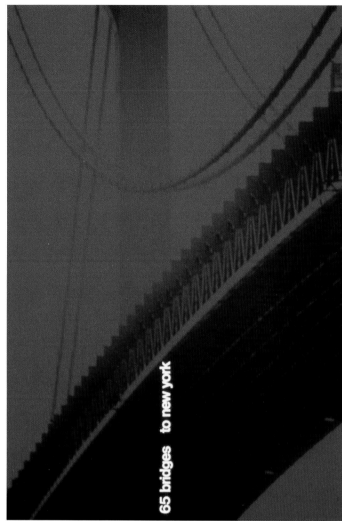

65 bridges to new york

Top left "Great Architecture in Chicago" poster (1967). Design firm: CARD, Chicago. Photographer: Rodney Galarneau. *Top right* "65 Bridges to New York" poster (1967). Design firm: CARD, New York. Photographer: Harvey Lloyd. *Bottom right* "Empire City, Empire State" poster (1967). Design firm: CARD, New York. Photographer: Harvey Lloyd.

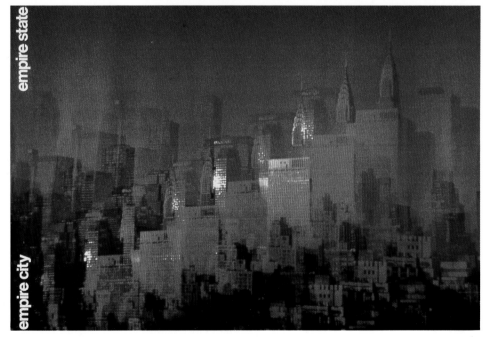

empire state

empire city

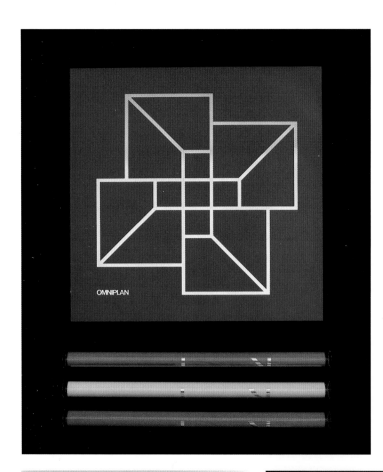

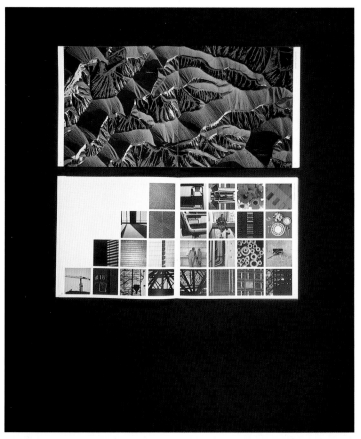

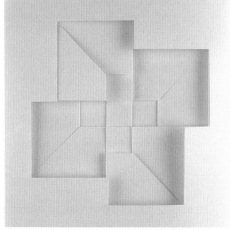

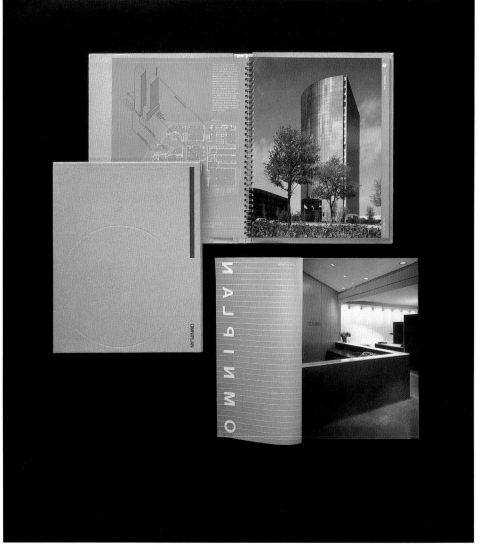

Top left Posters to introduce new name and symbol for Omniplan Architects, Dallas (1971). Design firm: CARD, New York. *Top right* Omniplan brochure spreads (1971). Design firm: CARD, New York. Photographers: William Garnet and Steph Leinwohl. *Bottom right* Omniplan brochure with hardcover and jacket (1985). Design firm: Tomoko Miho Co. *Bottom left* Christmas card with Omniplan symbol in relief, formed with die cuts and folds (1972). Design firm: CARD, New York. Designed with James Sebastian.

Giovanni Pintori; near Lausanne, Switzerland, they visited painter and sculptor Hans Erni; in Basel they spent time with poster artist and designer Herbert Leupin; in Germany they toured Hochschule für Gestaltung — the famed Ulm design school — and made contact with graphic designer Tomás Gonda; in Finland they were introduced to Armi Ratia, creator of the Marimekko image, and to industrial designer Tapio Wirkkala. By the end of this trip, Tomoko understood what would be her mandate — to "join space and substance," as she later wrote. To draw the big picture, its message and its context — to be a graphic designer.

Tomoko and Jim toured Europe in their new silver Porsche, creating quite a stir in small villages. They were the future — a new generation of inquisitive, upbeat, and energetic design professionals. During their marriage, a creative partnership that lasted two decades, the Mihos retained their distinctive individuality. He, charming and charismatic; she, quiet and observant. They shared the same passion for graphic excellence — and sometimes even the same clients — but always kept their respective points of view and independence intact.

Tomoko's impenetrable demeanor conceals an innate ability to confront unfamiliar situations, absorb new information, and

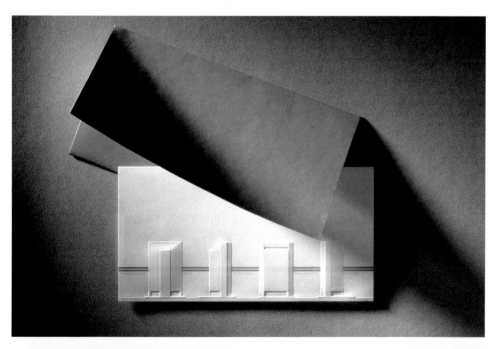

integrate jarring contradictions. She sees order in clutter; she enjoys translating abstract concepts in clear visual terms. As a result, her design solutions have an unassuming, effortless, and lucid quality.

Her serene way with problem-solving made her, right from the start, an ideal team player. After her European tour, she joined George Nelson and Co. Inc., in New York City, as a graphic designer. Irving Harper, a renaissance man — architect, furniture and industrial designer, exhibit and graphic designer, and advertising maverick — who acted as creative director for the Nelson office, became an early influence. When he left to start his own design firm, she was named head of the graphic design department. "Perfection was Tomoko's very own mandate," Harper remembers. "Her work was remarkably clean, beautiful, pristine." Tomoko's first major challenge was to handle the graphics portion of George Nelson's main account, Herman Miller. It turned out to be the match of a lifetime. For twelve years, the innovative Michigan-based

office furniture company would be almost a constant in Tomoko's work — and an important outlet for her creative inspiration.

During the late sixties and the early seventies, Tomoko worked on various Herman Miller projects — but this time with John Massey, a consummate designer, painter, and communicator. Director of advertising, design, and public relations at Container Corporation of America, Massey was also director of the Center for Advanced Research in Design (CARD), a design office that functioned as a CCA subsidiary and profit center. CARD developed design and communications programs for organizations in the private and public sectors. The clients included Atlantic Richfield Company, Herman Miller Inc. — and its own parent company, Container Corporation of America.

Tomoko worked for a couple of years in the CARD Chicago office before going to New York to open a branch to serve CARD's East Coast clients. During that time — for about eight years — she was handling a flow of

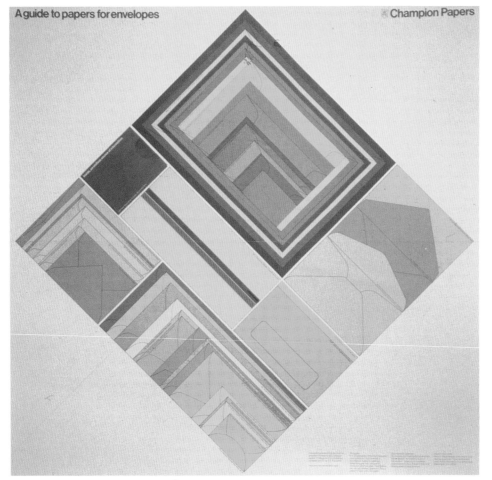

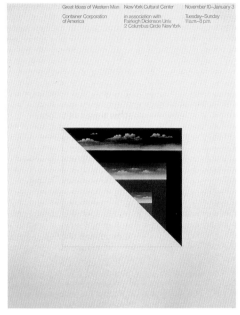

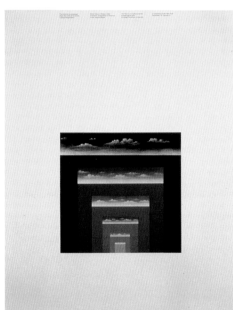

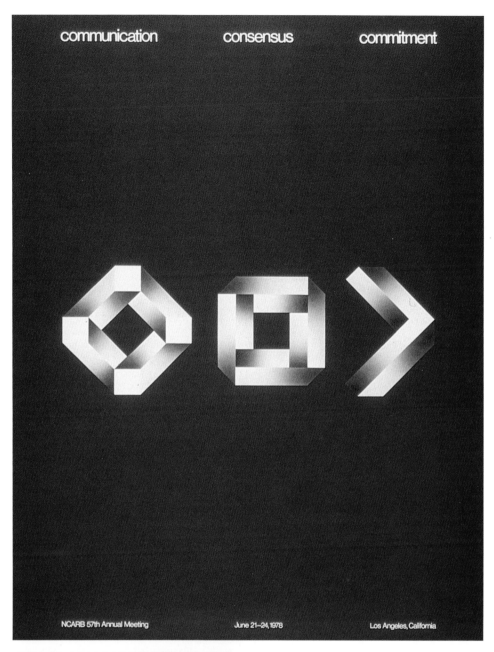

communication consensus commitment

NCARB 57th Annual Meeting June 21–24, 1978 Los Angeles, California

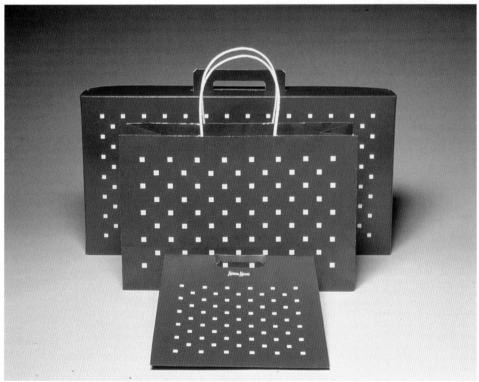

Top and center left Poster for Container Corporation's exhibition of art from the "Great Ideas of Western Man" ad series (c. 1972). Design firm: CARD, New York. *Top right* "Communication, Consensus, Commitment" poster for annual meeting of the National Council of Architectural Registration Boards (1978). *Bottom left* Packaging designs for Neiman Marcus (1972). Design firm: CARD, New York.

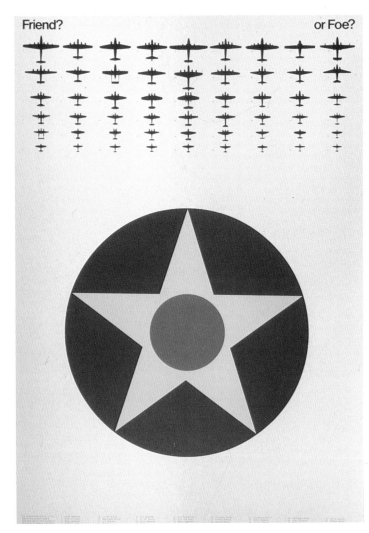

Friend? or Foe?

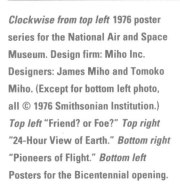

Clockwise from top left 1976 poster
series for the National Air and Space
Museum. Design firm: Miho Inc.
Designers: James Miho and Tomoko
Miho. (Except for bottom left photo,
all © 1976 Smithsonian Institution.)
Top left "Friend? or Foe?" *Top right*
"24-Hour View of Earth." *Bottom right*
"Pioneers of Flight." *Bottom left*
Posters for the Bicentennial opening.

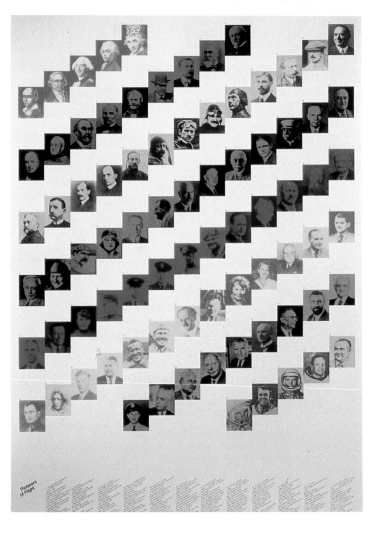

Pioneers
of Flight

Herman Miller print and communications material.

In the eighties, as principal of Tomoko Miho Co., she reestablished contact with Herman Miller, this time creating environmental art and display for the New York, IDC/NY Long Island and Los Angeles showrooms, as well as special invitations and a poster.

To explain her particular sense of space, Tomoko alludes to *shakkei*, a traditional Japanese garden design discipline that integrates the background with the foreground, bringing distant views into clear focus. Meaning "borrowing scenery," *shakkei* transforms the experience of space, imparting a sense of depth, width, and breadth to a small environment.

Tomoko Miho carefully gardens every inch of graphic space. She often borrows spatial conventions from the three-dimensional world, making the two-dimensional plane appear larger, deeper, more inclusive. For her, the page is not an opaque screen, but a threshold. Her designs invite viewers to cross over into a multilayered world.

To create a sense of spaciousness, she sometimes punctures holes through her design. A poster for Container Corporation of America, announcing the opening of the Great Ideas of Western Man exhibition at the New York Cultural Center, has a die-cut window with a diagonal flap revealing a section of a Herbert Bayer composition illustrating the Wittgenstein quote "The limits of my language mean the limits of my world." For Tomoko, though, the limit of the graphic design language does not mean the limit of her imagination.

To expand space, she also borrows from the laws of perspective. For Omniplan,

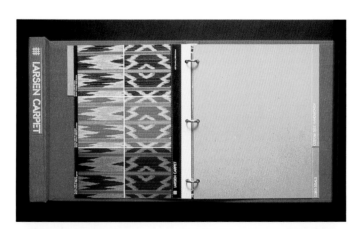

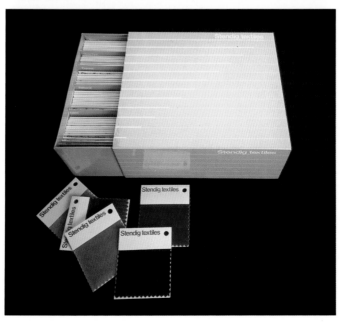

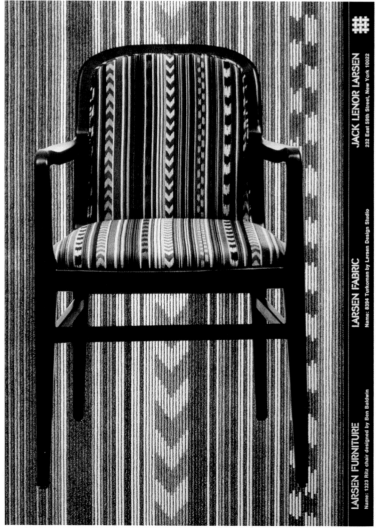

Center right Invitation for West Week reception at Herman Miller Showroom (1984). Artist: Isadore Seltzer. *Left and bottom* Environmental art and graphics for a "Designer's Saturday" event at Herman Miller NY Showroom (1984). Design firm: Tomoko Miho Co. Photographs © 1984 John Alexanders.

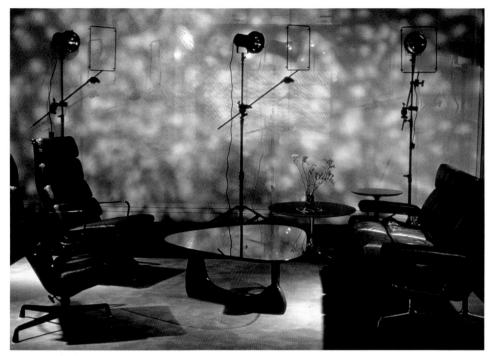

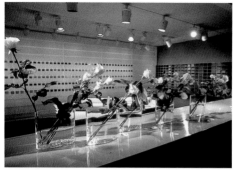

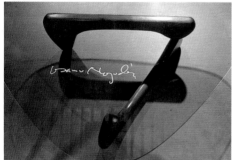

a Dallas-based architectural firm, she designed a logo that tricks the eye, and looks either concave or convex. Four interlocking schematic squares, arranged in a cross pattern, suggest the firm's multidisciplinary capabilities. Working in collaboration with designer James Sebastian, she decided to push the limits of the logo's graphic identity as far as possible. A concept as well as a logotype, the Omniplan emblem lent itself to multiple interpretations — as a paperweight, a die-cut Christmas card, and a mirrored sculpture for the lobby.

Like the surrealists, Tomoko plays with trompe l'oeil illusions. A wall chart for Champion Papers, showing a wide range of envelope sizes and shapes, integrated a real envelope among the fake ones.

For a series of posters on architecture in New York and Chicago — now in the permanent collection of the Museum of Modern Art — she captured the urban scale by showing partially obscured buildings: the fractured reflection of a skyscraper or the monochromatic outline of a bridge in fog. As modern today as they were in 1967, these posters are timeless examples of Tomoko's masterful sense of composition and pictorial ingenuity.

A direct application of the *shakkei* principle is a three-layer translucent poster for the Herman Miller "Ethospace" office system. Wafer-thin sheets of tracing vellum, fastened by an eyelet, rotate to create new

and unexpected layouts and vistas. Like the Ethospace tile system designed to open up the office worker's field of vision, Tomoko's conceptual poster opens up the viewer's spatial perceptions.

Tomoko's signature is her exquisite sense of scale. A series of posters for the National Air and Space Museum, designed in partnership with Jim Miho when they were principals of Miho Inc., demonstrates how easy it is for skilled graphic designers to transform a plain piece of paper into a boundless patch of sky. The "Friend? or Foe?" poster contrasts a huge Air Force symbol in the foreground with a fleet of tiny World War II fighter planes silhouetted at the top. The clever juxtaposition emphasizes the helplessness of the pilot — stuck, like the symbol, in the middle — faced with a swarm of almost unidentifiable aircraft. But what really captures the imagination is the way the type helps create a sense of urgency. Captions identifying the planes are arranged in short columns at the bottom, suggesting a low horizon line. To decipher this information, one must hunker down. An ominous emptiness looms above the reader's eyes.

Another poster, "Pioneers of Flight," features eighty famous pilots and notable aeronautics figures. A narrow vertical grid creates a checkerboard effect. Miniature portraits are laid out in diagonal, forming ascending zigzagging rows. But here again, the fascina-

tion one feels when looking at the poster comes from the scale of negative versus positive space, arranged to generate a strong graphic updraft that simulates flight.

For Tomoko, scale is not simply a question of contrasts and relationships, but also a concern for detail. Small elements, not large ones, create a sense of hierarchy; short captions, set in small type, make a picture seem majestic; a twelve-foot-long architectural sign, dwarfed by a glass-and-steel tower, lends magnitude to an entrance; an invisible grid confers authority to an uncluttered layout. "Tomoko gives as much thought to a personal letterhead as to a major corporate project," notes Martin Pedersen. Tomoko Miho's broad yet thorough vision is an invaluable asset to the design community. The quality she brings to her discipline benefits everyone. First, her clients — the list includes Herman Miller Inc., but also Champion

International Corporation; Omniplan Architects; Hellmuth, Obata & Kassabaum Inc. Architects; the Museum of Modern Art, New York; the National Endowment for the Arts; the Isamu Noguchi Foundation, Inc.; Neiman Marcus; and Jack Lenor Larsen Inc., to name a few.

Her work also benefits us, her colleagues. It reminds us that modernity is not a trend, not a style, not even an attitude. It is a lifelong pursuit to remain curious, lucid, relevant.

Last, but not least, her work benefits the people who use the posters, brochures, books, invitations, and architectural signage she designs. They enter with her into a harmonious relationship with the information presented to them, its form and its content. "It is that harmony that creates the ringing clarity of statement that we sense as an experience," she writes, "as a meaningful whole, as a oneness — as good design."

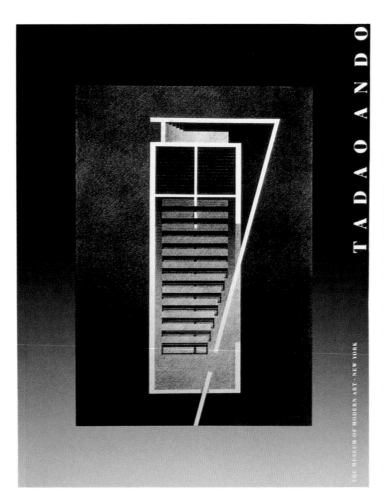

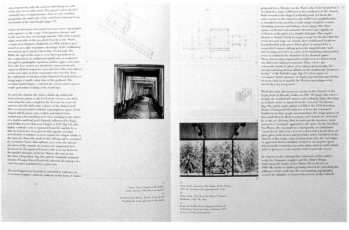

Top left Office stationery and business cards for Roberdeau Properties (1987). *Center and bottom right* Architectural signage for the building at 546 Fifth Avenue, New York (1990). *Bottom left* Executive stationery for Michael Roberdeau (1987).

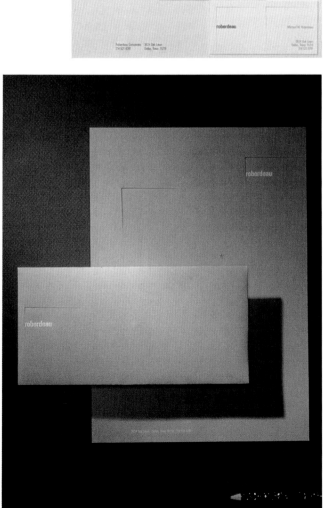

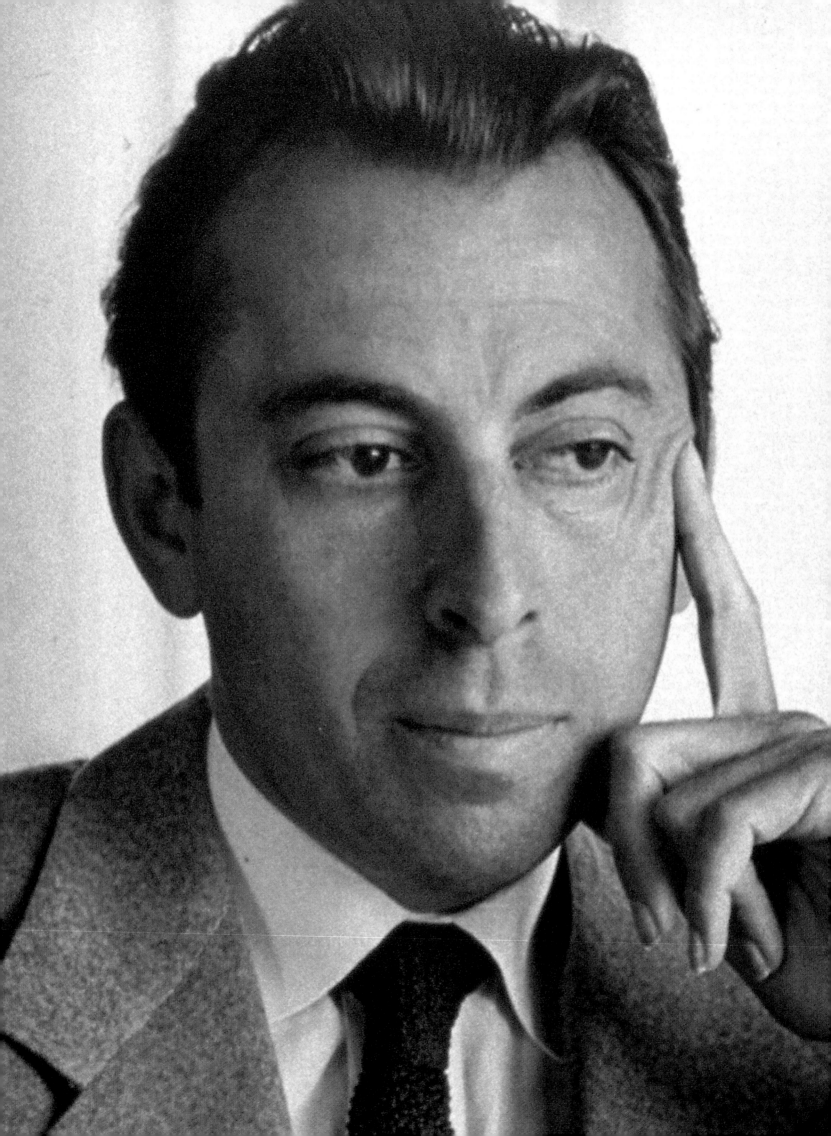

ALVIN LUSTIG

Born Modern

BY STEVEN HELLER

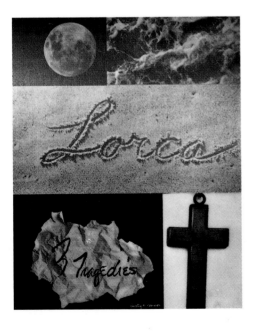

Opposite Alvin Lustig (1949). Book cover for *Lorca: 3 Tragedies* (1949).

Alvin Lustig's contributions to the design of books and book jackets, magazines, interiors, and textiles as well as his teachings would have made him a credible candidate for the AIGA Lifetime Achievement award when he was alive. By the time he died at the age of forty in 1955, he had already introduced principles of Modern art to graphic design that have had a long-term influence on contemporary practice. He was in the vanguard of a relatively small group who fervently, indeed religiously, believed in the curative power of good design when applied to all aspects of American life. He was a generalist, and yet in the specific media in which he excelled he established standards that are viable today. If one were to reconstruct, based on photographs, Lustig's 1949 exhibition at The Composing Room Gallery in New York, the exhibits on view and the installation would be remarkably fresh, particularly in terms of the current trends in art-based imagery.

Lustig created monuments of ingenuity and objects of aesthetic pleasure. Whereas graphic design history is replete with artifacts that define certain disciplines and are also works of art, for a design to be so considered it must overcome the vicissitudes of fashion and be accepted as an integral part of the visual language. Though Lustig would consider it a small part of his overall output, no single project is more significant in this sense than his 1949 paperback cover for *Lorca: 3 Tragedies*. It is a masterpiece of symbolic acuity, compositional strength, and typographic craft that appears to be, consciously or not, the basis for a great many contemporary book jackets and paperback covers.

The current preference among American book jacket designers for fragmented images, photo-illustration, minimal typography, and rebus-like compositions can be traced directly to Lustig's stark black-and-white cover for *Lorca,* a grid of five symbolic photographs linked in poetic disharmony. This and other distinctive, though today lesser known, covers for the New Directions imprint transformed an otherwise realistic medium — the

Top left Commencement announcement for the Art Center (c. 1938).
Bottom "Philately in Europe" (c. 1939). Both are examples of Lustig's early typographic experiments using typecase materials and sans serif type.
Top right "Tomorrow: Equipment for Living" (1945), an advertisement for Knoll using the kind of abstract design also applied to his book jackets.

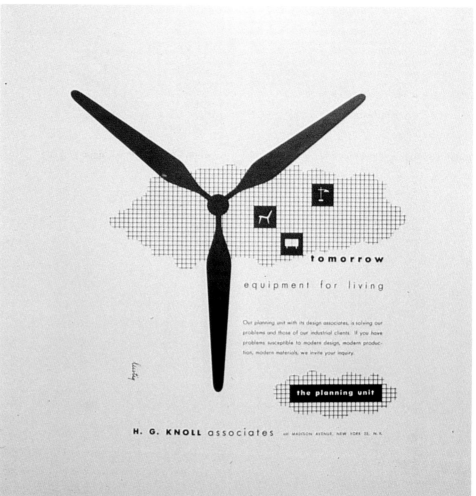

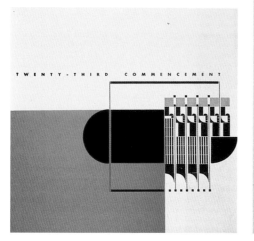

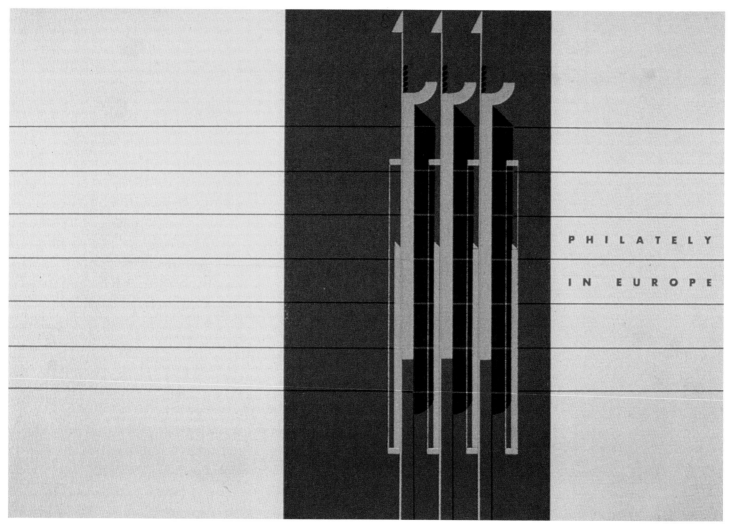

photograph — into a tool for abstraction through the use of reticulated negatives, photograms, and still-lifes. When Lustig's approach (which developed from an interest in montage originally practiced by the European Moderns, particularly the American expatriate E. McKnight Kauffer) was introduced to American book publishing in the late 1940s, covers and jackets were mostly illustrative and also rather decorative. Hard-sell conventions were rigorously followed. Lustig's jacket designs entered taboo marketing territory through his use of abstraction and small, discreetly typeset titles, influenced by the work of Jan Tschichold. Lustig did not believe it was necessary to "design down," as he called it, to achieve better sales.

He further rejected the typical cover design that summarized a book through one generalized image. "His method was to read a text and get the feel of the author's creative drive, then to restate it in his own graphic terms," wrote James Laughlin in "The Book Jackets of Alvin Lustig" (*Print,* vol. 10 no. 5, October 1956). As publisher of New Directions, Laughlin hired Lustig in the early 1940s and gave him the latitude to experiment with personal graphic forms. New Directions' quirky list of reprints, which featured such authors as Henry Miller, Gertrude Stein, D. H. Lawrence, and James Joyce, was a proving ground for the designer's visual explorations and distinctive graphic poetry.

Lustig's first jacket for Laughlin, a 1941 edition of Henry Miller's *Wisdom of the Heart,* eclipsed the jacket designs of previous New Directions books, which Laughlin described as "conservative" and "booky." At the time, Lustig was experimenting with non-representational constructions made from slugs of metal typographic material, revealing the influence of Frank Lloyd Wright, with whom he studied for three months at Taliesen East. The most interesting of these slug compositions was for *Ghost in the Underblows* (1940) for Ward Ritchie Press, which echoed Constructivist typecase experiments from the early twenties yet revealed a distinctly native American aesthetic. Though these designs were unconventional, some years later Laughlin noted that they "scarcely hinted at the extraordinary flowering which was to follow."

Laughlin was referring to the New Classics series by New Directions that Lustig designed from 1945 to 1952. With few exceptions, the New Classics are as inventive today as when they premiered almost fifty years ago. Lustig had switched over from typecase compositions to drawing his distinctive symbolic "marks," which owed more to the work of artists like Paul Klee, Joan Miró, and Mark Rothko than to any accepted commercial style. Although Lustig rejected painting as a being too subjectivized and never presumed to paint or sculpt himself, he liberally borrowed from painting and integrated the abstract sensibility into his total design.

The New Classics succeeded where other popular literary series, such as the Modern Library and Everyman's Library, failed because of inconsistent art direction and flawed artwork. Each New Classics jacket had its own character, with Lustig brilliantly maintaining unity through strict formal consistency. At no time did his look overpower the books. This kind of consistency is virtually unheard of today in a publishing field where, according to Lustig's former client and friend Arthur Cohen, design is "wedded to rapidity and obsolescence, immediacy without subtlety." Lustig's jacket designs for New Directions demanded contemplation: they were not point-of-purchase visual stimulants.

It is not surprising that Lustig's early work would challenge the norm. He once proclaimed that he was "born Modern" and had made an early decision to practice as a "Modern" rather than a "traditional" designer. He was born in 1915 in Denver to a family that he said had "absolutely no pretensions to culture." He was a poor student who avoided going to classes by becoming an itinerant magician for various school assemblies around Los Angeles, where the family had resettled. And yet it was in high school that he was introduced by "an enlightened teacher" to Modern art, sculpture, and French posters. "This art hit a fresh eye, unencumbered by any ideas of what art was

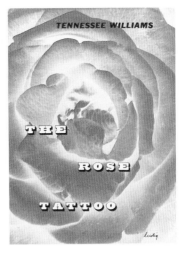

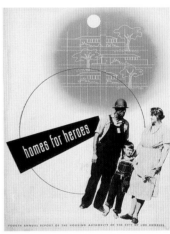

Top Book jacket for *The Rose Tattoo* (New Directions, 1950), for which Lustig used a reticulated close-up of a rose blossom. *Bottom* "Homes for Heroes" (1942), an advertisement for the Housing Authority of Los Angeles using photomontage.

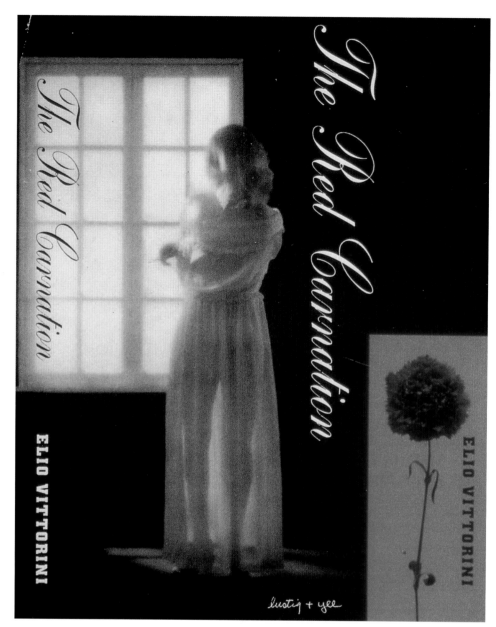

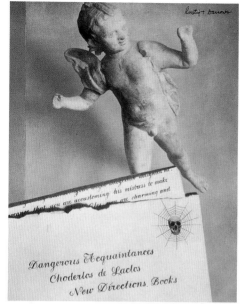

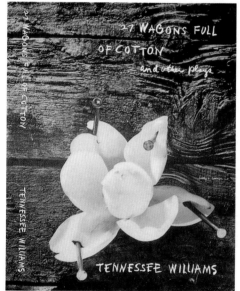

lustig + yee

or should be, and found an immediate sympathetic response," he wrote in "Personal Notes on Design" (*AIGA Journal,* vol. 3 no. 4, 1953). "This ability to 'see' freshly, unencumbered by preconceived verbal, literary, or moral ideas, is the first step in responding to most modern art." Fascinated by posters, he began devoting more time to making his own magic-show posters than to refining his act.

At twenty-one, he became a freelance printer and typographer doing jobs on a letterpress that he kept in the back room of a drugstore. It was there that he began to create purely abstract geometric designs using type ornaments, or what a friend termed "queer things with type." A year or so later he retired

from printing to devote himself exclusively to design. He became a charter member of a very small group (including Saul Bass, Rudolph de Harak, John Folis, and Louis Danziger) called The Los Angeles Society for Contemporary Designers, whose members were frustrated by the dearth of creative vision exhibited by West Coast businesses.

The paucity of work in California forced Lustig to move to New York in 1944, where he became visual research director of *Look* magazine's design department until 1946. He not only designed progressive-looking printed house organs and promotional materials, he designed the actual department in a Modern manner. While in New York, he took up interior design

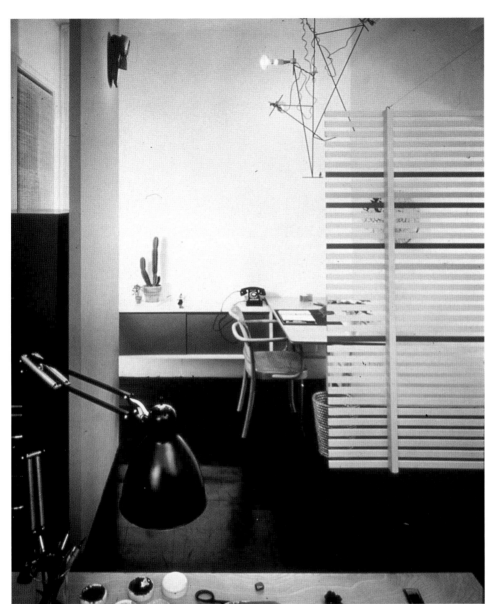

Left Interior design by Lustig for his New York office (1952–1955), one of many spaces he designed while in New York. *Center* Lamp designed by Lustig, which hung in his office. *Bottom* Interior design by Lustig for his Los Angeles office (1947), which includes a wall graphic of his abstract designs influenced by Paul Klee.

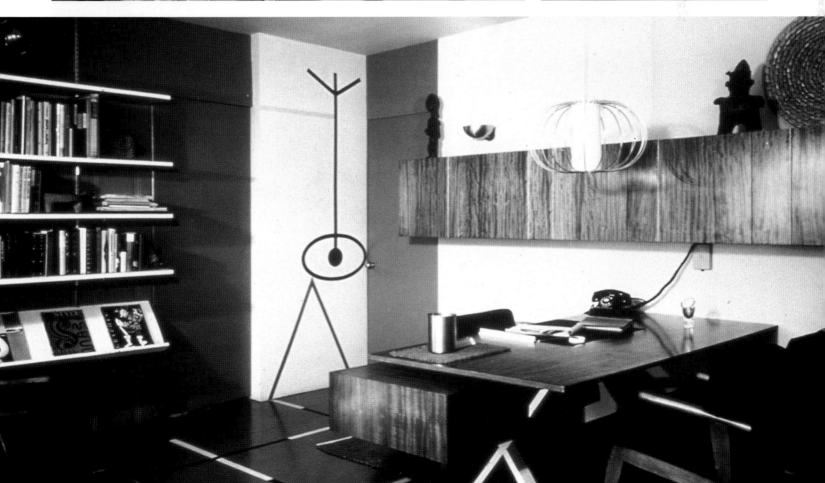

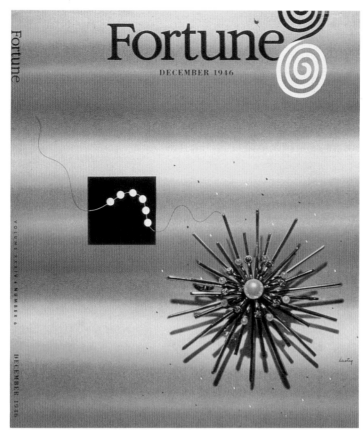

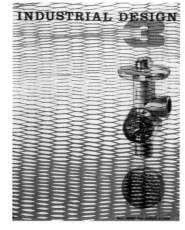

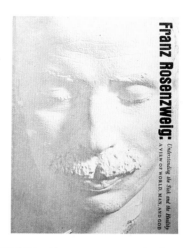

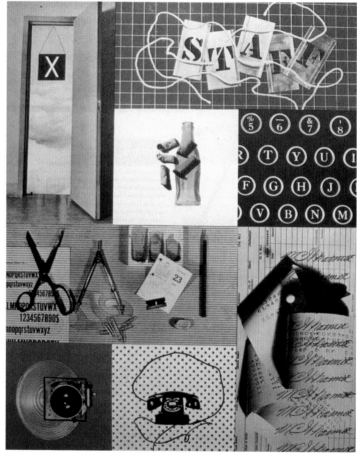

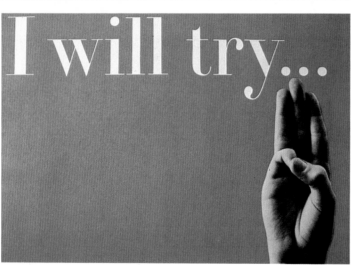

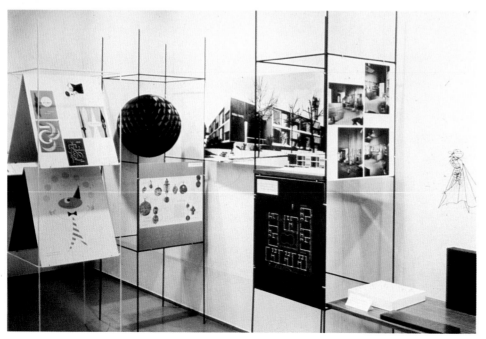

Clockwise from top left Cover of *Fortune* magazine (1946), a photomontage in which images are used for their abstract qualities. Cover for *Industrial Design 3* (1951). Book cover for *Franz Rosenzweig* (Noonday Press, 1953). Cover for *Look* magazine's in-house newsletter (1944–1945). Alvin Lustig's traveling exhibition (1949), originally mounted at New York's A.D. gallery and designed by Lustig. "I Will Try," catalog graphic for the Girl Scouts of America (1953).

and began exploring industrial design as well. In 1946 he returned to Los Angeles and for five years ran an office specializing in architectural, furniture, and fabric design, while continuing his book and editorial work. To hire Lustig was to get more than a cosmetic makeover. He wanted to be totally involved in an entire design program — from business card to office building. His designs for both the print materials and office interiors for Lightolier exemplify the strict and total unity of his vision.

Lustig is known for his expertise in virtually all the design disciplines, which he seamlessly integrated into his life. He designed record albums, magazines (notably the format and some covers of *Industrial Design*), advertisements, commercial catalogs, annual reports, and office spaces and textiles. In the late forties he designed a helicopter for Rotoron, a pioneering though short-lived aerospace company. In 1950 he was commissioned by Gruen and Associates, a California architectural firm headed by the Viennese architect Victor Gruen, to design the coordinated signage (entrance and parking lot signs and watertower) for J. L. Hudson's Northland in Detroit, the first American shopping mall. As evidence of his eclecticism, around 1952 he designed the opening sequence for the popular animated cartoon series *Mr. Magoo*. In 1953 he designed various print materials for the Girl Scouts of America and transformed aspects of their graphic identity from homespun quaintness to sophisticated Modern. He was passionate about design education, and developed design courses and workshops for Black Mountain College in North Carolina and the design department at Yale. Yet for all his accomplishments, he wanted most to be an architect, for which he had neither the training nor the credentials.

Although Lustig's work appeared revolutionary in the 1940s, he was not the radical that critics feared. His design stressed the formal aspects of a problem, and in matters of formal practice he was precise to a fault. In his essay "Contemporary Book Design" (*Design Quarterly*, no. 31, 1954), he notes: "The factors that produce quality are the same in the tradi-

tional and contemporary book. Wherein, then, lies difference? Perhaps the single most distinguishing factor in the approach of the contemporary designer is his willingness to let the problem act upon him freely and without preconceived notions of the forms it should take." While the early Moderns vehemently rejected the sanctity of the classical frame — the central axis — Lustig sought to reconcile old and new. He understood that the tradition of fine bookmaking, for example, was closely aligned with scholarship and humanism, and yet the primacy of the word, the key principle in classic book design, required reevaluation. "I think we are learning slowly how to come to terms with tradition without forsaking any of our own new basic principles," he wrote in "Personal Notes on Design." "As we become more mature we will learn to master the interplay between the past and the present and not be so self-conscious of our rejection or acceptance of tradition. We will not make the mistake that both rigid modernists and conservatives make, of confusing the quality of form with the specific forms themselves."

Lustig's covers for Noonday Press (Meridian Books), produced between 1951 and 1955, avoid the rigidity of both traditional and Modern aesthetics. They serve as signposts for the direction his general design had taken. At the time American designers were obsessed with the new types being produced in Europe — not just the modern sans serifs, but recuts of old gothics and slab serifs —

Top to bottom Book jackets for New Directions Classics series: *Selected Poems of William Carlos Williams* (1950); *Muriel Rukeyser, Selected Poems* (1949); *The Longest Journey* (1946); and *Exiles* (1945).

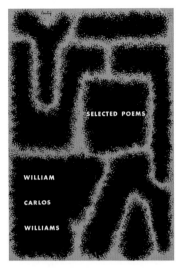

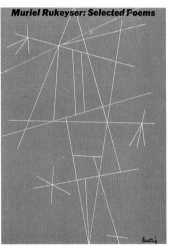

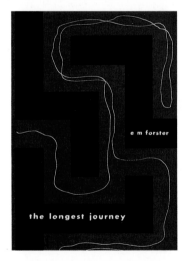

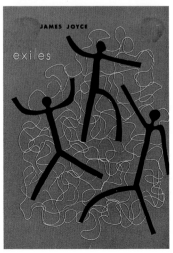

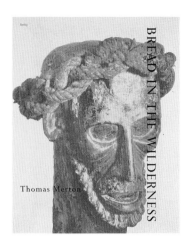

Top Book cover for *Bread in the Wilderness* (Meridian Books, 1952). Lustig designed the entire book in a cinematic fashion. *Bottom* Pages from *Ghost in the Underblows* (Ward Ritchie Press, 1940), one of Lustig's masterpieces of typecase composition, influenced by Frank Lloyd Wright.

which were difficult to obtain in the United States. Lustig ordered specimen books from England and Germany that he would photostat and either piece together or redraw. These faces became the basis for more eclectic compositions. Lustig also became interested in, and to a certain extent adopted, the colder Swiss approach. Perhaps this accounts for the decidedly more quiet look of the Noonday line. To distinguish these particular books, which focused on literary and social criticism, philosophy, and history, from his New Directions fiction covers, he switched from pictorial imagery to pure typography set against flat color backgrounds. The typical paperback cover of that era was characterized by overly rendered illustrations or thoughtlessly composed calligraphy. Lustig's subtle economy was a counterpoint to the industry's propensity for clutter and confusion.

Lustig's work reveals an evolution from an experimental to mature practice — from total abstraction to symbolic typography. One cannot help but speculate about how he would have continued had he lived past his fortieth year. Diabetes began to erode his vision in 1950 and by 1954 he was virtually blind, yet even this limitation did not prevent him from teaching or designing. After learning that he was losing his vision, he invited his clients to a cocktail party in order to announce it to them, and give them the option to take their business to other designers. Most remained with Lustig. Philip Johnson, a key client and patron, even contracted Lustig to design the signs for the Seagram's building. His wife, Elaine Lustig Cohen, recalls that he fulfilled his obligations by directing her and his assistants in every meticulous detail to complete the work he could no longer see. He specified color by referring to the color of a chair or sofa in their house and used simple geometries to express his fading vision.

In the 1950s, Lustig decided to emigrate to Israel, not from any religious conviction, but because he believed that in this infant state good design could exert a significant impact on society. But Lustig died in 1955 before he had the chance to test this theory. Instead, he left behind a body of unique design that stands up to the scrutiny of time, and models how a personal vision wedded to Modern form can be effectively applied in the public sphere.

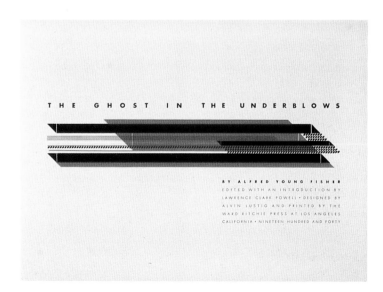

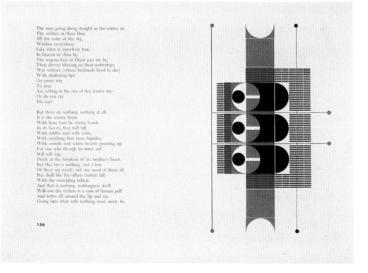

Clockwise from top left Chair
designed by Lustig for Paramount
Furniture, Los Angeles (1949). Textile
designed by Lustig while in Los
Angeles (1949). Lighting designed by
Lustig in 1949. Sign system design
for the American Crayon Company's
promotion in Aspen, Colorado (1952).

NIKE

Just Doing It

BY ERIC LA BRECQUE

am standing in what might best be described as the Temple of the Air Huarache. It is a vestibule inside Nike Town in Costa Mesa, California, one of four such showcases Nike has developed over the past four years. Set into the floor of the cylinder-shaped chamber, a stainless-steel disk several times larger than a manhole cover bears the globe-themed logo of Nike International, an elite line of running shoes. Wall panels describe a minimalist design approach inspired by the huarache, the traditional leather sandal of Mexico. Large-scale photographs show athletes wearing the product, and four small Plexiglas display cases each present a single shoe. I can't help but contemplate the shoe as sculpture, precious as Cinderella's glass slipper, essential as one of Plato's ideal forms.

The 30,000-square-foot environment is more than a high-concept retail outlet in which every fixture is custom designed. It is also part theater, gallery, hall of fame filled with attractions. Plaques, artifacts, and life-size sculptures made of white-painted resin, in some cases suspended in air by cables, commemorate the athletes who have helped to build the Nike brand. On a monitor, visuals assembled from various product research and development sources create techno-imagery entertainment.

Not every company can pull together such a cohesive and articulate retail environment. The organization must have a well-defined sense of itself as well as a rich visual universe to draw upon. In this setting, at least, Nike's rivals that of a major entertainment company. Nike Town is the one store that can accommodate the full range of Nike merchandise and display all of Nike's design disciplines at once. Nothing could better epitomize how design is integrated through all aspects of Nike, Inc.

For all its completeness, of course, Nike Town is only one manifestation of the Nike image. The company first captured the American imagination with a series of groundbreaking advertising campaigns beginning in the early 1980s.

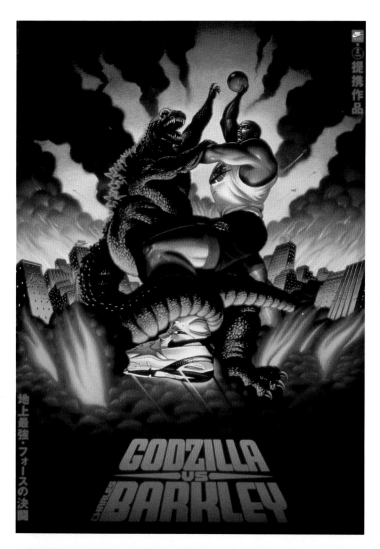

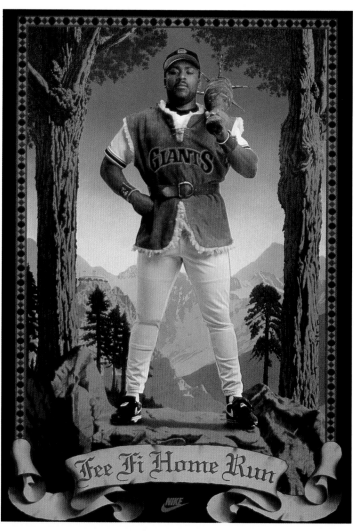

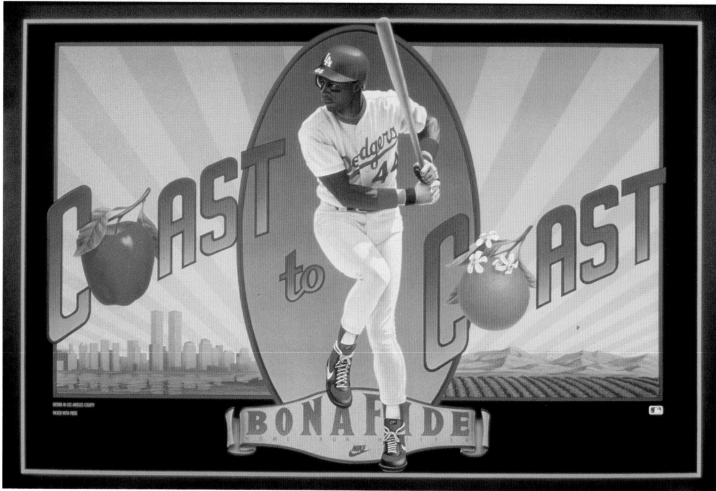

"The ad campaigns redefined what you can do in shoe advertising," says *Graphis* publisher Martin Pedersen, one of the AIGA judges who selected Nike for the 1993 Design Leadership award. "Up until the Nike campaigns, shoe advertising was abominable — nobody remembers what it looked like. It took an enormous amount of courage and savvy to make those campaigns happen."

Adds Meredith Davis, head of graphic design at North Carolina State University and another of the AIGA's judges, "Nike's ads not only hold together well as a campaign, but hold the corporate identity long after you've seen the work. It doesn't look like they rely on any formula. They're constantly reinventing their relationship to the market. They have a good sense of the visual culture in which their audience lives."

With the exception of the three years in the 1980s in which Nike's television business went to the Chiat/Day agency, its advertising has remained in the hands of Wieden Kennedy & Associates in Portland, Oregon. It has been a symbiotic relationship: The Nike account launched the agency, and the agency launched Nike.

Technically accomplished and brilliantly conceived, campaigns such as "Just Do It" and "Bo Knows" have also made consummate use of celebrity. One of Nike's greatest accomplishments in building its market-driven image has been its ability to develop celebrity personalities and then to incorporate them into its own. Ultimately, the campaigns have gone beyond selling more shoes than anyone could have imagined. They have also helped to fuel the athletic shoe's heraldic status in contemporary American society.

It's hard to say which caused the sneaker's elevation in status: aggressive marketing and inspired advertising by Nike and other companies or America's discovery of the athletic shoe as an ideal reflection of our essential selves. Whichever the case, the combination resonates in our collective psyche. Our sneakers mean a lot to us. They manifest many of our better traits — our esteem for fitness, well-being, and the positive aspects of competition — and, at times, our negative ones. Sneakers have become such important status symbols in some inner-city neighborhoods that a young person might feel compelled to get a new pair every three weeks. At more than $100 apiece, it's an expensive addiction.

Tallying up nearly $4 billion in sales in 1993, Nike is the world's largest footwear manufacturer and its namesake brand the most successful in its industry today. The impor-

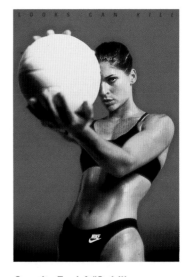

Opposite: Top left "Godzilla vs. Barkley" poster (1992). Designer: John Norman. Illustrator: Jessel. *Top right* "Fee, Fi, Home Run" poster (1991). Designers: Ron Dumas, Michael Tiedy, Jim Nudo. Illustrator: Robert Florzcak. Photographer: Gary Nolton. *Bottom* "Coast to Coast" poster (1992). Designers: Ron Dumas and Jim Nudo. Illustrator: Rick Lovell. *This page: Top* "Looks Can Kill" poster of television ad (1993). Designer: Michael Tiedy. Photographer: Peggy Sirota. *Bottom* Poster commemorating the opening of Nike Japan store in Harajuku area (1993). Illustrator: Gerald Bustamante.

Top All-Condition Gear logo. *Center* Air Huarache logo. *Bottom* Total Body Conditioning logo.

tance of design to the firm's success is readily acknowledged. A remark by chairman and founder Philip Knight is often cited to support the premise that good design is good business: "Design, in its broadest sense, means life or death for a company."

Who would have guessed all of this from the Nike of twenty or even fifteen years ago?

The now ubiquitous "Swoosh" symbol was developed in 1971 by a graphic design student named Carol Davidson. It cost the company exactly $35; Davidson set the fee herself. (Some years later, a party was thrown in her honor and she was compensated further.) Despite less-than-enthusiastic response from the company's decision-makers at the time, the "Swoosh" caught on with distributors and customers. It has remained Nike's brand mark ever since.

The company began to get serious about image-building with the arrival in 1977 of Robert Strasser, its first marketing director, and graphic design consultant Peter Moore. The two laid the foundation for the Nike image we know today. From an initial assignment to develop a single poster, Moore went on to design all of the company's collateral items, and to advise on image matters.

By 1984, Moore, already functioning as Nike's creative director, joined the in-house staff. There, among other things, he designed the logo and packaging for Air Jordan, the line built around basketball superstar Michael Jordan. The company's capabilities in environmental design and architecture were firmly established with the addition in 1989 of Gordon Thompson III, designer of the first Nike Town in Portland, Oregon.

Ronald Dumas, who succeeded Moore in 1987, came to Nike as a senior designer with Moore in 1984 (as one of a staff of eight), after having worked on the Nike account with Moore since 1979. The graphic design staff now numbers some forty graphic designers, writers, and illustrators. (Approximately 3,500 employees work at Nike World Headquarters in Beaverton, Oregon.)

Nike's product lines have proliferated along with its graphic design staff, which

keeps busy creating a constellation of logos for them. Besides the "Swoosh," which serves as the corporate logo and Nike brand mark, Dumas identifies two other types of mark: those for distinct businesses, such as Golf, Kids, or outdoor footwear and apparel; and those cutting across business categories to identify the technology behind the product, as with Nike Air, Air Maxx, and Huarache. "It just helps break up the hundreds of products we design into meaningful groups, and it helps us to build a story around them," says Dumas.

"The Nike brand logo hasn't changed and won't change," he continues. "These other logos are much shorter-term in most cases. They react to market conditions, or are even athlete-driven, like Jordan. Some, like Air Jordan and maybe ACG, we've embraced for such a long time, and put so much money behind, that they have become meaningful marks in their own right."

As identities go, Nike's is generous — one is tempted to say organic. Working with it is more a matter of orchestration than management. Considered in isolation, any given Nike product, environment, advertisement, or package design is unmistakably part of the whole, but that whole — the "Nike look" — isn't so easy to qualify.

Says Dumas, "The interesting thing about Nike is that people recognize it, but outside of very basic rules about the corporate logo, there are no rules. In a way, that's what makes the image work, part of what keeps it fresh. It's not as buttoned down as a lot of corporations'. There are certain collection marks, and there are ways we want to handle type around them, but coloring and other things are controlled through the product development process. You don't goof around with the Swoosh, but outside of that, you have a lot of freedom."

For guidance, designers can turn instead to a set of attributes that form Nike's philosophical underpinning: innovation, youthfulness, irreverence, fun, authenticity, winning, and American. All derive from the same gestalt: "authentic sport."

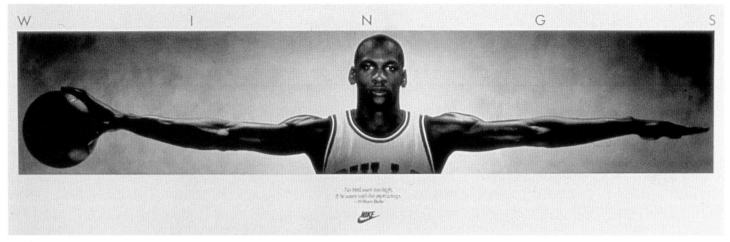

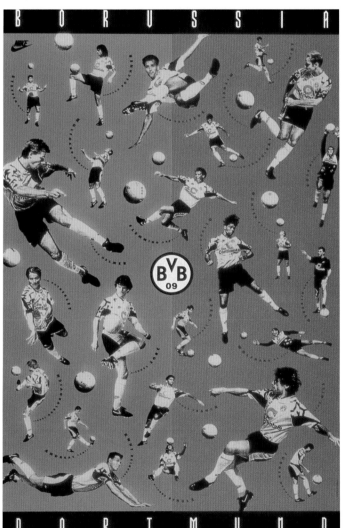

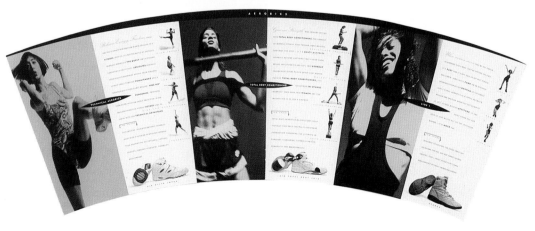

Top "Wings" poster (1991). Designer: Ron Dumas. Photographer: Gary Nolton. *Center right* "International Basketball" poster (1992). Designer/illustrator: John Norman. *Center left* "Dortmund" poster of German soccer team (1992). Designer/illustrator: Jeff Weithman. Photographer: Richard Corman. *Bottom* "It's Time" brochure (1993). Designer: Valerie Taylor-Smith. Photographers: Gary Hush and Cliff Watts.

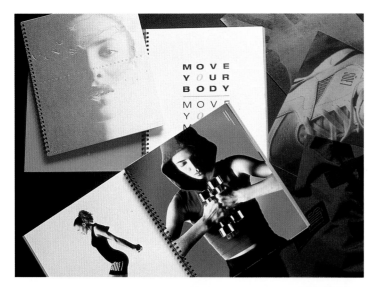

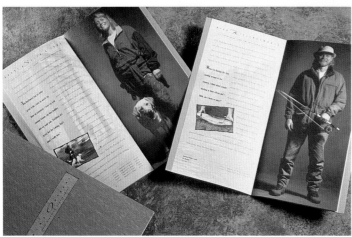

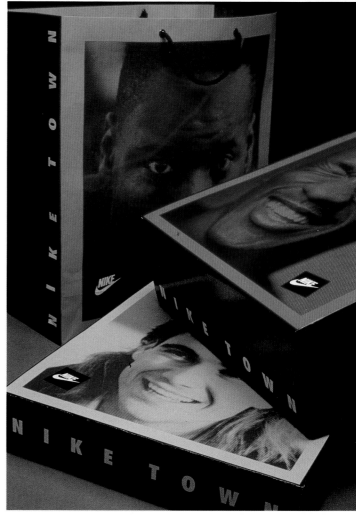

At Nike, design disciplines are organized
in two broad categories: Product Design, under
the creative direction of Tinker Hatfield; and
Image Design, under Gordon Thompson III.
Graphic design, environmental design (which
includes merchandising and retail design),
writing, film and video, illustration, and multi-
media are all discrete groups within the
85-person Image Design sector. The scope of
last year's 3,000 or so graphic design projects
ranges from invitations to 250-page catalogs
for international markets to the company's
44-page annual report. Dumas's group designs
all logos, collateral items, sales literature, hang
tags, and point-of-purchase displays for its
retail accounts. Graphic designers also work
closely with designers in the environmental
group on Nike Town's displays, sconces, sign-
age, and furniture. The illustration staff illus-
trates all of the apparel for the sales catalog

and designs all of the 50 to 60 retail posters
Nike produces annually.

All of this and shoe graphics, too.

Developing a shoe involves creative con-
tributions from several areas. Teams now come
together early — often during the naming of
products and categories. A logo may be devel-
oped while a product is being confirmed. "It
used to be that you got the shoe and kind of
stuck the logo on there," says Dumas. "You
might see the actual product, or you might not.
Now we're trying to bring the design disciplines
together more closely, and earlier in the
process."

It's the graphic designer's job to sit with
the product designers and translate their inspi-
ration. A shoe might have a retro, aggressive,
or rounded feeling — sometimes inspired by a
particular athlete. Designers must also consider
every place the graphics will appear. "We

know that whatever's on the shoe is going to be translated to point-of-purchase, packaging, hang tags, Nike Town — all the way down the food chain," Dumas says. "It's often a balancing act between something that works really well on a product but that also works well in literature, print, posters. It has to be reproducible. That's not difficult with print, but when you're talking about rubber patches or embroidery, it gets more challenging."

The biggest challenge facing Nike isn't a matter of design per se, however, but of organization. The 1993 Graphic Design Leadership Award comes at a transitional time for the company. As its worldwide operations grow, Nike is striving to establish itself as a truly global brand. In Dumas's estimation, the transition won't be easy. "The challenge is, how do you keep a feel for who you are as your company grows and relates to different cultures?" he says. "It's a transition that other companies in the past haven't handled too well. But I do think other cultures relate to fun, irreverent, winners — the things that Nike's all about."

In presenting Nike with the leadership award at this time, the AIGA recognizes the company's promise for making this transition with exemplary élan. Graphic design at Nike is not a fussy entrepôt of corporate will but an agent for strengthening the business, and an integral part of the ongoing corporate dialog.

As the ads say, there is no finish line.

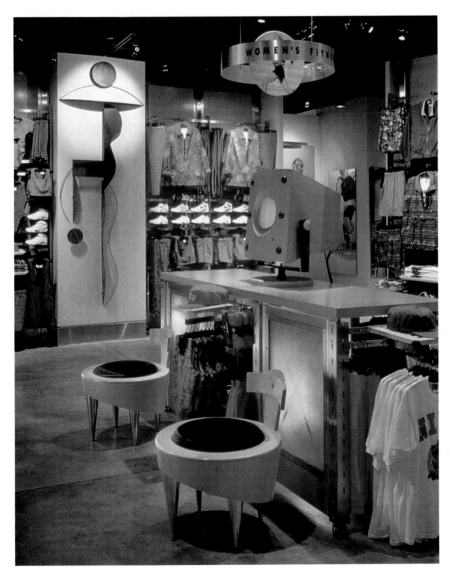

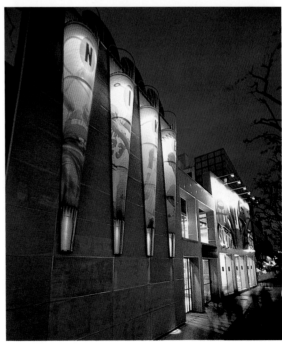

EX LIBRIS

100 International Contemporary Bookplates

BY DANA BARTELT

The Raleigh chapter of the American Institute of Graphic Arts invited artists from around the globe to participate in the *100 International Contemporary Bookplates (Ex Libris)* exhibition. Some of the artists whose work was accepted are experienced bookplate designers, such as Peter Ford of England and Peter Israel of Germany, while others designed their first bookplate specifically for this show. Participants range from internationally famous designers (Kazumasa Nagai of Tokyo, Seymour Chwast of New York, and Jirí Slíva of Prague, to name a few) to students studying the art of bookplate design. (Karla Hammer produced her bookplate while participating in the North Carolina State University Summer Study in Prague Program at the Academy of Applied Arts.)

First placed in valuable handmade books, bookplates have been around for more than five hundred years. Although styles and techniques may have changed over time, according to James P. Keenan of Cambridge Bookplate, the concept remains the same: "to complement treasured volumes and to act as a guardian for prized possessions. An ex libris is essentially a personalized logo identifying the owner of a collection of books" (*American Artist*, May 1992).

Traditionally, an ex libris reflects the owner's work, character, or interests and the way the artist of the bookplate interprets these attributes. The design by Gabriel Ellison of Zambia evolved from her interest in preserving the natural environment of her country. Those familiar with the work of Kit Hinrichs will readily recognize his American flag theme. István Orosz of Hungary produces bookplates in the style of the artist M. C. Escher, himself an ex libris designer.

This collection shows the diversity of artistic techniques and expression used in bookplate design. Techniques range from woodcut, engraving, lithography, and letterpress to offset, original drawings, paintings, photography, and computer printouts. Some designs are simple initials or intriguing images such as Shigeo Fukuda's angelic figure

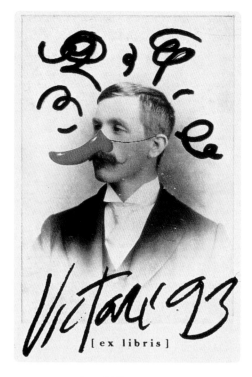

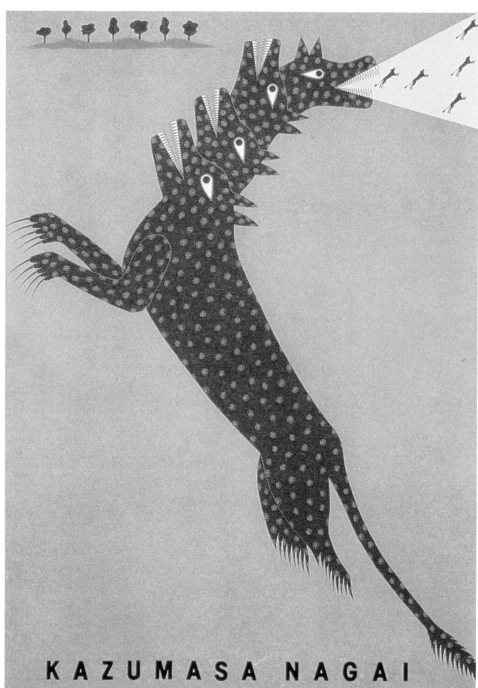

EX LIBRIS

KAZUMASA NAGAI

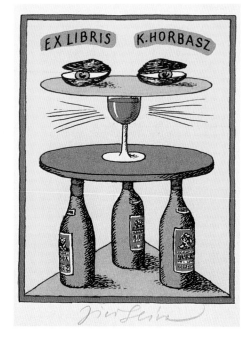

Top left James Victore, New York,
New York. *Top right* Kazumasa
Nagai, Tokyo, Japan. *Bottom right*
Dana Bartelt, Raleigh, North Carolina.
Bottom center Jirí Slíva, Prague,
The Czech Republic. *Bottom left*
Molly Renda, Durham, North Carolina.

representing Japan, whose wings make up the hemispheres. He and a few others chose to omit the traditional words "ex libris."

Today, there are many enthusiastic designers and collectors, and bookplate societies exist around the world. Six entries in this exhibition were submitted by members of the Estonian Bookplate Society. The American Society of Bookplate Collectors and Designers was founded in 1922. Another organization, the Cambridge Bookplate, directed by James P. Keenan, sponsors exhibitions and publishes *American Artists of the Bookplate*, a directory

providing information about bookplate artists to international collectors and potential clients.

With the advent of television, video, and especially paperbacks, the sense of the hardcover book as a treasure may be diminished. But to the many who still appreciate a well-written, illustrated, and designed book, this exhibition stands as a celebration and proud expression of ownership — of an object of art in every sense of the word.

Photographic reproduction by Bruce DeBoer at Erickson Productions, Raleigh, North Carolina.

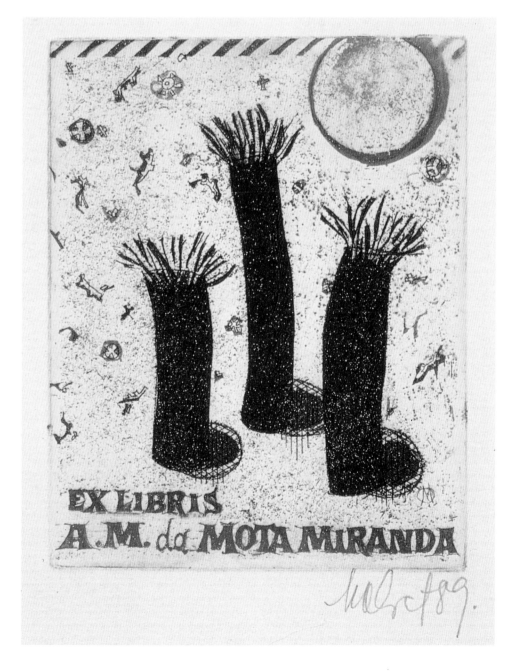

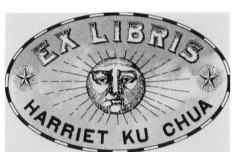

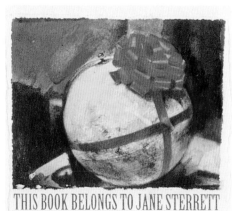

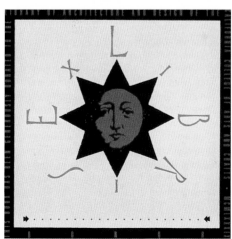

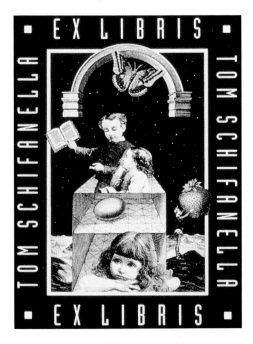

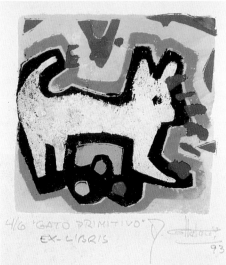

Ex libris Dr. Albrecht Scholz

Top left Tom Schifanella, Jacksonville, Florida. *Top right* Peter Israel, Neugersdorf, Germany. *Bottom right* Joani Spadaro, Raleigh, North Carolina. *Bottom left* Shigeo Fukuda, Tokyo, Japan. *Center left* Raul Cattelani, Montevideo, Uruguay.

Top left Takis Katsoulidis, Athens,
Greece. *Top right* Peter Ford, Bristol,
England. *Center right* Karla Hammer,
Raleigh, North Carolina. *Bottom
right* Kit Hinrichs, San Francisco,
California. *Bottom center* Zhong Yi
Sun, Shenyang, People's Republic
of China. *Bottom left* Gabriel Ellison,
Lusaka, Zambia. *Center* John Evans,
Dallas, Texas.

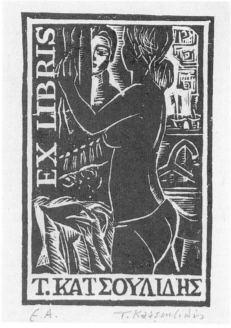

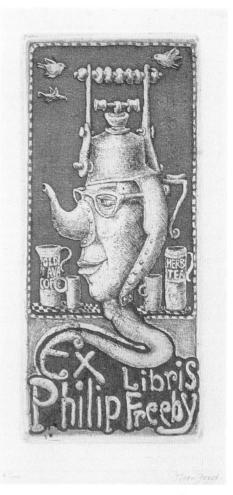

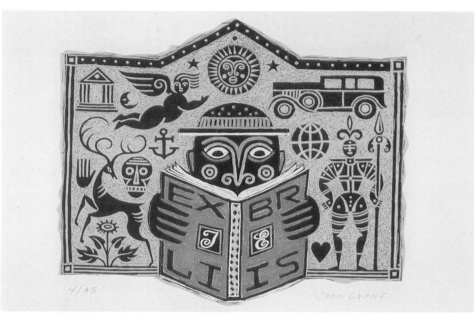

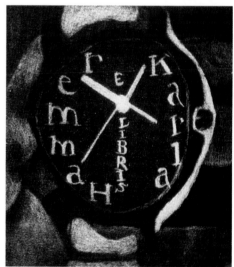

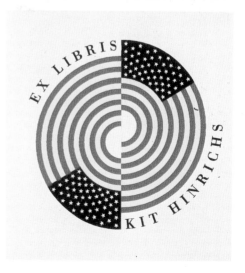

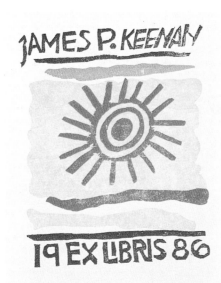

JAMES P. KEENAN

19 EX LIBRIS 86

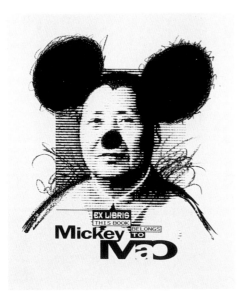

EX LIBRIS
THIS BOOK
Mickey BELONGS TO Mac

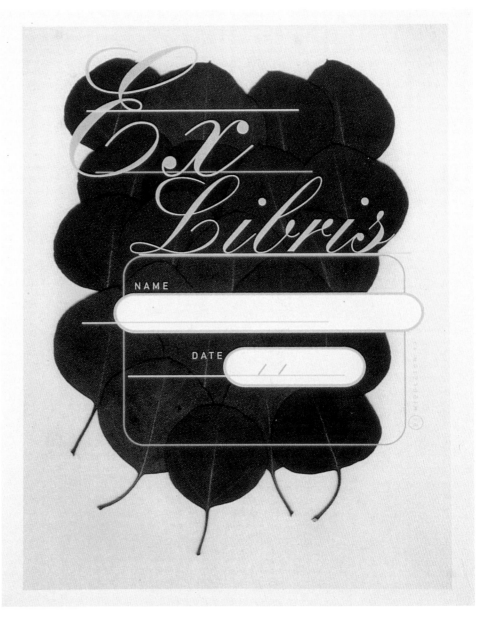

Ex Libris

NAME

DATE

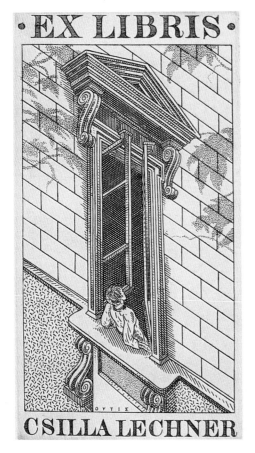

· EX LIBRIS ·

CSILLA LECHNER

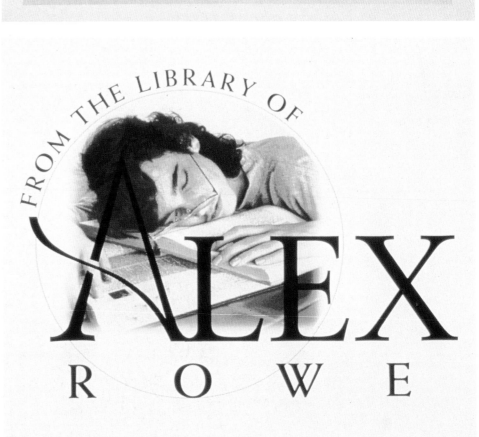

FROM THE LIBRARY OF

ALEX
ROWE

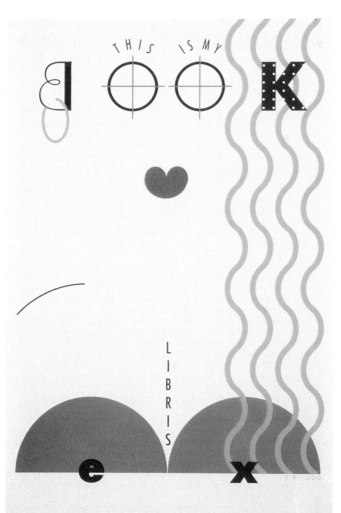

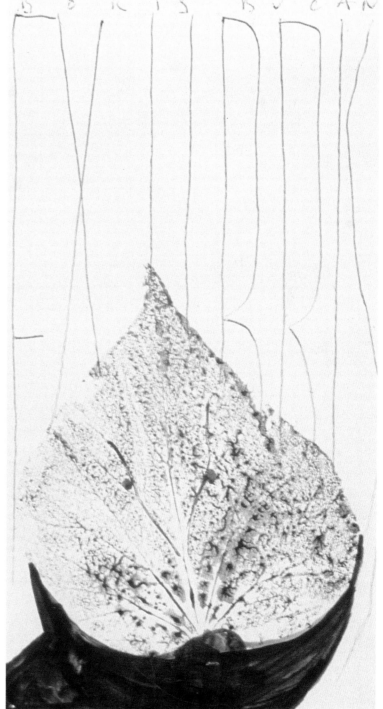

Facing page: Top left Wang Hui Ming, Amherst, Massachusetts (lent by James P. Keenan, Cambridge Book-plate). *Top right* P. Lyn Middleton, Pasadena, California. *Bottom right* Robert Rowe, Huntington, West Virginia. *Bottom left* István Orosz, Budapest, Hungary. *Center left* Stefano Rovai, Florence, Italy. *This page: Top left* Ellen R. Hood, Raleigh, North Carolina. *Right* Boris Bucán, Zagreb, Croatia. *Bottom left* Seymour Chwast, New York, New York.

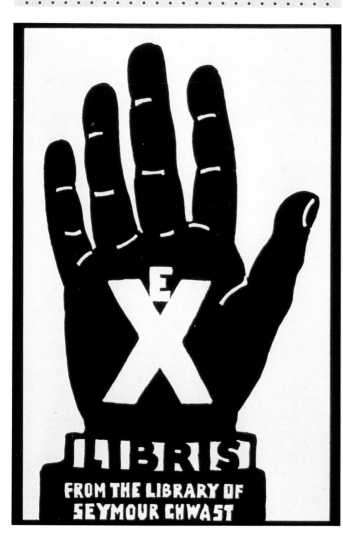

THE YEAR IN GRAPHIC DESIGN

The Search for Meaning

BY MOIRA CULLEN

At no time in graphic design's brief but vivid history has the present posed so great a challenge to the future. The practice looks on as converging technologies and disciplines force a collision of competitive industries. Exhilaration or entropy? Will communications designers choose to ride the wild evolutionary beast in search of uncharted horizons or huddle, backs to the wind, against the sweeping forces of inexorable change?

"Profound and powerful forces are shaking and remaking our world. And the urgent question of our time is whether we can make change our friend and not our enemy. We know we have to face hard truths and take strong steps. Instead, we have drifted" (President Clinton, Inaugural address, January 1993). Nearly two years have passed since a new president voiced this bold challenge. America was swept up in the symbolism of the day as the nation took a collective pause to recognize change. Cynicism and apprehension tethered a fragile euphoria. Only months before the inauguration, Los Angeles was racked by riots, Miami was left stunned by a devastating hurricane, war spread to Sarajevo, American troops hit the beaches of Somalia, and IBM, immutable fortress of job security, announced that it would slash its workforce by 40,000 employees.

Change? The country was steeped in it. Perhaps with a changing of the guard, a new generation of leaders armed with promises of inclusion and empowerment, and a poet at the podium who proclaimed a season of renewal, America would recover from what was surely a temporary disruption, a blip on the screen.

After all, it was just the economy, a mild recession. There were even signs that design had an advocate in the White House, as a transition team hosted a designer roundtable immediately after the elections, from which came proposals for government and industry support of design's strategic value. So strong was the hope that in January 1993, a majority of Americans believed that government would create a significant number of new jobs. Just one year later, many feared losing the jobs they had.

A public intoxication with the new that blurred much harsher realities soon gave way,

in a series of missteps, fumbles, and failings, to the sober realization that current crises were structural rather than cyclical. It was time to get real. We had entered a phase as critical as it was transitional: time to rethink, retool, reinvent, and redefine.

No industry, no profession, no individual was immune. Not even the landscape was spared. Unbridled nature punctuated the theme of upheaval throughout 1993 and into 1994 as torrential rains and floods rerouted the rivers of the Midwest; earthquakes, fires, and mudslides carved out parts of Los Angeles; and blizzards and record snowfalls paralyzed the East.

Doggedly, a stagnant economy dragged on while industry continued to rightsize itself, trimming costs and shedding workers at an alarming rate. Though the boom years of the 1980s were history, many designers and firms, still flush from those heady times, were able to ride out the slump for a while. Thousands of other designers, finding themselves suddenly out on their own, used severance pay or savings to set themselves up as independent contractors, joining a pool already saturated with freshly trained students and assorted freelancers in a highly mobile, economically formidable, competitive but temporary workforce.

Finally, the economy turned the corner. Business rebounded late in 1993; by January 1994, Democrats were trumpeting the success of their economic policies, claiming the most productive first term in office in national history. With a 95 percent rise in consumer confidence and unemployment rates at their lowest levels since 1991, the numbers were there.

But appearances proved deceptive. This was a qualified recovery, for in recent years, the economy had hollowed out and radically changed form. Some likened it to a barbell with a growing number of low-paid service workers at one end and highly paid information providers at the other. Those whose skills lay at points in between occupied a narrow, highly competitive band of limited opportunities for real career growth.

The economic trend had its counterpart in design. The increasing need for designers to differentiate themselves from the competition was

redefining the food chain and segmenting the practice. A collaborative group of highly trained, well-compensated designers as planners, strategists, and conceptualizers emerged at one end. Next came formally trained and technically skilled mid-level practitioners who were able to structure more complex communications problems, followed by an ever-expanding block of designers with interchangeable production skills. Put simply, design was fast becoming a concept or commodity, with designers as the creators or implementors.

Under pressure to maintain profits by slicing labor costs, many companies made the contracting of independent workers a permanent rather than a temporary condition. To meet the demand, design recruitment firms opened subsidiaries to place freelancers at all levels of the communications process: as desktop publishers, comp assemblers, copywriters, proofreaders, designers, art directors, sales, marketing, and media professionals, account managers and administrators.

This was a new economy. Across the country, designers found that as business picked up there were jobs, but not the same jobs. Budgets were tighter, margins slimmer, and many clients — especially those in the tourism, construction, and aerospace sectors — were hit hard by the recession, acts of nature, or both. Some now had need for design but little to spend. Firms competed with independents, who competed with in-house design departments, who competed with desktop publishers. Inevitably, some competed on spec.

Increasingly, more substantial jobs went to designers or firms who distinguished themselves by providing strategy and marketing support. Designers-cum-entrepreneurs began working out other deals, forming equity partnerships with their clients based on principles of risk and reward, a secret fashion designers have long understood. Success, wealth, and fame come to those who sell not the dress but the design, and the thinking behind the design.

Across the country, designers for the most part were busier but not necessarily earning more. And with technology now geared to six-month cycles of obsolescence, the frequent

spending on upgrades required just to stay in the game became a constant financial strain.

Nonetheless, the computer found its rightful place as a tool, not a toy. Its ubiquitous use seemed to defuse the temptation to grandstand with tricks or in-your-face graphics, and the pendulum swung back to sober, honest, effective design. But many designers missed something in the process. A craving for the simple joy of making led to a backlash of "back to design" weekends and retreats. Designers reveled in the sensual — hand, surface, texture, paper — to reunite with their first love — the direct tactile experience of designing, which had become an activity where plastic buttons moved glowing points of light behind a lifeless sheet of glass.

Are we designers or communicators? Behind the economy lay murky questions of identity and meaning, intangible issues of convergence and content. What will it mean to be a designer in the twenty-first century now that the boundaries of dimension, skill, or media that defined disciplines have all but vanished? What will be the value of design in a digital, wireless world where products like information and images are fluid?

America was asking similar questions of itself. As the balance of power in the post–Cold War world shifted from military force to economic might, what role would America play on the global stage? Would our frontier independence mesh with a cooperative new world order? One by one countries split off, were renamed, or cleaved apart. Loyalties wavered, new trade blocks were formed. Archrivals were cautiously viewed as allies. Who now was the enemy?

At home, a third wave of immigration of staggering proportions and diversity strained the myth of the American dream, challenging the very notion of freedom and justice and access for all. Rather than melting differences, the complexities of cultures clashed, sparking poverty, crime, and violence. Who was an American? Whose family values? We were frayed around the edges. Could we be one nation? Were there common values all of us could share?

Designers sought desperately to fend off the onslaught of interlopers into their own private domain. But once publishing and illustration

software for Macintosh and Windows fell into the hands of the masses, there was no barring the gate. Surprise attacks came from all sides. Fine artists, their own profession in turmoil, crossed over to snatch bread from the mouths of designers. And when NBC invited a group of creatives to modernize its peacock, not one graphic designer was among the big-name digital and fine artists, animators, and cartoonists supplying ideas. Certification may be an ineffective tactic against such encroachments. As John Perry Barlow commented in "The Economy of Ideas" (*Wired*, March 1994), "The more security you hide your goods behind, the more likely you are to turn your sanctuary into a target."

As rising nationalism and protectionism flared world-wide, efforts to temper change and protect cultural identity barred entry to the unfamiliar, the foreign, and the new, whether they be people, products, language, or ideas. "Each country has the right to define its own images, " declared France's President Mitterrand, who, determined to block the threat of American cultural hegemony, threatened the signing of the international trade agreement in December 1993. Conventional products of an industrial economy — wheat, automobiles, computers — were no longer at issue. The critical commodity was images, specifically film and audiovisual services, which after aircraft are America's second-largest export.

It was fast becoming clear that in a more fluid economy, the notion of "product" would take on new meaning. Both markets and technology will need to develop before real guidelines for pricing and control can be established, especially in the ether zone of multimedia and electronic rights. At the end of the project, who owns the disk and to whom does authorship belong? Can ideas be possessed or are they merely rumors passed on freely by all? The debate was on and designers began to explore the values and limitations of this new currency. Print, which will remain a viable though less important element of the media mix, will also be affected.

Scientists announced that they had cloned the first human embryo. A later Supreme Court ruling gave designers food for thought on the subject of rights and appropriation. The case: the

rap group 2 Live Crew's recombinant mix of Roy Orbison's "Pretty Woman." The court ruled that parody was a form of social commentary and thus constituted fair use of the original under the law. But in a time when images, more than words, are often the message, ethics and accuracy must rule over aesthetics. For once digitized, all data is unstable, allowing hybrid photos and electronic alterations to pass off fiction as truth.

And truth is hard enough to come by. Diversions and obstacles to progress conveniently appear. Just after Vice President Gore announced government plans to realize an information superhighway by the year 2000, just as the nation prepared to tackle the core issues of health care and welfare reform, national interest took a sharp turn to Whitewater, Arkansas, to pursue instead a media frenzy of sensationalist scandal.

Resistance to change takes many forms and the design community succumbed to similar sidetracks, attaching their anxieties about the future to incidents and personalities rather than issues. What prevailed was a desire for drama, the juicier story — anything but facing the rumor that the practice of graphic design might not survive the transition to the next century. Headlines predicted the death of advertising in the digital age. Could graphic design be far behind?

And so, like bipartisan bickering on the Hill, the outbursts among graphic designers began. Tensions between generations, genders, and ideologies swelled and sank in a rhythm of tirades, filibusters, and aspersions cast on quality and competence.

And just as Americans were wary of government's capacity for leadership and reform, designers turned a critical eye on their own professional organizations, venting frustration and concern that not enough had been done to reassure them that the profession would remain intact. Designers were looking for vision and guidance for the future, not beauty contests dressed as competitions or conferences that on the surface lacked conviction more than contradiction. The AIGA bore the brunt of the attacks. First it was the name. Graphic design, some thought, was outdated. The Code of Ethics? It

was ineffectual and possibly illegal. Were organizations even relevant to designers' needs or had they, like government, grown to sustain only themselves? These were difficult times.

Sadly, designers continued to feel powerless, ignored, and misunderstood despite the fact that great strides had been made to educate business, government, and culture on the value of design. Chrysler-Plymouth inaugurated an Innovation in Design award offering $10,000 to six designers last September; *Fortune* magazine and the American Center for Design teamed up to create the Beacon Awards to recognize integrated corporate design programs; and the Scholastic Art & Writing Awards, which draws nearly a quarter of a million entries from students across the country in grades 7 through 12, decided to give equal weight to design in both its title and awards.

Even the Presidential Design Awards, which had languished in apathy since 1992, were presented in April 1994 and policy initiatives spawned at the design roundtable back in 1992 moved forward with renewed interest. Indeed, design had an advocate in Washington. The new chair of the NEA, former actress Jane Alexander, proved to be a design enthusiast and ardent supporter of the government-sponsored Design Arts Program.

Design also featured in several key museum shows while typography strode boldly off the pages of *Bazaar, Ray Gun,* and *Emigre* magazines, scrolled and flashed across millions of screens to star in assorted television commercials, and landed big-time in articles in *Time, Esquire,* and *The New York Times,* exposing new eyes to design's presence. Designers, not the public, may be the ones underappreciating themselves and the impact of design.

Around the country — and indeed, the world — conferences addressed the need for designers to reconsider what they do and why. In various groups they gathered in search of knowledge, support, and inspiration. Both the AIGA and the American Center for Design launched annual business conferences as the focus shifted from design for business to the business of design. In Aspen, the crisis of conscience that led to the 1993 gay rights boycott of

the International Design Conference was a memory. The 1994 conference, with fashion designer Alexander Julian as chair, was a celebration of both the body and design.

But if it was multimedia that was hot on everyone's lips, its meaning buzzed in virtually everyone's mind. Of all the components for change, this one had the most potential to transform. For its inherent promise was collaboration without hierarchy, direct interaction and individual choice. What will give shape to this new media? Shopping, sex, education, entertainment — it was too soon to tell. Current technology, though impressive, was still crude and unwieldy. Yet there was a certain innocence and naiveté to the experimentation. In presentation after presentation, rows of humming, hyper-powered machines lined the stage, bare backs of boxes exposed to the crowd in a snarl of wires, cable, and cords. Following the lead of the meta-communications-entertainment giants, people rushed to secure a piece of the unknown.

Should half the hype prove true, communication designers, as the mediators of culture, will have a major role to play. The emerging models are those of shared conversation, of scenario building, of media as theater, as designers balance the choreography of movement, sound, and content. Users become full participants in a self-directed journey; author and audience become one and the same.

But the untold story may lie encoded in a generation for whom the new media is not transitional but elemental. Forty years ago, another generation plugged in, amped up a driving language of individual expression, and unleashed a new world of creativity that continues to define the dominant culture of popular communication. "Technology is the rock and roll of the nineties," said Louis Rossetto, editor of *Wired.* The Mac is the new electric guitar.

Nineteen ninety-four was neither the best of times nor the worst. In retrospect, it may have been a watershed year when designers turned to look not behind them but ahead, raising the questions they no doubt are brave enough to face. "We must travel in the direction of our fears," the American poet John Berryman wrote. The future? Let's go there.

1
Magazine Cover *Rolling Stone ("U2/Bono")*
Art Director/Designer *Fred Woodward*
Photographer *Andrew MacPherson*
Design Firm/Client *Rolling Stone Magazine, New York, NY*
Publisher *Straight Arrow Publishers*

2
Magazine Cover *Rolling Stone ("Dana Carvey")*
Art Director/Designer *Fred Woodward*
Photographer *Mark Seliger*
Design Firm/Client *Rolling Stone Magazine, New York, NY*
Publisher *Straight Arrow Publishers*

3
Magazine Cover *Rolling Stone ("David Letterman")*
Art Director/Designer *Fred Woodward*
Photographer *Mark Seliger*
Design Firm/Client *Rolling Stone Magazine, New York, NY*
Publisher *Straight Arrow Publishers*

1

2

ISSUE 650 • FEBRUARY 18TH, 1993 • $2.50 • CAN $2.95

RollingStone

SCREAMING TREES · VAN HALEN · HENRY ROLLINS

Heeeeeeeerrre's Dave!

0 140235 3

07

3

1
Magazine Cover *Rolling Stone ("Inside Batman")*
Art Director/Designer *Fred Woodward*
Photographer *Herb Ritts*
Design Firm/Client *Rolling Stone Magazine, New York, NY*
Publisher *Straight Arrow Publishers*

2
Magazine Cover *Rolling Stone ("Artist of the Year, Sinéad O'Connor")*
Art Director/Designer *Fred Woodward*
Photographer *Herb Ritts*
Design Firm/Client *Rolling Stone Magazine, New York, NY*
Publisher *Straight Arrow Publishers*

3
Magazine Cover *Push! (Premiere Issue)*
Art Director *Lloyd Ziff*
Photographer *Edward Ruscha*
Design Firm *Push! Communications, Inc., New York, NY*
Client/Publisher *American Express Publishing*

4
Magazine Cover *L.A.X. ("The Art of Kitsch")*
Art Directors *Shan Ogdemli, David Willardson*
Designer *Shan Ogdemli*
Illustrator *Phil Hom*
Letterer *Peter Greco*
Design Firm *Ogdemli/Feldman Design, North Hollywood, CA*
Printer *Miller Graphics*

L.A.X

THE ART OF

Kitsch

1

2

1
Magazine Cover *Southbeach, May–June 1993*
Art Directors *Victoria Maddocks, Jaime Ferrand*
Photographer *Gallen Mei*
Design Firm/Client *Southbeach Magazine, Miami Beach, FL*
Printer *American National*

2
Magazine Cover *Pitt Magazine ("What's The Secret Behind...?")*
Art Director *Joseph Tomko*
Photographer *Andrea London*
Design Firm/Client *University of Pittsburgh, Pittsburgh, PA*
Printer *R.R. Donnelley & Sons Co.*

REVIEW 7

Exploring the
territory of ideas
and images
defined by the
worlds of design
education and
the design
professions.

10 Happy 60th. A fond look back at Art Center's early days.

Pasadena Brown's annual impact highlights our 1991 accomplishments.

2 A new director at Art Center (Europe), and an update on the new south wing.

No.7

Keith Haring's legacy includes a striking mural painted at Art Center.

4

8 A sampling of student projects ranging from typography to transportation.

Keith Haring (1958–1990)

4 **XX!st century** $7.50

Brodkey
Hitchens
Pinckney
Schuyler

Animal Life of Ideas
Do the Wrong Thing
The New Negro
Poems and Diaries

Buruma
Cockburn
Equi
Flavin
Hejduk
Judd
Kelley
Lebowitz
Merwin
Rieff
Ritchin
Sellars

Colonial Pop
The Yurok Indians
Men in Camisoles
Ossorio Sails
Adam and Eve
Real Furniture
Dirty Toys
Save the Children
Target Island
TV Confessions
Marshmallow Bombs
Life After Death

5 **WIRED** July/August 1993

Branchez!
Mitch Kapor Maps
the Digital Highway
Digital Domain:
IBM Goes Hollywood
Exclusive:
Peter Drucker Interview

Peter Gabriel
Cuts the First Interactive
Rock CD-ROM

(But
can you
still dance
to it?)

3

Magazine Cover *Art Center Review, Fall 1990*
Art Director *Kit Hinrichs*
Designer *Piper Murakami*
Photographer *Steven Heller*
Design Firm *Pentagram Design, San Francisco, CA*
Client *Art Center College of Design*
Printer *Color Graphics*

4

Magazine Cover *XXIst Century (Premiere Issue)*
Art Director/Designer *José Conde*
Photographer *Mike Kelley*
Design Firm *José Conde Design*
Client/ Publisher *XXIst Century, Inc., New York, NY*

5

Magazine Cover *Wired ("Peter Gabriel Cuts the First Interactive Rock CD-Rom")*
Art Directors/Designers *John Plunkett, Barbara Kuhr*
Photographer *Matt Mahurin*
Design Firm *Plunkett + Kuhr, Park City, UT*
Client *Wired Magazine*
Printer *Danbury Printing & Litho*

1

1

Magazine Cover *Los Angeles Times Magazine*
("Five x Five: New California Fiction")
Art Director *Nancy Duckworth*
Design Firm *The Los Angeles Times, Los Angeles, CA*
Client/Publisher *The Los Angeles Times*

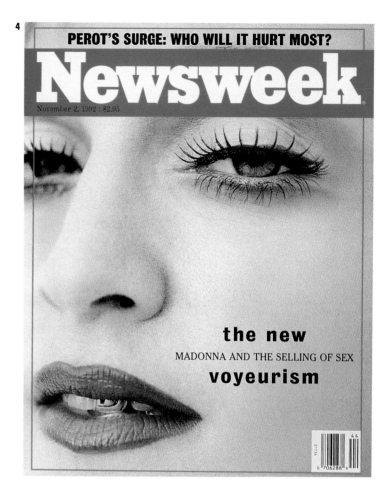

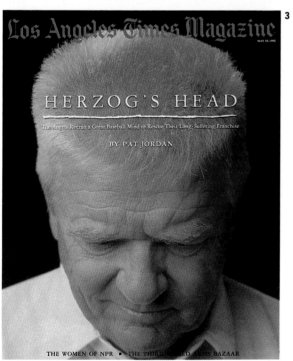

2

Magazine Cover *Los Angeles Times Magazine ("The Invisible Dad")*
Art Director *Nancy Duckworth*
Photo-Illustrator *William Duke*
Design Firm *The Los Angeles Times, Los Angeles, CA*
Client/Publisher *The Los Angeles Times*

3

Magazine Cover *Los Angeles Times Magazine ("Herzog's Head")*
Art Director *Nancy Duckworth*
Photographer *Mark Seliger*
Design Firm *The Los Angeles Times, Los Angeles, CA*
Client/Publisher *The Los Angeles Times*

4

Magazine Cover *Newsweek ("The New Voyeurism")*
Art Directors/Designers *Patricia Bradbury, Peter Comitini*
Photographer *Wayne Maser*
Design Firm *Newsweek, Inc., New York, NY*
Client/Publisher *Newsweek, Inc.*

1

Does it exist — or
do bad things just happen?

JUNE 18, 1990

$2.50

2

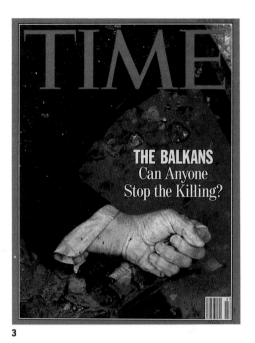

THE BALKANS
Can Anyone
Stop the Killing?

3

4 ▪▪▪▪▪▪▪▪▪▪▪▪▪▪▪▪▪▪▪▪▪▪▪▪▪▪▪▪▪▪▪

NUMERO 737

APRILE 1992

domus

MONTHLY REVIEW OF ARCHITECTURE INTERIORS DESIGN ART

Editoriale: Progetto e durata □ John Hejduk, due monumenti a Praga □ Michael Hopkins, edificio per uffici a Londra □ Enric
Miralles, cimitero a Barcellona □ Mario Botta, studio a Lugano □ Tre interni: a Londra, New York e Parigi □ Mobili: l'arredo
svizzero 1925-1950 □ Saggio sul concetto di qualità □ Frank Lloyd Wright: la tecnica del *textile block* e itinerario in California.

1

Magazine Cover *Time ("Evil")*
Art Directors *Arthur Hochstein, Mirko Ilic*
Design Firm/Client *Time Magazine, New York, NY*
Publisher *Time, Inc.*

2

Magazine Cover *Time Magazine ("Canada")*
Art Director *Rudolph C. Hoglund*
Designer *Arthur Hochstein*
Illustrator *Mirko Ilic*
Design Firm/Client *Time Magazine, New York, NY*
Publisher *Time, Inc.*

3

Magazine Cover *Time ("The Balkans")*
Art Director *Rudolph C. Hoglund*
Designer *Arthur Hochstein*
Photographer *Christopher Morris/Black Star*
Design Firm/Client *Time Magazine, New York, NY*
Publisher *Time, Inc.*

4

Magazine Cover *Domus ("Cardinal's Hat")*
Art Director/Illustrator *Henry Wolf*
Design Firm *Henry Wolf Productions, Inc., New York, NY*
Client/Publisher *Domus Magazine*

5

Magazine Cover *Esquire ("Spike Lee Strikes a Pose Behind Malcolm X")*
Art Director *Rhonda Rubinstein*
Photographer *Frank W. Ockenfels III*
Design Firm/Client *Esquire Magazine, New York, NY*
Publisher *Hearst Magazines*

6

Magazine Cover *Esquire ("White People")*
Art Director/Designer *Rhonda Rubinstein*
Design Firm/Client *Esquire Magazine, New York, NY*
Publisher *Hearst Magazines*

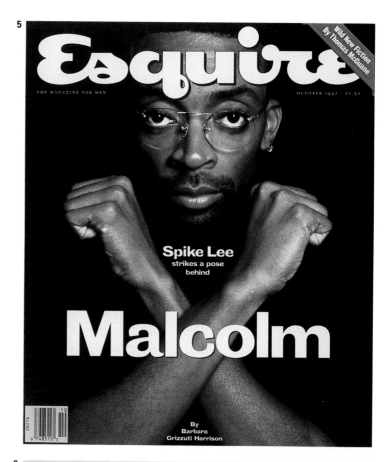

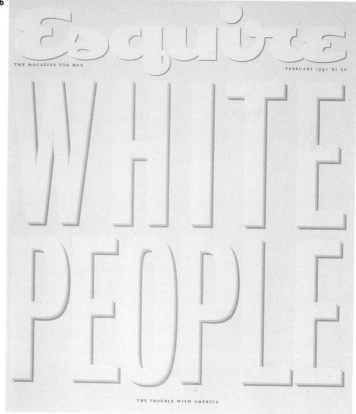

1

Magazine Cover *Turnstile*
Designer/Photographer *John Gall*
Design Firm *John Gall Graphic Design, Hoboken, NJ*
Printer *Bookcrafters*

2

Magazine Cover *L.A. Style ("Winger Country")*
Art Director *Lloyd Ziff*
Design Firm *Travel & Leisure Magazine, New York, NY*
Client/Publisher *American Express Publishing*

3

Magazine Cover *L.A. Style ("Malcolm X")*
Art Director *Lloyd Ziff*
Design Firm *Travel & Leisure Magazine, New York, NY*
Client/Publisher *American Express Publishing*

4

Magazine Cover *Swiss Typographic Monthly*
Art Director/Designer *Hans V. Allemann*
Photographer *Jan C. Almquist*
Design Firm *Allemann Almquist & Jones, Philadelphia, PA*
Client/Publisher *Swiss Typographic Monthly*

TM / SGM
RSI

6 1991

The work presented on the following pages represent class projects designed students in the third an fourth year of study graphic design departm of the University of the Arts, Philadelphia the assignments have to be considered in the conte

+

Typographische Monatsblätter
Schweizer Graphische Mitteilungen _____ Zeitschrift für Schriftsatz, Gestaltung, Sprache, Druck und Weiterverarbeitung Herausgegeben von der Gewerkschaft Druck und Papier zur Förderung der Berufsbildung
Revue suisse de l'imprimerie _____ Revue pour la composition, la conception graphique, la langue, l'impression et l'apprêt Editée par le Syndicat du livre et du papier pour l'éducation professionelle
Swiss Typographic Monthly Magazine _____ Journal for Typographic Composition, Design, Communication, Printing and Production Published by the Printing and Paper Union of Switzerland for the advancement of education in the profession

4

A Publication for Art Center Alumni, Volume 3, Number 1, Fall 1992

PEOPLE HAVE BEEN DESIGNING CHAIRS FOR SOME FIVE THOUSAND YEARS. THE EARLIEST KNOWN EXAMPLES INCLUDE SCULPTED THRONES FOUND IN THE TOMBS OF ANCIENT EGYPTIAN KINGS. UNTIL THE RENAISSANCE CHAIRS WERE RESERVED FOR PEOPLE OF HIGH RANK, AND ALTHOUGH ITS USE HAS BECOME MUCH MORE WIDESPREAD, THIS BASIC PIECE OF FURNITURE, WITH ITS BLENDING OF FORM AND FUNCTION, RETAINS A CERTAIN MYSTIQUE. MANY OF THE OUTSTANDING DESIGNERS OF OUR CENTURY—MIES, BREUER, AND EAMES, TO NAME A FEW—HAVE CREATED DISTINCTIVE AND ENDURING CHAIR DESIGNS. YET THE CHALLENGE OF BUILDING A BETTER CHAIR REMAINS, AND THREE CALIFORNIA-BASED ART CENTER ALUMNI ARE FASHIONING CHAIRS THAT ARE LIKELY TO MAKE DESIGNERS AND NONDESIGNERS ALIKE SIT DOWN AND TAKE NOTICE. (CONTINUED ON PAGE 4)

hot seats

abridged

Tracy Fong's Martyn Vanity Bench

Warren Snodgrass's Princeton stack dining chair

1

A publication for Art Center alumni. Volume 2, Number 1, Fall 1991

Strother "Mac" MacMinn
in his Cord Phaeton, Pasadena, 1941.
Fifty years later Mac became the fifth recipient
of the Don Kubly Professional
Attainment Award.
The life and times of Strother MacMinn.
page 4

abridged

Newsfolio: Extracts from national press coverage of Art Center . . .

2

1
Magazine Cover *Abridged ("Hot Seats," Vol. 3)*
Art Director *Rebeca Mendez*
Designer *Darren Namaye*
Photographer *Tracy Fong*
Design Firm/Client *Art Center College of Design, Pasadena, CA*
Printer *Sinclair Printing Company*

2
Magazine Cover *Abridged ("Mac MacMinn," Vol. 2)*
Art Director *Rebeca Mendez*
Designers *Rebeca Mendez, Ellen Eisner, Darin Beaman*
Design Firm/Client *Art Center College of Design, Pasadena, CA*
Printer *Typecraft Inc.*

3

Magazine Cover *Mirabella ("Nothing to Wear?")*
Art Director *Alejandro Gonzalez*
Photographer *Fabrizio Ferri*
Design Firm/Client *Mirabella Magazine, New York, NY*
Publisher *Murdoch*

4

Magazine Cover *Graphis 283*
Art Director/Designer *B. Martin Pedersen*
Photographer *David Stewart*
Design Firm *Graphis Magazine, New York, NY*
Client/Publisher *Graphis Press Corporation*

5

Magazine Cover *Graphis 279*
Art Director/Designer *B. Martin Pedersen*
Photographer *Matthew Rolston*
Design Firm *Graphis Magazine, New York, NY*
Client/Publisher *Graphis Press Corporation*

4

5

3

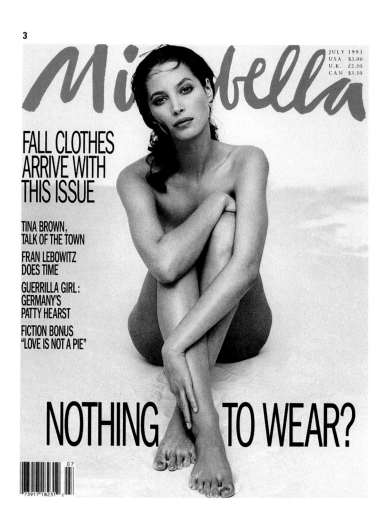

1
Book Cover *Whisper*
Art Director/Designer *Wendy Bass*
Illustrator *Vivienne Flesher*
Design Firm *Macmillan Publishing Co., New York, NY*
Client/Publisher *Scribner's/Macmillan Publishing Co.*

2
Book Cover *Olga*
Art Directors *Carin Goldberg, Krystyna Skalski*
Designer *Carin Goldberg*
Design Firm *Carin Goldberg Design, New York, NY*
Client/Publisher *Grove Press*

3
Book Cover *Various Antidotes*
Art Director *Raquel Jaramillo*
Book Jacket Designer/Illustrator *Richard Tuschman*
Design Firm *Henry Holt & Co., New York, NY*
Client/Publisher *Henry Holt & Co.*

1

2

STORIES

VARIOUS
ANTIDOTES

JOANNA SCOTT

1
Book Cover *The Foursome*
Art Director *Michaela Sullivan*
Designer/Illustrator *Wendell Minor*
Design Firm *Wendell Minor, Washington, CT*

2
Book Cover *The Thing Happens*
Art Director *Krystyna Skalski*
Designer *Louise Fili*
Photographer *William Duke*
Design Firm *Louise Fili Ltd., New York, NY*
Client/Publisher *Grove Weidenfeld*

3
Book Cover *Motor City*
Art Director/Designer *John Gall*
Illustrator *James McCarron*
Design Firm *John Gall Graphic Design, Hoboken, NJ*
Client/Publisher *Washington Square Press*

4

5

6

4

Book Cover *City of Boys*
Art Director *Susan Mitchell*
Photographer *Bruce Davidson/Magnum*
Design Firm *Random House, Inc., New York, NY*
Client/Publisher *Vintage Books, Random House*
Printer *Color Graphic Services, Inc.*

5

Book Cover *Underdog*
Art Director *Jackie Merri Meyer*
Designers *Jackie Merri Meyer, Yarrot Benz*
Photographer *Yarrot Benz*
Design Firm *Warner Books, New York, NY*
Client/Publisher *Warner Books/Mysterious Press*

6

Book Cover *Sylvia*
Art Director/Designer *Steven Brower*
Design Firm *Carol Publishing Group, New York, NY*
Client/Publisher *Carol Publishing Group*

The Werewolf of Paris

Guy Endore

Introduction by Robert Bloch

1

Book Cover *The Werewolf of Paris*
Art Director *Steven Brower*
Designer *James Victore*
Design Firm *Victore Design Works, New York, NY*
Client/Publisher *Carol Communications Group*

2

Book Cover *Bone*
Art Director *Victor Weaver*
Designer *Carin Goldberg*
Design Firm *Carin Goldberg Design, New York, NY*
Client/Publisher *Hyperion*

3

Book Cover *Where You Form the Letter L*
Art Director *Mark Fox*
Designers *Mark Fox, Denise Liddell Lawson*
Photographer *David Peterson*
Design Firm *BlackDog, San Rafael, CA*
Publisher *San Francisco State University*

4

Book Cover *Johnny Got His Gun*
Art Director *Steven Brower*
Designer *James Victore*
Design Firm *Carol Publishing Group, New York, NY*
Client/Publisher *Carol Publishing Group*

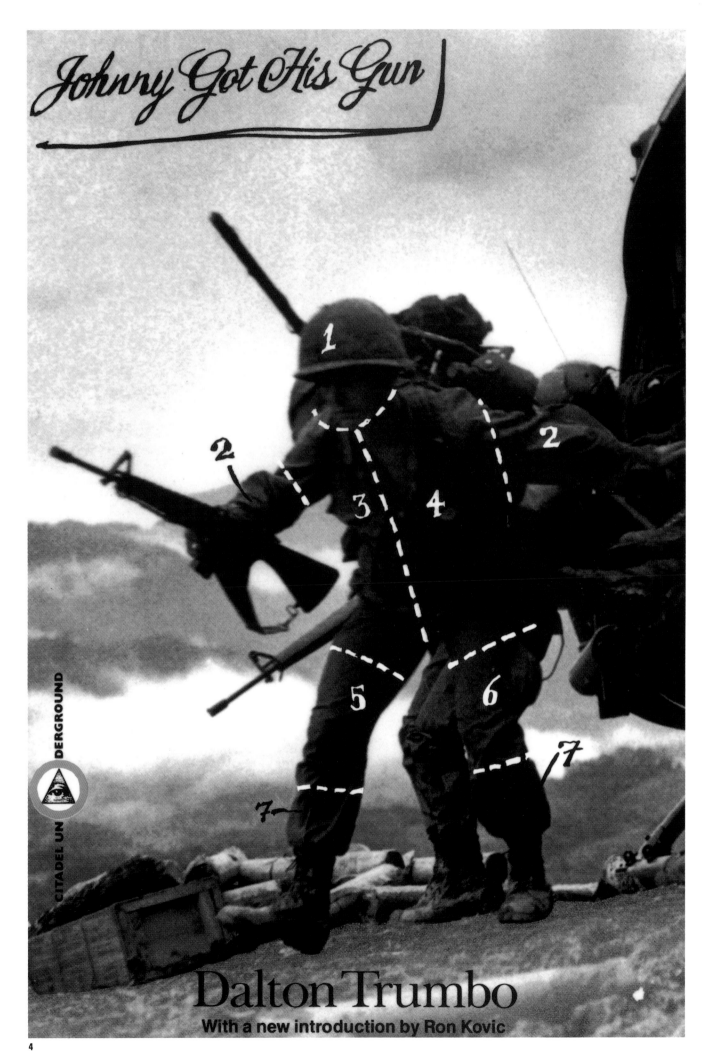

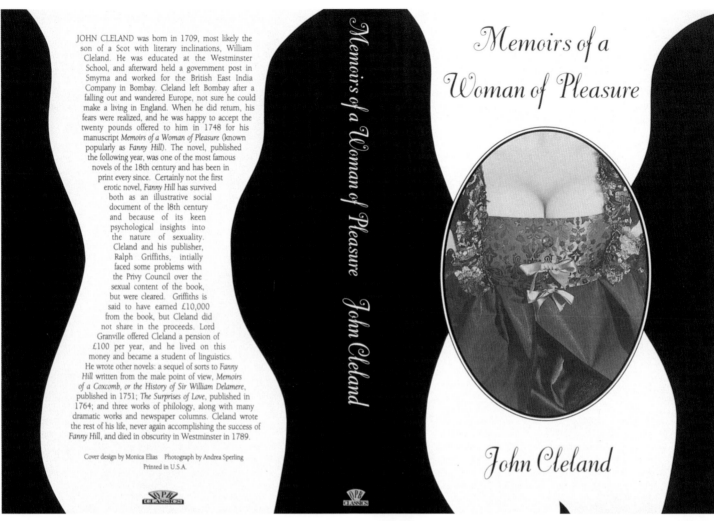

JOHN CLELAND was born in 1709, most likely the son of a Scot with literary inclinations, William Cleland. He was educated at the Westminster School, and afterward held a government post in Smyrna and worked for the British East India Company in Bombay. Cleland left Bombay after a falling out and wandered Europe, not sure he could make a living in England. When he did return, his fears were realized, and he was happy to accept the twenty pounds offered to him in 1748 for his manuscript *Memoirs of a Woman of Pleasure* (known popularly as *Fanny Hill*). The novel, published the following year, was one of the most famous novels of the 18th century and has been in print every since. Certainly not the first erotic novel, *Fanny Hill* has survived both as an illustrative social document of the 18th century and because of its keen psychological insights into the nature of sexuality. Cleland and his publisher, Ralph Griffiths, intially faced some problems with the Privy Council over the sexual content of the book, but were cleared. Griffiths is said to have earned £10,000 from the book, but Cleland did not share in the proceeds. Lord Granville offered Cleland a pension of £100 per year, and he lived on this money and became a student of linguistics. He wrote other novels: a sequel of sorts to *Fanny Hill* written from the male point of view, *Memoirs of a Coxcomb, or the History of Sir William Delamere*, published in 1751; *The Surprises of Love*, published in 1764; and three works of philology, along with many dramatic works and newspaper columns. Cleland wrote the rest of his life, never again accomplishing the success of *Fanny Hill*, and died in obscurity in Westminster in 1789.

Cover design by Monica Elias Photograph by Andrea Sperling
Printed in U.S.A.

Memoirs of a Woman of Pleasure
John Cleland

Memoirs of a
Woman of Pleasure

John Cleland

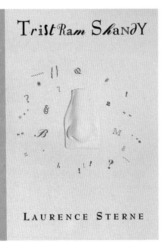

1
Book Cover *Memoirs of a Woman of Pleasure*
Art Director/Designer *Monica Elias*
Photographer *Andrea Sperling*
Design Firm *Book-of-the-Month Club, New York, NY*
Client/Publisher *Book-of-the-Month Club*

2
Book Cover *Tristram Shandy*
Art Director/Designer *Monica Elias*
Photographer *Andrea Sperling*
Design Firm *Book-of-the-Month Club, New York, NY*
Client/Publisher *Book-of-the-Month Club*

3
Book Cover *Them*
Art Director/Designer *Monica Elias*
Photographer *UPI/Bettmann Archives*
Design Firm *Book-of-the-Month Club, New York, NY*
Client/Publisher *Book-of-the-Month Club*

4

Book Cover *The Swing Era*
Art Directors *Diti Katona, John Pylypczak*
Designer *Diti Katona*
Photographer *Karen Levy*
Design Firm *Concrete Design Communications, Inc., Toronto, Canada*
Printer *John Deyell*

5

Book Cover *California Cool*
Art Director *Bill Cahan*
Designer *Cicero DeGuzman*
Design Firm *Cahan & Associates, San Francisco, CA*
Client/Publisher *Chronicle Books*

6

Book Cover *Love Enter*
Art Director *Michaela Sullivan*
Designer *Clifford Stoltze*
Photographers *Rebecca Fagan, Clifford Stoltze*
Design Firm *Stoltze Design, Boston, MA*
Client/Publisher *Houghton Mifflin*

1
Book Cover *Shares and Other Fictions*
Art Director/Designer *Milton Charles*
Illustrators *Lisa Falkenstern, Milton Charles*
Design Firm *Milton Charles Design, Califon, NJ*
Client/Publisher *Delphinium Books*

2
Book Cover *Cat, Thy Name Is Edith*
Art Director *John Baskin*
Letterer *Linda Scharf*
Design Firm *Linda Scharf Illustration, Boston, MA*
Client/Publisher *Orange Frazer Press*

1

2

ISBN 0-9619637-7-8

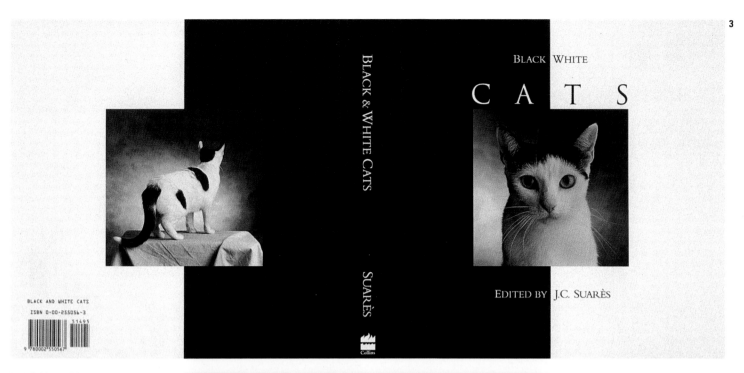

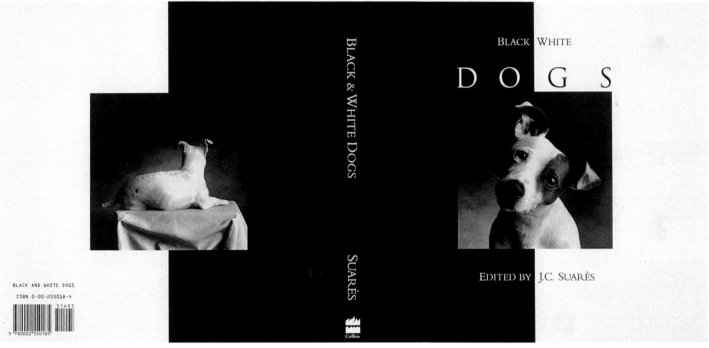

3
Book Cover *Black and White Cats*
Art Director/Designer *Jennifer Barry*
Photographer *Dennis Mosner*
Design Firm *Collins Publishers, San Francisco, CA*
Client/Publisher *Collins Publishers*

4
Book Cover *Black and White Dogs*
Art Director/Designer *Jennifer Barry*
Photographer *Dennis Mosner*
Design Firm *Collins Publishers, San Francisco, CA*
Client/Publisher *Collins Publishers*

1

Book Cover *Graphis Nudes*
Art Director/Designer *B. Martin Pedersen*
Photographers *Barbara Bordnick, Herb Ritts*
Design Firm *Graphis Magazine, New York, NY*
Client/Publisher *Graphis Press Corporation*

2

Book Cover *The Kiss*
Art Director *Jennifer Barry*
Photographer *Helmut Newton*
Design Firm *Collins Publishers, San Francisco, CA*
Client/Publisher *Collins Publishers*

1

2

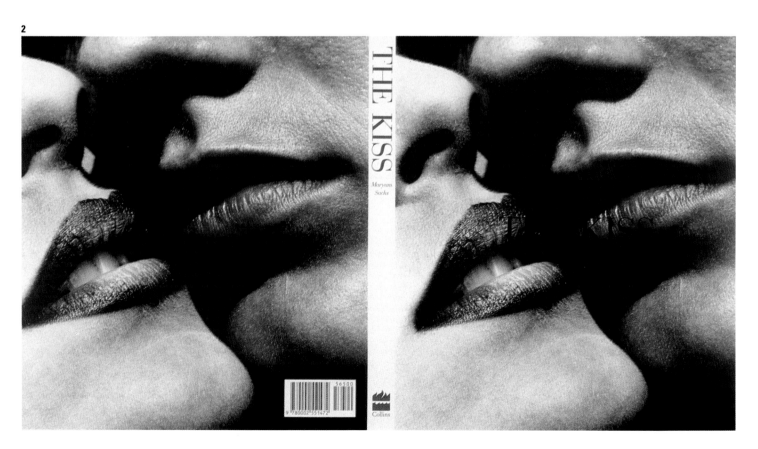

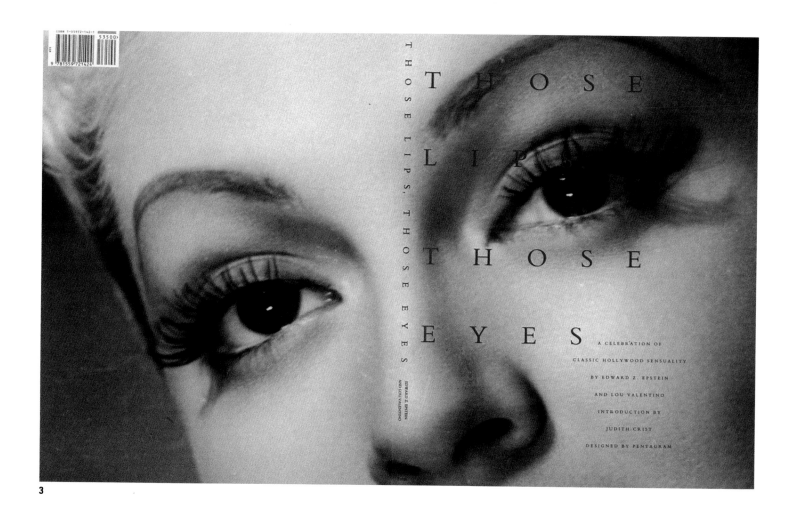

3

Book Cover *Those Lips, Those Eyes*
Art Directors *Steve Brower, Paula Scher*
Designer *Paula Scher*
Design Firm *Pentagram Design, New York, NY*
Client/Publisher *Birch Lane Press*

4

Book Cover *Chic Simple: Clothes*
Art Director *Robert Valentine*
Designers *Robert Valentine, Dina Dell'Arciprete, Wayne Wolf*
Illustrator *Eric Hanson*
Design Firm *Robert Valentine Inc., New York, NY*
Publisher *Alfred A. Knopf*

5

Book Cover *Chic Simple: Home*
Art Director *Robert Valentine*
Designers *Robert Valentine, Dina Dell'Arciprete, Wayne Wolf*
Illustrator *Eric Hanson*
Design Firm *Robert Valentine Inc., New York, NY*
Publisher *Alfred A. Knopf*

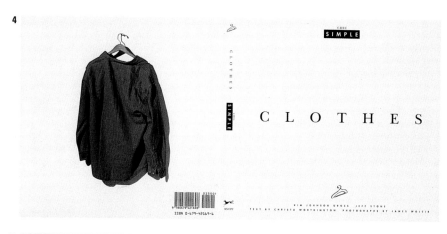

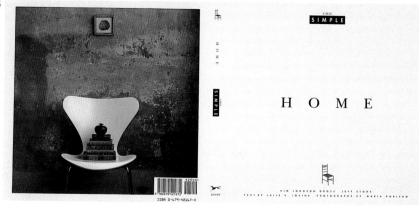

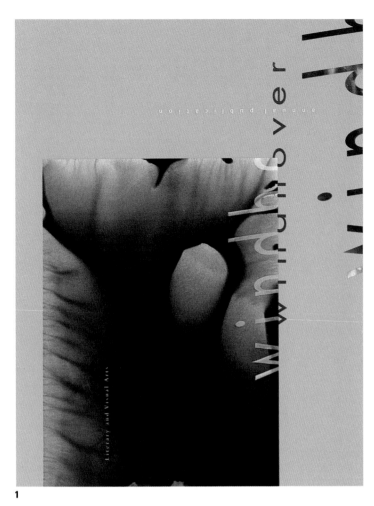

1

2

3

1
Book Cover *Windhover*
Art Director/Designer *Angela Norwood*
Design Firm *North Carolina State University Press*
Client/Publisher *North Carolina State University Press*
Printer *Theo Davis Sons, Inc.*

2
Book Cover *Pacific Wall*
Art Director *Robert Shapazian*
Designer *Patrick Dooley*
Photographer *J. Stephen Hicks*
Design Firm *The Lapis Press, Venice, CA*
Client/Publisher *The Lapis Press*

3
Book Cover *A Witch*
Art Director *Robert Shapazian*
Designer *Jeffrey Mueller*
Design Firm *The Lapis Press, Venice, CA*
Client/Publisher *The Lapis Press*

4
Book Cover *False Pretenses*
Art Director *Jackie Merri Meyer*
Designer/Illustrator *John Sayles*
Design Firm *Sayles Graphic Design, Des Moines, IA*
Client/Publisher *Warner Books*

5
Book Cover *Rebecca Horn*
Art Director *Takaaki Matsumoto, Michael McGinn*
Designer *Takaaki Matsumoto*
Design Firm *M Plus M, Inc., New York, NY*
Printer *Cantz*

ISBN 0-89207-110-9

1

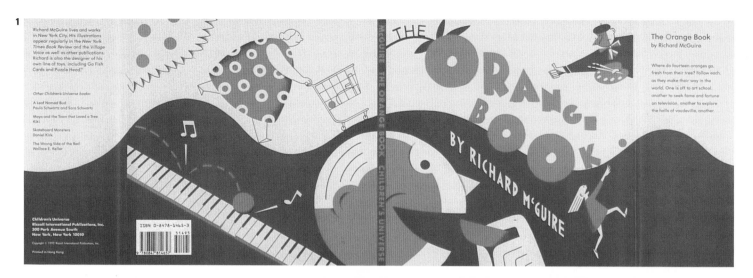

1

Book Cover *The Orange Book*
Designer/Illustrator *Richard McGuire*
Design Firm *Richard McGuire, New York, NY*
Client/Publisher *Rizzoli International*

2

Book Cover *How to Rake Leaves*
Art Director/Designer *Leonard Koren*
Design Firm *Stone Bridge Press, Berkeley, CA*
Client/Publisher *Stone Bridge Press*

3
Book Cover *Let Me Hear Your Voice*
Art Director *Carol Devine Carson*
Designer *Michael Bierut*
Design Firm *Pentagram Design, New York, NY*

4
Book Cover *Family Values*
Art Directors *Carin Goldberg, Frank Metz*
Designer *Carin Goldberg*
Design Firm *Carin Goldberg Design, New York, NY*
Client/Publisher *Simon and Schuster*

5
Book Cover *The Insanity of Normality*
Art Director *Krystyna Skalski*
Designer *Carin Goldberg*
Design Firm *Carin Goldberg Design, New York, NY*
Client/Publisher *Grove Press*

1
Book Cover *Uncle Wizzmo's New Used Car*
Art Director *Harriett Banton*
Designer *David Saylor*
Illustrator *Rodney A. Greenblatt*
Design Firm *HarperCollins, New York, NY*
Client/Publisher *HarperCollins*

2
Book Cover *Fat Girl*
Art Director *Michele Wetherbee*
Designer *Carrie Leeb*
Illustrator *Irene O'Garden*
Design Firm *Harper San Francisco, San Francisco, CA*
Client/Publisher *Harper San Francisco*

3
Book Cover *The Noisy Giants' Tea Party*
Art Director *Michael di Capua*
Designer/Illustrator *Jim McMullan*
Design Firm *HarperCollins, New York, NY*
Client/Publisher *HarperCollins*

4
Book Cover *Ferrington Guitars*
Designers *Nancy Skolos, Tom Wedell*
Design Firm *Skolos Wedell, Charlestown, MA*
Client/Publisher *Callaway Editions/HarperCollins*

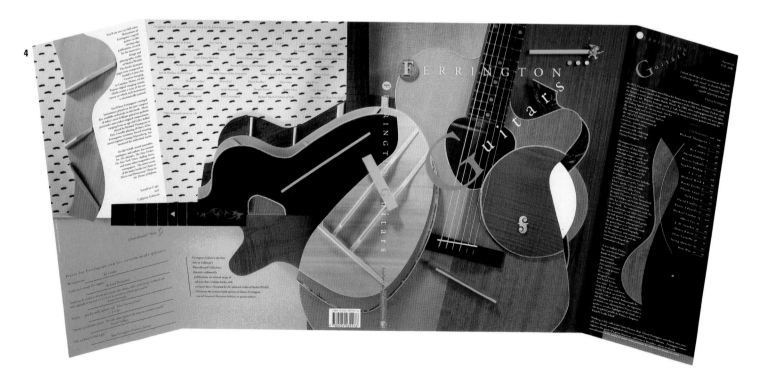

Easy access to cost-effective, industry-standard layout programs lowers production costs and gives excellent return on investment.

Atex Press2Go: The smart way to link your editorial front-end to desktop design

Pagination products work either as a single unit or as a set.

■ Enjoy the simplicity and economy of QuarkXPress yet retain the power of your front-end system.

■ This seamless link from front-end to QuarkXPress facilitates page layout.

■ Parallel pagination process helps staff do more, right up to deadline.

ATEX

2

4

5
Catalog Cover *Art Center College of Design 1993–94*
Art Director *Rebeca Mendez*
Designers *Rebeca Mendez, Darren Namaye, Darin Beaman*
Photographer *Steven A. Heller*
Design Firm/Client *Art Center College of Design, Pasadena, CA*
Printer *Typecraft Inc.*

6
Brochure Cover *Art Center at Night*
Art Director *Rebeca Mendez*
Designers *Tara Carson, Rebeca Mendez*
Photographer *Steven A. Heller*
Design Firm/Client *Art Center College of Design, Pasadena, CA*
Printer *Typecraft Inc.*

7
Brochure Cover *Teaching at Art Center*
Art Director *Rebeca Mendez*
Designers *Rebeca Mendez, Ellen Eisner*
Illustrator *Marjo Wilson*
Design Firm/Client *Art Center College of Design, Pasadena, CA*
Printer *Typecraft Inc.*

5

6

7

1
Brochure Cover *Atex Press 2 Go/Desktop Design*
Art Directors *Roger Sametz, David Horton, Stuart Darsch*
Designers *Roger Sametz, David Horton*
Photographer *Stuart Darsch*
Design Firm *Sametz Blackstone Associates Inc., Boston, MA*
Client *Atex Connections*
Printer *John C. Otto*

2
Brochure Cover *Student Handbook 1994*
Art Director *Rebeca Mendez*
Designer/Photographer *Darin Beaman*
Design Firm/Client *Art Center College of Design, Pasadena, CA*
Printer *Typecraft Inc.*

3
Brochure Cover *Massachusetts College of Art '93–'95*
Art Director *Clifford Stoltze*
Designers *Clifford Stoltze, Kyong Choe*
Photographers *Laura McPhee, Alexander Heria*
Illustrator *Michael St. Germain*
Design Firm *Stoltze Design, Boston, MA*
Client *Massachusetts College of Art*
Printer *Andrews Printing*

4
Brochure Cover *Atex Connections*
Art Directors *Stuart Darsch, David Horton*
Designer/Photographer *Stuart Darsch*
Design Firm *Sametz Blackstone Associates Inc., Boston, MA*
Client *Atex Connections*
Printer *Reynolds-DeWalt*

1

Brochure Cover *ASMP*
Art Director/Designer *Scott Paramski*
Design Firm *Peterson & Company, Dallas, TX*
Client *ASMP*

2

Brochure Cover *The Lynnfield Series 500L*
Art Director/Designer *Bruce Crocker*
Photographer *Gallen Mei*
Design Firm *Crocker Inc., Brookline, MA*
Client/Publisher *Boston Acoustics*

3

Brochure Cover *The Lynnfield Series 300L*
Art Director/Designer *Bruce Crocker*
Photographer *Gallen Mei*
Design Firm *Crocker Inc., Brookline, MA*
Client/Publisher *Boston Acoustics*

4

Brochure Cover *Burned Objects*
Art Director *Steve Liska*
Designer *Kim Nyberg*
Photographer *Stephen Wilkes*
Design Firm *Liska and Associates, Inc., Chicago, IL*
Printer *Shepard Poorman*

2

3

1

BURNED OBJECTS

ANGST

confusion, contradiction and anxiety in today's recycled paper industry

forum

1

2

3

1
Brochure Cover *Paper Forum 3 ("Angst")*
Designer *Terrance Zacharko*
Photographer *James Vabonte*
Design Firm *Zacharko Design Partnership, Vancouver, Canada*
Printer *McAra Printing*

2
Brochure Cover *You Can't Throw Away an Idea*
Art Director *John Bielenberg*
Designers *John Bielenberg, Brian Boram, Allen Ashton*
Design Firm/Client *Marks/Bielenberg Design, San Francisco, CA*
Printer *Warrens Waller Press*

3
Brochure Cover *French Paper Company Portfolio Notebook*
Art Director *Charles S. Anderson*
Designers *Charles S. Anderson, Todd Hauswirth*
Design Firm *Charles S. Anderson Design Company, Minneapolis, MN*
Client *French Paper Company*
Printer *Print Craft, Inc.*

4

Brochure Cover *Looking*
Art Director *John Clark*
Designers *John Clark, Paul Langland*
Design Firm *Looking, Los Angeles, CA*
Publisher *Elk Design*
Printer *Marina Graphics; Platinum Press*

5

Catalog Cover *Works*
Art Director *William Reuter*
Designers *William Reuter, José Bilá-Rodriquez, Michael Bain*
Design Firm *William Reuter Design, San Francisco, CA*
Printer *AAA Lettershop/Graphic Options*

6

Brochure Cover *Barber-Ellis (The Grade Report Show)*
Art Director *Charles S. Anderson*
Designers *Charles S. Anderson, Daniel Olson*
Illustrator *Randall Dahlk*
Design Firm *Charles S. Anderson Design Company, Minneapolis, MN*
Client *Barber-Ellis Paper*
Printer *Print Craft, Inc.*

1
Brochure Cover *Richard Solomon*
Art Director/Designer *Louise Fili*
Design Firm *Louise Fili Ltd., New York, NY*
Printer *Terwilliger*

2
Brochure Cover *Hat Life 1992*
Art Director *Alex Bonziglia*
Photographer *Scott Whippermann*
Design Firm *David Morris Design Associates, Jersey City, NJ*
Client *Hat Life Publications*
Printer *Thompson*

3
Brochure Cover *If You Don't Cut It Here…*
Art Director/Designer/Illustrator *Frank Viva*
Design Firm *Viva Dolan Communications and Design, Toronto, Canada*

4
Brochure Cover *Instinct: The Color Green*
Designers *Terrance Zacharko, Sandy Duveywaardt*
Photographer *Robin Bartholick*
Design Firm *Zacharko Design Partnership, Vancouver, Canada*

UNITED COLORS OF BENETTON.

GLOBAL VISION

1

1
Brochure Cover *United Colors of Benetton/Global Vision*
Art Director/Designer *Tamotsu Yagi*
Photographer *Oliviero Toscani*
Design Firm *Tamotsu Yagi Design, San Francisco, CA*
Client *Benetton*
Publisher *Robundo Publishing, Inc., Tokyo*

2
Catalog Cover *The Andrews University 1991 Student Directory*
Art Directors *Marcos Chavez, Geoffrey Isaak*
Design Firm *Michael Stanard, Inc., Evanston, IL*
Client *Andrews University*

3
Catalog Cover *Hollywood Paramount Products*
Designers *Charles S. Anderson, Daniel Olson, Haley Johnson*
Photographer *Dave Bausman*
Design Firm *Charles S. Anderson Design Company, Minneapolis, MN*
Client *Paramount Pictures*
Printer *Print Craft, Inc.*

4
Catalog Cover *Warner Home Video 1992–1993*
Art Director *Michael Brock*
Designers *Michael Brock, Daina Howard-Kemp*
Photographer *Robert Peak*
Design Firm *Michael Brock Design, Los Angeles, CA*
Client *Warner Home Video*
Printer *Alan Lithograph*

1

Brochure Cover *Gemini Consulting*
Art Director *Tom Geismar*
Designer *Cathy Schaefer*
Design Firm *Chermayeff & Geismar Inc., New York, NY*
Client *Gemini Recruiting*
Printer *Milocraft*

2

Brochure Cover *Levi's Sweats*
Art Director *Dennis Crowe*
Designer *Neal Zimmermann*
Design Firm *Zimmermann Crowe Design, San Francisco, CA*
Client *Levi Straus & Co.*
Printer *Colorbar*

3

Catalog Cover *Capp Street Project 1989–1990*
Art Director *Jennifer Morla*
Designers *Jennifer Morla, Sharrie Brooks*
Design Firm *Morla Design, San Francisco, CA*
Client *Capp Street Project*
Printer *Sung-In Printing America*

4

Catalog Cover *UCLA Extension Fall Quarter 1992*
Art Director *InJu Sturgeon*
Designer *Paula Scher*
Design Firm *UCLA Extension Design Services, Los Angeles, CA*
Client *UCLA*
Printer *California Offset*

5

Catalog Cover *AAUP Book, Jacket, and Journal Show 1993*
Art Director/Designer/Illustrator *Sylvia Steiner*
Design Firm *Sylvia Steiner Graphic Design*
Client *AAUP*
Printer *New England Book Components*

1

Brochure Cover *Undercoats*
Art Director *Timothy Eaton*
Photographer *Marty Berglin*
Design Firm *Eaton & Associates Design Co., Minneapolis, MN*
Client/Publisher *Mohawk Paper Mills*

2

Brochure Cover *Champion Felt*
Art Director *Peter Good*
Illustrators *Peter Good, George Booth*
Design Firm *Peter Good Graphic Design, Chester, CT*
Client *Champion Paper*
Printer *Dolan/Wohlers*

3

Catalog Cover *UCLA Summer Sessions 1993*
Art Director *InJu Sturgeon*
Designer *Paul Rand*
Design Firm *UCLA Extension Design Services, Los Angeles, CA*
Client *UCLA*
Printer *Navigator Press*

1

2

UCLABC
DEFGHIJ
KLMNOP
QRSTUV
WXYZ93

UCLA Summer Sessions 1993

University of California, Los Angeles
Los Angeles, California 90024
March 1993

Session A: June 28–August 6
Session B: July 19–August 27
Session C: August 9–September 17

3

The Cover Show *Annual Reports*

1
Annual Report Cover *EG & G 1990*
Art Directors *Peter Harrison, Harold Burch*
Photographers *Scott Morgan, Burton Pritzker*
Design Firm *Pentagram Design, New York, NY*
Client *EG & G*
Printer *Colorgraphics*

2
Annual Report Cover *The Earth Technology Corporation 1992*
Art Director *Lana Rigsby*
Designers *Lana Rigsby, Troy S. Ford*
Photographer *Gary Faye*
Design Firm *Rigsby Design, Inc., Houston, TX*
Client *The Earth Technology Corporation*
Printer *Emmott-Walker Printing, Inc.*

3

Annual Report Cover *Duracell 1992*
Art Directors *Aubrey Balkind, Kent Hunter*
Designer *Ruth Diener*
Design Firm *Frankfurt Balkind Partners, New York, NY*
Client *Duracell Batteries*
Printer *Heritage Press*

4

Annual Report Cover *Neenah Paper 1992*
Art Director/Designer *Kerry Grady*
Photographers *Kerry Grady, Tim Hartford*
Design Firm *Grady, Campbell Inc., Chicago, IL*
Client/Publisher *Neenah Paper*

5

Annual Report Cover *Profiles in Initiative/Serv-Tech 1991*
Art Director *Lana Rigsby*
Designers *Lana Rigsby, Troy S. Ford*
Photographer *Jim Sims*
Design Firm *Rigsby Design, Inc., Houston, TX*
Client *Serv-Tech Corporation*
Printer *Emmott-Walker Printing, Inc.*

4

5

3

1

Annual Report Cover *Reebok '90*
Art Director *Leslie Segal*
Designer *Victor Rivera*
Photographer *Charlie Pizzarello*
Design Firm *Addison Design Company, New York, NY*
Client *Reebok*

2

Annual Report Cover *"Closing the Loop"*
Art Director *Steve Pattee*
Designer *Kelly Stiles*
Design Firm *Pattee Design, Des Moines, IA*
Client *Des Moines Metro Area Solid Waste Agency*
Printer *Professional Offset Printing*

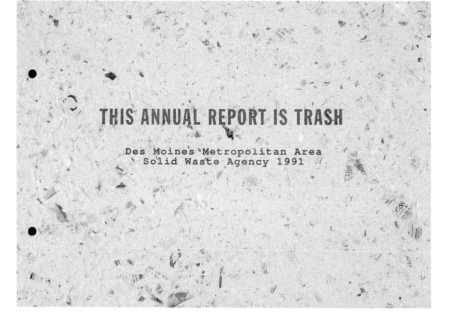

3

Annual Report Cover *"This Annual Report Is Trash"*
Art Director *Steve Pattee*
Designer *Kelly Stiles*
Design Firm *Pattee Design, Des Moines, IA*
Client *Des Moines Metro Area Solid Waste Agency*
Printer *Professional Offset Printing*

4
Annual Report Cover *Lasertechnics 1992 ("Back to Basics")*
Art Director *Steve Wedeen*
Design Firm *Vaughn Wedeen Creative, Albuquerque, NM*
Printer *Prisma Graphic*

5
Annual Report Cover *Genentech, Inc. 1991*
Art Director *Bill Cahan*
Designer *Melinda Maniscalco*
Design Firm *Cahan & Associates, San Francisco, CA*
Client *Genentech, Inc.*
Printer *Anderson Lithograph*

6
Annual Report Cover *Viking Council Boy Scouts of America*
Designers *Dan Olson, Haley Johnson*
Photographer *Paul Irmiter*
Design Firm *Olson Johnson Design Co., Minneapolis, MN*
Client *Viking Council Boy Scouts of America*
Printer *Diversified Graphics, Inc.*

1

Annual Report Cover *The Progressive Corporation 1991*
Art Directors/Designers *Mark Schwartz, Joyce Nesnadny*
Photographers *Nesnadny + Schwartz*
Design Firm *Nesnadny + Schwartz, Cleveland, OH*
Client *The Progressive Corporation*
Printer *Fortran Printing*

2

Annual Report Cover *The Progressive Corporation 1992*
Art Directors *Mark Schwartz, Joyce Nesnadny*
Designers *Joyce Nesnadny, Michelle Moehler*
Photographer *Neil Winokur*
Design Firm *Nesnadny + Schwartz, Cleveland, OH*
Client *The Progressive Corporation*
Printer *Fortran Printing*

3

Annual Report Cover *Time Warner Inc. 1989*
Art Directors *Aubrey Balkind, Kent Hunter*
Designers *Kent Hunter, Riki Sethiadi*
Photographer *Scott Morgan*
Design Firm *Frankfurt Balkind Partners, New York, NY*
Client *Time Warner Inc.*

4
Annual Report Cover *COR Therapeutics, Inc. 1992*
Art Director *Bill Cahan*
Designer *Jean Orlebeke*
Design Firm *Cahan & Associates, San Francisco, CA*
Client *COR Therapeutics, Inc.*
Printer *Anderson Lithograph*

5
Annual Report Cover *Mylan Laboratories, Inc. 1993*
Art Director *John Brady*
Designer *Kathy Kendra*
Photographer *Tom Gigliotti*
Design Firm *John Brady Design Consultants, Pittsburgh, PA*
Client *Mylan Laboratories, Inc.*
Printer *Geyer Printing*

1

Annual Report Cover *Freedom House 1989–1990*
Art Director *Jurek Wajdowicz*
Designers *Lisa LaRochelle, Jurek Wajdowicz*
Photographer *Tim Simmons*
Design Firm *Emerson, Wajdowicz Studios, Inc., New York, NY*
Client/Publisher *Freedom House*

2

Annual Report Cover *Transamerica Corporation 1992*
Art Director *Kit Hinrichs*
Designer *Susan Tsuchiya*
Illustrator *Dugald Stermer*
Design Firm *Pentagram Design, San Francisco, CA*
Client *Transamerica Corporation*
Printer *Anderson Lithograph*

3

Annual Report Cover *Airborne Express 1992*
Art Director *John Hornall*
Designers *Julia LaPine, Heidi Hatlestad, John Anicker*
Photographer *Tyler Boley*
Design Firm *Hornall Anderson Design Works, Inc., Seattle, WA*
Client *Airborne Express*
Printer *Bradley Printer*

4

Annual Report Cover *TVX Gold 1991*
Art Directors *Diti Katona, John Pylypczak*
Designer *Scott Christie*
Photographers *Deborah Samuel, Tom Hunt*
Design Firm *Concrete Design Communications Inc., Toronto, Canada*
Client *TVX*
Printer *Matthews Ingham & Lake*

5

Annual Report Cover *Dupont 1992*
Art Directors *Aubrey Balkind, Kent Hunter*
Designer *Kin Yuen*
Photographer *Greg Weiner*
Illustrator *Holland*
Design Firm *Frankfurt Balkind Partners, New York, NY*
Client *Dupont Corporation*
Printer *Anderson Lithographics*

6

Annual Report Cover *Comcast Corporation 1991*
Art Directors *Danny Abelson, Kent Hunter, Aubrey Balkind*
Designer *Riki Sethiadi*
Illustrator *Vintage Magazine Covers*
Design Firm *Frankfurt Balkind Partners, New York, NY*
Client *Comcast Corporation*
Printer *Lebanon Valley Offset*

1

Poster/Folder Cover *Z-Pix*
Art Director *Charles S. Anderson*
Designers *Daniel Olson, Charles S. Anderson*
Design Firm *Charles S. Anderson Design Company, Minneapolis, MN*
Client *Z-Pix*
Printer *Print Craft, Inc.*

2

Folder Cover *Bumbershoot '93, The Seattle Arts Festival*
Art Director *Kerry Burg*
Designers *Klindt Parker, Susan Dewey*
Illustrator *Joe Cachero*
Design Firm *NBBJ Graphic Design, Seattle, WA*
Publisher *One Reel/Seattle Arts Commission*

1

3
Folder *"The Grand Old Game"*
Art Director/Designer *Karen G. Meyers*
Photographer *Gary Kellner*
Design Firm *Watt, Roop & Co., Cleveland, OH*
Client *The Cleveland Indians*
Printer *Corporate Packaging, Inc.*

4
Folder *Total Multimedia*
Art Director/Designer *Eddie Lee*
Design Firm *Square Two Design, Inc., San Francisco, CA*
Printer *Venture Graphics*

5
Folder *BP Station Quarterly, Spring 1992*
Art Director *Jamie Feldman*
Illustrator *J. Otto Siebold*
Design Firm *Feldman Design, Cleveland, OH*
Printer *Bedford Lithograph*

3

4

5

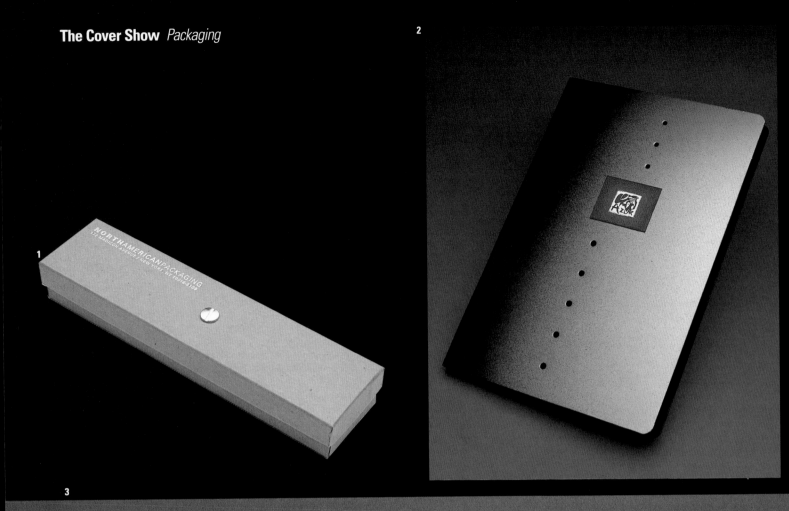

1
Packaging Cover *Deluxe Packaging Kit*
Art Director *John De Stefano*
Designers *John De Stefano, Walter Quick, Jr.*
Design Firm/Client *North American Packaging, New York, NY*

2
Menu and Guest Check Covers *Azur Restaurant*
Art Director/Designer *Sharon Werner*
Illustrators *Sharon Werner, Lynn Schulte*
Design Firm *Joe Duffy Design Inc., Minneapolis, MN*
Client *Azur Restaurant*
Printer *Print Craft, Innovative Building*

3
Packaging Cover *CNET*
Art Directors/Designers *Michael Gericke, Donna Ching*
Design Firm *Pentagram Design, New York, NY*
Client *CNET*
Printer *Queens Group*

4
Check Cover *Z Contemporary Cuisine*
Art Directors/Designers *Joyce Nesnadny, Mark Schwartz*
Photographer *Tony Festa*
Design Firm *Nesnadny + Schwartz, Cleveland, OH*
Client *The Progressive Corporation*
Printer *Fortran Printing*

5
Sleeve/Envelope *Promotional Sleeve*
Art Director/Photographer *Michael Golob*
Design Firm/Client *Geffen Records, Los Angeles, CA*
Printer *Graphic Alliance*

2

3

1

Packaging Cover *Fossil Tins*
Art Director *Charles S. Anderson*
Designers *Charles S. Anderson, Daniel Olson, Haley Johnson*
Illustrator *Randall Dahlk*
Design Firm *Charles S. Anderson Design Company, Minneapolis, MN*
Client *Fossil Watches*

2

Calendar/Agenda Cover *Bonehead At A Glance Weekly Planner*
Art Director *Charles S. Anderson*
Designers *Charles S. Anderson, Daniel Olson*
Design Firm *Charles S. Anderson Design Company, Minneapolis, MN*
Printer *Print Craft, Inc.*

3

Packaging Cover *Scientific Notation Cards*
Art Director *Charles S. Anderson*
Designers *Charles S. Anderson, Todd Hauswirth*
Design Firm *Charles S. Anderson Design Company, Minneapolis, MN*
Printer *Print Craft, Inc.*

4

Packaging Cover *Monster Candy Box*
Art Director *Charles S. Anderson*
Designer *Charles S. Anderson, Daniel Olson*
Illustrator *Randall Dahlk*
Design Firm *Charles S. Anderson Design Company, Minneapolis, MN*
Printer *Print Craft, Inc.*

4

1

3

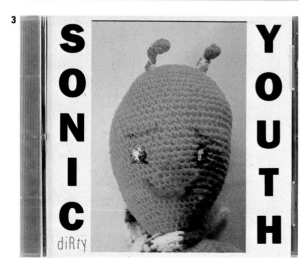

2

1

Compact Disk Cover *Lush, "Spooky"*
Art Directors *Vaughan Oliver, Jeff Gold*
Designer *Vaughan Oliver*
Photographer *Jim Friedman*
Design Firm/Client *Warner Bros. Records, Burbank, CA*
Printer *Ivy Hill*

2

Compact Disk Cover *New Order, "Republic"*
Art Directors *Jeff Gold, Steven Baker, Peter Saville*
Design Firm/Client *Warner Bros. Records, Burbank, CA*

3

Compact Disk Cover *Sonic Youth, "Dirty"*
Art Director *Kevin Reagan*
Designer *Mike Kelley*
Photographer *R. Kern*
Design Firm/Client *Geffen Records, Los Angeles, CA*
Printer *A.G.I./Specialty*

4
Compact Disk Cover *Infidels, "100 Watt Bulb"*
Art Director *Hugh Brown*
Designers *Neil Kellerhouse, Hugh Brown*
Illustrator *Hugh Brown*
Design Firm/Client *IRS Records, Universal City, CA*
Printer *Ivy Hill*

5
Compact Disk Cover *Road Kill CD Sampler*
Art Director *Kevin Reagan*
Design Firm/Client *Geffen Records, Los Angeles, CA*
Jacket Printer *Queens*
Label Printer *Specialty*

6
Compact Disk Cover *Warren Zevon, "Learning to Flinch"*
Art Directors *Jeri Heiden, Lyn Bradley*
Cover Artwork *Jimmy Wachtel*
Photographer *Willie Gibson*
Design Firm/Client *Warner Bros. Records, Burbank, CA*
Printer *A.G.I.*

4

5
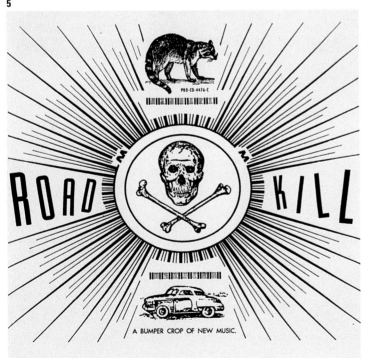

6

1

2

3

1
Compact Disk Cover *Quicksand, "Slip"*
Art Director *Michael Bays*
Designer/Illustrator *Phil Yarnall*
Design Firm/Client *Polygram Records, New York, NY*
Printer *AGI*

2
Compact Disk Cover *School of Fish, "Human Cannonball"*
Art Directors *Tommy Steele, Stephen Walker*
Designer *Stephen Walker*
Illustrator *Bar-Min-Ski*
Design Firm *Capitol Records, Inc., Hollywood, CA*
Client/Publisher *Capitol Records, Inc.*

3
Compact Disk Cover *Uakti, "Mapa"*
Art Director *Margery Greenspan*
Designer/Illustrator *Phil Yarnall*
Design Firm/Client *Polygram Records, New York, NY*
Printer *AGI*

4

5

R.S.V.P.: INVITATIONS ONLY Apparently, much of what we consider formal etiquette, of which the invitation is only a part, originated during the 1600s and 1700s in the French royal courts.

An *étiquette*, French for *ticket*, was a daily list of functions, giving the time, place, and proper dress. It was posted at the Versailles of Louis XIV to tell the nobles what was expected of them, and soon became a code of behavior that was adopted by the courts of other nations throughout the Western world.

In judging this show, particularly the early rounds, we soon became aware that the invitation has evolved beyond a simple daily list of functions, easily posted. Many of the 1,157 total entries to this show were extremely elaborate, and seemed to have been dragged through the production salad bar and loaded with excessive materials and techniques. Foil stamping, embossing, die-cutting, complicated binding and folding were often used in a heavy-handed manner—in some cases, all used on a single piece.

These efforts greatly diminished the primary message of the invitation, to the point where we could not easily determine the date, time, or place of the event. The jurors agreed that each accepted piece had to communicate that information effectively.

The final forty-four selected entries were almost universally simpler in execution, in both materials and technique, and the production values were not compomised. Some were very conceptual in approach, while others were just quietly elegant. Those that incorporated humor did so without over-working it. These were the invitations that met all of our criteria and that we felt were worthy of posting.

I would like to thank Lana, Craig, Heidi, and Eric for their help with the judging, and Peter Nappi for his efforts in coordinating the exhibition.

Eric Madsen
Chairman

JURY

ERIC MADSEN
President
The Office of Eric Madsen
Minneapolis, MN

ERIC BAKER
Principal
Eric Baker Design Associates
New York, NY

CRAIG FRAZIER
Principal
Frazier Design
San Francisco, CA

HEIDI RICKABAUGH
Principal
Principia Graphica
Portland, OR

LANA RIGSBY
Principal
Rigsby Design, Inc.
Houston, TX

CALL FOR ENTRIES

Design
The Office of Eric Madsen

Paper
Crane Parchment Crest White

Printer
Fine Arts Engraving Company

1
Invitation *Croatia Fundraiser*
Art Director/Designer *Scott Mires*
Illustrator *Gerald Bustamante*
Copywriter *Anuska Smith*
Design Firm *Mires Design, Inc., San Diego, CA*
Printer *Rush Press*
Paper *Kraft*

2
Invitation *"Vote"*
Art Director/Designer *John Ball*
Illustrator *David Quatrocchiochi*
Copywriter *John Ball*
Design Firm *Mires Design, Inc., San Diego, CA*
Printer *Graphics Ink*
Paper *Evergreen Birch*

3
Invitation *AIGA/LA "Issues & Causes"*
Art Director/Designer *Sean Adams*
Typographer *Icon West*
Design Firm *Adams/Morioka, Los Angeles, CA*
Printer *Glendale Rotary*
Paper *Newsprint*

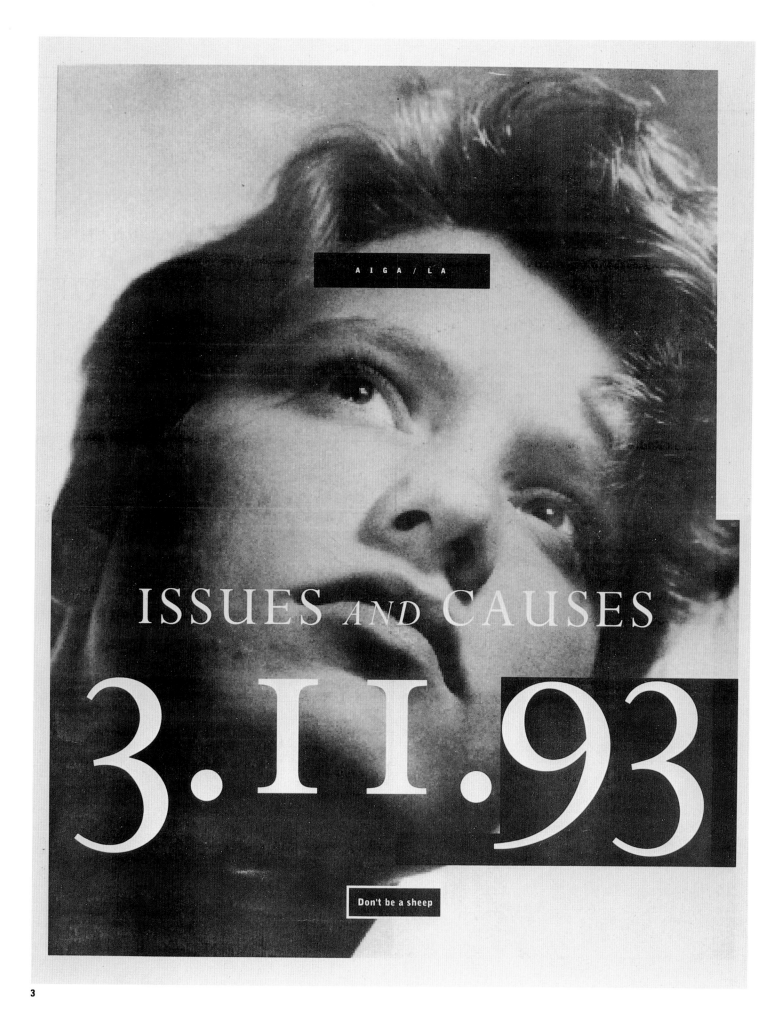

AIGA / LA

ISSUES AND CAUSES

3.11.93

Don't be a sheep

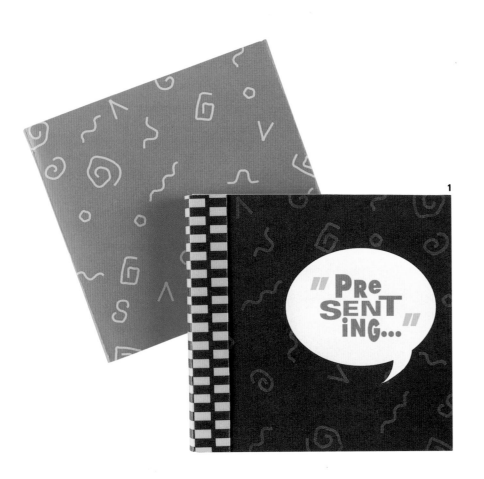

1
Invitation *AIGA Flip Book*
Art Director *Melanie Bass*
Designers *Melanie Bass, Julie Sebastianelli, Richard Hamilton,*
Jim Jackson, Andres Tremols, Pam Johnson
Illustrators *Melanie Bass and Julie Sebastianelli*
Copywriter *Jake Pollard*
Printer *Peake Printers*
Paper *Champion Carnival White*

2
Invitation *Paper and Ink Seminar*
Art Directors *Keith Puccinelli and Tom Hinkle*
Designers *Keith Puccinelli and Heidi Palladino*
Illustrator *Keith Puccinelli*
Design Firm *Puccinelli Design, Santa Barbara, CA*
Printer *Haagen Printing*
Paper *Karma*

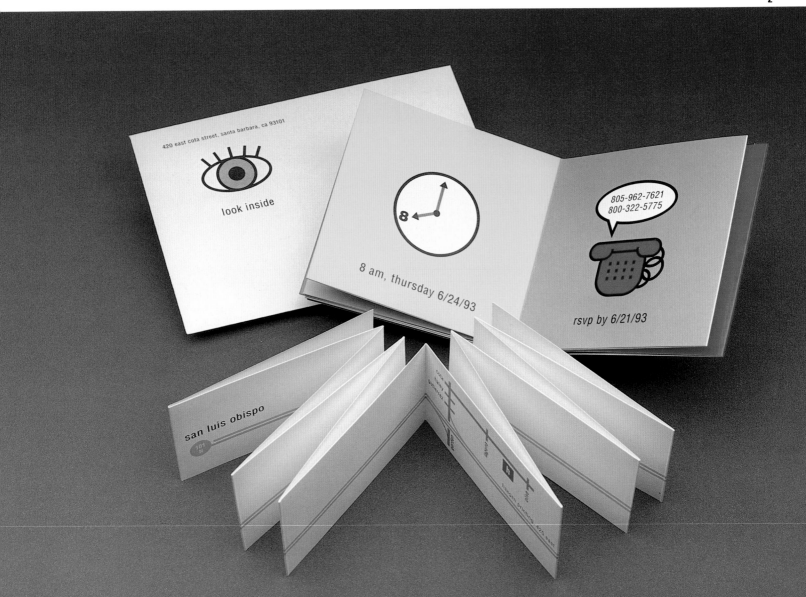

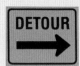

On March 23, 1988, Lance and Shawn met for the

first time. It was an event that

would change the course of their lives.

3

So, on June 17, 1989, Shawn M. Hoffacker,

Lance W. Cantor and their families cordially invite

you to celebrate the sharing of their marriage

vows. This joyous event will be held underneath the

oak trees of the Richardson Women's Club at

7:30 P.M., with reception following. Please join us.

All signs are pointing to a wonderful marriage.

R.S.V.P. by June 11, (214) 245-2929.

3
Invitation *Cantor Wedding*
Art Director *Willie Baronet*
Designers *Willie Baronet and Mike Connors*
Illustrator *Willie Baronet*
Design Firm *GibbsBaronet, Dallas, TX*
Printer *Padgett Printing*
Paper *French Cream Blanc*

4
Invitation *Mead Speaking Engagement*
Art Director *Dana Arnett*
Designer *Curt Schreiber*
Design Firm *VSA Partners, Inc., Chicago, IL*
Printer *Available Business Forms*
Paper *Fasson Crack 'n' Peel Plus*

4

1

1

Invitation *Alley Theatre 1991 Gala*
Art Director/Designer *Lana Rigsby*
Illustrators *Lana Rigsby and Deborah Brochstein*
Copywriter *Paule Hewlitt*
Typographer *Characters*
Design Firm *Rigsby Design, Inc., Houston, TX*
Printer *International Printing and Publishing*
Paper *Mead Signature Dull*

2

Invitation *New Year's Eve, Siegel Photographic*
Art Directors *Forrest and Valerie Richardson*
Designer/Copywriter *Neill Fox*
Design Firm *Richardson or Richardson, Phoenix, AZ*
Printer *Woods Lithographics, Arizona Embossing*

3

Invitation *Opening, National Postal Museum*
Art Director *Lana Rigsby*
Designers *Lana Rigsby and Michael B. Thede*
Copywriter *Elizabeth Little*
Typographer *Characters*
Design Firm *Rigsby Design, Inc., Houston, TX*
Printer *The Pikes Peak Lithographing Co.*
Paper *SuperMax Cover*

2

3

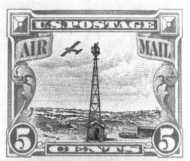

3

La société NIKE est heureuse de vous inviter à la conférence de presse organisée à

l'occasion de la venue d'André Agassi, Jim Courier et John McEnroe au Paris Country Club

à l'occasion du BMW Trophy · Samedi 22 Mai, immédiatement après le match d'1h30 · Paris

V'Club, 121 Rue du Lieutenant-Colonel de Montbrison, 92500 Rueil Malmaison · Vous

la carte de visite de votre contact chez NIKE afin de lui communiquer votre

'us à la porte principale munis de la présente invitation.

SW O

NIKE TOWN ORANGE COUNTY

NIKE TOWN. BORN IN PORTLAND. GREW UP IN CHICAGO. JUST FINISHED BUILDIN

1
Invitation *Agassi Opening*
Designers *John Norman and Jeff Weithman*
Illustrator *Greg Maffei*
Copywriter *Bob Lambi*
Typographer *Grey Matter*
Design Firm *Nike Inc., Beaverton, OR*
Printer *Lith Tech Printing*
Paper *UV Ultra II Filare Linen*

2
Invitation *Niketown Openings, Georgia*
Art Director/Designer *Clark Richardson*
Illustrator *Clark Richardson*
Copywriter *Bob Lambie*
Design Firm *Nike Inc., Beaverton, OR*
Printer *Irwin Hodson*

3
Invitation *Tenth Anniversary*
Art Director *Nancy Gardner*
Designer/Illustrator *Brian Collins*
Copywriter *Chuck Carlson*
Design Firm *Gardner Design, Minneapolis, MN*
Printer *Co-op Printing*
Paper *Torchglow Opaque*

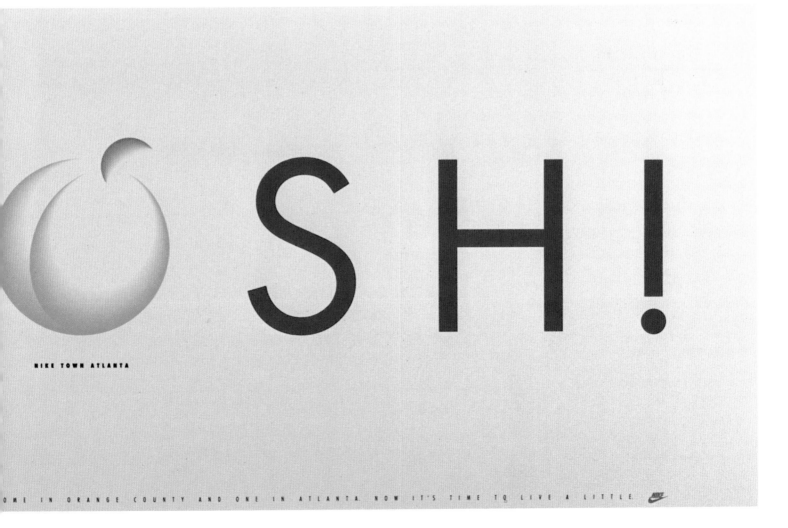

on Thursday, December 31, 1987 at the Walhalla Country Club, Walhalla, North Dakota.

Hector and Ethyl Johnstone request the pleasure of your company at the wedding reception of their daughter Haidee Morna Johnstone and Donald Michael Skjei,

Please respond on or before December 8, 1987

M _____

will _____

_____ attend

1

1
Invitation *Johnstone/Skjei Wedding*
Art Director/Designer *Michael Skjei*
Illustrators *Michael Skjei and Haidee Johnstone*
Typographer *Spartan Typography*
Design Firm *M. Skjei Design Co., Minneapolis, MN*
Paper *Simpson Protocol 100*

2
Invitation *Virginia Paper Company*
Art Director/Designer *James A. Stygar*
Copywriter *Penelope H. Stygar*
Design Firm *Stygar Group, Inc., Richmond, VA*
Paper *Cover, Simpson Filare; Text, Various*

Virginia Paper Company 1983 Annual Reports

2

3
Invitation *Party at Wright*
Art Director/Designer *Nanette Wright*
Design Firm *Wright Communications Inc., New York, NY*
Printer *Anchor Engraving Co.*
Paper *Simpson Quest*

4
Invitation *"Bah Hum Bug," Cato Gobe Christmas Party*
Art Director *Peter Levine*
Designer *Charles Hamilton*
Design Firm *Cato Gobe & Associates, New York, NY*
Printer *Rosepoint*
Paper *Kraft*

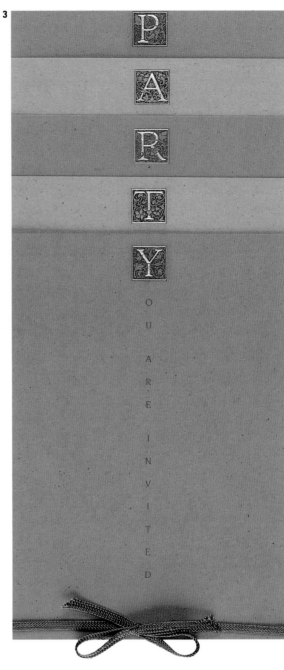

1

Invitation *Pecan Harvest: Mixed Nuts*
Art Director/Designer *Forrest Richardson*
Design Firm *Richardson or Richardson, Phoenix, AZ*
Printer *Arrowhead Press*

2

Invitation *Pecan Report '93*
Art Director/Designer *Forrest Richardson*
Illustrator *Forrest Richardson*
Design Firm *Richardson or Richardson, Phoenix, AZ*
Printer *Arrowhead Press*

3

Invitation *Herman Miller Opening, IDCNY*
Art Director/Designer *Linda Powell*
Design Firm *Ferris State University, Big Rapids, MI*
Printer *The Etheridge Company*
Paper *Neenah UV Ultra II, Simpson Vicksburg Vellum*

4

Invitation *"Russian Graphic Design Before the Revolution: 1880–1917"*
Art Director/Designer *Rebeca Mendez*
Design Firm *Art Center College of Design, Pasadena, CA*
Printer *Typecraft, Inc.*
Paper *Graphika Lineal*

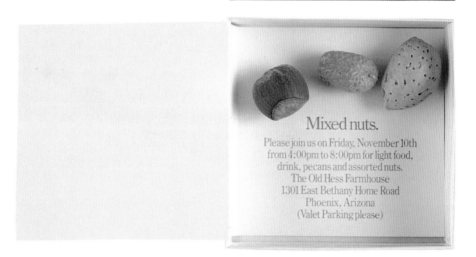

1

What do you get when you invite 42 clients, 114 suppliers, and a bunch of relatives and friends to a Pecan Harvest?

Mixed nuts.

Please join us on Friday, November 10th from 4:00pm to 8:00pm for light food, drink, pecans and assorted nuts.
The Old Hess Farmhouse
1301 East Bethany Home Road
Phoenix, Arizona
(Valet Parking please)

2

THE
PECAN REPORT
1993

Palm Springs, California

Menasha, Wisconsin

Cupertino, California

Clinton, New Jersey

Los Angeles
San Diego

Kona-Kailua, Hawaii

Phoenix, Arizona

Atlanta, Georgia

Orlando, Florida

WHERE OUR CLIENTS ARE
(Map not to scale)

We realize our limitations. We don't expect to change the world — only a small part of it. Together with our clients, we made a dent. The results went beyond our neighborhood.

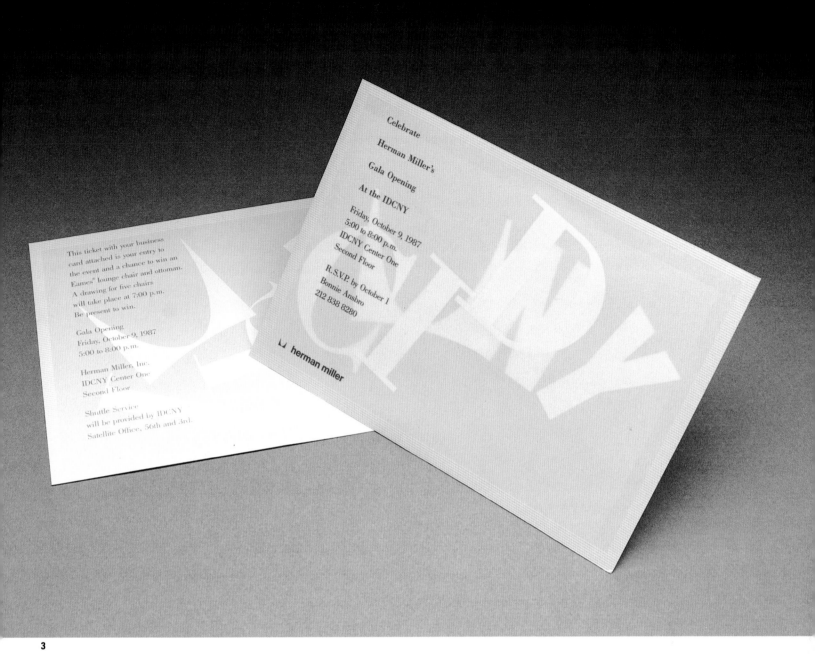

3

This ticket with your business
card attached is your entry to
the event and a chance to win an
Eames® lounge chair and ottoman.
A drawing for five chairs
will take place at 7:00 p.m.
Be present to win.

Gala Opening
Friday, October 9, 1987
5:00 to 8:00 p.m.

Herman Miller, Inc.
IDCNY Center One
Second Floor

Shuttle Service
will be provided by IDCNY
Satellite Office, 56th and 3rd.

Celebrate

Herman Miller's

Gala Opening

At the IDCNY

Friday, October 9, 1987
5:00 to 8:00 p.m.
IDCNY Center One
Second Floor

R.S.V.P. by October 1
Bonnie Ansbro
212 838 8280

⊔ herman miller

4

the **OFFICIAL** handbook on
TYING THE KNOT

1

the **HITCH**

This is one of the strongest and most permanent of all knots, and can only be tied after much practice. It is useful for holding two people together, bringing them closer. It also comes in handy for carrying them over rough spots. Even under stress, the bond will not be loosened and the two ends cannot be pulled apart.

THIS KNOT WAS TIED ON 9-17-93

Jodie Gould & Joel Templin

[*For which they have earned a Merit Badge and a hearty congratulations.*]

WASHINGTON SQUARE BAR & GRILL
CORDIALLY INVITES YOU & YOUR FRIENDS
TO A
BENEFIT AUCTION & SALE
OF THE WORKS OF
DUGALD STERMER
ON SUNDAY, DECEMBER THIRD,
FROM THREE TO SIX IN THE AFTERNOON,
AT THE SQUARE, 1707 POWELL STREET,
SAN FRANCISCO.

All proceeds will directly assist
those hardest hit by the recent earthquake.

Live Jazz Refreshments

2

1
Invitation *"The Official Handbook on Tying the Knot"*
Art Director/Designer *Joel Templin*
Illustrator *Joel Templin*
Photographer *Paul Sinkler*
Copywriter *Lisa Pemrick*
Design Firm *Templin Design, Minneapolis, MN*
Printer *General Litho Services*
Letterpress *Spring Harvey*
Paper *French Speckletone*

2
Invitation *Benefit Art Auction for Earthquake Relief*
Art Director/Designer *Dugald Stermer*
Illustrator *Dugald Stermer*
Design Firm *Dugald Stermer, San Francisco, CA*
Typographer/Printer *Delancey Street Print & Copy*
Paper *Simpson Lee Vicksburg, Ivory*

3
Invitation *Shannon Gibbons: Blue Note*
Art Director/Designer *Tom Wood*
Photographer *Gloria Baker*
Design Firm *Wood Design, New York, NY*
Printer *Artanis Offset*
Paper *Simpson Evergreen*

3

TO LOVE *for* THE

SAKE *of* BEING

OVED IS

THE FAVOUR OF A REPLY IS REQUESTED

BEFORE *the* FIRST *of* MAY.

m _____

WILL _____ ATTEND

1

1
Invitation *Wedding*
Art Director/Designer *James Koval*
Design Firm *VSA Partners, Inc., Chicago, IL*
Printer *Ace Graphics*
Paper *Teton+ T2000*

2
Invitation *Wedding*
Art Director/Designer *John Norman*
Illustrators *John Norman and Ben Wong*
Copywriter *Deirdre Hanley*
Typographer *Grey Matter*
Design Firm *John Norman, Portland, OR*
Printer *Year of the Horse Press, Irwin Hodson*
Paper *Essa — Gill Clear*

2

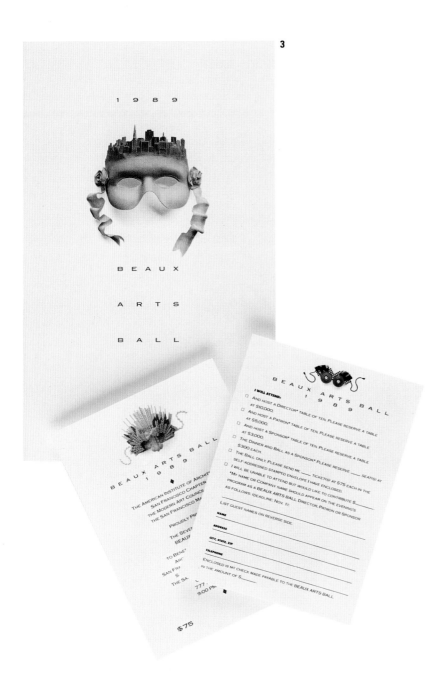

3
Invitation *1989 Beaux Arts Ball*
Art Director *Kit Hinrichs*
Designers *Kit Hinrichs and Susan Tsuchiya*
Illustrators *Kit Hinrichs and Susan Tsuchiya*
Photographer *Barry Robinson*
Typographer *Euro Type*
Design Firm *Pentagram Design, San Francisco, CA*
Printer *Color Graphics*
Paper: *Simpson Starwhite, Vicksburg Tierra White*

4
Invitation *Master Card Annual Meeting*
Art Director *Gail Wiggin*
Designer *Robert Innis*
Photographer *Amos Chan*
Copywriter *Alec Wiggin*
Design Firm *Wiggin Design Inc., Darien, CT*
Printer *Diversified Graphics*
Paper *Strathmore*

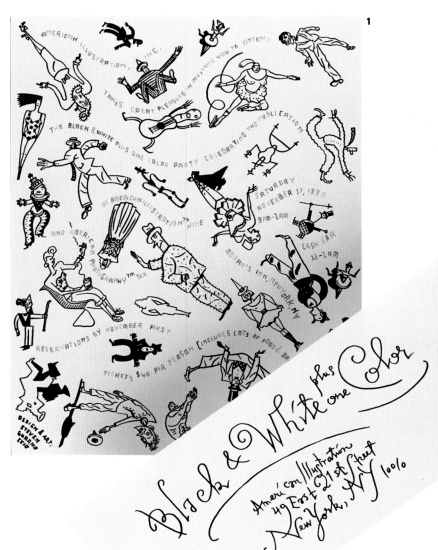

1

2

IRONWORK

A SHOW OF
OBJECTS &
DRAWINGS BY

STEVEN GUARNACCIA

OPENING NOVEMBER 1, 1991
6PM - 10PM
SHOW RUNS UNTIL DECEMBER 8, 1991

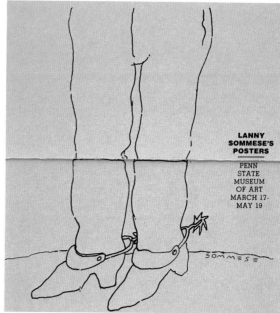

1

Invitation *Black and White Plus One Color*
Art Director/Designer *Steven Guarnaccia*
Illustrator *Steven Guarnaccia*
Design Firm *Studio Guarnaccia, New York, NY*
Printer *Terwilliger-Sterling Roman*
Paper *Vellum*

2

Invitation *Ironwork*
Art Director/Designer *Steven Guarnaccia*
Illustrator *Steven Guarnaccia*
Design Firm *Studio Guarnaccia*
Printer *Lunar-Caustic Press*
Paper *Speckletone*

3

Invitation *AIGA/NY Season Opening*
Art Director *Robert Valentine*
Designers *Robert Valentine, Dina Dell'Arciprete*
Illustrator *Jean-Michel Basquiat*
Design Firm *Robert Valentine Inc., New York, NY*
Printer *Diversified Graphics*
Paper *Gilbert Esse*

4

Invitation *Lanny Sommese's Posters*
Art Director/Designer *Lanny Sommese*
Illustrator *Lanny Sommese*
Design Firm *Sommese Design, State College, PA*
Printer *Grove Printing*
Paper *Hammermill*

1

Invitation *Council of Fashion Designers of America '93 Gala*
Art Director *Michael Bierut*
Designers *Michael Bierut and Esther Bridavsky*
Copywriter *Fern Mallis*
Design Firm *Pentagram Design, New York, NY*
Printer *Diversified Graphics*
Paper *Neenah Vellum, Simpson Brightwater, vinyl acetate*

2

Invitation *Opening, Alexandria Mall*
Art Director/Designer *Rex Peteet*
Illustrator *Rex Peteet*
Typographer *Robert Hilton Typographers*
Design Firm *Sibley/Peteet Design, Inc., Dallas, TX*
Printer *Williamson Printing*
Paper *Simpson Starwhite, Vicksburg Text*

1

2

Because now we're all dressed up.

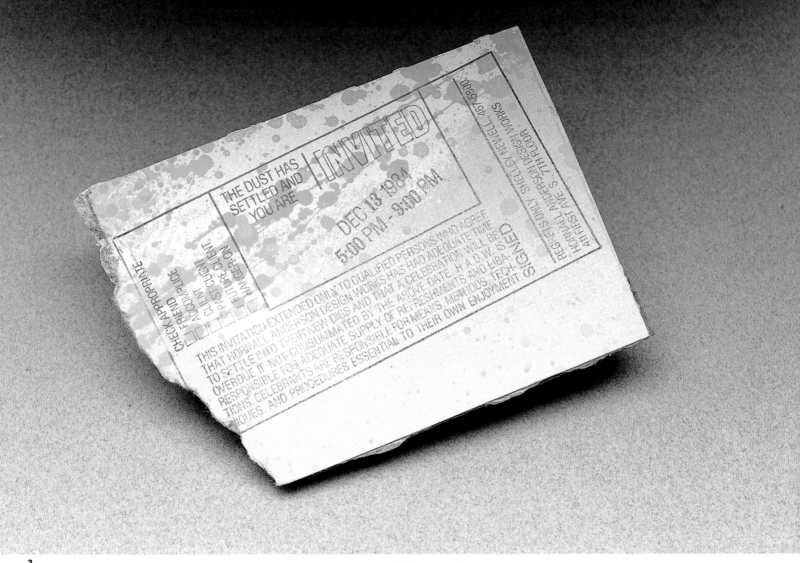

3

3
Invitation *Hornall Anderson Design Works*
Art Directors/Designers *Jack Anderson and John Hornall*
Illustrator *Hornall Anderson Design Works*
Typographer *The Type Gallery*
Design Firm *Hornall Anderson Design Works, Seattle, WA*
Printer *Hornall Anderson Design Works (stamp)*
Material *Drywall Sheetrock*

4
Invitation *Thirtieth Birthday*
Art Director/Designer *Susan Silton*
Design Firm *SOS/Los Angeles, Los Angeles, CA*
Printer *Samper Silkscreen*

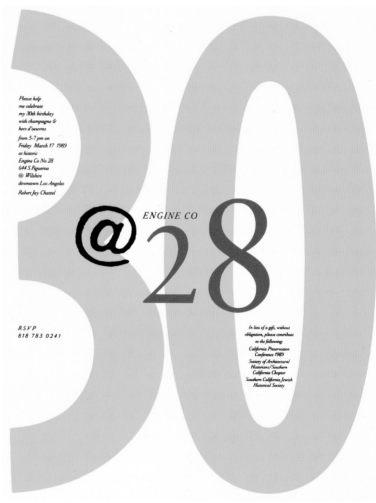

Please help
me celebrate
my 30th birthday
with champagne &
hors d'oeuvres

from 5-7 pm on
Friday March 17 1989
at historic
Engine Co No 28
644 S Figueroa
@ Wilshire
downtown Los Angeles
Robert Jay Chattel

ENGINE CO

@28

RSVP
818 783 0241

In lieu of a gift, without
obligation, please contribute
to the following:
California Preservation
Conference 1989
Society of Architectural
Historians/Southern
California Chapter
Southern California Jewish
Historical Society

4

COMMUNICATION GRAPHICS The AIGA's *Communication Graphics* show for 1994 is precisely what we hoped it would be — a marvelously diverse body of work representing an ever-growing number of voices, styles, and generational vantage points. In my view, it reflects the efforts of a design population struggling to communicate with a collective audience that is increasingly design literate, more technologically astute than ever before, and clearly overburdened with a cacophony of — more often than not — uninvited messages.

This jury believes that the 282 pieces selected for inclusion here represent the best and the brightest of American graphic design at this particularly challenging moment in our rapidly changing society.

Woody Pirtle
Chairman

JURY

WOODY PIRTLE
Designer and Partner
Pentagram Design Inc.
New York, NY

GAIL ANDERSON
Deputy Art Director
Rolling Stone
New York, NY

DANA ARNETT
Founding Principal
VSA Partners, Inc.
Chicago, IL

KENNY GARRISON
Designer and Principal
RBMM
Dallas, TX

DEBORAH SUSSMAN
Principal
Sussman/Prejza & Co., Inc.
Culver City, CA

CALL FOR ENTRIES

Design and Illustration
Woody Pirtle
Pentagram Design Inc.

Printer
Finlay Brothers Company

Paper
French Speckletone
70 lb. Cream Text

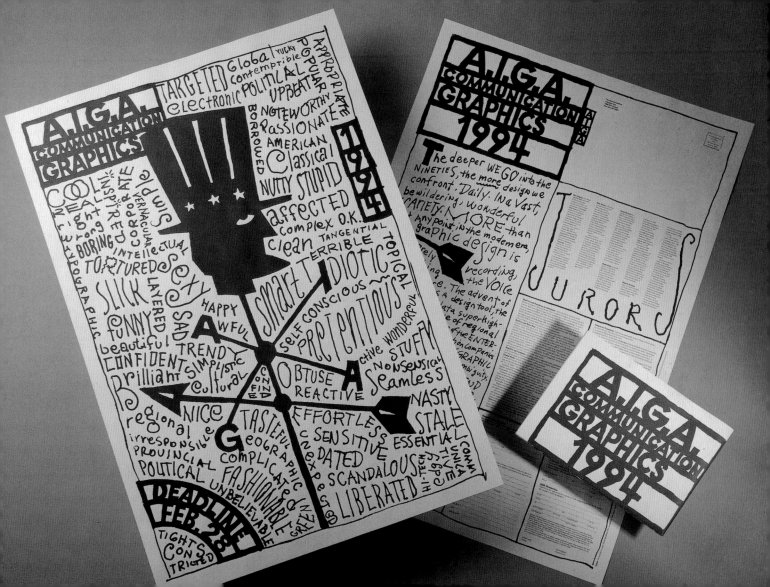

Art Directors *Alicia Johnson and Hal Wolverton*
Designers *Hal Wolverton, Kat Saito,*
Jerome Schiller, and Chris King
Photographers *Various*
Design Firm *Johnson & Wolverton, Portland, OR*
Publisher *Amnesty International U.S.A.*
Printer *The Irwin-Hodson Company*
Paper *Resolve*

1

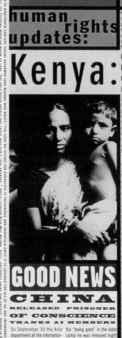

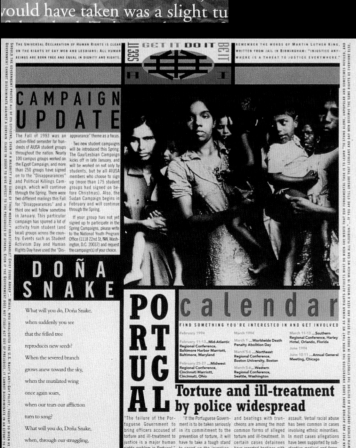

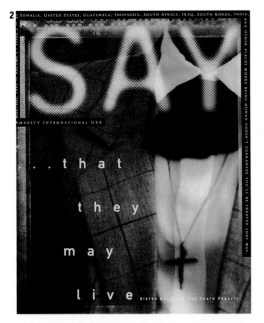

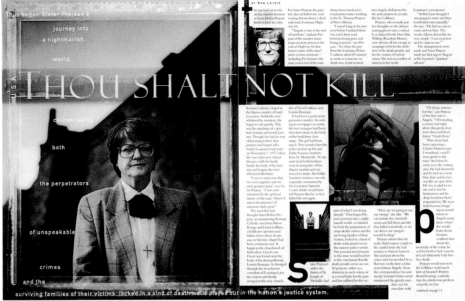

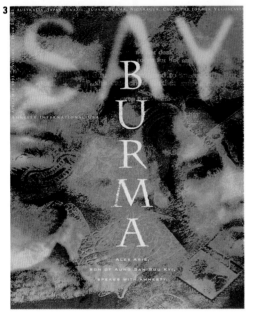

continued on page 11

2

Title *Say Magazine Nov./Dec. 1993*

Art Directors *Alicia Johnson and Hal Wolverton*

Designers *Hal Wolverton, Kat Saito,*
Jerome Schiller, and Chris King

Photographers *Various*

Design Firm *Johnson & Wolverton, Portland, OR*

Publisher *Amnesty International U.S.A.*

Printer *The Irwin-Hodson Company*

Paper *Resolve*

3

Title *Say Magazine April/May 1993*

Art Directors *Alicia Johnson and Hal Wolverton*

Designers *Hal Wolverton, Kat Saito,*
Jerome Schiller, and Chris King

Photographers *Various*

Design Firm *Johnson & Wolverton, Portland, OR*

Publisher *Amnesty International U.S.A.*

Printer *The Irwin-Hodson Company*

Paper *Carnival Groove, Graphika Lineal, Gilbert Esse*

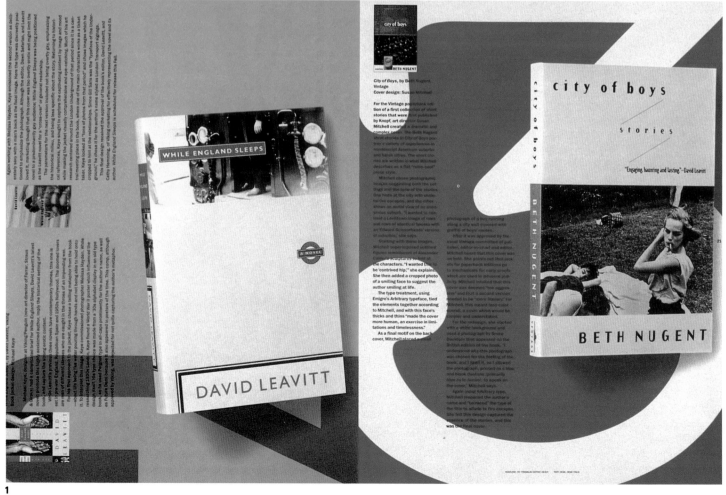

1

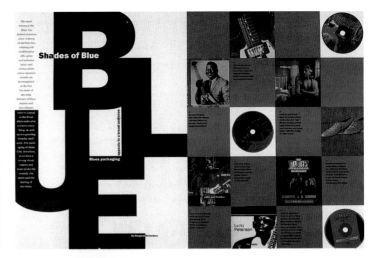

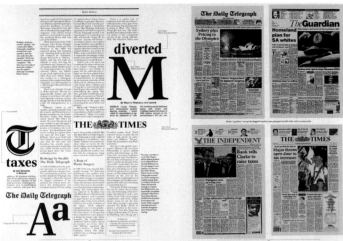

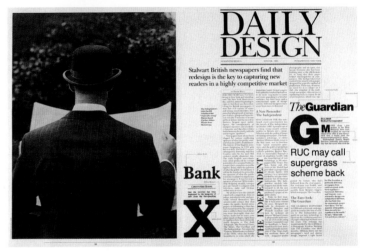

2

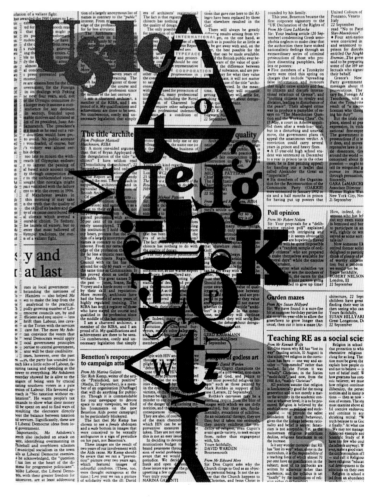

1

Title *u&lc Summer/Fall 1993*

Art Directors *Woody Pirtle and John Klotnia*

Designers *John Klotnia and Ivette Montes de Oca*

Design Firm *Pentagram Design, New York, NY*

Publisher *International Typeface Corporation*

2

Title *u&lc Winter 1993*

Art Directors *Woody Pirtle and John Klotnia*

Designers *John Klotnia and Ivette Montes de Oca*

Design Firm *Pentagram Design, New York, NY*

Publisher *International Typeface Corporation*

1

DIGITAL NEWS

NUMBER 2 VOLUME 4 — 1993

digital

There's more to service
than

"Have a nice day"

From just a supplier to
their customers' real business partner is a repo-
sitioning many companies are laying claim to.
But have they earned it? Well, the proof is in the
pudding, as they say. The "pudding" when it
comes to Digital, has two main ingredients; one a
cause, the other an effect. The effective ingredient
is testimonial statements by customers themselves
(many published in the pages of Digital News)
plainly applauding Digital's role in helping them
achieve operating efficiencies and competitive
advantages. The cause is Digital's determined
expansion of capabilities far beyond hardware

The
Natural
habitat of

[innovative management]

"**It** never comes as any surprise to
people that the Ministry of Natural Resources' mandate is to manage the prov-
ince's natural resources," says Bev Vintcent, MNR's Assistant Deputy Minister,
Information Resources Division. "What does surprise many people is that 87%
of the land in the province is Crown land, and that's the scope of our task. In
fact," he goes on, warming to his topic, "the land is just the beginning. We are
also responsible for the fish, the trees, the wildlife, and even some of the mineral
resources, on land and under the water." It is the heart of these activities is infor-
mation about the resources: what they are, where they are, and their condition.
Answering the "what," "how," and "how much" questions requires resource
inventories. Answering the "where" question requires a geographic reference.
Putting together the tabular (inventory) data and spatial (geo-referenced) data
for analysis is one of the most important systems development challenges in
Ontario. ¶ Vintcent recounts that technology didn't exist to electronically integrate
spatial data, to manipulate it and to present it. But new technology is catching

Digital's Alpha chip makes Guinness Book of Records
Digital's Alpha chip now appears in the Guinness Book of Records as being the world's fastest microprocessor. The Book's 1993 edition,
published in October, includes the following entry: **Fastest chip** — In March 1992 it was reported that DEC of Maynard, MA had developed an
all-purpose computer chip, a 64-bit processor known as Alpha, which could run at speeds of up to 150 MHz (compared with 25 MHz for many
modern personal computers). One Alpha chip is claimed to have about the same processing power as a CRAY-1, which went on sale in 1976
as the Cray company's first supercomputer, at a cost of $7.5 million U.S.

The world's fastest chip now powers the world's fastest computers from desktop
to datacentre. Just ask Microsoft or Cognos, SAS or ORACLE, or any other of the
hundreds of applications partners.

Alpha.

↓

→ | Ready. | ←

↑

Digital introduces Alpha AXP computing —

Before 1992 ended, Digital introduced Alpha AXP computing: a complete set of systems,

software, applications and services with new business practices, that provide a universal

platform enabling unlimited open computing possibilities far into the future. ¶ Alpha AXP

computing — the first advanced 64-bit, 21st century architecture — is a major technology

milestone for the computing industry. For Digital, it reflects a renewed determination to

7

1

Title *Digital News Number 2, Volume 4 1993*
Art Director/Designer *Mark Koudys*
Illustrator *Barry Blitt*
Photographers *Alan Abrams and Francesca Lacagnina*
Design Firm *Atlanta Art and Design, Toronto, Ontario*
Printer *BGM*

2

Title *Digital News Number 3, Volume 4 1993*
Art Director/Designer *Mark Koudys*
Illustrator *Barry Blitt*
Photographers *Alan Abrams and Francesca Lacagnina*
Design Firm *Atlanta Art and Design, Toronto, Ontario*
Printer *BGM*

2

DIGITAL NEWS

NUMBER 3 VOLUME 4 — 1993

2

Open to choices
Digital responds to the market with a unified UNIX
that's always equal to the task.

6

A brilliant balancing act
Mohawk Oil has had a tradition of daring to work
differently if it means better business. Some things
never change.

17

Chip Chat
News on partnerships. Close-up views of products.
Check out DECathena, for instance — a multivendor
integration solution now available in Canada.

McMASTER HOSPITALS

FINDING THE PERFECT PARTNER

IT MIGHT HAVE SEEMED LIKE A TIGHTROPE WALK

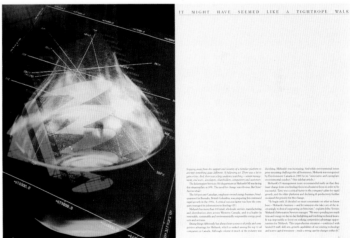

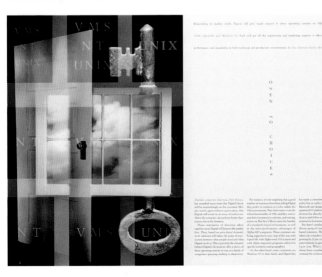

OPEN TO CHOICES

DUPONT FINISHES BUSINESS

BOB WEBB (TRAN '83X)

POSITION: Consultant, H. N. and Frances C. Berger Foundation (provides grants to civic and educational programs, primarily in Southern California). **DESIGN CREDITS:** Automotive concepts for the movies Knghtrider and Robocop, with noted entertainment designer George Barris; coordinator of high-profile alternative-fuel vehicle project at Art Center and Art Center (Europe) sponsored by the Berger Foundation. **MAJOR INTERESTS:** Research, educational funding. **PRESENT PROJECT:** Collaboration with Barris on automobile designs for Hollywood production.

"In the transportation design project at Art Center's two campuses, we wanted, through the publicity, to give the public an idea of what they'll be driving in the year 2000. It helped the students immeasurably, and their ideas were realistic. I find the postal van is very workable solution for today. It could be applied to a wide variety of services." "Eventually the push for alternative fuel sources would have appeared because of miniaturization and the public outcry for solutions to pollution. But without government intervention it wouldn't have become the prominent issue it is right now." "So the market is there, but it's very honest. Government must be supportive the whole way, and that support will be strengthened by the increase and exposure of private research efforts. I'd like to see more lecture programs at schools like Art Center, which address all aspects of alternative energy sources. There's real power in going into Art Center's library and watching tapes of lectures from various experts. That's the way to document where we are today, so that in 10 or 20 years we can see who was right."

ZERO-EMISSIONS VEHICLES ON THE FAST TRACK
THREE ALUMNI DISCUSS ALTERNATIVE ENERGY VEHICLES

HARDLY A DAY GOES BY AT THE PASADENA CAMPUS WHEN THE WORDS "ALTERNATIVE ENERGY VEHICLES" AREN'T SPOKEN. THE RACE TO FIND THE FLAWLESS FUEL HAS BEEN SPURRED BY CALIFORNIA LEGISLATION, CALLING FOR 2 PERCENT OF AUTOMAKERS' SALES IN THE STATE TO BE OF ZERO-EMISSIONS VEHICLES (ZEVS) BY 1998. AT LEAST ONE-THIRD OF THE NATION'S STATES ARE EXPECTED TO FOLLOW SUIT. CONSEQUENTLY ALUMNI AND STUDENTS ALIKE HAVE PLUNGED INTO POWER TECHNOLOGY RESEARCH TO FIND VIABLE SOLUTIONS FOR TOMORROW'S ENVIRONMENTALLY FRIENDLY VEHICLES, BOTH FOR PERSONAL USE AND FOR MASS TRANSIT.

ABRIDGED INTERVIEWED THREE ALUMNI WHO HAVE PURSUED DIFFERENT AREAS OF THE ALTERNATIVE TRANSPORTATION INDUSTRY TO GET THEIR VIEWS ON MASS TRANSIT, ELECTRIC TECHNOLOGY, AND GOVERNMENT SUPPORT. — ANN BURNHAM

1. An electric college commuter car by student Jung Kim, designed to transport students at large universities, to classes, and nearby shopping centers. (Berger project)
2. An electric mail truck designed by student Kelly Wright. (Berger project)
3. Ron Powers's design for a mass-transit vehicle adaptable to various types of rail systems.
4. Built by Amergon and MD CALSTART'S Showcase Electric Vehicle (SEV), for which Bruce Severance served as principal designer.

RON POWERS (TRAN '71)

POSITION: Owner, Powers Design International, Newport Beach, California. **DESIGN CREDITS:** (1989 Cadillac El Dorado, the two cars produced by India's state-run automobile industry; manned space station "Freedom" transit vehicles for various kinds of rail systems. **MAJOR INTEREST:** Pneumatic or air-powered transit system. **PRESENT PROJECT:** Working on one of four teams chosen by the federal government to design a national system for high-speed magnetic-levitation trains.

"When cities start to look into mass transit, they look at extensions, guideways, road requisition costs, and power systems, and they realize that it's going to cost $50 to $100 million a mile. Then they close the books because they don't have $50 to $100 million a mile." "I've looked the world over for affordable power technology, and I've tried to talk up this pneumatic power system to cities and countries in need of rapid transit." (An air-powered system is currently running in a public park in Indonesia. The operating cost is less than $1 per passenger, per day.) "People sit on freeways and surface streets gridlocked and say, 'We need a monorail.' Well, we've got a great bus system in Los Angeles right now, and nobody rides it. If our system doesn't get people to and from the station, it's not going to be used." "Five years ago I started seeing some renewed interest in mass transit. People were finally gridlocked enough to say, 'Please, we need some help.' Well, as a transportation designer and not just a car designer, I think I can do that. There are alternatives out there. It's all about compromise. My job is to find a compromise people will make."

BRUCE SEVERANCE (TRAN '90)

POSITION: Designer, Amergon Inc. (aimed at redirecting the aerospace industry to transportation technology). **DESIGN CREDITS:** Principal designer of Showcase Electric Vehicle, in collaboration with alumni Larry Rodgers (TRAN '77) and David Heller (PROD '74); author of "Instant Electric Refueling" in SunWorld, Journal of the International Solar Energy Society; development of educational curricula on solar power for schools nationwide (grades 3 to 12) and on environmental ethics for Art Center. **MAJOR INTEREST:** Solar-thermal power. **PRESENT PROJECT:** Amergon's Neighborhood Electric Vehicle.

"There is a niche market for electric vehicles that exists today—to sell affordably to 3 to 5 percent of the population, specifically families that already have a couple of cars in the garage. I have a hard time understanding why no one is seizing the opportunity faster, because I really believe that if American companies don't do it, foreign companies will. And we may lose both a good market and an opportunity to boost our economy." "Even if the power is coming from fossil fuels, electricity is cleaner than gasoline. And electric technology is always moving toward a cleaner state. It's easier to control a generating source than it is to control six million tail pipes." "With the advancement of technology making it increasingly possible to transfer energy from coast to coast, I envision the country eventually converting to solar power for stationary sources of electricity and eventually for moving vehicles." "I don't think it's something that is on the fringe anymore. There's a mainstream of people who are extremely concerned about the environment." "As designers we are enormously empowered. We owe it to ourselves, society, and posterity always to consider the potential of our choices."

THE PAST FEW YEARS HAVE REPRESENTED A KIND OF COMING OF AGE FOR MARK TANSEY, WHO MAY BE ART CENTER'S MOST CELEBRATED FINE ART ALUMNUS. IN 1990-91 AN EXHIBITION OF HIS WORK ORGANIZED BY THE SEATTLE ART MUSEUM TRAVELLED TO MUSEUMS THROUGHOUT THE UNITED STATES AND CANADA. IN 1992 HE WAS THE SUBJECT OF A BOOK BY THE DISTINGUISHED PHILOSOPHER AND CRITIC ARTHUR DANTO, AND HIS PAINTING BECAME KNOWN TO A WIDER AUDIENCE THROUGH PROFILES IN VANITY FAIR AND ESQUIRE. IN JUNE OF THIS YEAR A TRAVELING RETROSPECTIVE OF HIS WORK OPENED AT THE LOS ANGELES COUNTY MUSEUM OF ART, AN HONOR RARELY ACCORDED TO AN ARTIST IN MID CAREER.

ON THE DAY HIS EXHIBITION OPENED, TANSEY SPOKE TO AN ATTENTIVE AUDIENCE OF ART CENTER STUDENTS, ALUMNI, FACULTY, STAFF, AND FRIENDS, INTRODUCING THE ARTIST TO THE CROWDED AUDITORIUM, LAURENCE DREIBAND, CHAIR OF THE FINE ART DEPARTMENT, DESCRIBED HIM AS "A UNIQUELY COMPLEX REPRESENTATIONAL PAINTER WHOSE WORK IS NEITHER REALIST NOR REACTIONARY, BUT RATHER EXTENDS THE DIDACTIC TRADITION OF RENÉ MAGRITTE AND JASPER JOHNS IN ITS QUESTIONING OF THE VERY NATURE OF REPRESENTATION AND IN ITS LINKING OF IMAGE AND IDEA."

TANSEY'S TURN

INDEED TANSEY'S WORK IS FULL OF PARADOXES. HE IS A REPRESENTATIONAL PAINTER WHO DEALS WITH ABSTRACT CONCEPTS, AN ACCOMPLISHED ARTIST WHO WORKS WITH PRIMITIVE TOOLS OR HIS FINGERS. BORN IN SAN JOSE, CALIFORNIA, IN 1949, HE GREW UP IN AN ATMOSPHERE IN WHICH ART AND INTELLECTUAL DISCOURSE WERE APPRECIATED. HIS FATHER IS A PROFESSOR OF ART HISTORY, AND HIS MOTHER IS A SLIDE LIBRARIAN WHO ALSO TAUGHT ART HISTORY. TANSEY STUDIED HUMANITIES AT SAN JOSE STATE UNIVERSITY FROM 1967 TO 1969, THEN WENT ON TO STUDY FINE ART AT ART CENTER, GRADUATING IN 1972. IN THE MID 1970S HE MOVED TO NEW YORK TO ATTEND GRADUATE SCHOOL AT HUNTER COLLEGE. HE ALSO BEGAN WORKING AS AN ILLUSTRATOR, PRIMARILY FOR THE NEW YORK TIMES BOOK REVIEW. WHILE SOME ARTISTS MIGHT LOOK DOWN ON ILLUSTRATION, DISMISSING IT AS A WAY OF EARNING MONEY WHILE ESTABLISHING A FINE ART CAREER, TANSEY REGARDS THE EXPERIENCE AS AN ESSENTIAL PART OF HIS EDUCATION.

"I THINK THERE ARE BASICALLY TWO TYPES OF ART EDUCATION," HE SAYS. "ONE IS ABOUT THE BREAKING DOWN, THE ANALYSIS OF THE CONTENT OF ART ... TO FIND ITS ESSENTIAL NATURE OR SOME BASIC TRUTH ABOUT ART ITSELF. AND THEN THERE'S A KIND OF EDUCATION THAT'S ABOUT THE BUILDING UP OF CONTENT, THE EXPANSION OF IT. IN MY CASE THIS MORE CONSTRUCTIVE EDUCA-

1
Title *Abridged 5*
Art Director *Rebeca Méndez*
Designer *Mary Cay Walp*
Photographer *Various*
Copywriters *Krista Brown, Ann Burnham,*
and Karen Jacobson
Design Firm *Art Center College of Design, Pasadena, CA*
Printer *Typecraft Inc.*
Paper *Grafika Lineal*

2
Title *Auto Emissions October/November 1993*
Art Director *Susan Slover*
Designer *Sonia Biancalani*
Design Firm/Printer *Canfield Printing Company, Inc.,*
New York, NY
Paper *French Butcher Paper*

From Boston Acoustics

1

1

Title *Number 01*

Art Director/Designer *Bruce Crocker*

Illustrators *Mark Fisher and Bruce Crocker*

Photographer *Various*

Copywriters *Grant Sanders, Louisa Hufstader, and others*

Design Firm *Crocker Inc., Brookline, MA*

Typographer *Lee Busch*

Printer *Quebecor*

Paper *Siamacote Web*

UP close

B I L L Y C H I L D S

Ask nearly any jazz musician about composer/pianist Billy Childs, and the tone of the conversation changes. There's respect in their voices. They are slightly in awe. Andy Narell, co-producer of each of Billy Childs' four albums, and himself a ground-breaking jazz musician (Narell single-handedly brought the steel drum to the jazz mainstream and made it stick), says of Billy Childs, "He's come up through the tradition and has learned all the schools of playing, but he's really adventurous and forward-looking in his writing and his playing. He's one of the more adventurous guys out there right now that's come through the mainstream of jazz." Some people state it more succinctly when they say Childs is where jazz is going. But when you put this to Billy, a grounded, extremely soft-spoken man, he jokes: "But I don't know where I'm going." In fact, he doesn't like to classify his music as "jazz." Too much baggage, perhaps.

The truth is, Billy Childs, musically, is going in many directions at once. Which makes perfect sense given that he's come down several paths to get to this point. First, he received formal classical training at U.S.C., where he majored in composition and was a keen student of Western European music. Later, he toured for six years with Freddy Hubbard's Band. "I learned how to refine my jazz skills in his group," notes Billy. He's also played with other greats. Like Diane Reeves, Eddie Daniels and J.J. Johnson.

This combination of a strict classical education and a free-form improvisational jazz internship yields compositions of incredible intricacy. Says Narell, "His music is very difficult. You really need some extraordinary players to play some of these tunes." Luckily, great players they have had. People like saxophonist Bob Sheppard. Bassists Tony Dumas and Jimmy Johnson. Drummers Mike Baker and Billy Kilson. And several other top guns. To get ready for a given recording session, Childs and band put themselves through a rigorous rehearsal schedule, and play a number of gigs before stepping in front of the microphone. And in the studio, every attempt is made to hold onto that live feeling. Eye contact among the players is maintained despite isolation techniques necessary in the studio. And little fixing is done in the mix. The result is worthy of those hushed tones used to describe the artist.

During his first three albums, Billy stretched out as a composer. "What I was trying to do," he explains, "was take compositional forms and techniques that I had learned from listening to Western European music and make that apply to a jazz context." In fact, he's done more than take Mozart or Haydn and make it kick. Many of his compositions, like "Backwards Bop" and "Where It's At," have a racing quality. But they're not a bit hurried. They change rhythm a dozen times or so. But they don't stutter. They show off chord progressions that your brain has a tough time following—but your ears have absolutely no trouble taking in. Straight ahead? No, sir. Other songs, such as "Quiet Girl" and "Rapid Transit," come from another place altogether—offering up hooks (gasp) that would make any pop musician green with envy.

While his first three albums stressed composing first and playing second, his latest album, *Portrait of a Player*, was intended to allow the artist to show off his piano playing. It's a stripped-down trio album that features a number of jazz standards, plus two originals written in a traditional vein. If his previous studio efforts hadn't convinced listeners that Billy could play, then songs like "34 Skidoo" and "The End of Innocence" will undoubtedly prove that the man has chops.

"I never want to be pigeonholed into one thing," says Billy. "I never want to do two albums in a row the same way." In keeping with this, his next studio project will be a disc that will, in his words, "utilize a lot of electric instruments." More than that, he's not saying. Rest assured, it will be different.

Recently, he's been working on some orchestral pieces as well. His latest effort, a work commissioned by the L.A. Philharmonic, was performed earlier this year. Says producer Narell, "The L.A. Phil piece will blow your mind." With any luck, it will be recorded sometime in '94. With more commissioned work to follow, if Childs has his way. "I just want to put my music out there," he states sincerely. And, deservedly, a growing number of people feel the same way.

2

3

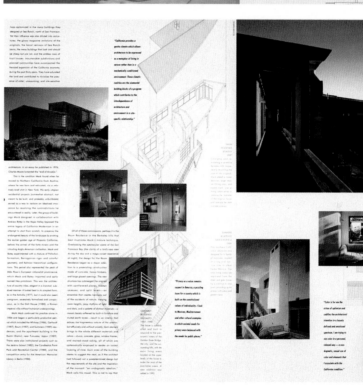

2
Title *Metro Furniture Neocon Tabloid*
Art Director/Designer *Michael Mabry*
Illustrators *Michael Mabry and Metro Graphic Design*
Photographers *Richard Barnes, Steve Burnes, Jeff Goldberg,*
FPG International, and Michael Mabry
Design Firm *Michael Mabry Design, San Francisco, CA*
Printer *Warrens Waller Printing*

3
Title *The Color of Elements Journal Volume 3, Number 1*
Art Director/Designer *Linda Hinrichs*
Illustrator *Mark Mack*
Photographers *Richard Barnes and Jock McDonald*
Copywriter *Paolo Poledri*
Design Firm *Powell Street Studio*
Printer *Hennegan*
Paper *Potlatch Decade 10 Matte*

nostalgia and

geography
of home
by akiko
busch
illustration
by mara
kurtz

fear

1
Title *Metropolis Magazine ("Geography of Home" Series)*
Art Directors *Carl Lehmann-Haupt and Nancy Cohen*
Illustrator/Photographer *Mara Kurtz*
Design Firm *Metropolis, New York, NY*

geography of

home

work?

geography of home

the kitchen
by akiko busch
illustration by
mara kurtz

science and emotion

geography of home

the library

by akiko busch · illustration by mara kurtz

geography of home
the laundry room

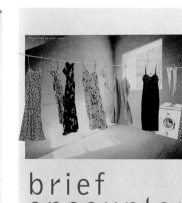

by akiko busch

brief
encounter

geography of home:

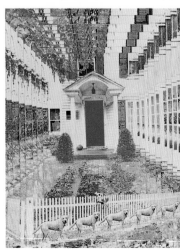

open the door

all my

geography of home

TO FACE THE
DAY

2

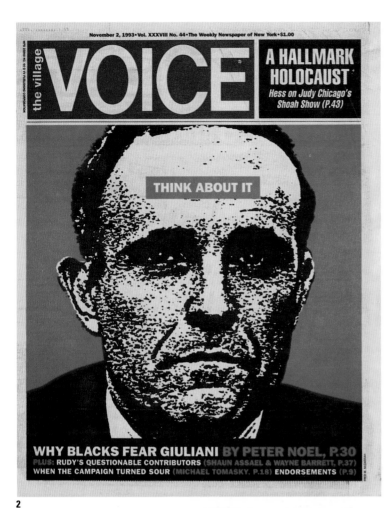

the village VOICE

November 2, 1993 • Vol. XXXVIII No. 44 • The Weekly Newspaper of New York • $1.00

A HALLMARK HOLOCAUST
Hess on Judy Chicago's Shoah Show (P.43)

THINK ABOUT IT

WHY BLACKS FEAR GIULIANI BY PETER NOEL, P.30
PLUS: RUDY'S QUESTIONABLE CONTRIBUTORS (SHAUN ASSAEL & WAYNE BARRETT, P.37)
WHEN THE CAMPAIGN TURNED SOUR (MICHAEL TOMASKY, P.18) ENDORSEMENTS (P.9)

3

$5.95/$6.95 Canada

WINTER 1994

STORY

4

IN A TIME WHEN OPTIMISM HAS BEEN ERODED BY TOXIC FUMES, OZONE HOLES, SOCIAL UNREST AND THE SPECTER OF NUCLEAR ANNIHILATION, IT IS HARD TO IMAGINE THE INNOCENT VISION OF THE FUTURE THAT PERMEATED THE AMERICAN CONSCIOUSNESS IN THE YEARS PRIOR TO THE ATOMIC AGE. THIS NAIVE VIEW WAS PERPETUATED IN PART BY PULP MAGAZINES OF THE 1920S, WHOSE COVERS, EMBLAZONED WITH FUTURISTIC VISIONS, PROMISED A WORLD DEVOID OF EVERYDAY CARES WHERE TECHNOLOGY HELD FORTH AS A PANACEA FOR SOCIETY'S ILLS. THIS SCIENCE FICTION FANTASY PROVIDED A POPULATION SLOWLY BEING DRAWN INTO WORSENING FINANCIAL CONDITIONS WITH A CONVENIENT ESCAPE TO A WORLD OF UNLIMITED POSSIBILITIES.

WITH THE DEPRESSION IN FULL SWING BY THE EARLY 1930S, GOVERNMENT AND BIG BUSINESS ENDEAVORED TO CREATE THE OPTIMISM AND CONFIDENCE NECESSARY FOR ECONOMIC RECOVERY. ONE STRATEGY TO REKINDLE INTEREST IN THE FUTURE WAS THE

FUTURE PERFECT

PROLIFERATION OF EXPOSITIONS AND WORLD'S FAIRS THROUGHOUT THE DECADE. THE CENTURY OF PROGRESS IN CHICAGO IN 1933, AND THE NEW YORK WORLD'S FAIR AND THE SAN FRANCISCO GOLDEN GATE EXPOSITION, BOTH HELD IN 1939, BLENDED PRIVATE AND PUBLIC SECTORS SHOWCASING THE SHAPE OF THINGS TO COME. THE EXPOS' TACTIC OF PREDICTING THE ADVANCES AMERICANS COULD EXPECT FROM NEW MACHINES AND INVENTIONS PROVED TO BE A POWERFUL TOOL IN BOOSTING PUBLIC CONFIDENCE. FUTURISTS AND SCIENTISTS OF THE PERIOD ACTIVELY PROPOSED THROUGH THE EXHIBITS THAT TECHNOLOGY WOULD FREE COMMON PEOPLE FROM MUNDANE CHORES, GIVING THEM INCREASED LEISURE TIME AND BUYING POWER.

THE POPULARITY OF DO-IT-YOURSELF PUBLICATIONS OF THE ERA WERE TESTAMENT TO A PUBLIC HUNGRY FOR THE FUTURE. COMMERCIAL ARTISTS EXUBERANTLY ILLUSTRATED THESE VISIONS ON THE COVERS OF POPULAR MECHANICS AND MODERN MECHANIX, HINTING THAT SOMEDAY MOM, POP AND THE KIDS

POPULAR SCIENCE
Monthly
Mechanics & Handicraft
JUNE 15¢
Coming in 2 Years!
SEE PAGE 78

YOUR HOME ON WHEELS
POPULAR MECHANICS MAGAZINE
DEC. 25 CENTS

MODERN MECHANIX AND INVENTIONS
NOW 15¢
SEPT
Building Speed Planes for World's Greatest Air Race

MODERN MECHANIX & INVENTIONS MAGAZINE
September
NOW 15¢
AIRPLANE-ZEPPELIN SEE PAGE 82
Uncle Sam Harnesses Moon's Power

PIRATES OF THE ETHER
POPULAR MECHANICS MAGAZINE
JAN. 25 CENTS
SEE PAGE 94

MODERN MECHANIX AND INVENTIONS
April
NOW 15¢
327
AERO-DRIVE MONORAIL EXPRESS SEE PAGE 65
Building Stratosphere Air Liners
By Allan Lockheed • Noted Plane Designer

165

1
Title *Rolling Stone Cover ("David Letterman")*
Art Director/Designer *Fred Woodward*
Photographer *Mark Seliger*
Design Firm *Rolling Stone, New York, NY*
Printer *World Color*

2
Title *Rolling Stone Cover ("U2/ Bono")*
Art Director/Designer *Fred Woodward*
Photographer *Andrew MacPherson*
Design Firm *Rolling Stone, New York, NY*
Printer *World Color*

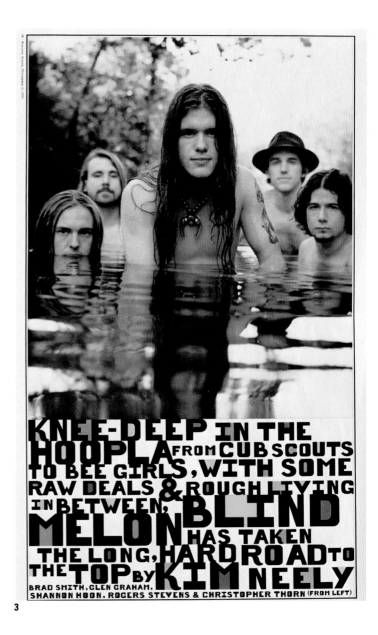

3

1

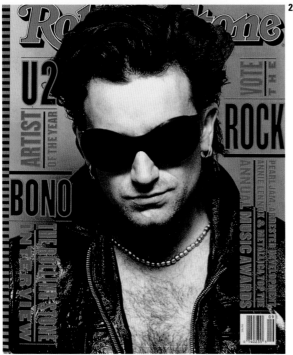

2

3
Title *"Knee Deep in the Hoopla," Rolling Stone Article*
Art Director/Designer *Fred Woodward*
Photographer *Mark Seliger*
Design Firm *Rolling Stone, New York, NY*
Printer *World Color*

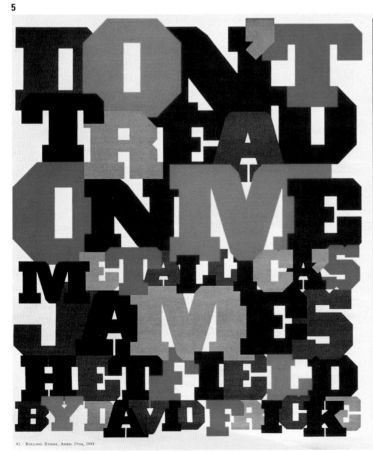

Popular culture operates on the principle of the eternal return, which is why we are once more confronted with *The Brady Bunch*, Abba and the Hot List. Now, a Hot List can't be all things to everybody. But this year's model does have a few simple goals: to celebrate, to educate and to irritate. We've tried to err on the side of the underdog. We've tried to be politically correct *and* politically incorrect, and if we've pissed off Tipper and Al, so be it. What else? We've tried to capture the sublime and the ridiculous. We've tried to come up with a lot that won't embarrass the hell out of us in two years. In order to do all that, we've picked the brains of a few nonresident experts. So. The 1993 Hot List: Because we care enough to share. Because we do it every year. Because we can.

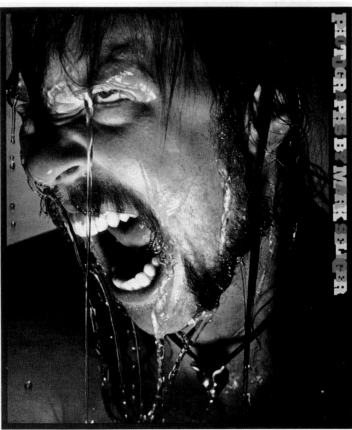

4
Title *"The Hot List," Rolling Stone Article*
Art Director *Fred Woodward*
Designer *Debra Bishop*
Photographer *Doug Rosa*
Design Firm *Rolling Stone, New York, NY*
Printer *World Color*

5
Title *"Don't Tread on Me," Rolling Stone Article*
Art Director/Designer *Fred Woodward*
Photographer *Mark Seliger*
Design Firm *Rolling Stone, New York, NY*
Printer *World Color*

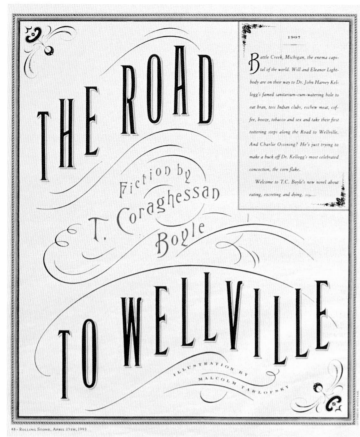

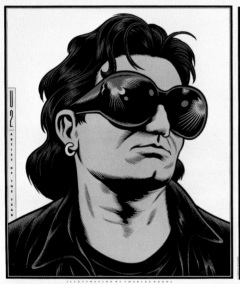

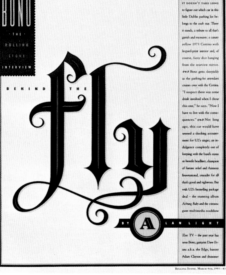

1

Title *"The Road to Wellville," Rolling Stone Article*

Art Director *Fred Woodward*

Designer *Catherine Gilmore-Barnes*

Illustrator *Malcolm Tarlofsky*

Letterer *Anita Karl*

Design Firm *Rolling Stone, New York, NY*

Printer *World Color*

2

Title *"Behind the Fly," Rolling Stone Article*

Art Director *Fred Woodward*

Designer *Debra Bishop*

Illustrator *Charles Burnes*

Letterer *Anita Karl*

Design Firm *Rolling Stone, New York, NY*

Printer *World Color*

3
Title *"David Letterman," Rolling Stone Article*
Art Director *Fred Woodward*
Designers *Fred Woodward and Gail Anderson*
Illustrator *Al Hirschfeld*
Design Firm *Rolling Stone, New York, NY*
Printer *World Color*

4
Title *"The Making of the Soviet Bomb," Rolling Stone Article*
Art Director *Fred Woodward*
Designer *Gail Anderson*
Photographer *Matt Mahurin*
Design Firm *Rolling Stone, New York, NY*
Printer *World Color*

3

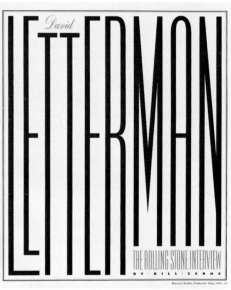

4

THE OLD MEN AND KC As Kansas City gains a legendary quarterback 37-year-old Nick Lowery '78 gets his chance for immortality

1

Okay,

we all know he

can act, thought

our cultural

correspondent

Moriarty Ad Lib

when he saw

Moriarty in

New York.

But when he

started to play...

By Robert Sullivan '75

1
Title *"The Old Men and K. C.," Dartmouth Magazine*
Art Director/Designer *Scott Menchin*
Photographer *Ken Shung*
Design Firm *Scott Menchin, New York, NY*

2
Title *"Moriarty Ad Lib," Dartmouth Magazine*
Art Director/Designer *Scott Menchin*
Illustrator *Drew Friedman*
Design Firm *Scott Menchin, New York, NY*

3
Title *"Good Vibrations"*
Art Director *David Armario*
Designer *James Lambertus*
Photographer *Geof Kern*
Design Firm *Discover Magazine, Disney Magazine Publishing, Burbank, CA*

4
Title *"In the Realm of the Chemical"*
Art Director/Designer *David Armario*
Photographer *Geof Kern*
Design Firm *Discover Magazine, Disney Magazine Publishing, Burbank, CA*

5
Title *"Life in a Whirl"*
Art Directors *David Armario and James Lambertus*
Designer *James Lambertus*
Illustrator *Philip Anderson*
Design Firm *Discover Magazine, Disney Magazine Publishing, Burbank, CA*

3

4
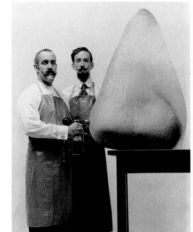

5

Communication Graphics *Brochures/Catalogs*

1

Title *K2 Snowboard Brochure*

Art Directors *Vittorio Costarella, Brent Turner, and Luke Edgar*

Designers/Illustrators *Vittorio Costarella and Michael Strassburger*

Photographers *Jules Frazier, Eric Berger, and Jeff Curtes*

Copywriters *Luke Edgar, Brent Turner, and Jason Kasnitz*

Design Firm *Modern Dog, Seattle, WA*

Printer *Direct Color*

Paper *Champion Carnival Grove, Quintessence Remarque*

2

Title *Wieland Capabilities Brochure*

Art Director/Designer *Neil Powell*

Photographer *Mark La Favor*

Copywriter *John Jarvis*

Design Firm *Joe Duffy Design, Minneapolis, MN*

Printer *Diversified Graphics*

Paper *Centura*

2

Assign ment: killer graph ics

(LOGO RULE # 1: NEVER USE IT THE SAME WAY TWICE.)

SCREEN TEST

3 __ SCREEN

4 __ SCREEN

4

a generation ago,

most people would not have had a chance against many forms of leukemia and cancer. Today, the survival rate is astounding. A decade ago, most of us had never heard of AIDS. Now the battle against the AIDS virus is one of the most important research efforts in medical history.

Through the support of the music industry and people like you, the T.J. Martell Foundation for Leukemia, Cancer and AIDS Research has raised more than 55 million dollars since its inception eighteen years ago.

Your contributions fund important research at foundation laboratories at major medical centers in the United States and Europe, including the Mt. Sinai Medical Center and the Memorial Sloan-Kettering Cancer Center in New York City, the Neil Bogart Memorial Laboratory at Children's Hospital in Los Angeles, the Frances Williams Preston Laboratory at Vanderbilt University in Nashville, Cancer and Leukemia Group B at Dartmouth University and The European Organization for Research and Treatment Cancer in Brussels.

heart of music 93

rsvp

5

3
Title *Killer Graphics Brochure*
Art Director *Craig Frazier*
Designers/Copywriters *Craig Frazier and Rene Rosso*
Design Firm *Frazier Design, San Francisco, CA*
Printer *Watermark*
Paper *Simpson Evergreen*

4
Title *Screen Test, The Edge Screen Studio Brochure*
Art Directors *Bob Hambly and Barb Woolley*
Designers *Mercedes Rothwell and Gord Woolley*
Illustrators *Barry Blitt and Bob Hambly*
Copywriters *Bob Hambly, Barb Woolley, and Helen Battersby*
Design Firm *Hambly & Woolley Inc., Toronto, Ontario*
Printer *The Edge Screen Studio*

5
Title *Heart of Music '93 Program Brochure*
Art Director *Neal Ashby*
Designers *Neal Ashby and Melinda Russell*
Photographer *Michele Clement*
Design Firm *Recording Industry Association of America*
Printer *Steckel Printing*

1
Title *Knoll Identity Guidelines Brochure*
Art Director *Tom Geismar*
Designer *Cathy Rediehs Schaefer*
Design Firm *Chermayeff & Geismar Inc., New York, NY*
Printer *Lebanon Valley*
Paper *Monadnock*

2
Title *Foamex Capabilities Brochure*
Art Directors *Peter Harrison and Susan Hochbaum*
Designers *Susan Hochbaum and Kevin Lauterbach*
Photographers *John Madere and Kenji Toma*
Copywriter *Bruce Duffy*
Design Firm *Pentagram Design, New York, NY*
Printer *Sandy Alexander*

3
Title *Simpson Sundance Lingo Brochure*
Art Director *Kit Hinrichs*
Designer *Belle How*
Illustrators *Dave Stevenson, Jack Unruh, Regan Dunnick, Lisa Miller, Erick Schreck, McRay Magleby, Will Nelson, Cathie Bleck, John Hersey, David Wilcox, and Tim Lewis*
Photographers *Bob Esparza, Charly Franklin, FPG International, Bybee Digital, and Russel Kloer*
Copywriter *Delphine Hirasuna*
Design Firm *Pentagram Design, San Francisco, CA*
Typographer *Eurotype*
Printer *Woods Lithographers*
Paper *Simpson Mesquite Felt Cover*

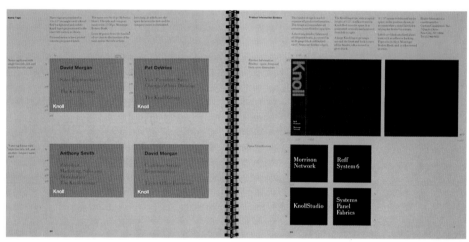

Energetic, spontaneous and youthful, the New West from which **Sundance** derives its character thrives on the challenges of the outdoors. Its lingo describes a land of open spaces, endless possibilities, **inventive** thinking and **hard-working** values. The attitudes and trends that grow out of this multi-cultural region create a mystique that lingers in the American **imagination**. Sundance—with its new redefined palette of 19 **colors,** all made with **recycled** fibers—is true to the **natural** spirit of the West. Playful yet **sophisticated,** Sundance encourages individual expression and stimulates **vitality** and style.

4

Title *Champion Benefit Identity Launch*
Art Director *Stephen Doyle*
Designer *Mats Hakansson*
Design Firm *Drenttel Doyle Partners, New York, NY*
Paper *Champion Benefit*

5

Title *Herman Miller Liaison Cabinet System Direct Mail Package*
Art Directors/Designers *Michael Barile and Yang Kim*
Illustrator *James Yang*
Copywriter *Clark Malcolm*
Design Firm *Herman Miller Inc., Zeeland, MI*
Printer *Burch Inc.*
Paper *Simpson Starwhite Vicksburg, Gilbert Esse*

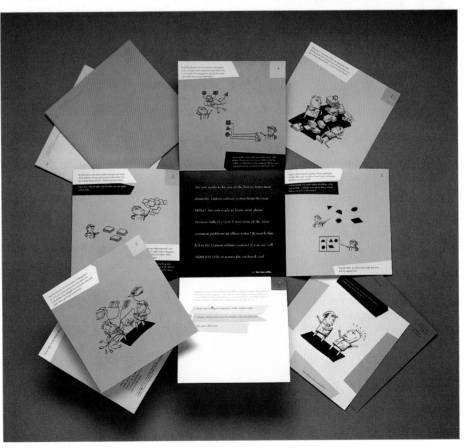

1

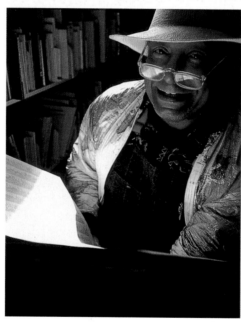

2

Acting

1

Title *Jeff Degan Promotional Brochure*
Art Director/Designer *Tyler Smith*
Photographer *Julie Forsythe*
Design Firm *Tyler Smith, Providence, RI*
Printer *Universal Press*

2

Title *Jeff Corwin Photography Promotion Brochure*
Art Director *John Van Dyke*
Designers *John Van Dyke and Ann Kumasaka*
Photographer *Jeff Corwin*
Copywriter *Tom McCarthy*
Design Firm *Van Dyke Company, Seattle, WA*
Printer *H. MacDonald Printing*
Paper *Mead Signature Dull, Aquabee Art Paper,
Cement Bag Liner*

3

Title *Yunker Designs Spring/Summer '94 Brochure*
Art Director *Del Terrelonge*
Designers *Robert Aloe and Del Terrelonge*
Photographer *Shin Sugino*
Design Firm *Terrelonge Design, Toronto, Ontario*
Printer *C.J. Graphics, Inc.*

4

Title *"How Does It Feel to Think?" Brochure*
Designers *Jilly Simons and Susan Carlson*
Photographers *Various*
Copywriter *Deborah Barron*
Design Firm *Concrete, Chicago, IL*
Printer *Active Graphics, Inc.*
Paper *Mohawk Poseidon Perfect White and Chipboard*

5

Title *"A Demand Performance" Brochure*
Art Director *Ruth Ansel*
Photographer *Annie Liebovitz*
Copywriter *Rosemary Kuropat*
Design Firm/Printer *Canfield Printing Company, Inc.,
New York, NY*
Paper *LOE Dull*

1
Title *Marin Headlands Brochure*
Art Director/Designer *Nancy E. Koc*
Illustrators *Lawrence Ormsby and Todd Telander*
Photographer *Brenda Tharp*
Copywriters *Harold and Ann Gilliam*
Design Firm *Koc Design, San Francisco, CA*
Typographer *Eurotype*
Printer *Reliance Production/Interprint*
Paper *Simpson Evergreen, Kanzaki Topcoat*

2
Title *The Guide to Sensible CD/ROM Packaging Brochure*
Art Director *Dana Arnett*
Designers *Dana Arnett and Curt Schreiber*
Photographer *François Robert*
Copywriter *Nancy Lerner*
Design Firm *VSA Partners, Inc., Chicago, IL*
Printer *Northwestern Printing*
Paper *James River Jersey, French Speckletone, Potlatch Karma*

3
Title *"Texas/Between Two Worlds" Catalog*
Art Director *Lana Rigsby*
Designers *Lana Rigsby and Troy S. Ford*
Photographers *Chris Shinn and Lynn Girouard*
Copywriter *Peter Doroshenko*
Design Firm *Rigsby Design, Inc., Houston, TX*
Typographer *Characters*
Printer *Emmott-Walker Printing, Inc., Drake Printing*
Paper *Starwhite Vicksburg*

4
Title *Cell Genesys Capability Brochure*
Art Director *Duane Maidens*
Designers *Roy Tazuma, Duane Maidens, and Dan O'Brien*
Illustrators *Roy Tazuma and Laura Dearborn*
Photographers *Cell Genesys and O. Smithies*
Copywriters *Jack Murphy and Stephen A. Sherwin, M.D.*
Design Firm *Michael Patrick Partners, Palo Alto, CA*
Printer *House of Printing*
Paper *Simpson Evergreen, James River Graphika*

5
Title *"Photographs of Science" Exhibition Catalog*
Designer *Alison Lackey*
Photographer *Various*
Copywriter *Edwin A. Martin*
Design Firm *Burney Design, Raleigh, NC*
Printer *Peake Printing*
Paper *Karma*

1

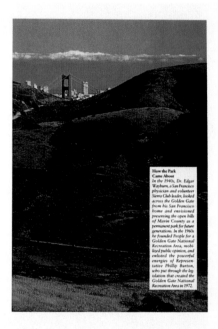

2

3

THE ARENZ

4

CELL GENESYS

THERAPEUTIC PROTEIN PRODUCTS

5

PHOTOGRAPHS of SCIENCE

APOLLO 8 EARTH VIEW, DECEMBER 1968
NASA
Silver gelatin print, 7¾ x 7¾, Gift of NASA

HIGH SPEED
PHOTOGRAPHY

1
Title *Phillips Capabilities Brochure*
Art Director *Joe Duffy*
Designers *Alan Leusink and Kobe*
Photographer *Paul Irmiter*
Copywriter *Chuck Carlson*
Design Firm *Joe Duffy Design, Minneapolis, MN*
Printer *Print Craft*
Paper *French Dur-o-tone*

2
Title *Lee Apparel Brochure*
Art Director *Joe Duffy*
Designers *Joe Duffy and Jeff Johnson*
Photographers *Various*
Copywriter *Chuck Carlson*
Design Firm *Joe Duffy Design, Minneapolis, MN*
Printer *Diversified Graphics*
Paper *Neenah Environment*

3
Title *Amnesty International Student Membership Brochure*
Art Directors *Alicia Johnson and Hal Wolverton*
Designer *Hal Wolverton*
Design Firm *Johnson & Wolverton, Portland, OR*
Printer *The Irwin Hodson Company*
Paper *Evergreen*

4
Title *"The Official Handbook on Tying the Knot"*
Art Director/Designer/Illustrator *Joel Templin*
Calligrapher *Kara Fellows*
Photographer *Paul Sinkler*
Copywriter *Lisa Pemrick*
Design Firm *Charles S. Anderson Design Company, Minneapolis, MN*
Printer *General Litho Services*
Paper *French Speckletone*

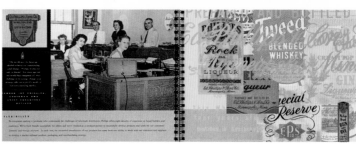

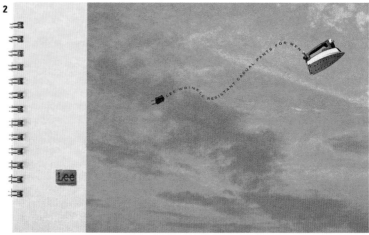

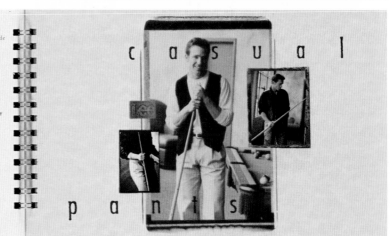

SPREAD
"RUMORS"

Governments around the world consider supporters
of human rights to be dangerous enemies. Dangerous
enough to try to discredit them — and minimize the
reality of human rights abuses. Amnesty itself,
when founded in 1961, was called "one of the larger
lunacies of our time."

PROPAGATE
"LIES"

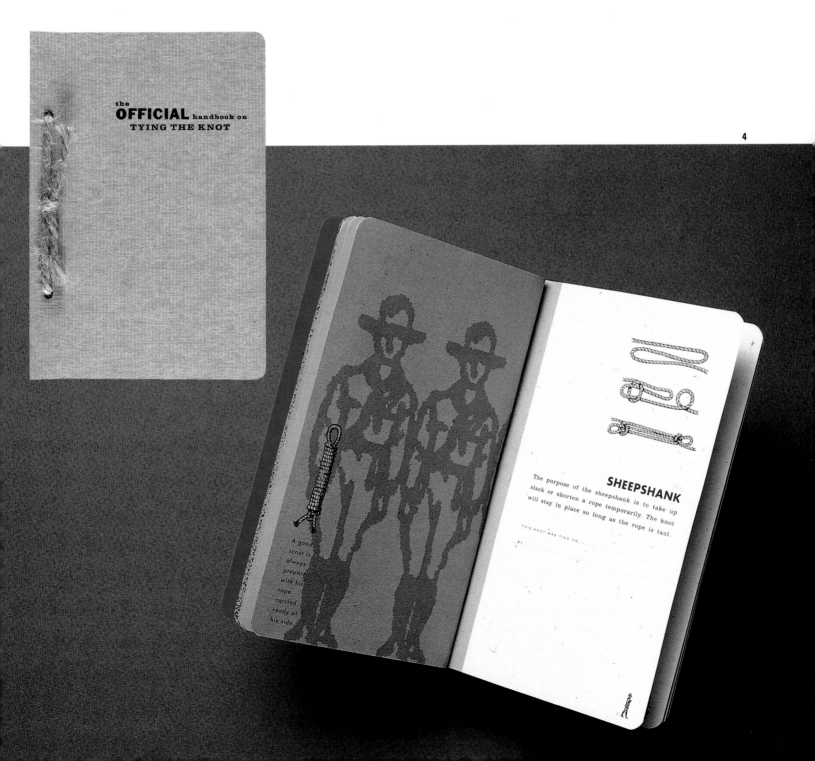

the **OFFICIAL** handbook on
TYING THE KNOT

SHEEPSHANK

The purpose of the sheepshank is to take up
slack or shorten a rope temporarily. The knot
will stay in place so long as the rope is taut.

THIS KNOT WAS TIED ON

BY

A good
scout is
always
prepared
with his
rope
carried
ready at
his side.

1

Fundamental Principles

Distilled from the inherent geometry
of nature, the Golden Mean ratio is
identified by the Greek letter Φ, Phi.
Throughout history, architects have used
this proportion to give their work order.

Villa Emo, 1555-1565
Measured plan: Mario Zocconi and Andrzej Pareswiet Soltan
Courtesy of Centro Internazionale di Studi Architettura "A. Palladio"
Geometric study by Rachel Fletcher

2

1993 – 1994

Cleveland Institute of Art a professional college of art and design

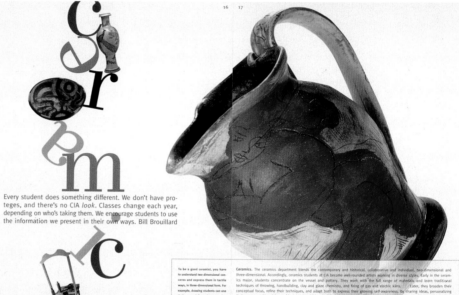

16 17

Every student does something different. We don't have pro-
teges, and there's no CIA *look*. Classes change each year,
depending on who's taking them. We encourage students to use
the information we present in their own ways. Bill Brouillard

To be a good ceramist, you have
to understand two-dimensional con-
cerns and express them in tactile
ways, in three-dimensional form. For
example, drawing students can use
their own information on clay
instead of paper. Most students
have more knowledge than they
realize. Undiscovered resources
abound, and they should be explored
and considered. Realize what you
know and use it. Judith Salomon

Ceramics. The ceramics department blends the contemporary and historical, collaborative and individual, two-dimensional and
three-dimensional. Accordingly, ceramics students at CIA become well-rounded artists working in diverse styles. Early in the ceram-
ics major, students concentrate on the vessel and pottery. They work with the full range of materials and learn traditional
techniques of throwing, handbuilding, clay and glaze chemistry, and firing of gas and electric kilns. Later, they broaden their
conceptual focus, refine their techniques, and adopt both to express their growing self awareness, by sharing ideas, personalizing
their sources, taking risks, and learning to criticize, they find their own voices. During their final year, students concentrate on
their individual needs and build a cohesive body of work. Our exceptional facilities become especially valuable at this point: plenty
of individual studio space, a 20-foot-long skylight, five student-constructed gas-fired kilns, many electric kilns, a separate glazing
room. Advanced students also learn how they will work alone, set up their own studios, and compete in the marketplace. Some
go on to graduate school and teaching. Others work as independent artists, with work in galleries and museums nationally and
internationally. An increasing number receive commissions for architectural and other large-scale works, while others become art
consultants and conservators.

3

Bulletin

1993 1994

Cleveland Institute of Art

Liberal Arts Electives

Please Note: Liberal Arts electives
are offered on a rotating basis.

Optional Minor in Liberal Arts.

Students may elect to complete a
minor in Liberal Arts by selecting at
least nine credits (at least three
classes) in any of the following five
categories:

Literature/Criticism/
Creative Writing

Social Studies

Multi-Cultural Studies

Art/Film History

Art Therapy

electives

1
Title *AEW Fundamental Principles Brochure*
Art Director *Michael Gericke*
Designers *Michael Gericke and Donna Ching*
Illustrator *Rachel Fletcher*
Copywriter *Beverly Russell*
Design Firm *Pentagram Design, New York, NY*
Printer *Royal Offset*
Paper *Mohawk Superfine*

2
Title *The Cleveland Institute of Art Catalog*
Art Directors *Joyce Nesnadny and Mark Schwartz*
Designers *Joyce Nesnadny and Brian Lavy*
Photographers *Mark Schwartz and Robert A. Muller*
Copywriter *Anne Brooks Ranallo*
Design Firm *Nesnadny + Schwartz, Cleveland, OH*
Printer *Fortran Printing, Inc.*
Paper *S.D. Warren Lustro Dull, Gilbert Gilclear
Medium Vellum*

3
Title *The Cleveland Institute of Art Bulletin*
Art Directors *Mark Schwartz and Joyce Nesnadny*
Designers *Michelle Moehler and Joyce Nesnadny*
Copywriter *Anne Brooks Ranallo*
Design Firm *Nesnadny + Schwartz, Cleveland, OH*
Printer *S.P. Mount Printing, Inc.*
Paper *French Dur-o-tone*

4
Title *French Paper Co. Dur-o-tone Books*
Art Director *Charles S. Anderson*
Designers *Charles S. Anderson, Todd Hauswirth,
and Paul Howalt*
Illustrator *CSA Archive*
Photographer *Paul Irmiter*
Copywriter *Lisa Pemrick*
Design Firm *Charles S. Anderson Design Company,
Minneapolis, MN*
Printer *Print Craft, Inc.*
Paper *French Dur-o-tone*

5
Title *French Paper Co. Portfolio*
Art Director *Charles S. Anderson*
Designers *Charles S. Anderson and Todd Hauswirth*
Illustrator *CSA Archive*
Photographer *Paul Irmiter*
Copywriter *Lisa Pemrick*
Design Firm *Charles S. Anderson Design Company,
Minneapolis, MN*
Printer *Print Craft, Inc.*
Paper *French Dur-o-tone*

6
Title *Metro Furniture Teamwork Brochure*
Art Director *Michael Mabry*
Designers *Michael Mabry and Peter Soe, Jr.*
Illustrator *Metro Graphic Design*
Photographer *Steve Burns*
Design Firm *Michael Mabry Design, San Francisco, CA*
Printer *Paragraphics*
Paper *Quintessence Remarque, French Dur-o-tone*

4

5

6

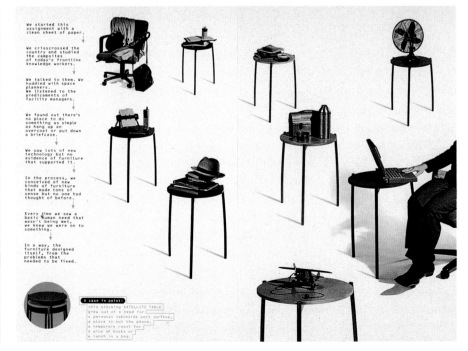

THE FEEL-O-METER NEVER LIES. TAKE A SPIN
AND YOU'LL BE CONVINCED – POTLATCH ELOQUENCE SILK
IS FLAWLESS TO THE TOUCH.

FEEL-O-METER: 2 HITS OF BLACK, UV COATING, DIE-CUT CIRCLE AND FINGER HOLE, 100# ELOQUENCE SILK COVER
85# ELOQUENCE SILK COVER

Behind every unwilling compromise is a conscience waging war with itself.

So, now is definitely not the time to compromise, that is if ideas are your business. It is in fact time for us to get uncompromising with our own consciences and answer the big question. What's this all for? Is it for the bucks, the glory, the love? If the answer doesn't jump up and bite you, ask yourself what feels better, championing a good idea to the bitter end, or witnessing its demise like the whittling of a bar of soap.

So, if you can look to the left and see just as far as you can to the right, beware, you may find yourself firmly planted right in the middle.

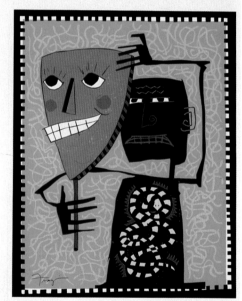

1

Title *Potlatch Touch See Brochure*

Art Director *Curt Schreiber*

Designers *Melissa Waters and Ken Fox*

Photographer *Howard Bjornson*

Copywriter *Nancy Lerner*

Design Firm *VSA Partners, Inc., Chicago, IL*

Printer *The Hennegan Company*

Paper *Potlatch Eloquence Silk*

2

Title *"Now Is Not the Time to Compromise"*

Potlatch Brochure

Art Director/Illustrator *Craig Frazier*

Designers *Craig Frazier/Rene Rosso*

Copywriter *Craig Frazier*

Design Firm *Frazier Design, San Francisco, CA*

Printer *Watt/Peterson*

Paper *Potlatch Remarque*

3
Title *"Perfectly Ordinary" Mohawk Vellum Promotion Brochure*
Art Director *Michael Bierut*
Designers *Michael Bierut and Lisa Cerveny*
Photographer *John Paul Endress*
Copywriter *Michael Bierut*
Design Firm *Pentagram Design, New York, NY*
Printer *Diversified Graphics*
Paper *Mohawk Vellum*

4
Title *Fox River Confetti Promotion, "Random Order" Brochure*
Art Directors/Designers *Steven Tolleson and Jennifer Sterling*
Illustrators *Gary Baseman, Emily Lisker, Ann Field, and Whitney Sherman*
Photographers *John Casado, Everard Williams, Henrik Kam, Hans Neleman, Gary Hush, and Scott Morgan*
Copywriter *Lindsay Beaman*
Design Firm *Tolleson Design, San Francisco, CA*
Printer *Lithographix, Inc.*
Paper *Fox River Confetti*

3

4

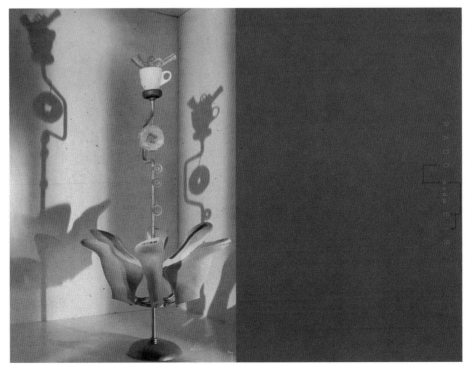

1

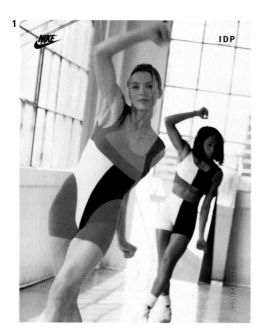

NIKE IDP

2

AIR**MAX**

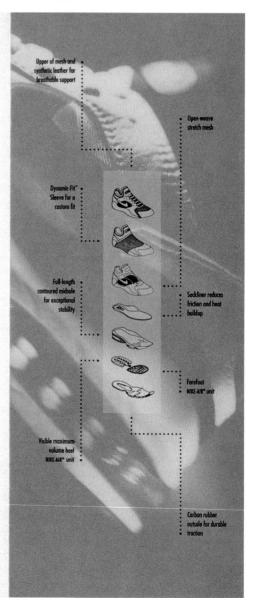

RUNNING
AIR MAX

Runners require superior comfort on impact, nearly 600 times every kilometer. Each step generates two to three times your body weight. Air Max cushioning reduces these impact

shocks more efficiently than any previous NIKE shoe. The larger size of the Air Max cushioning unit is obvious when you look at the heel of the new Air Max running shoe.

Upper of mesh and synthetic leather for breathable support

Open-weave stretch mesh

Dynamic-Fit Sleeve for a custom fit

Full-length contoured midsole for exceptional stability

Sockliner reduces friction and heat buildup

Visible maximum-volume heel NIKE-AIR unit

Forefoot NIKE-AIR unit

Carbon rubber outsole for durable traction

1
Title *Nike Instructor Discount Program Catalog (Holiday 1993)*
Art Director/Designer *Carol Richards*
Photographers *Barb Penoyar and Dan Langley*
Copywriters *Laura Houston-Emery and Mary McMahan*
Design Firm *Nike, Inc., Beaverton, OR*
Printer *Ronographic*
Paper *Ikonofix*

2
Title *Nike Air Max Brochure*
Art Director/Designer *Jeff Weithman*
Illustrator *Mike Fraser*
Photographer *Gary Hush*
Design Firm *Nike, Inc., Beaverton, OR*
Typographer *Gray Matter Inc./Greg Maffei*
Printer *Graphic Arts Center*
Paper *Simpson Starwhite Vicksburg, Gilbert Gilclear*

3
Title *Alpha Industries Brochure*
Art Director *Rosemary Conroy*
Designer *Joe Barsin*
Photographer *Charles Freeman*
Copywriter *Tom Daniel*
Design Firm *Siquis, Ltd., Baltimore, MD*
Printer *French-Bray, Inc.*
Paper *Neenah Environment*

4
Title *Dr. Martens 1993 Catalog*
Designer *Sally Hartman Morrow*
Photographers *Gary Hush and Peter Rose*
Copywriter *Jim Carey*
Design Firm *Cole & Weber, Portland, OR*
Typographer *V.I.P. Typographers*
Printer *Schulz Wack Weir*
Paper *Warren Lustro Dull*

1
Title *Al Held Watercolors Brochure*
Designer *Renate Gokl*
Design Firm/Printer *University of Illinois,*
Office of Printing Services
Paper *Esse, Champion Benefit, Simpson Evergreen,*
Hammermill Opaque

2
Title *Mead Annual Report Show 1993 Brochure*
Art Directors *Joyce Nesnadny and Mark Schwartz*
Designers *Joyce Nesnadny, Brian Lavy, and*
Michelle Moehler
Illustrators *Nesnadny + Schwartz*
Photographer *Roman Sapecki*
Copywriter *Robert A. Parker*
Design Firm *Nesnadny + Schwartz, Cleveland, OH*
Printer *Fortran Printing, Inc.*
Paper *Mead Signature Gloss*

3
Title *School of Visual Arts Undergraduate Catalog*
Art Director *Kurt Houser*
Designers *Kurt Houser and Beverly Perkin*
Photographer *Chris Callis*
Design Firm *Visual Arts Press, School of Visual Arts,*
New York, NY
Printer *ACME*
Paper *Quintessence Dull*

4
Title *Reorientations Catalog, The Gallery at Takashimaya*
Art Director/Designer *Takaaki Matsumoto*
Photographers *Various*
Design Firm *M Plus M Inc., New York, NY*
Printer *Stinehour Press and Monarch Press*
Paper *French Dur-o-tone, Mohawk Poseidon*

5
Title *"The Search for Beauty" Brochure*
Art Director *Milton Glaser*
Designer *David Freedman*
Illustrators *Various*
Copywriter *Robert Grudin*
Design Firm *Milton Glaser, Inc., New York, NY*
Printer *Toppan Printing Co., Inc.*
Paper *Gilbert Esse*

1

2

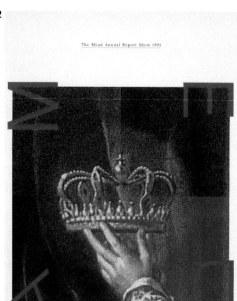

3

A College of the Arts

1994-1995 School of Visual Arts

The energy that fuels the art teacher is joy — at unveiling a wider world to the child through art. In teaching, we are constantly renewing ourselves and our students through creativity. The Art Education Department has designed a sequential, structured, teacher-training program leading to New York State K-12 Art Teacher Certification. SVA students begin to work with children as soon as they enter the program. We teach in the public schools, homeless shelters, museums, community centers, and after school programs. As students progress through the department, they take on more responsibility. The hands-on experience gained in City schools over the three years in the program is invaluable to the maturation of the SVA student teacher. At each stage of development the SVA student is supervised, supported and encouraged. Our excellent job placement figures, and the success of our students as art teachers once they graduate, are testimonials to the dynamic combination of artist and teacher which we develop in the program.

Art Education

4

10,000 Songs, 1991
Oilstick and acrylic on canvas
64 x 72 inches (213 x 183 cm)

WADE SAUNDERS

5

Beautiful Landscapes: Collaborative Composites

For Plato the intensifying concentration on abstract beauty simultaneously makes philosophers themselves more beautiful in spirit. In the *Phaedrus*, he accounts for the inner transformation mythically as a purging of the impurities incurred by the soul in prior lives; but it can also be explained as a special version of the psychological toning that is inevitable in any healthy intellectual exercise. We cannot understand beauty without participating in it, or participate in it without subsuming its principles.

Plato's theory reflects an experience that we have all had in one way or another: the insight, gained from our own efforts or these combined with someone else's teaching, that fills us with unspeakable delight and seems to renew the world. This experience resembles other sorts of love in every respect except that it has no personal object or physical goal.

As a kind of intellectual eroticism, moreover, the enjoyment of beauty implies a unison of reason and emotion. When we experience beauty, reason and emotion operate reciprocally, conscious thought producing an emotional delight, which in turn impels it further. Properly developed, the sense of beauty imposes neither priorities nor distinctions between emotional and intellectual impulses, but rather is open to both as partners in the search for form. By extension, we might characterize the insightful mind as a government that realizes that the quest for order (reason) is impossible without the guarantee of freedom (emotion).

All these premises suggest a rather surprising conclusion. If beauty is a necessary factor in a natural relationship, if it follows inevitably from the accurate perception of form, if it inspires pleasure and love, unifies reason and emotion, and provokes continued achievement, then all true education is education in beauty. Excellence of mind itself, rightly conceived, is expertise in beauty; creativity is wise love.

How can one sharpen one's sense of beauty? If beauty is indeed the concomitant of true insight into reality, of accurate apprehension of form, the sense of beauty can be developed through growth in the creative "habits" that have already been discussed. The frame of mind described in the early chapters — unbiased alertness to outer experience, readiness to review and alter prior assumptions, openness to inner promptings, unstinting study and practice — may offer the surest training in the appreciation of beauty.

1

Title *Fox River Confetti Promotion,*
"Writing That Sounds Out" Brochure
Art Directors/Designers *Steven Tolleson and*
Jennifer Sterling
Photographer *Henrik Kam*
Copywriter *Lindsay Beaman*
Design Firm *Tolleson Design, San Francisco, CA*
Printer *Graphic Arts Center*
Paper *Fox River Confetti*

2

Title *Simpson NEO Promotion Brochure*
Art Directors *Woody Pirtle and John Klotnia*
Designers *Woody Pirtle, John Klotnia, Ron Louie, and Ivette*
Montes de Oca
Design Firm *Pentagram Design, New York, NY*
Printer *Heritage Press*
Paper *Simpson*

3

Title *Exploring the Business Environment Brochure*
Art Directors *Margaret Biedel and James A. Sebastian*
Designers *Margaret Biedel and Sarah Kloman*
Illustrators *Steven Sikora, Jose Ortega, Cathie Bleck, Coco*
Masuda, and Doug Smith
Copywriters *Ralph Caplan and Laura Silverman*
Design Firm *Designframe Inc., New York, NY*
Printer *Bogart's Graphics Group*
Paper *Strathmore*

4

Title *Fox River Bond Promotion Brochure*
Art Director *John Van Dyke*
Designers *John Van Dyke and Ann Kumasaka*
Photographer *Terry Heffernan*
Copywriter *Tom McCarthy*
Design Firm *Van Dyke Company, Seattle, WA*
Printer *H. MacDonald Printing*
Paper *Fox River Bond*

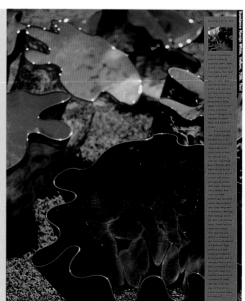

3

EXPLORING THE
BUSINESS ENVIRONMENT

STRATHMORE WRITING RECYCLED

CONTROL

We can't control the environment.
That's why we need TV weathermen to tell us
how to dress for the day. We can't control
the business environment either,
but we can affect it by controlling what
we can. How we are perceived,
for example, is affected by what *we can* control:
the quality of our communication.

10

RECYCLED IVORY, SUB. 24, WOVE

4

f o x

r i v e r

b o n d

193

1
Title *Connecticut Fund for the Environment Annual Report*
Designes *Adrienne and Jeff Pollard*
Photographer *Bill West*
Design Firm *Pollard Design, East Hartland, CT*
Printer *John C. Otto Printers*
Paper *Monadnock Revue*

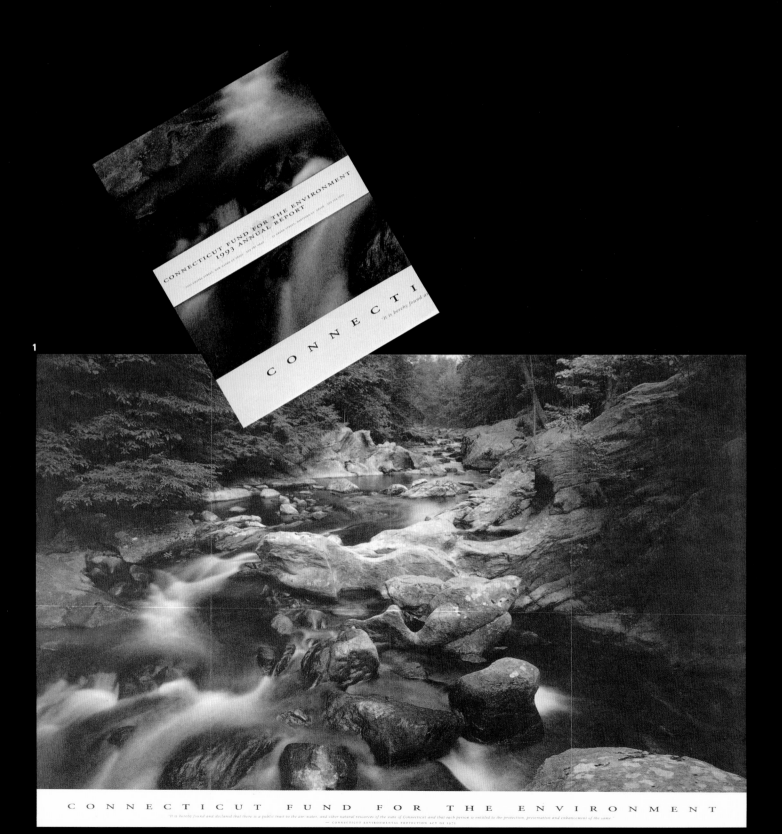

1

2

3

2
Title *Ariad Pharmaceuticals 1992 Annual Report*
Art Director/Designer *Susan Hochbaum*
Illustrators *Jack Unruh and Barbara Kelly*
Design Firm *Pentagram Design, New York, NY*

3
Title *U.S. Long Distance 1993 Annual Report*
Art Directors *Ron Sullivan and Kelly Allen*
Designer/Illustrator *Kelly Allen*
Photographer *John Dyer*
Copywriters *Tabitha Zane and Mark Perkins*
Design Firm *SullivanPerkins, Dallas, TX*
Printer *Yaquinto*
Paper *Ikonofix, Gilbert Oxford, Quest*

1

2

1

Title *Adia Annual Report*

Art Directors/Designers *Steven Tolleson*
and Jennifer Sterling

Photographer *Henrik Kam*

Copywriter *Lindsay Beaman*

Design Firm *Tolleson Design, San Francisco, CA*

Printer *Lithographix*

2

Title *Neurex Corporation 1993 Annual Report*

Art Director *Bill Cahan*

Designer *Bob Dinetz*

Design Firm *Cahan & Associates, San Francisco, CA*

Printer *Graphic Arts Center*

Paper *Kashmir, Benefit Book*

3

4

3

Title *BC TEL 1992 Annual Report*

Art Directors/Designers *John Van Dyke and Dave Mason*

Illustrator *Wendy Wortsman*

Photographer *Howard Fry*

Copywriter *Matt Hughes*

Design Firm *A Design Collaborative, Seattle, WA*

Typographer *Novatype*

Printer *Mitchell Press*

Paper *Simpson Coronado and ReCollection*

4

Title *Radius Annual Report*

Art Director *Steven Tolleson*

Designers *Steven Tolleson and Mark Winn*

Photographer *Coll Photography*

Copywriter *Lindsay Beaman*

Design Firm *Tolleson Design, San Francisco, CA*

Printer *Pacific Lithograph*

Paper *Karma Bright White*

1

2

High blood pressure is a sneaky killer. It forces the heart to work harder than normal, damaging the heart, brain and kidneys. But it rarely has symptoms — many people who die from heart attack and stroke caused by hypertension never knew they had it.

Hypertension

Over 63 million Americans have high blood pressure.

46 percent of them don't know it. We are bringing the essential message of early detection and treatment directly to where people will hear it: in church, on the job, at home. Through our Heart At Work and Church-Based Hypertension programs, community screenings and public and professional education, we are fighting a public health enemy no one can see.

Ricardo Espinosa-Tanguma, M.Sc., M.D. ▶ 1992-94: "Ionic Translocation of the Na/Ca Exchanger," University of Health Sciences/Chicago Medical School

1

Title *The George Gund Foundation 1992 Annual Report*

Art Director *Mark Schwartz*

Designer/Illustrator *Michelle Moehler*

Photographer *Judith Joy Ross*

Copywriters *David Bergholz and Deena Epstein*

Design Firm *Nesnadny + Schwartz, Cleveland, OH*

Printer *Fortran Printing, Inc.*

Paper *S.D. Warren Lustro Dull*

2

Title *American Heart Association Annual Report*

Art Director *Pat Samata*

Designers *Dan Kraemer, Pat and Greg Samata*

Photographer *Marc Norberg*

Copywriter *Liz Horan*

Design Firm *Samata Associates, Dundee, IL*

Typographer *K. C. Yoon*

Printer *Columbia Graphics*

Paper *French Butcher Block*

3
Title *American Red Cross 1993 Annual Report*
Art Directors *Tim Thompson and Kathleen Matthews*
Designer *John Parisi*
Photographers *Joseph Matthews, Daniel Cima, Harry Naltchayan, and Jim Mahoney*
Design Firm *Graffito, Baltimore, MD*
Printer *Peake Printers*
Paper *Zanders Ikonofix Dull*

3

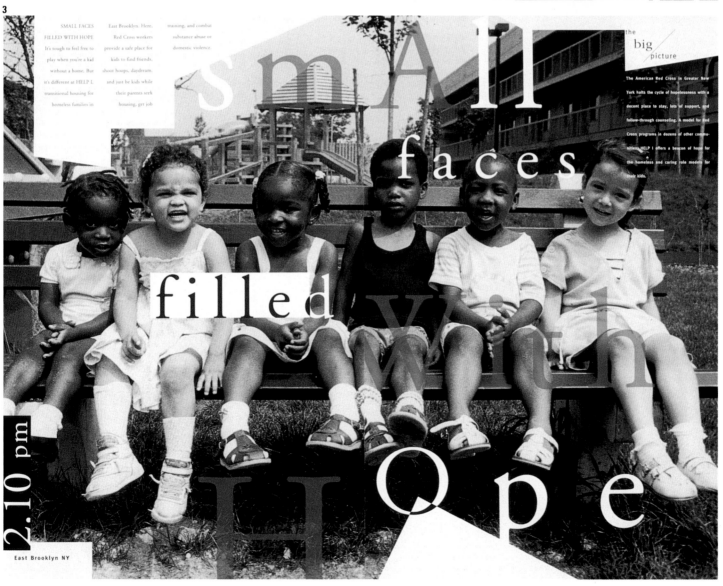

1
Title *Trident Microsystems 1993 Annual Report*
Art Director *Bill Cahan*
Designer *Sharrie Brooks*
Photographer *Various*
Copywriter *Mike Maia*
Design Firm *Cahan & Associates, San Francisco, CA*
Printer *U-Tap*
Paper *Karma*

2
Title *Rockefeller Foundation 1992 Annual Report*
Art Director/Designer *John Klotnia*
Design Firm *Pentagram Design, New York, NY*
Typographer *Typogram*
Printer *The Finlay Brothers Company*
Paper *Weyerhauser Cougar Opaque, French Dur-o-tone*

1

2

C
O
R

w o r r y

Each year, heart disease kills twice as many women as all cancers combined. More than 35 million women suffer from various forms of cardiovascular disease.

More than 300,000 people die each year from a heart attack before reaching a hospital. Half of all heart attack victims wait more than 2 hours before getting help.

f e a r

COR Therapeutics, Inc. 1992 Annual Report Cardiovascular Care Issues and Insights

THE PROGRESSIVE CORPORATION ANNUAL REPORT

Core Business Results, Objectives, Strategy and Outlook Progressive's core business is writing nonstandard private passenger automobile and small commercial vehicle insurance for people whose insurance has been cancelled or rejected by another insurance company, plus insurance for motorcycles, motor homes and mobile homes. This insurance is sold principally by independent agents and accounts for 93% of Progressive's total premiums. In 1991, we reported California results separately because they so distorted the picture of our other businesses. With our California business now stabilized, we again include its results. The core business produced an 8% underwriting profit in 1992, compared to a 1% loss (which included 4 points for the reserve for premium rollbacks) in 1991. In 1992, net premiums written grew 18% to $1,155 million, compared to $1,143 million in 1991 (excluding California, net premiums written in 1991 grew 20%). • The core business has the following strategies. People - attract, retain, recognize and reward high performing people and teams in a healthful and supportive environment. Products - expand beyond our specialty niches and ultimately provide an attractive package of insurance and services to every licensed driver and vehicle owner. Processes - continuously increase customer satisfaction while reducing transaction cost and cycle time using Quality methods. Distribution - offer our products where, when and how the customer wants to buy them by working with independent insurance agents and other cost-effective distribution methods. • In addition, we want to deliver the following to auto insurance customers: Low Competitive Prices - which we produce by lowering our costs, achieving fair claim settlements more quickly and improving our rate segmentation. No Surprises - which we will achieve by eliminating all but non-pay cancellations, not rejecting any licensed operator, eliminating most sharp rate increases and simplifying our billing practices. We are building the basis for customers to trust us to deliver unprecedented service at the lowest possible cost. Personal Service - which we achieve by selecting and supporting the excellent independent agents who produce most of our business. We will augment service with our new community marketing techniques, by refining and developing Immediate Response™ claims service, as well as prompt, courteous handling of all billing, endorsement and cancellation issues. A Recognized, Reputable Insurance Company - which will happen by word of mouth from our satisfied customers, publicizing how our innovations benefit customers and advertising when we have programs in place that appeal to a broader range of customers. • During 1992, our core business Division Presidents each undertook responsibility for the continuous improvement of one of our major processes: claims service, rate revision, premium quoting, premium billing, customer service, customer retention and distribution. The process leaders formed teams to develop vision statements, measurement systems and plans to improve their processes. They agreed to measure improvement by realized cost reductions and customer satisfactions and to work together to adopt each of the process improvements developed by their colleagues' teams.

KAREN HOGARTH 12/21

3

Title *COR Therapeutics 1992 Annual Report*

Art Director *Bill Cahan*

Designer *Jean Orlebeke*

Photographers *Stan Muselick, Walter Lopez, David Scharf, Jock McDonald, Jeffrey Newbury, and Larry Berlow*

Design Firm *Cahan & Associates, San Francisco, CA*

Printer *Anderson Lithograph*

Paper *Karma and Teton*

4

Title *The Progressive Corporation 1992 Annual Report*

Art Directors *Mark Schwartz and Joyce Nesnadny*

Designers *Joyce Nesnadny and Michelle Moehler*

Photographer *Neil Winokur*

Copywriter *Peter B. Lewis*

Design Firm *Nesnadny + Schwartz, Cleveland, OH*

Printer *Fortran Printing, Inc.*

Paper *Potlach Quintessence Remarque, Strathmore Renewal*

AT HARLEY-DAVIDSON, WE DON'T SELL MOTORCYCLES AND RECREATIONAL VEHICLES. WE SELL LIFESTYLE EXPERIENCES WITH NO EQUALS. TO BE A HARLEY-DAVIDSON OR HOLIDAY RAMBLER ENTHUSIAST IS TO KNOW LIFE AS MOST ONLY DREAM IT.

1

1
Title *Harley-Davidson, Inc. 1992 Annual Report*
Art Director *Dana Arnett*
Designer *Curt Schreiber*
Photographer *Jim Schnepf*
Copywriter *Ken Schmidt*
Design Firm *VSA Partners, Inc., Chicago, IL*
Printer *George Rice and Sons*
Paper *Kimberly-Clark Durable Buckskin, Champion Mainebrite*

2
Title *Nintendo 1993 Annual Report*
Art Director/Designer *Kerry Leimer*
Photographers *Eric Myer and Tyler Boley*
Copywriter *Kerry Leimer*
Design Firm *Leimer Cross Design, Seattle, WA*
Printer *H. MacDonald Printing*
Paper *Simpson Teton, Kashmir, and Starwhite Tiara*

3
Title *Cracker Barrel Old Country Store 1993 Annual Report*
Art Director/Designer *Thomas Ryan*
Illustrators *Paul Ritscher and Thomas Ryan*
Photographer *McGuire*
Copywriter *John Baeder*
Design Firm *Thomas Ryan Design, Nashville, TN*
Printer *Buford Lewis Co.*
Paper *French Dur-o-tone*

2

3

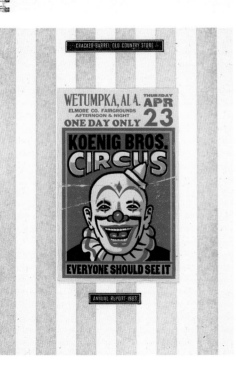

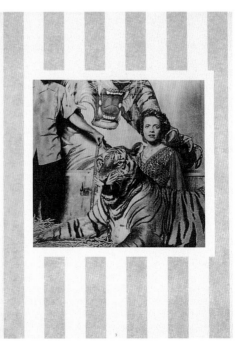

1

Title *Fox River Confetti Promotion,*
"1/4ly Reports on Stock"
Art Directors/Designers *Steven Tolleson*
and Jennifer Sterling
Photographer *John Casado*
Copywriter *Lindsay Beaman*
Design Firm *Tolleson Design, San Francisco, CA*
Printer *Lithographix, Inc.*
Paper *Fox River Confetti*

2

Title *San Francisco International Airport*
1993 Annual Report
Art Director *Jennifer Morla*
Designers *Jennifer Morla and Craig Bailey*
Photographer *Holly Stewart Photography*
Design Firm *Morla Design, San Francisco, CA*
Printer *Fong & Fong*
Paper *Simpson Gainsborough, Champion Benefit*

3

Title *Chicago Board of Trade 1992 Annual Report*
Art Director *Dana Arnett*
Designer *Curt Schreiber*
Photographers *François Robert and Wayne Cable*
Copywriters *Michael Oakes and Anita Liskey*
Design Firm *VSA Partners, Inc., Chicago, IL*
Printer *The Hennegan Company*
Paper *Gilbert Cottons Neutech*

1

2

3

many new possibilities for futures trading at the CBOT. Exchange officials already have begun looking into other environmental areas that could benefit from futures trading.

Additionally, the CBOT, through the successful launch of Project A, the exchange's innovative local area network trading system designed to trade unconventional products during regular exchange trading hours—launched four new futures contracts including Barge Freight Rate Index futures, Zero Coupon Note futures, Zero Coupon Bond futures, and deferred month U.S. Treasury Bond futures-options. A Ferrous Scrap futures contract, also approved by the membership for Project A listing, is scheduled to be added to the system at a later date.

Along with creating new products, the CBOT has been looking at ways to enhance customer service and member opportunity by developing innovative working agreements with other exchanges.

FINANCIAL COMPLEX Our financial complex continues to prosper and is the mainstay of the exchange as we continue to expand globally. Our U.S. Treasury Bond contract remains the world's leading volume producer while our Two-, Five- and Ten-year Treasury note futures and options contracts have averaged more than 192 percent growth in the past year.

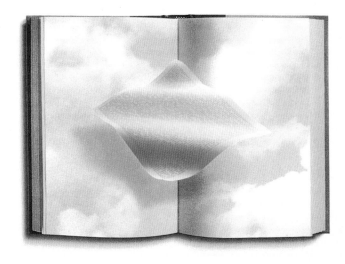

4

5

4
Title *South Texas College of Law 1993 Dean's Report*
Art Director *Mark Geer*
Designers *Mark Geer and Heidi Flynn Allen*
Illustrator *Morgan Bomar*
Photographer *Beryl Striewski*
Copywriters *Debra K. Maurer, Richelle Perrone,*
and Kathie Scobee
Design Firm *Geer Design, Inc., Houston, TX*
Printer *Wetmore & Co.*
Paper *Simpson Starwhite Vicksburg,*
Neenah Environment, Ward Brite-Hue

5
Title *Transamerica 1992 Annual Report*
Art Director *Kit Hinrichs*
Designer *Susan Tsuchiya*
Illustrators *Gary Overacre, Jeffrey West, David Wilcox,*
Dugald Stermer, Justin Carroll, Nigel Holmes, Tim Lewis,
and Ed Lindlof
Photographers *Tome Tracy and Barry Robinson*
Design Firm *Pentagram Design, San Francisco, CA*
Printer *Anderson Lithograph*
Paper *Simpson Coronado, Potlatch Evergreen and Remarque*

1
Title *Nine West 1993 Annual Report*
Art Director *John Klotnia*
Designer *Ivette Montes de Oca*
Copywriter *Rita Jacobs*
Design Firm *Pentagram Design, New York, NY*
Typographer *Typogram*
Printer *Toppan*
Paper *Environ Green, Simpson Dull, Evergreen Text*

2
Title *Adobe Systems 1992 Annual Report*
Art Directors *Aubrey Balkind and Kent Hunter*
Designers *Kin Yuen*
Illustrators *Henrik Dresher and Pamela Hobbs*
Photographers *Jeffrey Newbury, Jock McDonald, and Julie Powell*
Copywriters *Michael Clive and Molly Detwiler*
Design Firm *Frankfurt Balkind Partners, New York, NY*
Printer *Heritage Press*
Paper *Futura Matte White, Consolidated*

3
Title *The Limited, Inc. 1992 Annual Report*
Art Directors *Aubrey Balkind and Kent Hunter*
Designers *Robert Wong and Matt Rollins*
Copywriter *Robert Minkoff*
Design Firm *Frankfurt Balkind Partners, New York, NY*
Printer *Heritage Press*
Paper *Recovery Matte Text*

1 9 9 3

N W

NINE WEST GROUP INC. ANNUAL REPORT

The 9&Co.
Woman.
She's young,
fashionable
and wants
footwear that's
fashion right
and timely.
9&Co.'s skim-
mers and tai-
lored pumps

get her around
town, and
Route 9 all-
terrain shoes
take her any-
place she
wants to go.
In 9&Co. shoes,
she's never
cut out of the
cutting edge
of fashion.

9 & Co

9 & C O

2

ADOBE SYSTEMS INCORPORATED
1992 ANNUAL REPORT

WORDS

IMAGES

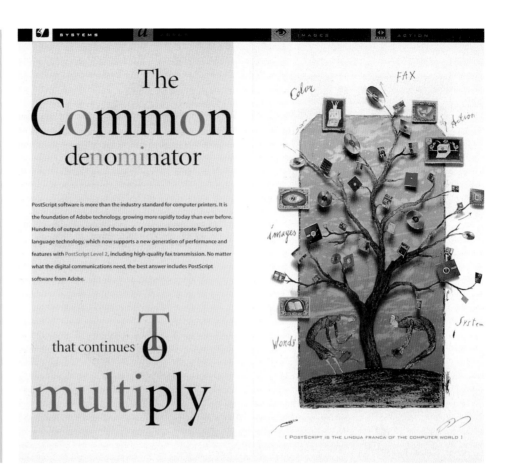

ACTION

SYSTEMS

the means of
Expression

The
Common
denominator

PostScript software is more than the industry standard for computer printers. It is the foundation of Adobe technology, growing more rapidly today than ever before. Hundreds of output devices and thousands of programs incorporate PostScript language technology, which now supports a new generation of performance and features with PostScript Level 2, including high-quality fax transmission. No matter what the digital communications need, the best answer includes PostScript software from Adobe.

that continues TO

multiply

[POSTSCRIPT IS THE LINGUA FRANCA OF THE COMPUTER WORLD]

3

Questioning is good business. A year ago, we responded to more than 10,000 questions from our associates.

QuestioningThinkingActing
The process continues.

The Limited, Inc.
1992 Annual Report

1

Annual Report 1992

EG&G

data blitz p.30
stage 3 p.20
smart p.36
clean up p.40

p.32 zero leakage

"By Western standards, we're driving this reactor blindly. We have no computers telling us what's going on inside it or controlling the process" – Vasil Manolov, chief manager of Bulgaria's Kozloduy nuclear power plant. Last year, Russian technicians at the plant, angered when the Bulgarians did not pay them, walked off the job and took the operating manuals with them.

hot dust

An article in Warsaw's *Życie Warszawy* reveals that the concrete sarcophagus covering the damaged nuclear reactor at Chernobyl is riddled with holes, contrary to official assurances that it is intact. Mice and rats go through the openings, and birds fly in and out, as do larger-than-normal mosquitoes. The fuel inside the reactor has turned into 35 tons of dust, and the fear is that the weakened sarcophagus will collapse, sending geysers of deadly dust high up into the atmosphere. Even now, small dust storms frequently break out. Meanwhile, *Business Week* reports that Chernobyl-like accidents could still occur at any of the 56 reactors still operating in the former Soviet bloc. There have already been four major nuclear incidents since Chernobyl. Western scientists are discussing measures to deal with the problem, but until the dangers are brought under control, radiation monitors and warning networks will play a key role in protecting the public.

The black bars on the tape below are particles of dust that have been filtered out of the air by an *EG&G Berthold* radiation monitor and analysed for the presence of radioactive isotopes. Many countries, especially in Europe, are concerned by the possibility of accidents at nuclear reactors and are installing networks of these monitors to sound a speedy and detailed alert if higher-than-normal levels of radiation are detected.

2

The only con...

California Clean Air Act Amendments

Air Quality Project
California is always on the cutting edge of change and innovation...

California Council for Environmental and Economic Balance 1992 Annual Report

3

The loop in action: taming toxic waste

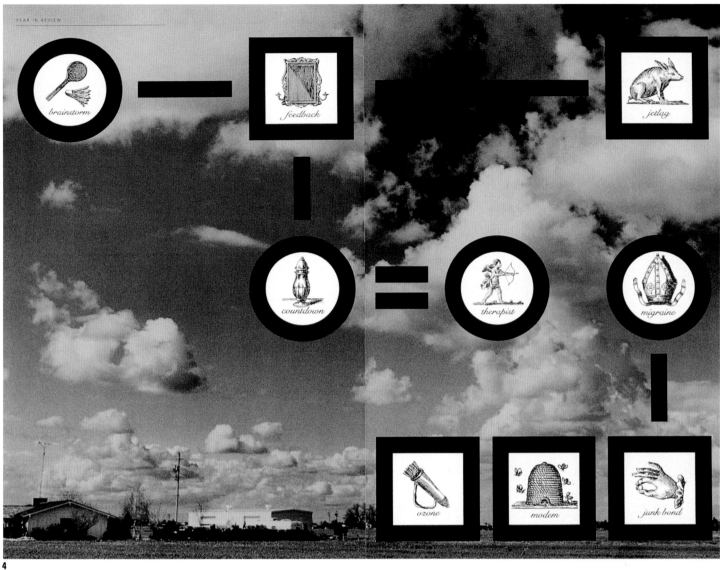

4

VIRTUAL
TELE
METRIX
1993
ANNUAL
REPORT

1

Title *EG&G 1992 Annual Report*
Art Directors *Aubrey Balkind and Kent Hunter*
Designers *Andreas Combuchen and Hans Neubert*
Photographers *Arnold Newman and Various*
Copywriter *John Berendt*
Design Firm *Frankfurt Balkind Partners, New York, NY*
Printer *Heritage Press*
Paper *Duramatte Text*

2

Title *California Council for Environmental & Economic Balance Annual Report*
Designer *Madeleine Corson*
Photographer *Thomas Heinser*
Copywriter *Lisa Bicker*
Design Firm *Madeleine Corson Design, San Francisco, CA*
Printer *Photon Press*
Paper *Coronado SST Recycled*

3

Title *Metro Waste Authority Annual*
Art Director *Steve Pattee*
Designers *Steve Pattee and Kelly Stiles*
Copywriter *Mike Condon*
Design Firm *Pattee Design, Des Moines, IA*
Printer *Professional Offset*
Paper *Fox River Confetti, French Dur-o-tone*

4

Title *Virtual Telemetrix 1993 Annual Report*
Art Director *John Bielenberg*
Designers *Dana Arnett, Allen Ashton, John Bielenberg, Michael Cronan, Jilly Simons, and Rick Valicenti*
Illustrators *Erik Adigard and Big Cheese*
Photographers *Allen Ashton and John Watson*
Design Firm *Bielenberg Design, San Francisco, CA*
Printer *Dharma Enterprises*
Paper *Kromekote Recycled Cover*

1
Title *ICOS Corporation 1992 Annual Report*
Art Director *John Van Dyke*
Designers *John Van Dyke and Ann Kumasaka*
Illustrator *Walter Stewart*
Photographers *Randy Allbritton and Jeff Corwin*
Design Firm *Van Dyke Company, Seattle, WA*
Printer *H. MacDonald Printing*
Paper *Simpson Coronado, Curtis Trans Fab Quilon*

1

A representation of leukocytes traversing the endothelial layer of a blood vessel to the site of inflammation.

ICOS scientists have found many different monoclonal antibodies that bind to leukocytes. One antibody also impeded leukocyte movement through the endothelium. That antibody is 23F2G. As a demonstration that blocking cell trafficking may be beneficial in chronic inflammation, we found 23F2G decreased brain lesions in an animal model of multiple sclerosis. Magnetic resonance imaging showed that the brain lesions not only stopped expanding but actually shrank or disappeared after treatment with 23F2G.

The 23F2G antibody was originally grown in mouse tissue. Mouse antibodies can be effective in the human body but, with time, the body recognizes mouse antibodies as foreign proteins and neutralizes their effectiveness. Even in the best settings, mouse antibodies have a very short survival time in the blood (a matter of several hours). A human antibody, on the other hand, circulates in the bloodstream for many days. Therefore, a crucial step toward making the 23F2G antibody into a useful drug was to "humanize" it — to transfer the active sites from the mouse antibody onto a human antibody framework that the immune system would be less likely to reject,

Computer-generated model of the humanized 23F2G structure.

2

I was at a friend's house—all of a sudden, boom, it happened—I couldn't walk. I was asking everyone to carry me but they couldn't because everyone was busy and stuff. I was standing on the stairs and I sort of crawled around. My friend Nikki picked me up and helped me. She's one of my best friends. Then Nana came and picked me up, and Nikki came with us to the hospital.

I had to change clothes into hospital clothes. I was on Surgical for a while and then went to Medical. There are two different parts of the floor. Surgical's for just broken bones and stuff. Medical's for really sick kids.

At first the doctors thought I was just playing a game.

They said, "Get up and walk." They wanted me to walk. Finally Nana got me a short chart tape. "Children should be seen and heard and believed." Nana put it on the window of my room.

Isolation means I can't come out of the room because I don't have any count. That's like my immune system and stuff like that, my whites and my polys and my hands. My white count was down to one. They brought me stuff from the playroom but it had to be washed off. Or brand new. But I didn't really feel like doing anything.

I'm swimming real good now. The rules are not to go into the deep end and have someone in the pool and not to go in the sun.

Sometimes kids ask what's that medicine, or what's that or that Or sometimes people say, "Look at those big cheeks," but that's fine. I know kids don't know what I've been through. They are always at school when I'm in the hospital.

Agouron Pharmaceuticals, Inc. *Annual Report 1993* *Fourteen* *Jennifer Cramer*

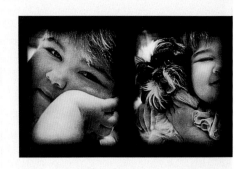

3

CHICAGO VOLUNTEER
LEGAL SERVICES
CASE FILES
1993 ANNUAL REPORT

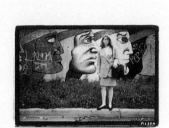

PILSEN

CVLS Annual Report
Page 15

CASE FILE #6

LAURA KABE

LORD, BISSELL & BROOK / ST. PROCOPIUS CHURCH LEGAL CLINIC
1641 South Allport

"Joke: A co-signer is defined as 'an idiot with a pen.'
Truth: Co-signers are often hard-working, generous, functionally illiterate people. At our Lord, Bissell & Brook Legal Clinic in Pilsen we see clients induced to sign forms containing government-mandated disclosures only because their creditors aggressively subverted the spirit of the law.

"Pedro guaranteed an auto loan so his daughter's boyfriend could get to work. The boyfriend was laid off and couldn't make payments. The bank repo'd the car, resold it to wholesalers for nearly nothing, and sued Pedro for the balance. Pedro didn't understand the legal documents and didn't appear. Hearing only the bank's testimony, the judge awarded it $3,800. Later realizing that a resulting wage deduction order would jeopardize his own job, Pedro asked us to help. The court granted my motion to vacate the default judgment. After I asked for proof that Pedro had been given the required notice of resale, the bank dismissed its own case. Justice prevailed."

2

Title *Agouron Pharmaceuticals 1993 Annual Report*
Art Directors *Rik Besser and Douglas Joseph*
Designer *Rik Besser*
Photographer *Eric Myer*
Design Firm *Besser Joseph Partners, Santa Monica, CA*
Printer *George Rice & Sons*
Paper *Kiana*

3

Title *Chicago Volunteer Legal Services 1992 Annual Report*
Art Directors *Ted Stoik and Chris Froeter*
Designer *Chris Froeter*
Photographer *Tony Armour*
Copywriter *Margaret Benson*
Design Firm *VSA Partners, Inc., Chicago, IL*
Printer *HM Graphics*
Paper *Jersey Reigel, Mohawk Superfine*

Communication Graphics *Packaging/Product Graphics*

1
Title *Pop Skull Beer Label*
Art Director/Designer *Paul Sahre*
Design Firm *GKV Design, Baltimore, MD*
Printer *Strine Printing*

2
Title *Atlantic Records Art Department*
Business-Card Placemat
Designers *Melanie Nissen, Richard Bates, Allen Hori,*
Frank Garguilo, Thomas Bricker, Charlie Becker, John Codling,
Jean Cronin, Larry Freemantle, Lynn Kowalewski, Donald May,
Cozbi Sanchez, Valerie Wagner, Eric Altenberger, Liz Barrett,
David Statman, Jennifer Roddie, Michelle Piza, Sung Lee,
Darren Crawforth
Design Firm *Atlantic Records, New York, NY*
Printer *Ivy Hill*
Paper *80 lb. Cover, dull coated one side*

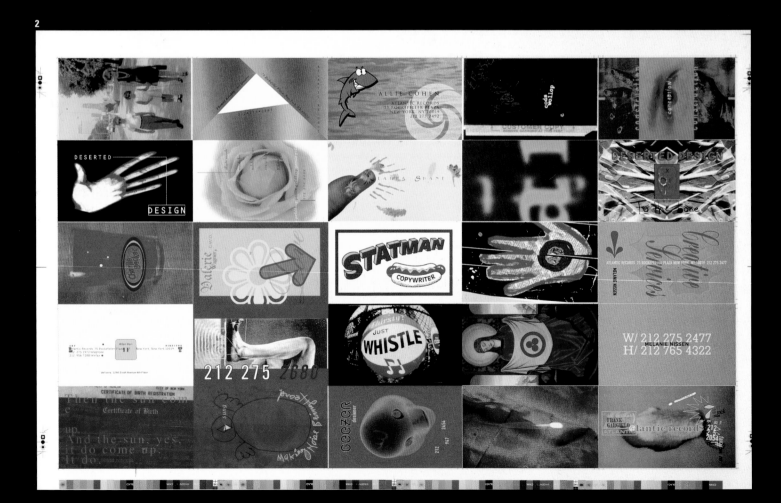

1

2

3
Title *Mississippi Madness Gourmet Dry Mix Gift Packaging*
Art Director/Designer *Hilda Stauss Owen*
Copywriter *David Adcock*
Design Firm *Communication Arts Company, Jackson, MS*
Printers *McCoy/Hederman Brothers*
Paper *Neenah Classic Crest*

4
Title *Prince of Orange Label*
Art Director *Michael Mabry*
Designers/Illustrators *Michael Mabry, Peter Soe, Jr.*
Design Firm *Michael Mabry Design, San Francisco, CA*
Paper *Fasson Crack 'n' Peel Plus*

5
Title *Christmas Stamps for Canada Post Corporation*
Art Director/Designer *Stephanie Power*
Illustrator *Jamie Bennett, Barry Blitt, Blair Drawson,
and Jeff Jackson*
Design Firm *Reactor Art & Design, Ltd., Toronto, Ontario*
Printer *Canadian Bank Note*

3

4

1

2

3

4

1

Title *Viansa Prindelo Bottle*
Art Director/Designer *Patti Britton*
Illustrators *Evans and Brown*
Photographer *Jesse Kumin*
Copywriter *Sam Sebastiani*
Design Firm *Britton Design, Sonoma, CA*
Typographer *Media Quest*
Printer *Bolling and Finke*
Paper *Neenah Classic Crest*

2

Title *"Le Gaucher" wine label for Bonny Doon Vineyard*
Art Director/Designer/Illustrator *Chuck House*
Copywriter *Randall Grahm*
Design Firm *Chuck House Design, Santa Rosa, CA*
Printer *O'Dell Printing Co., Inc.*
Paper *Estate Label #4 Laid Surface*

3

Title *Aleatico Wine Label*
Art Director *Michael Osborne*
Designer/Illustrator *Tom Kamegai*
Design Firm *Michael Osborne Design, San Francisco, CA*

4

Title *Snakebite Salsa Bloody Mary Mix*
Art Director/Designer *Leslie Pirtle*
Illustrator *Lisa Haney*
Copywriter *Leslie Pirtle*
Design Firm *Leslie Pirtle Design, New York, NY*
Paper *Genesis*

5

Title *Pour la France Dinner Menu*
Art Director *Robert Morehouse*
Designer/Illustrator *Jim Vogel*
Design Firm *Vermilion Design, Boulder, CO*
Printer *Sprint Denver*
Paper *Starwhite Vicksburg*

6

Title *Pow Wow Mix*
Art Director/Designer *Leslie Pirtle*
Illustrator *Lisa Haney*
Copywriter *Leslie Pirtle*
Design Firm *Leslie Pirtle Design, New York, NY*
Paper *Genesis*

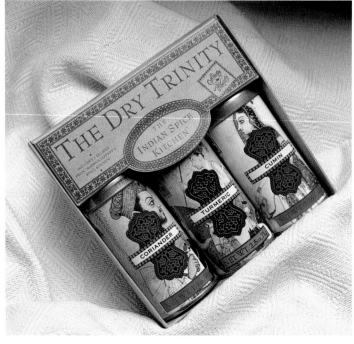

1
Title *The Indian Spice Kitchen Packaging*
Art Director *Michael Manwaring*
Designer *Elizabeth Ives Manwaring*
Design Firm *The Office of Michael Manwaring,*
San Francisco, CA
Printer *Dharma Enterprises, Forman-Leibrock*
Paper *Neenah Environment, Various*

1

2
Title *French Paper Co. Tattoos*
Art Director *Charles S. Anderson*
Designers *Charles S. Anderson and Paul Howalt*
Illustrator *CSA Archive*
Photographer *Darrell Eager*
Copywriter *Lisa Pemrick*
Design Firm *Charles S. Anderson Design Company, Minneapolis, MN*
Printer *Litho, Inc.*
Paper *French Speckletone True White 80# cover*

3
Title *Blue Q Stationery System*
Art Director/Designer/Illustrator *Michael Mabry*
Design Firm *Michael Mabry Design, San Francisco, CA*
Paper *French Dur-o-tone*

4
Title *Barry Myers Self-Promotion*
Art Director/Designer *Neal Ashby*
Photographer *Barry Myers*
Copywriters *Neal Ashby and Stuart Miller*
Design Firm *Ashby Design, Annapolis, MD*
Printer *Flashprint*
Paper *Starwhite Vicksburg*

2

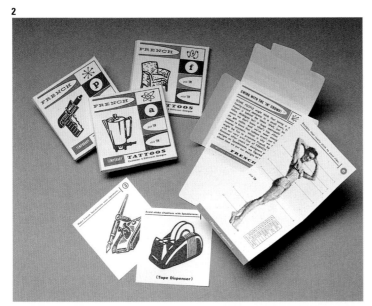

3

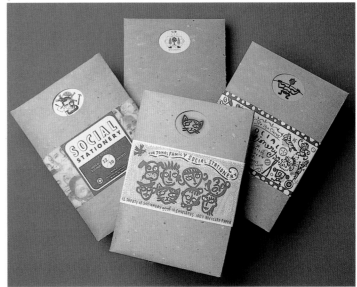

4

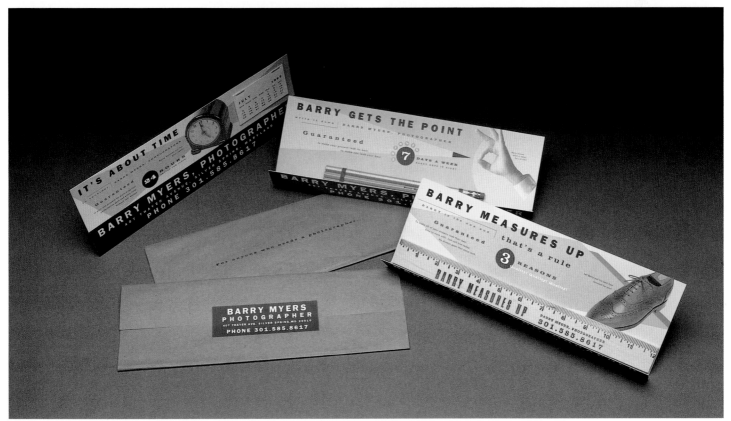

1

2

1
Title *Smith & Hawken Seed Collections*
Art Directors *Bonnie Dahan and Gaylen Blankenship*
Designer *Sandra McHenry*
Illustrator *Thorina Rose*
Copywriter *Georgeanne Brennan*
Design Firm *Sandra McHenry Design, San Francisco, CA*
Printer *The Dot, Printer*
Paper *Champion Benefit*

2
Title *Turner Pins*
Art Director *Charles S. Anderson*
Designers/Illustrator *Charles S. Anderson and Paul Howalt*
Photographer *Paul Irmiter*
Copywriter *Lisa Pemrick*
Design Firm *Charles S. Anderson Design Company,*
Minneapolis, MN
Printer *Lunalux (labels)*

3
Title *Self-Promotion Deck of Cards*
Art Director/Designer/Illustrator *Sunil Bhandari*
Design Firm *Harris Bhandari Design Associates, Toronto, Ontario*
Printer *Herzig Somerville*
Paper *Neenah Environment*

4
Title *Zzz Sleep Set*
Art Directors/Designers *Byron Glaser and Sandra Higashi*
Photographer *Rocki Pedersen*
Copywriters *Byron Glaser, Sandra Higashi, and others*
Design Firm *Higashi Glaser Design, Fredericksburg, VA*
Typographer *Trufont*
Printer *Carter Printing*
Paper *100% Recycled Carton, Curtis Parchment, Karma, Simpson Evergreen, and Beau Brilliant*

3

4

1

2

3

1
Title *Lee Printwear Conference Materials*
Art Director *Jaimie Alexander*
Designer *Kian Huat Kuan*
Copywriter *Michelle Geissbuhler*
Design Firm *Fitch Inc., Columbus, OH*
Printers *Eskco, Westcamp, Mid-Ohio, and Century Graphics*
Paper *Speckletone*

2
Title *Nike Town Holiday Bag*
Art Director/Designer/Illustrator *Clark Richardson*
Photographers *Dale Tait and Tom DiPace*
Design Firm *Nike, Inc., Beaverton, OR*
Printer *Champion*
Paper *Kraft*

3
Title *Chums Bush Pilot Cap*
Art Director *Kobe*
Designers *Alan Leusink and Kobe*
Design Firm *Joe Duffy Design, Minneapolis, MN*
Printer *Custom Performance Wear, Paramount*

4
Title *VistaLite VL200X Flashing Safety Light*
Art Director/Designer *Cathy Choi*
Photographer *Scott Gordon*
Design Firm *VistaLite/Bell Sports, Lancaster, PA*
Printer *Village Press*
Paper *French Speckletone Oatmeal*

5
Title *VistaLite VL200X Safety Light Clamp*
Art Director/Designer *Cathy Choi*
Photographer *Scott Gordon*
Design Firm *VistaLite/Bell Sports, Lancaster, PA*
Printer *Village Press*
Paper *French Speckletone Oatmeal*

1

Title *Paul Simon "1964/1993" CD Box Set*
Art Director/Designer *Jeri Heiden*
Photographer *Claude Gassian*
Copywriters *Kevin Howlett, Paul Zollo, Philip Glass*
Design Firm *Warner Bros. Records, Burbank, CA*
Printer *Ivy Hill*
Paper *Starwhite Vicksburg*

2

Title *Ella Fitzgerald, The Complete Song Books*
Art Director *Chris Thompson*
Illustrator *Jeffery Fulvimari*
Design Firm *Polygram Records, Inc., New York, NY*
Printer *Shorewood*

3

Title *Los Lobos, "Just Another Band From East L.A.—A Collection"*
Art Directors/Designers *Tom Recchion and Louie Perez*
Photographers *Keith Carter and Fredrik Nilsen*
Copywriters *Luis Torres and Bill Bentley*
Design Firm *Warner Bros. Records, Burbank, CA*
Printer *Ivy Hill*
Paper *Vintage Velvet Dull Cover and Text*

4

Title *Ella Fitzgerald, First Lady of Song*
Art Director/Designer *David Lay*
Design Firm *Polygram Records, Inc., New York, NY*
Printer *AGI*

5

Title *Paul Westerberg "14 Songs" Special CD Package*
Art Directors *Kim Champagne and Jeff Gold*
Designers *Kim Champagne and Jean Krikorian*
Photographers *Frank Ockenfels and Kim Champagne*
Copywriter *Bill Bentley*
Design Firm *Warner Bros. Records, Burbank, CA*
Printer *AGI*
Paper *Chipboard, Williamsburg Hi-Bulk*

4

5

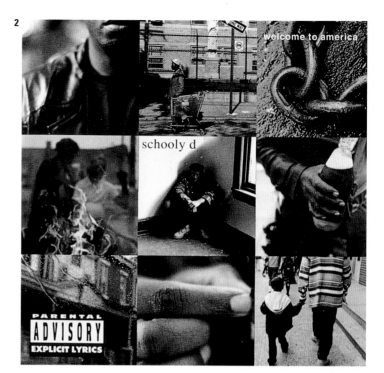

1
Title *"Big Cheese" Movie*
Art Director/Designer *Bob Aufuldish*
Illustrators *Eric Donelan and Bob Aufuldish*
Design Firm *Aufuldish & Warinner, Mill Valley, CA*

2
Title *"Welcome to America," Schooly D Package*
Art Director/Designer *Stacy Drummond*
Photographer *David Katzenstein*
Design Firm *Sony Music Entertainment, Inc., New York, NY*

3
Title *In-Store Play CD*
Art Director/Designer *Sara Rotman*
Design Firm *Sony Music Entertainment, Inc., New York, NY*

4
Title *CD Manufacturers' Ink Selector*
Art Director/Designer *Jerry King Musser*
Design Firm *KAO Optical Products, Harrisburg, PA*
Printer *KAO Optical Products Print Dept.*

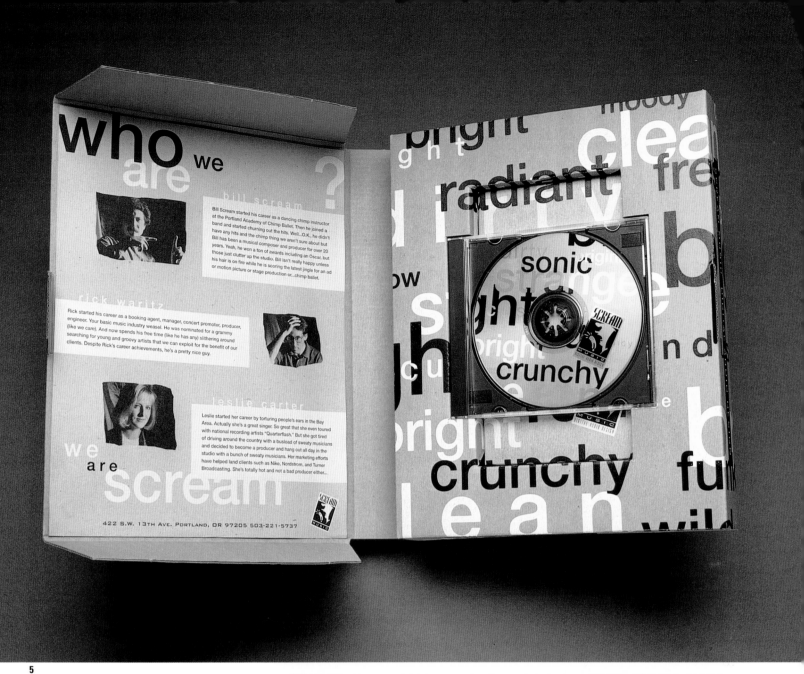

5

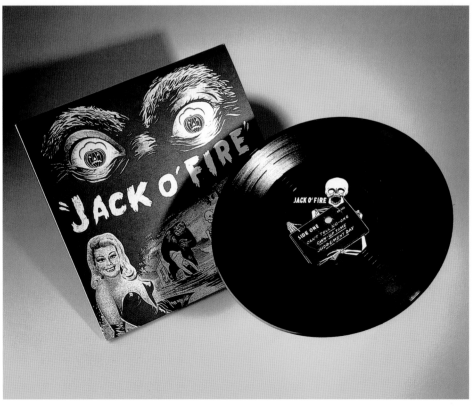

5
Title *Scream Music Mailer*
Art Director *Ross Patrick*
Design Firm *Graphic Media, Inc., Portland, OR*
Printer *Visuals N.W./NW Paper Box/Premier Press*
Paper *Corrugated Board/Speckletone*

6
Title *Jack o'Fire Record Jacket/Estrus Records*
Art Directors *Art Chantry, David Crider, and Tim Kerr*
Designer *Art Chantry*
Design Firm *Art Chantry Design, Seattle, WA*

6

Title *Industry and Ecology Poster*
Art Directors *Russ Ramage and Bill Grant*
Designer *Russ Ramage*
Photographer *Jerry Burns*
Design Firm *DESIGN!, Dalton, GA*
Client *Collins & Aikman Floor Covering*
Printer *Lee Printing*
Paper *Neenah Environment*

1

2

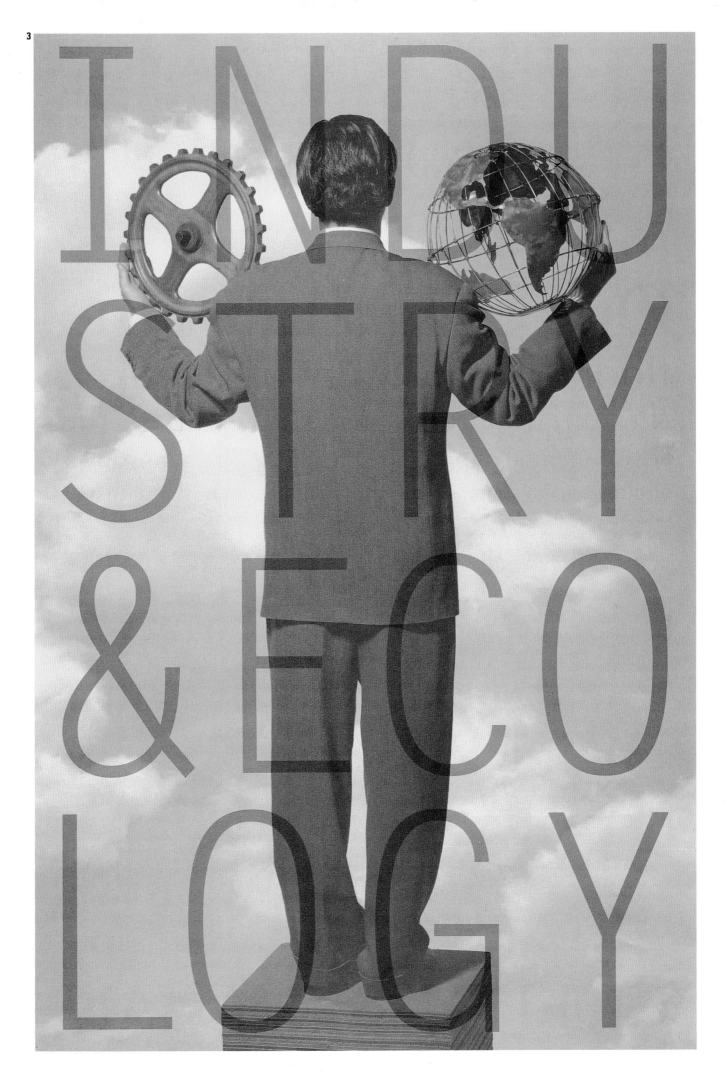

1

1
Title *AIGA/Portland Annual Meeting Poster*
Art Directors *Alicia Johnson and Hal Wolverton*
Designers *Hal Wolverton, Alicia Johnson, and Kat Saito*
Photographer *Hal Wolverton*
Design Firm *Johnson & Wolverton, Portland, OR*
Printer *Bridgetown Printing*
Paper *French Dur-o-tone*

2
Title *Art Chantry Poster*
Art Director/Illustrator *Art Garcia*
Copywriter *Mark Perkins*
Design Firm *SullivanPerkins, Dallas, TX*
Printer *Williamson Printing*
Paper *James River*

3

Title *1994–95 Fellowship Poster*
Art Director/Designer *Rebeca Méndez*
Photographers *John Kiffe and Douglas Benjamin*
Design Firm *J. Paul Getty Trust Publication Services,*
Santa Monica, CA
Printer *Monarch Litho Inc.*
Paper *Monarch "S" Dull*

4

Title *Amnesty International Human Rights Poster*
Art Directors *Alicia Johnson and Hal Wolverton*
Designers *Hal Wolverton, Adam McIsaac, and Kat Saito*
Photographer *Raphael Astorga*
Design Firm *Johnson & Wolverton, Portland, OR*
Printer *The Irwin-Hodson Company*
Paper *Evergreen*

3

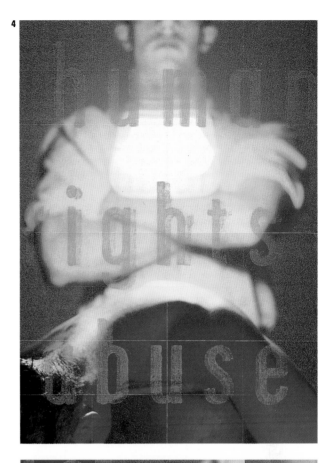

229

DOCUMENTS NORTHWEST : THE PONCHO SERIES

ART CHANTRY

SEATTLE ART MUSEUM
100 UNIVERSITY STREET
654-3100

JULY 15 - NOVEMBER 21, 1993

THIS EXHIBITION IS SUPPORTED BY GRANTS FROM PONCHO AND THE NATIONAL ENDOWMENT FOR THE ARTS, A FEDERAL AGENCY.
ADDITIONAL FUNDING FOR SEATTLE ART MUSEUM EXHIBITIONS AND PROGRAMS IS PROVIDED BY CONTRIBUTORS TO THE ANNUAL FUND.

1

1
Title *Art Chantry Exhibit/Seattle Art Museum Poster*
Art Director/Designer *Art Chantry*
Design Firm *Art Chantry Design, Seattle, WA*
Printer *Skip Jensen/Post-Industrial Press*

2
Title *"Summer in the City" Poster*
Art Director/Designer/Illustrator *Michael McGinn*
Design Firm *Designframe, Inc., New York, NY*
Printer *Techtron Print*
Paper *Finch Opaque*

3
Title *Teenage Fanclub Poster*
Art Director *Robin Sloane*
Designer *Greg Stata*
Photographer *Brian Spanklen*
Design Firm *Geffen Records, West Hollywood, CA*

3

2

1
Title *Des Moines Metro "Don't Drive Day" Poster*
Art Director/Designer/Illustrator *Eric Groves*
Design Firm *DesignGroup, Inc., Des Moines, IA*
Printer *Edwards Graphic Arts*
Paper *Simpson Starwhite Vicksburg*

2
Title *Happy New Year! Poster*
Art Director/Designer *Sam Kuo*
Design Firm *Kuo Design Office, New York, NY*
Printer *Enterprise Press*
Paper *Finch Opaque*

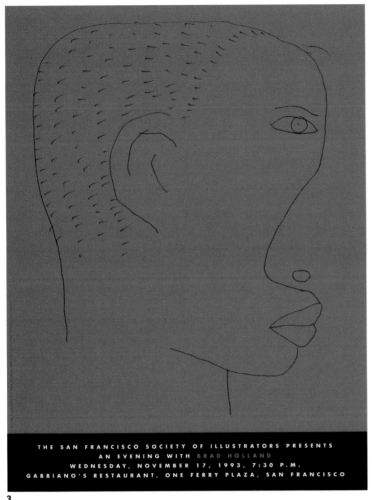

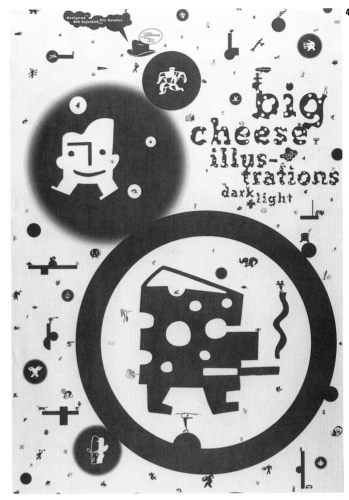

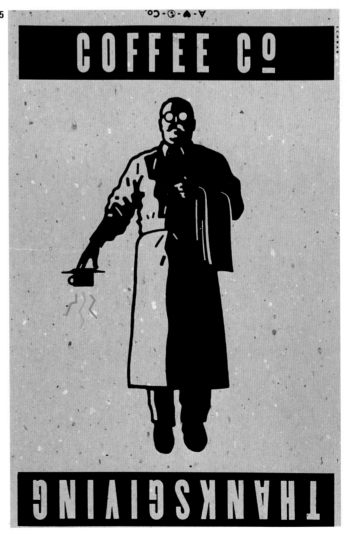

3

Title *Speaking Engagement Poster*
Art Director/Illustrator *Brad Holland*
Designer *Jim McCune*
Design Firm *Brad Holland, New York, NY*
Printer *Bacchus Press*

4

Title *"Big Cheese" Poster*
Art Director/Designer *Bob Aufuldish*
Illustrators *Eric Donelan and Bob Aufuldish*
Design Firm *Aufuldish & Warinner, Mill Valley, CA*

5

Title *Thanksgiving Coffee Poster*
Art Director *Chris Blum*
Designers *Chris Blum and Michael Schwab*
Illustrator *Michael Schwab*
Design Firm *Michael Schwab Design, Sausalito, CA*

1
Title *Simpson Sundance Lingo Poster*
Art Director *Kit Hinrichs*
Designers *Belle How and Amy Chan*
Illustrators *Dave Stevenson, Jack Unruh, Regan Dunnick,*
Lisa Miller, Erick Schreck, McRay Magleby, Will Nelson,
Cathie Bleck, John Hersey, David Wilcox, and Tim Lewis
Photographers *Bob Esparza, Charley Franklin,*
FPG International, Bybee Digital, and Russell Kloer
Copywriter *Delphine Hirasuna*
Design Firm *Pentagram Design, San Francisco, CA*
Typographer *Eurotype*
Printer *Woods Lithographics*
Paper *Sundance Vellum Navajo White Cover*

2
Title *Design Renaissance "Ambiguity" Poster*
Art Director/Designer *Paula Scher*
Design Firm *Pentagram Design, New York, NY*

3
Title *"Now Is Not the Time to Compromise" Potlatch Poster*
Art Director/Designer/Illustrator *Craig Frazier*
Design Firm *Frazier Design, San Francisco, CA*
Printer *Watermark*

1

2

3

Please join us for an evening with Craig Frazier and Potlatch, co-hosted by Nationwide Papers.

Craig Frazier, designer of the 5th brochure in the Potlatch series "Now is Not the Time to Compromise," will talk about the project and our daily pressure to compromise.

Debra Smith of Potlatch will present "Uncompromising Essentials– Elements of Coated Papers."

On display will be the Potlatch Private Annual Report Exhibit featuring 75 of this country's best annuals. Also Potlatch's latest pro- motional releases and Nationwide's newest coated paper samples.

December 14, 1993
Contract Design Center
600 Townsend St. (at 7th)
San Francisco
4:30–6:30 hors d'oeuvres
6:30–8:30 presentations

For information and RSVP contact Jesse Betancourt, Nationwide 800-652-1326 (Ext.319)

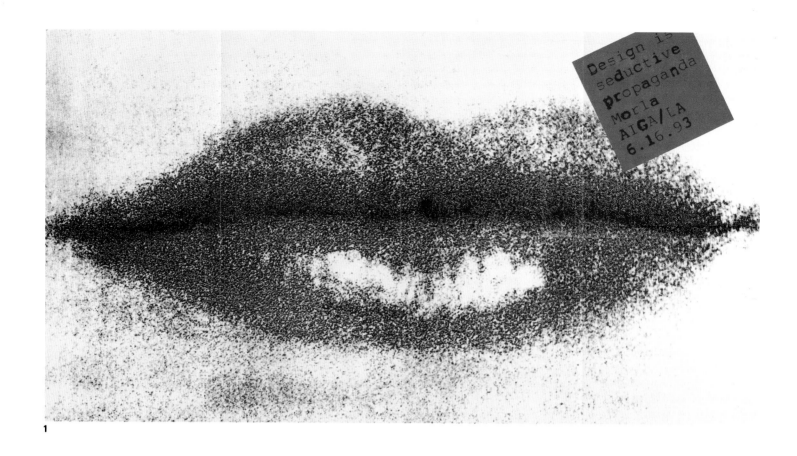

1

2

1

Title *AIGA/LA: Jennifer Morla Lecture Poster*
Art Director *Jennifer Morla*
Designers *Jennifer Morla and Craig Bailey*
Design Firm *Morla Design, San Francisco, CA*
Printer *Pace Lithographers, Inc.*
Paper *Evergreen Matte Natural*

2

Title *"Cigarette" Poster for AIGA/Raleigh*
Art Director/Designer *Paula Scher*
Photographer *John Paul Endress*
Design Firm *Pentagram Design, New York, NY*
Printer *Teagle & Little*
Paper *Finch Fine Smooth*

3

Title *Art Directors Club of Cincinnati Lecture Poster*
Art Director/Designer/Illustrator *Woody Pirtle*
Design Firm *Pentagram Design, New York, NY*

WOODY PIRTLE
IN THE CITY OF
SEVEN HILLS
FEBRUARY 8, 1994
CINCINNATI ART
MUSEUM
6 PM HORS D'OEUVRES
7 PM PRESENTATION
SPONSORED BY THE
ART DIRECTORS CLUB
OF CINCINNATI

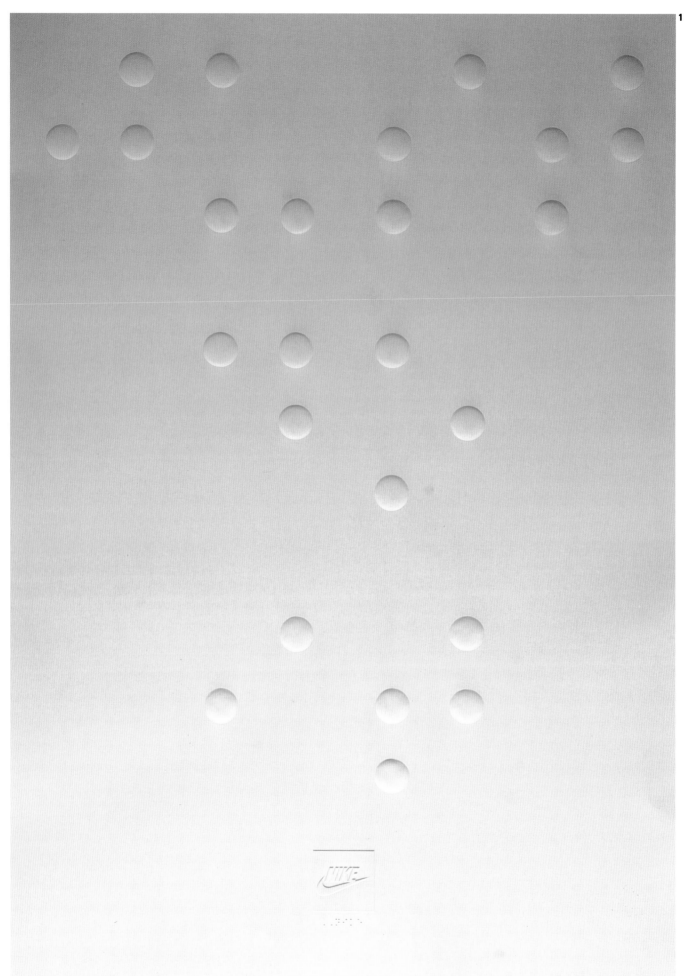

1

Title *"Just Do It" Braille Poster*
Art Director/Designer/Illustrator *Guido Brouwers*
Copywriter *Laura Houston-Emery*
Design Firm *Nike, Inc., Beaverton, OR*
Typographer *Schlagel Typesetting*
Printer *Creative Paper Crafting*
Paper *Illustro Dull*

2

Title *"Just Do It" Sign Language Poster*
Art Director/Designer *Guido Brouwers*
Photographer *John Emmerling*
Design Firm *Nike, Inc., Beaverton, OR*
Typographer *Schlagel Typesetting*
Printer *Irwin-Hodson Printing*
Paper *Productolith*

3

Title *"Ally Hoop" Poster*
Art Director/Designer *John Norman*
Illustrator *Gerald Bustamante*
Design Firm *Nike, Inc., Beaverton, OR*
Printer *Riverside Press*
Paper *Moisturerite Matte*

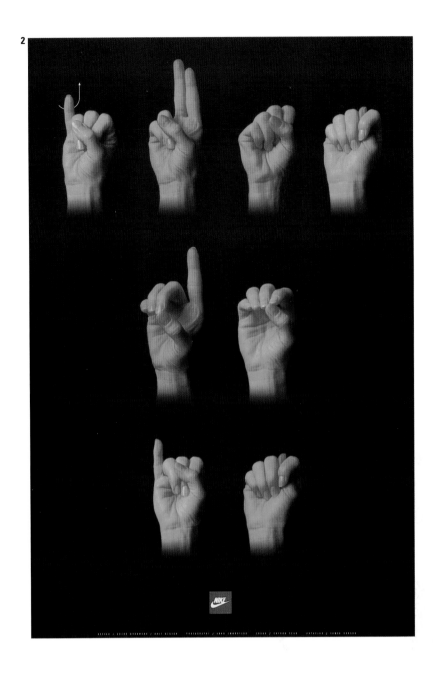

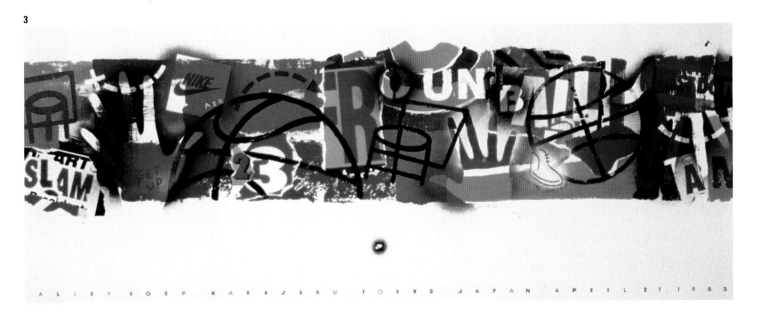

1
Title *"No Future" Poster/Rhino Records*
Art Director *Coco Shinomiya*
Designers *Art Chantry and Jeff Kleinsmith*
Design Firm *Art Chantry Design, Seattle, WA*
Typographer *Dymo Label Maker*

2
Title *"Double Justice" Poster*
Art Director *Kica Matos*
Designer/Illustrator *James Victore*
Design Firm *Victore Design Works, New York, NY*
Printer *Royal Offset*

3
Title *"Traditional Family Values" Poster*
Art Director/Designer *James Victore*
Design Firm *Victore Design Works, New York, NY*
Printer *Royal Offset*

4
Title *"Racism" Poster*
Art Director/Designer *James Victore*
Design Firm *Victore Design Works, New York, NY*
Printer *Ambassador Arts*

5
Title *Baby Bottle Poster*
Art Director *Steven Brower*
Designer *Steven Brower, John Gall, Leah Lococo,*
Morris Taub, James Victore, and Susan Walsh
Design Firm *Post No Bills, Matawan, NJ*
Printer *Royal Offset*

1

1

Title *Bay St. 1993 Theater Festival Poster*
Art Director/Designer/Illustrator *Paul Davis*
Design Firm *Paul Davis Studio, New York, NY*
Printer *Stevens Press*
Paper *Mohawk Superfine*

2

Title *Boston Indoor/Outdoor Speaker System Poster*
Art Director/Designer *Bruce Crocker*
Illustrator *Elwood Smith*
Design Firm *Crocker Inc., Brookline, MA*
Typographer *Lee Busch*
Printer *Fine Arts Press*
Paper *Lustro Cream Cover*

3

Title *Wolf Teaser Poster*
Art Directors *Peter Bemis and Kim Wexman*
Photographer *Michael O'Neill*
Copywriter *Art Sherman*
Design Firm *Frankfurt Balkind Partners, New York, NY*
Printer *Rice & Sons Printing*

4

Title *"One Tit, a Dyke, and Gin" Poster*
Art Directors/Designers/Illustrators
Paul and Carolyn Montie
Design Firm *Fahrenheit, Boston, MA*
Printer *Aldus Press*
Paper *Gleneagle Osprey Geo Dull Tint, UK Paper*

2

1

1

Title *"Endangered" (Series of Six Posters)*
Art Director/Designer/Illustrator *Lanny Sommese*
Design Firm *Sommese Design, State College, PA*
Printer *Jim Lilly*
Paper *French Speckletone*

1
Title *Heartbreak House Poster*
Art Directors *Vittorio Costarella and Douglas Hughes*
Designer *Vittorio Costarella*
Design Firm *Modern Dog, Seattle, WA*
Printer *Two Dimension (screen printing)*
Paper *Simpson Ecopaque*

2
Title *"Romeo Juliet" Poster*
Art Director/Designer/Illustrator *James Victore*
Design Firm *Victore Design Works, New York, NY*
Printer *Royal Offset*

3
Title *The Inspector Alleyn Mysteries Poster*
Art Director *Fran Michalman*
Designers *Paul Davis and Lisa Mazur*
Illustrator *Paul Davis*
Design Firm *Paul Davis Studio, New York, NY*
Printer *Edelman Associates/Perry Printing*
Paper *Mohawk Poseidon*

4
Title *Sherlock Holmes Poster*
Art Director *Fran Michalman*
Designer/Illustrator *Paul Davis*
Copywriter *Fran Michalman*
Design Firm *Paul Davis Studio, New York, NY*
Printer *Edelman Associates/Perry Printing*
Paper *Mohawk Poseidon*

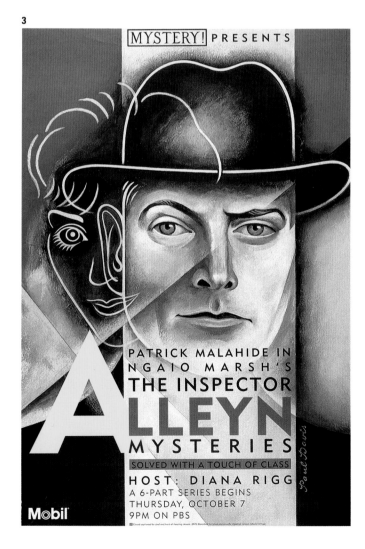

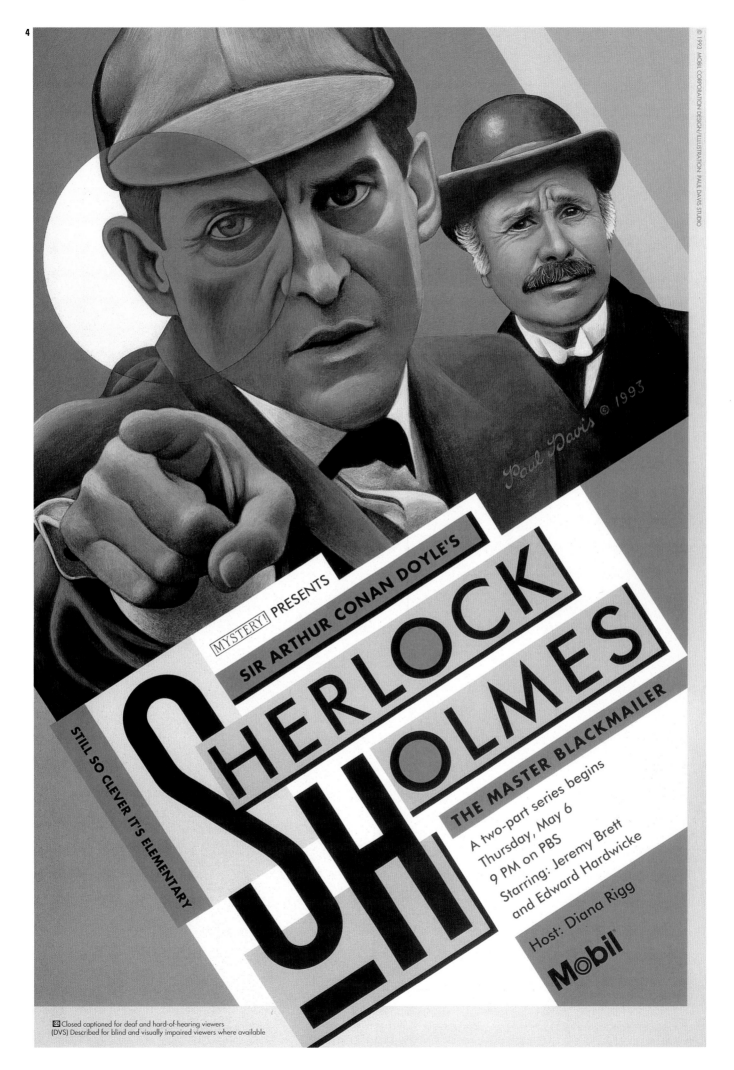

MYSTERY! PRESENTS

SIR ARTHUR CONAN DOYLE'S

SHERLOCK HOLMES

STILL SO CLEVER IT'S ELEMENTARY

THE MASTER BLACKMAILER

A two-part series begins
Thursday, May 6
9 PM on PBS
Starring: Jeremy Brett
and Edward Hardwicke

Host: Diana Rigg

Mobil

CC Closed captioned for deaf and hard-of-hearing viewers
(DVS) Described for blind and visually impaired viewers where available

For a round of recent shots, dial:

4

3

1

4 3 1 5 5 8 8

5

8

8

(AREA CODE 212)

STANLEY BACH PHOTOGRAPHY 417 CANAL ST. NO. 8A, NEW YORK CITY (10013)

2

3

1
Title *Stanley Bach Poster*
Art Director/Designer/Illustrator *Todd Waterbury*
Design Firm *Wieden & Kennedy, Portland, OR*
Printer *Ambassador Arts*
Paper *French Newsprint*

2
Title *"P" Poster for Ambassador Arts Alphabet*
Art Director/Designer *Paula Scher*
Design Firm *Pentagram Design, New York, NY*
Printer *Ambassador Arts*
Paper *Champion Pageantry*

3
Title *Mark Your Calendar Poster*
Art Director/Designer *Michael McGinn*
Copywriter *Independent Curators Inc.*
Design Firm *Designframe, Inc., New York, NY*
Printer *Monarch Press*
Paper *Newsprint*

Communication Graphics *Invitations/Announcements/Cards/Programs*

1
Title *Montgomery Watson Merger Announcement*
Art Director *Lowell Williams*
Designers *Lowell Williams and Bill Carson*
Illustrator *Michael Schwab*
Copywriter *Jo Ann Stone*
Design Firm *Pentagram Design, San Francisco, CA*
Typographer *Design & Type*
Printer *Williamson Printing*
Paper *Vicksburg Starwhite*

2
Title *1993 Conference Program*
Art Director *Jon Henderson*
Designer *David Carson*
Design Firm/Printer *Hallmark Cards, Inc., Kansas City, MO*

3
Title *Jan Baker Paper Poems*
Art Director *Jan Baker*
Designers *Jan Baker and Anita Meyer*
Lettering *Jan Baker*
Design Firm *plus design inc., Boston, MA*
Printer *Aldus Press*
Paper *Carnival Groove, Graphika Lineal, Gilbert Esse*

common thread

CREATIV
LEADER
P
CONFER

august 19
gust 20

Hallmark
FAV

GENDER

Losing your temper

Exhibiting anger is
don't vent their anger much
work — other working

hen you make the two o
en you make the inner
d the outer as the inner
the below, and when
u make the male and f
that the male will not b
: female not be female,
es in the place of an ey
the place of a hand, an
a foot, and an image
en shall you enter the K

The G

2
3
ThurSday, August 19

1:00 p.m. Harriet Lerner,
clinical psychologist
Menninger Clinic Auditorium

2:15 Steve Hess, CPDM
(Hallmark Promotions)
Eileen Drummond,
editorial manager
Darrell Holtz,
editorial manager Ambassador Promotions

3:00 B R E A Sculpture K
A Court

soCiologist, Recital Hall
(Hallmark Research)

3:30 Irv Hockaday,
prEsident & CEO Auditorium
(Hallmark)

4:15 Bob Firnhaber,
president
(Hallmark Brand)

5:00 Reception and
Exhibition Nelson-Atkins
"Common Ground / Uncommon
Visions" Museum of Art
Folk Art Exhibit

6:00 D I N N E

GENDER

GOOD PEOPLE...

AND HELPING HANDS,

1

2

1

Title *Moving Announcement*
Art Director *Bob Dennard*
Designers *Bob Dennard and Wayne Geyer*
Photographer *Jeff Ott*
Copywriters *Bob Dennard and Wayne Geyer*
Design Firm *Dennard Creative, Inc., Dallas, TX*
Printer *Ussery Printing*
Paper *French Dur-o-tone, Confetti Kaleidoscope, Ninja Text*

2

Title *Upfront Invitation*
Art Director *Jayne Tsuchiyama*
Designer *Marty Resetar*
Copywriter *Jayne Tsuchiyama*
Design Firm *Lifetime Television, New York, NY*
Printer *Bradford Graphics*
Paper *Strathmore Renewal*

3

Title *FAO Schwartz Party Invitation*
Art Director *David Vogler*
Designer *Sandy Goijburg*
Design Firm *MTV Networks, New York, NY*
Printer *Dee Jay Litho*

4

Title *Dinner Program: Jon Secada*
Art Director/Designer *Neal Ashby*
Design Firm *The Recording Industry of America,
Washington, D.C.*
Printer *Broomall*
Paper *French Dur-o-tone*

3

4

As any devotee of Latin music will tell you, Jon Secada is one of the most exciting new artists to emerge on the American music scene in years. Born in Cuba, the Miami-based artist's career took off after his debut album's single, "Just Another Day," was in the top 10 on Billboard's Pop Singles charts for 13 consecutive weeks. That self-titled album has since been certified Double Platinum by the RIAA, and has sold close to five million copies worldwide. It was number one on Billboard's Latin Pop chart for 10 months, and it has won Jon a series of prestigious awards, including a Grammy this year for Best Latin Pop album. Jon has become a crossover phenomenon, which laid the groundwork for Otro Dia Mas Sin Verte, the Spanish version of his popular debut album. Not surprisingly, it had four singles go number one on Billboard's Hot Latin charts. Prior to launching his solo career, Jon enjoyed a prolific, five-year songwriting and performing partnership with Gloria Estefan's Miami Sound Machine. The Recording Industry Association of America and EMI Records Group North America are proud to present Jon Secada for your entertainment this evening.

1
Title *MTV Video Music Awards 1993 Program*
Art Directors/Designers *Jeffrey Keyton,*
Stacy Drummond, and Stephen Byram
Illustrators *Various*
Photographer *Various*
Copywriter *Karin Henderson*
Printer *CR Waldman Graphics*
Paper *Glen Eagle Osprey Dull Coated*

2
Title *Agassi Opening*
Art Director *Jeff Weithman*
Designers *Jeff Weithman and John Norman*
Illustrator *Gray Matter Inc./ Greg Maffei*
Design Firm *Nike, Inc., Beaverton, OR*
Typographer *Gray Matter Inc./ Greg Maffei*
Printer *Lith Tech Printing*
Paper *Simpson Filare Duplex, Gilbert Gilclear*

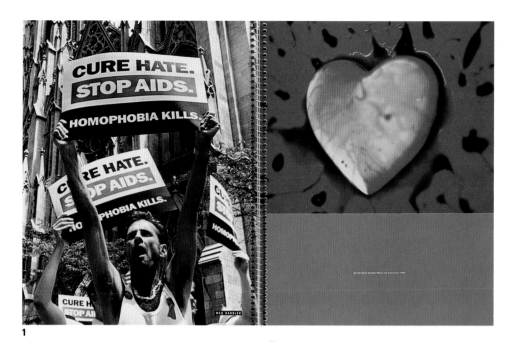

1

2

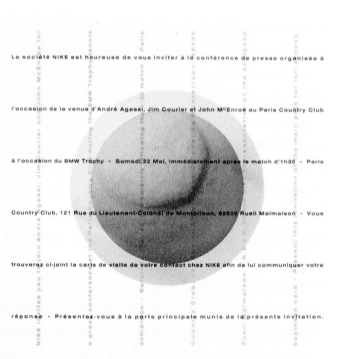

Title *VH-1 Awards Brochure*
Art Director *Cheri Dorr*
Designer *Sharon Werner, Werner Design Werks*
Copywriter *Dan Hedges*
Printer *Heartland Graphics*

3

IT'S A 2 HOUR, STAR-STUDDED LIVE TELEVISION EVENT FROM VH-1.

The first and only pop music entertainment channel targeted to viewers 18 to 49. They're upscale, music-loving adults who want entertainment that cuts to the chase. That reflects their tastes, passions, and lifestyles. That speaks to them.

That's why, for the past eight years, VH-1 has been their first choice. Their primary video music source. It's where 18 to 49s know they'll find the hits they want to hear by the world-class artists they love to watch—from Elton John and En Vogue, to Genesis, Gloria Estefan and Paul McCartney.

And VH-1 is the network that gives adult viewers more

than great entertainment as we enter our 5th year of presenting high profile pro-social/ pro-environment events like The Earth Day Concerts and programming like Good News People and World Alerts. All of it reflecting our viewers' concerns about the future. All of it supported by an incredible array of stars like Alec Baldwin, Blythe Danner, Jeff Goldblum, Oliver Stone, Goldie Hawn, Martin Sheen, Christie Brinkley, Billy Joel, Bonnie Raitt, Sting, Don Henley and Paul McCartney—just a few of the major names who've taken part in VH-1's environmental efforts in recent years.

It's a night that encompasses everything VH-1 is about. It's a major live television event with a mission: It's our gala awards tribute to the finest music video artists of the 90's. VH-1 Artists. Artists with vision. From k.d. lang, Michael Bolton and Don Henley, to Bruce Hornsby, Rod Stewart and Tina Turner, they're artists our viewers tell us they can't get enough of. Artists with proven and lasting appeal to discerning, music-loving adults 18 to 49.

It's a night when we'll honor the greatest adult contemporary performers with special awards that include "Best Female Video," "Best Male Video," "Best New Pop Artist," "Video of the Year," "Best Director" and "Visionary of the Year."

It's an electrifying night of superstar entertainment, too. You'll see live musical performances from major VH-1 artists like Michael Bolton, Whitney Houston, Vanessa Williams and Sting. Plus special appearances by many of today's hottest comics—like Jerry Seinfeld, Rosie O'Donnell, Steven Wright, Rita Rudner, Elayne Boosler and Paul Reiser.

And it's also a night when the stars will take time to shine for Planet Earth, and spotlight environmental organizations that are working to make our communities, our world, and our future a whole lot brighter.

THE CONCEPT

1

2

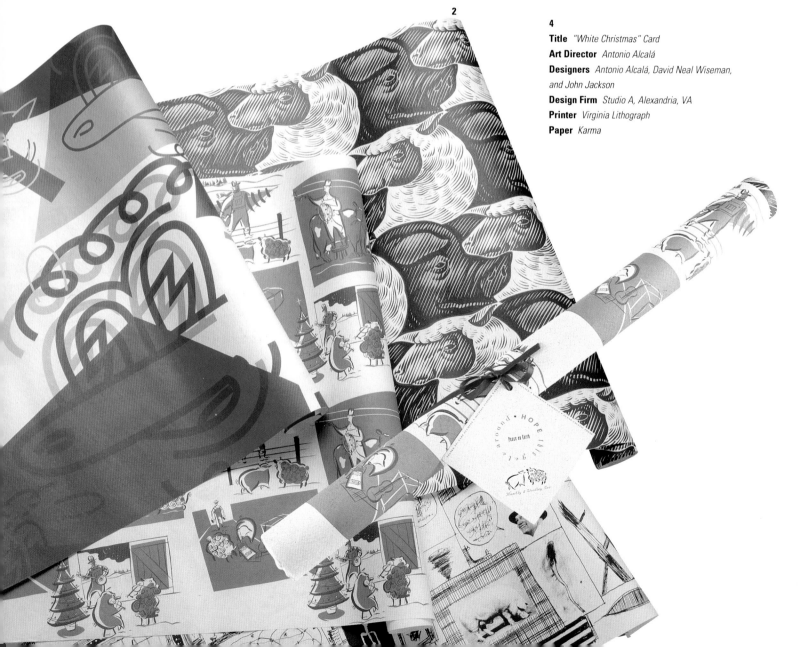

3

4

1
Title *"Objects: Sixteen L.A. Sculptors"*
Art Director *Rebeca Méndez*
Designers *Darin Beaman and Rebeca Méndez*
Photographer *Various students*
Design Firm *Art Center College of Design, Pasadena, CA*
Printer *Typecraft, Inc.*
Paper *Matrix Dull*

2
Title *"Burned Objects"*
Art Director *Steve Liska*
Designer *Kim Nyberg*
Photographer *Stephen Wilkes*
Design Firm *Liska and Associates, Inc., Chicago, IL*
Printer *Shepard Poorman*
Paper *Quintessence*

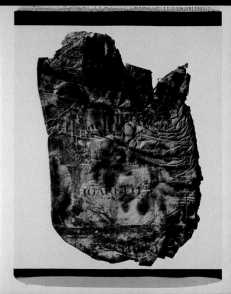

3

3
Title *"Blown Away"*
Art Director *Mike Salisbury*
Designer *Patrick O'Neal*
Photographers *Bruce Birmelin and Joel Warren*
Design Firm *Mike Salisbury Communications, Torrance, CA*
Typographer *Regina Grosveld*
Printer *Gore Graphics*
Paper *Neenah Environment*

4
Title *Johnny Mathis*
Art Director *Allen Weinberg*
Designers *Allen Weinberg and Paul Martin*
Photographer *Don Hunstein*
Design Firm *Sony Music Entertainment, Inc., New York, NY*
Printer *Fleetwood Printing*
Paper *Vintage Velvet*

1

Title *Barry Myers Self-Promotion*
Art Director/Designer *Neal Ashby*
Photographer *Barry Myers*
Copywriters *Neal Ashby and Stuart Miller*
Design Firm *Ashby Design, Annapolis, MD*
Printer *Flashprint*
Paper *Starwhite Vicksburg*

2

Title *Louise Fili Ltd. Promotion*
Art Director/Designer *Louise Fili*
Copywriters *Steven Heller and Louise Fili*
Design Firm *Louise Fili Ltd., New York, NY*
Typographers *Louise Fili Ltd./Wild Carrot Letterpress*
Printers *Wild Carrot Letterpress/Rohner Printing*
Paper *Fabbriano Roma, Magnani*

3

Title *Potlatch Remarks on Remarque*
Art Director *Curt Schreiber*
Designer *Ken Fox*
Photographer *François Robert*
Copywriter *Todd Lief*
Design Firm *VSA Partners, Inc., Chicago, IL*
Printer *Rohner Printing*
Paper *Potlatch Remarque*

1

2

3

4

Title *The Stadium Book*
Art Director *James Koval*
Designer *Jenniffer Wiess*
Photographers *Various*
Copywriters *Don Hayner and Tom McNamee*
Design Firm *VSA Partners, Inc., Chicago, IL*
Printer *CMI*
Paper *Centura Dull*

5

Title *Herman Miller for the Home Product Binder*
Art Director *Michael Barile*
Designers *Michael Barile, Yang Kim, Adam Smith,
and Glenn Hoffman*
Photographers *Phil Schaafsma and Herman Miller Archives*
Copywriter *Dick Holm*
Design Firm *Herman Miller Inc., Zeeland, MI*
Printer *Burch Inc.*
Paper *Beckett Expressions Ice Berg*

4

5

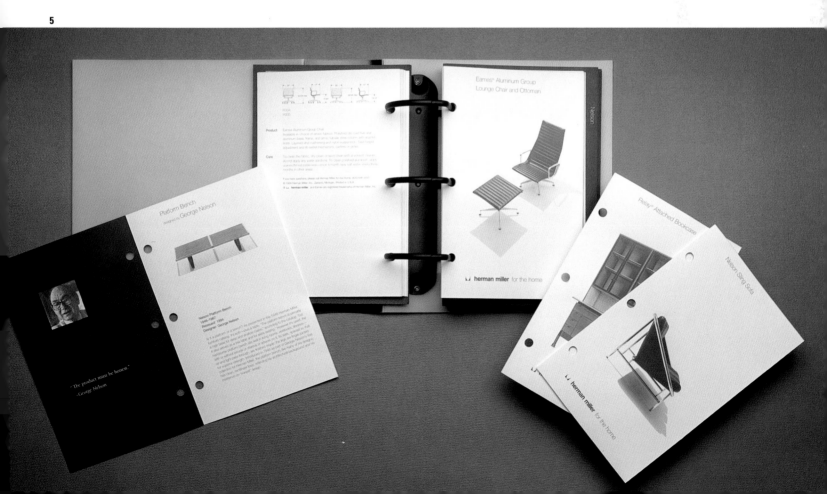

3

This page and opposite
Title *CSA Archive T-Shirts*
Art Director *Charles S. Anderson*
Designers *Charles S. Anderson, Paul Howalt,*
and Erik Johnson
Illustrator *CSA Archive*
Photographer *Paul Irmiter*
Copywriter *Lisa Pemrick*
Design Firm *Charles S. Anderson Design Company,*
Minneapolis, MN
Printer *Pilot Prints*

1

2

1
Title *Digital Composition Logomark T-Shirt*
Art Director/Designer *Bart Crosby*
Design Firm *Crosby Associates, Inc., Chicago, IL*
Typographer *Digital Composition Inc.*

2
Title *Brick T-Shirt*
Art Director/Designer *Tom Saputo*
Copywriter *Rob Schwartz*
Design Firm *Team One Advertising, El Segundo, CA*

Title *Ocean Aid Logo*
Art Director/Designer/Illustrator *Michael McIntyre*
Design Firm *Home Grown Design, Los Angeles, CA*

2
Title *CF2GS Stationery*
Art Director *Jack Anderson*
Designers *Jack Anderson and David Bates*
Design Firm *Hornall Anderson Design Works, Seattle, WA*
Printer *Pacific Printing*
Paper *Curtis Brightwater Rib Laid,*
James River Artesian White

3
Title *Acme Rubber Stamp Stationery*
Art Director *Bryan Peterson*
Designers *Bryan Peterson and Dave Eliason*
Design Firm *Peterson & Company, Dallas, TX*
Printer *Monarch Press*
Paper *French Dur-o-tone*

O C E A N A I D

3

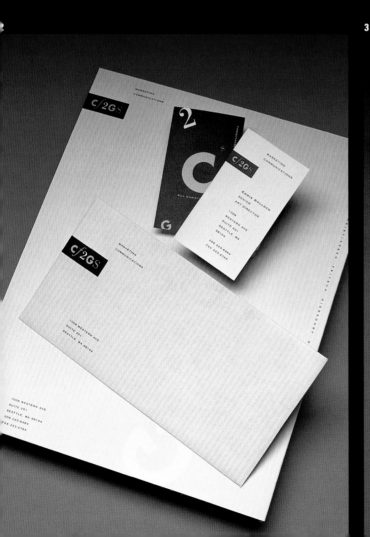

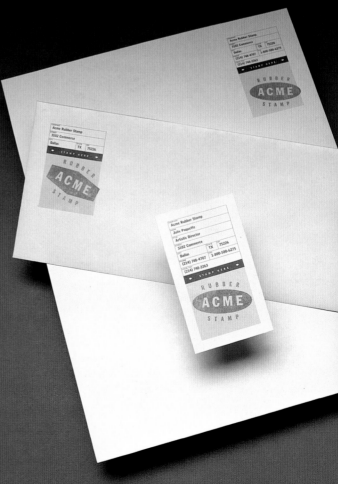

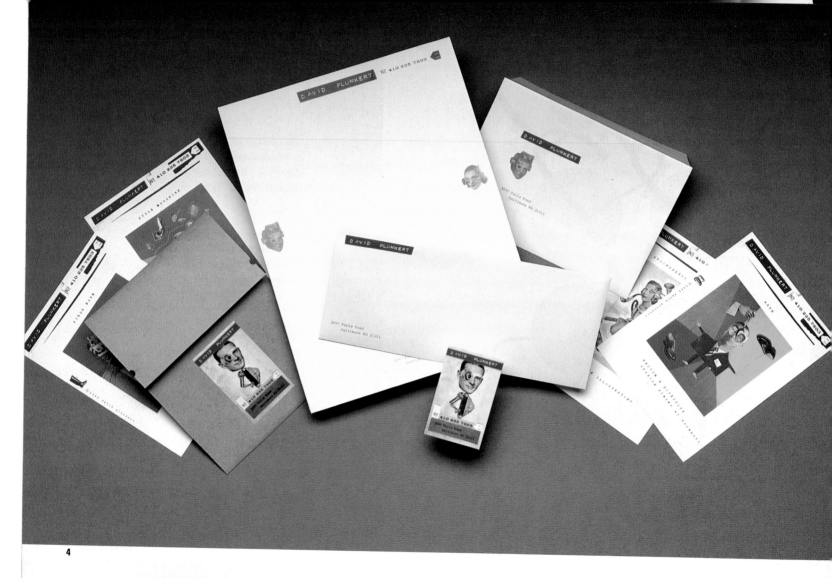

4

Bewear

4
Title *Self-Promotion Package and Stationery*
Art Director/Designer/Illustrator *David Plunkert*
Design Firm *David Plunkert Studio, Baltimore, MD*
Printers *Strine Printing, London Litho Services*
Paper *Domtar Natural Sand, Mohawk Superfine, Astrolite*

5
Title *Bewear Clothing Co. Logo*
Designer/Illustrator *Mark Fox*
Design Firm *Blackdog, San Rafael, CA*

6
Title *"Loose" Logo, Levi Strauss & Co.*
Art Director/Designer *Paul Woods*
Design Firm *SBG Partners, San Francisco, CA*

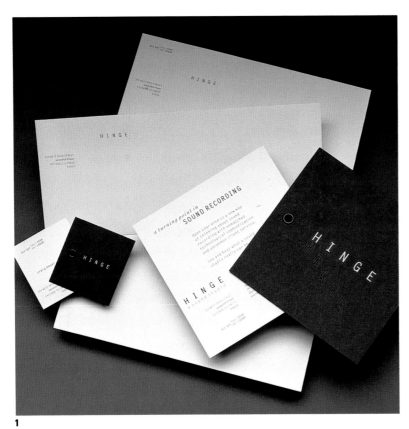

1

2

PARSONS & COMPANY 4

5

1
Title *Hinge Stationery*
Designers *Jilly Simons and Susan Carlson*
Design Firm *Concrete, Chicago, IL*
Printer *Unique Printers and Lithographers,*
Fine Arts Engraving
Paper *Envelope and letterhead: Simpson Starwhite Tiara.*
Business card: Neenah Shore Bond and Curtis Tuscan Black
Antique Cover

2
Title *Deluxe Company Stationery*
Art Director *Weston Bingham*
Designers *Weston Bingham and Chuck Rudy*
Design Firm *Deluxe, Brooklyn, NY*
Printer *Anchor Engraving*
Paper *Strathmore and Kimdura*

3
Title *Mary Carbine Logo*
Art Directors/Designers *John Marin and*
Michèle-Hoaiduc Nguyen
Design Firm *4th Primary, Chicago, IL*
Printer *QMS*
Paper *Arizona and French*

4
Title *E. Parsons & Company Corporate Identity/Logo*
Art Director *Ron Sullivan*
Designer *Kelly Allen*
Design Firm *SullivanPerkins, Dallas, TX*

5
Title *Warner Bros. Archives Logo*
Art Directors *Jeri Heiden and Michael G. Rey*
Designer *Greg Lindy*
Design Firm *Rey International, Los Angeles, CA*

6
Title *Metro Card for the Metropolitan Transportation Authority of New York (Logo and Application)*
Art Director *Kenneth R. Cooke*
Designers *Kristie Smith Williams and Patrick McCabe*
Design Firm *Siegel & Gale, New York, NY*

7
Title *Lee Hunt Associates Stationery*
Art Director/Designer *Carol Bokuniewicz*
Photographer *Ken Schles*
Design Firm *Carol Bokuniewicz Design, New York, NY*
Printer *Zenith Color*
Paper *Strathmore*

6

7

Communication Graphics *Environmental Graphics/Signage*

This page and opposite
Title *New York City Transit Museum Gift Shop
and Information Center*
Art Director *Stephen Doyle*
Designers *Mats Hakansson, Rosemarie Turk,
Gary Tooth, and Chuck Robertson*
Illustrator *Brian Cronin*
Photographer *Scott Frances*
Design Firm *Drenttel Doyle Partners, New York, NY*

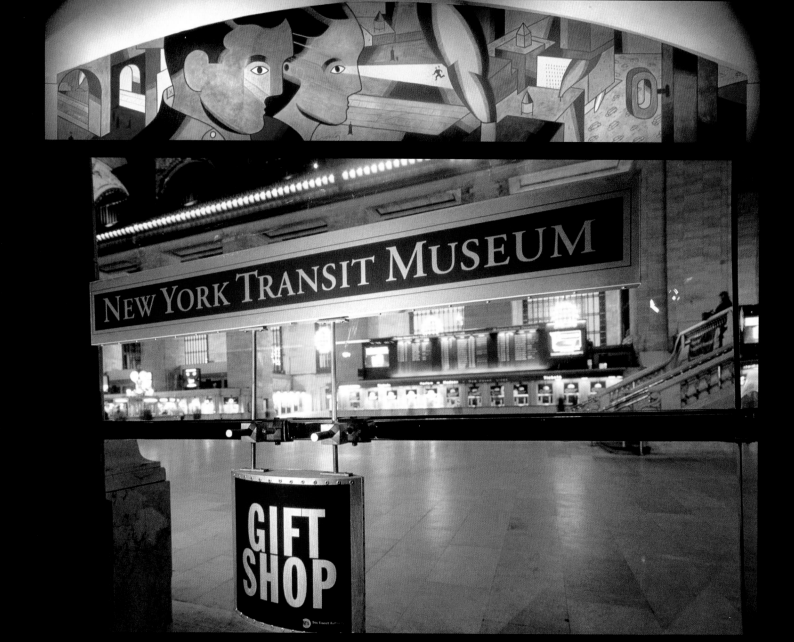

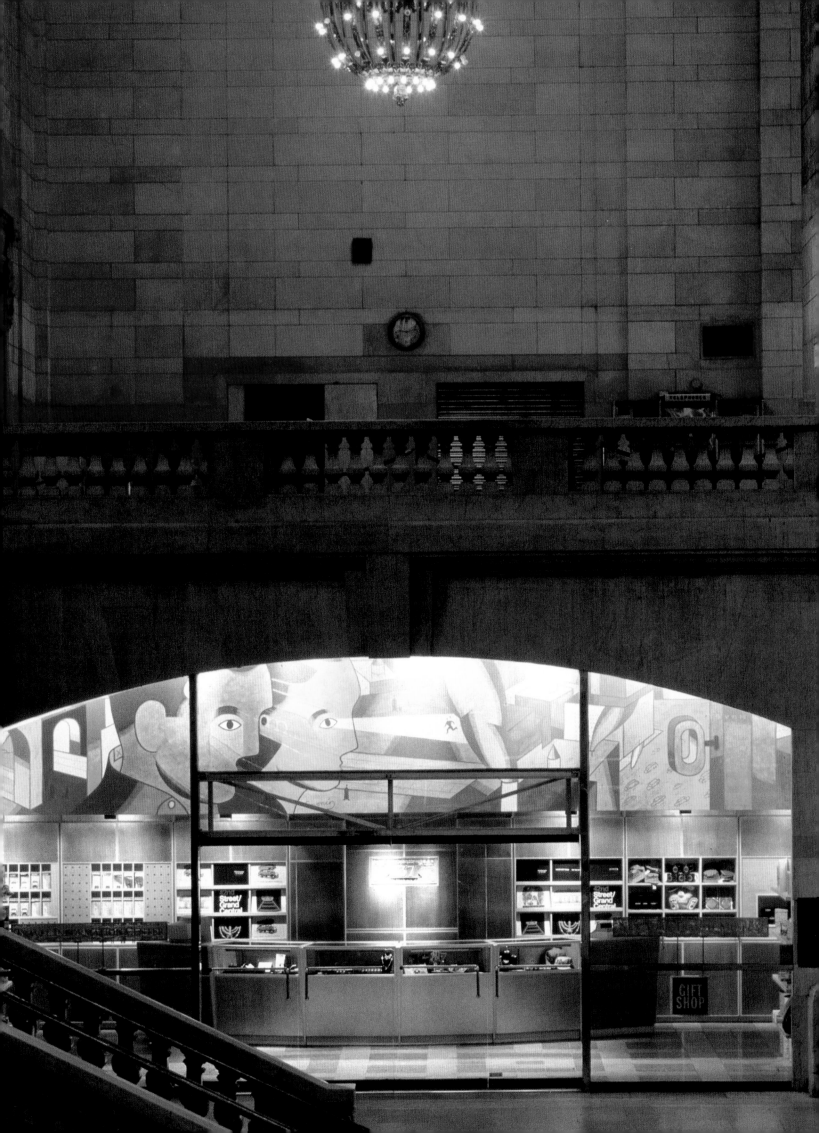

This page
Title *San Francisco Museum of Modern Art Beaux Arts Ball*
Designer/Illustrator *Mark Fox*
Copywriter *Rodchenko and others*
Design Firm *Blackdog, San Rafael, CA*
Printer *Wasserman Silk Screen Co.*

This page
Title *"Island at Work" Signage*
Art Director/Designer *Arlene Cotter*
Illustrators *Mike Lee and Laura Wallace*
Design Firm *Publik Information Design,*
Vancouver, British Columbia
Fabricator *Clay Signs*

This page
Title *San Jose Arena Environmental Graphics*
Project Designer *Michael Manwaring*
Designer *Jeffrey Inouye*
Design Firm *The Office of Michael Manwaring, San Francisco, CA*

Opposite page
Title *The Limited, Inc. Annual Stockholders Meeting*
Art Director *Kent Hunter*
Designers *Robert Wong and Laurel Shoemaker*
Photographer *Vintage Stock Images*
Design Firm *Frankfurt Balkind Partners, New York, NY*
Paper *Diazo Prints*

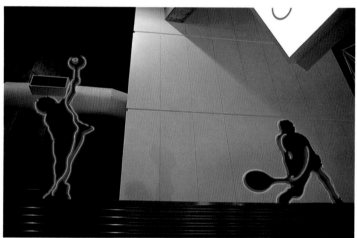

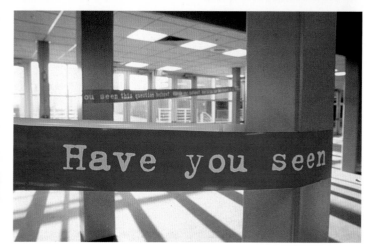

This page and opposite
Title *Harajuku Environment*
Art Directors *John Norman and Jeff Weithman*
Designer *John Norman*
Illustrators *John Norman, Benton Wong,*
and Gerald Bustamante (mural art)
Copywriter *Bob Lambie*
Design Firm *Nike, Inc., Beaverton, OR*

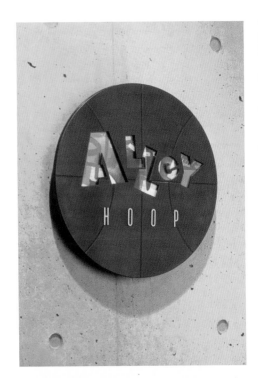

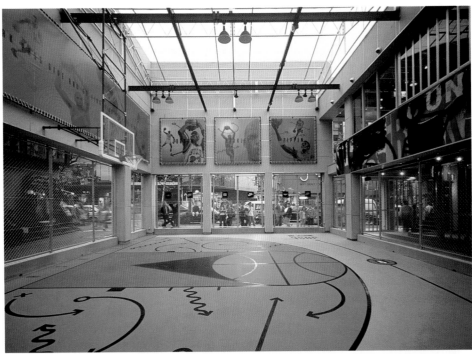

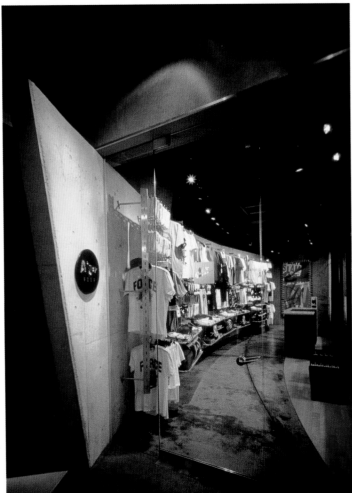

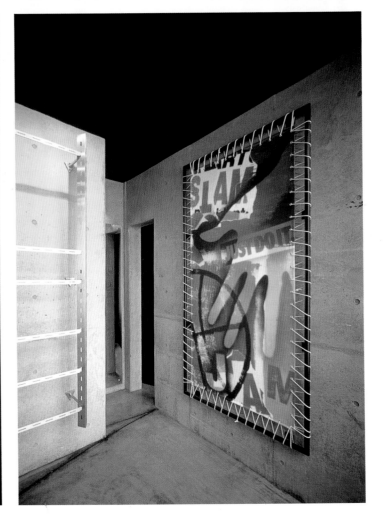

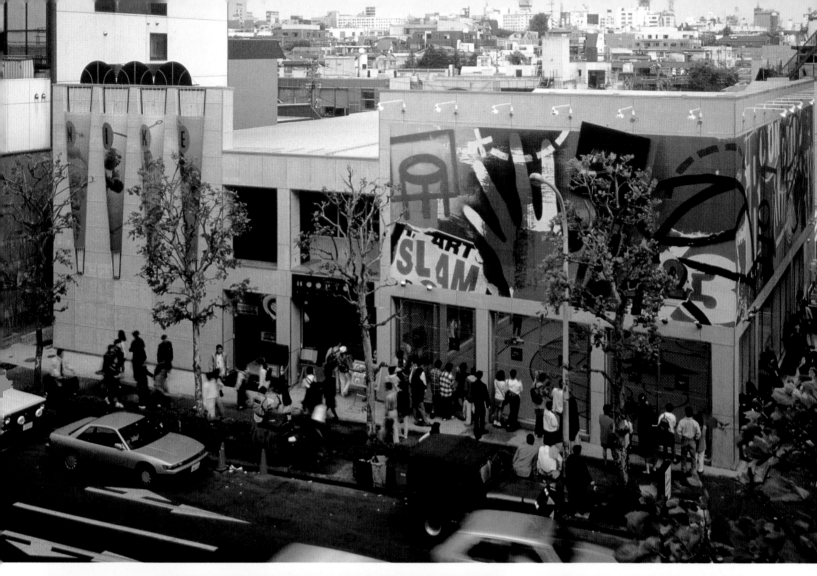

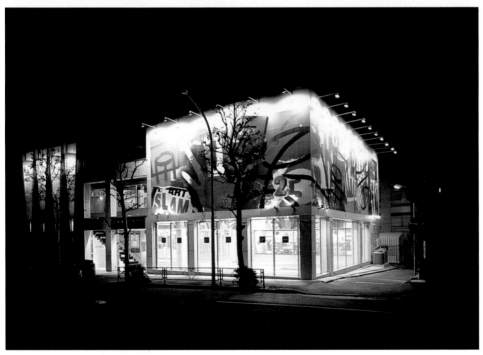

This page
Title *Apple Computer "R&D Campus"*
Art Director *Deborah Sussman*
Designers *Holly Hampton and Ron Romero*
Photographer *Mark Darley*
Design Firm *Sussman/Prejza & Co., Inc., Culver City, CA*

P118 P149 P234

P246 P357 P421

A226

Macintosh

Infinite Loop

Building Elevator 6

This page

Title *Roosevelt Field, "The Zeppelin"*

Art Directors *Fernando Vazquez and Paul Prejza*

Designers *John Johnston, Roseline Seng, Traer Price, and Chuck Milhaupt*

Photographer *Jeff Goldberg*

Design Firm *Sussman/Prejza & Co., Inc., Culver City, CA*

Title *"VH-1: TV For People Who Love Music"*
Creative Director *Thomas Tercek*
Art Director *Jason Harrington*
Design Firm *MTV Networks, New York, NY*

Title *Microsoft "Lachman Deal"*
Creative Director *Brian Murphy*
Director *Jeff Mishler*
Copywriter *Steve Lachman*
Design Firm *Graphic Media, Portland, OR*
Production Studio *Diane Haskin/The Production Team*

Title *"Everything You Need to Know"*
(Opening Titles for Comedy Central)
Art Director/Designer *Michael Bierut*
Design Firm *Pentagram Design, New York, NY*
Production Studio *Curious Pictures*

Title *Michigan Bell Television Commercial*
Art Director *Tim Bruns*
Animators *Jeff Jurich, Stan Fuka, and Dee Fransworth*
Computer Artist *Brian Larson*
Copywriter *Wendy Lapidus-Saltz*
Illustrator *Mark Fox*
Design Firm *BlackDog, San Rafael, CA*
Production Studio *Celluloid Studios*

Title *"MTV Top of the Hour Clock"*
Creative Director *Abby Terkuhle*
Art Director/Designer *Dennis Crowe*
Animators *Trey Thomas and Mike Belzer*
Model and Set Designers *Natalie Roth,*
Dennis Crowe, and John Pappas
Design Firm *Zimmermann Crowe Design, San Francisco, CA*
Production Studio *Colossal Pictures*

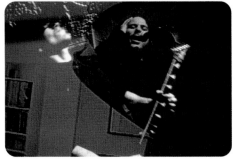

Title *"Only" Anthrax Video*
Creative Director *Paul Elledge*
Designer/Animator/Copywriter *Paul Elledge*
Design Firm *Mr. Big Productions, Inc., Chicago, IL*

Title *"The Age of Innocence" (Main Title)*
Art Directors/Designers *Elaine and Saul Bass*
Design Firm *Saul Bass/Herb Yager & Associates,*
Los Angeles, CA

Title *Levi's Hometown Blues In-Store Video*
Art Director/Designer *Dennis Crowe*
Director of Photography *Jeffrey Newbury*
Design Firm *Zimmermann Crowe Design, San Francisco, CA*

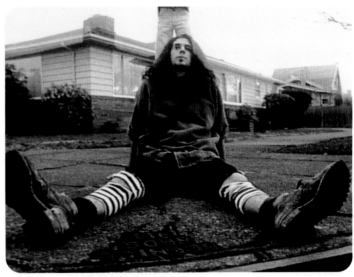

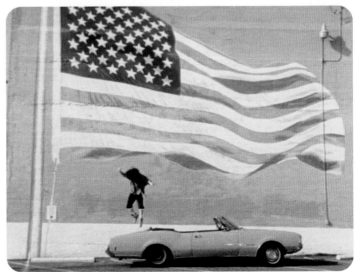

THE BOOK SHOW *The Fifty Books of 1993* presented its four judges with more than 500 titles and a broad spectrum of high-quality books and design solutions. I would hope that the fifty books chosen represent the very best of American publishing, demonstrating its vitality as well as its diversity. An effort was made to select books from all categories and regions. So there are books here from the smallest private presses to the largest commercial houses, from hand-set octavos printed letterpress on handmade paper to trade editions manufactured in the countless thousands.

Looking back over past shows, the judges were surprised, and often amused, to see how quickly new designs are adopted. One example was the use of Centaur, a typeface that Albert Bruce Rogers designed clearly with the private press in mind, which now seems to appear in everything from children's books to novels. We were also disappointed that more books of pure "text" were not submitted. Perhaps this show has the reputation of being the last refuge of the coffee-table tome, but it should be clear that as much thought and imagination go into making a scholarly text readable as into the often better financed illustrated book. A review of past shows on the work of such designers as P. K. Conkwright, Joseph Blumenthal, and Carl Purington Rollins (to name a few whose work centered primarily on scholarly texts) is as instructive as considering the work of their modern counterparts, designers like Richard Eckersley and Richard Hendel.

Special mention should be made of the work of The Stinehour Press. In both this year's show and last year's, their work has been recognized as setting the national standard for elegant, restrained design and impeccable black-and-white printing (sometimes so good that it appears to improve on the original).

As judges, we lift our collective hat to those whose work was selected, but also to everyone who took the time and trouble to submit their books for consideration. No show is ever better than the material it has to work with. We had the opportunity to look at some of the best.

David R. Godine
Chairman

JURY

DAVID R. GODINE
Publisher
David R. Godine, Inc.
Boston, MA

ANITA WALKER SCOTT
Design and Production Manager
Johns Hopkins University Press
Baltimore, MD

FRED BRADY
*Manager of New
Typographical Development*
Adobe Systems Inc.
Mountain View, CA

ANNE CHALMERS
Senior Designer
Trade and Reference Division
Houghton Mifflin Company
Boston, MA

CALL FOR ENTRIES

Design Anne Chalmers

Printers' Leaves
Adobe's Minion Ornaments,
Monotype Corporation's Arabesque
One and Two, and Linotype
Hell's Caravan Three

Electronic Imaging and Proofing
Prepress Company, Inc.

Printer The Stinehour Press

Paper Mohawk Opaque Cream
Fiber Smooth

AIGA

THE FIFTY BOOKS OF 1993

CALL FOR ENTRY

THE FIFTY BOOKS OF 1993

STATEMENT OF THE CHAIRMAN

My initial reaction to the AIGA request to chair this year's book competition was benign bewilderment. I have not, for the past decade, been a fan of this show, and I haven't been reticent in my opinions about its choices or policies. But the changes in direction in last year's show gave me reason for real hope — and I said yes.

Oscar Wilde was right: personalities move the age more than principles do. The competition process hasn't changed. It is the judges who determine the shape and content of this competition: Anne Chalmers has been designing interiors for Houghton Mifflin for nine years. She is in earnest about the minutiae of her craft: real small caps, old style figures, judicious letterspacing. Eloisa Ichiyasu has been a senior designer at Abrams for the last five years and has a number of AIGA award-winning books to her credit. Fred Brady put together the type group at Adobe and has brought about changes in the last few years that have made digital type the true successor to the Monotype Corporation. But the best judges in the world can do little without the best books.

I urge publishers, art directors, designers, and printers to send us your best. And to trust us to do the rest.

DAVID R. GODINE

The reader's intellect being focused upon the text, the decoration can whisper by some sly curve of arabesque or flower the memento pulchritudinis that reminds us subconsciously that our chief engagements are not with, but above, the intellect.

BEATRICE WARDE
from an article published in The Fleuron,
between 1923 and 1930

IT'S FINALLY SPRING! TIME TO FELT SOME LEAVES

By Margaret Kaufman

Designed by Claire Van Vliet

Aunt Sallie's Lament

"He was a tonic in himself,
As quick consumed as what
He sold in bottles,
And I was thirsty,

Yes."

Title *Aunt Sallie's Lament*
Art Director *Nancy Reid*
Designer *Claire Van Vliet*
Design Firm *The Janus Press, West Burke, VT*
Client/Publisher *Chronicle Books*
Typographer *Laura Lovett*
Printer *Interprint*
Paper *Permalin*

Title *The Measure of Our Success: A Letter to My Children and Yours*
Art Director *Sara Eisenman*
Jacket Designer *Carin Goldberg*
Text Designer *Anne Chalmers*
Lettering *Julian Waters*
Design Firm *Beacon Press, Boston, MA*
Client/Publisher *Beacon Press*
Typographer *Wilsted & Taylor*
Printer *New England Book Components (jacket) and R.R. Donnelley (text)*
Paper *Warren Sebago*

on earth, yet our incarceration, drug addiction, and child poverty rates are among the highest in the industrialized world. Don't condone or tolerate moral corruption whether it's found in high or low places, whatever its color. It is not okay to push or use drugs even if every person in America is doing it. It is not okay to cheat or lie even if countless corporate or public officials and everybody you know do. Be honest. And demand that those who represent you be honest. Don't confuse legality with morality. Dr. King noted that everything Hitler did in Nazi Germany was legal. Don't give anyone the proxy for your conscience. And don't confuse legality with fairness. The policies that took tens of billions of dollars from the poor and middle class and gave them to the very rich in the 1980s as tax loopholes and capital gains were legal. But they were not just. That 106 employees at Salomon Brothers can make over a million in one year— the equivalent of what 15,000 families who live at half the poverty level in America must survive on each year—is legal. But it's not fair. Somehow we are going to have to develop a concept of *enough* for those at the top and at the bottom so that the necessities of the many are not sacrificed for the luxuries of the few.

I do not begrudge billionaires or millionaires their incomes as long as children's basic needs of food and health and shelter and child care and education are met. But something's out of balance when the number of millionaires in the 1980s almost doubled and the number of poor children increased by three million—almost 30 percent—and children and the poor still face a vastly uneven playing field in the budget process compared with the military and the wealthy. Every dollar for domestic and poor children's program spending requires a huge fight, while the military trough seems bottomless, even as Communism is crumbling worldwide and violence and child abuse and neglect and poverty and joblessness are epidemic nationwide. It is time for America to give children and parents the same floor of social security we provided the elderly in 1972. And last don't, like our nation, spend more than every dollar you earn. Save a dime and share a dime.

LESSON 5: *Don't be afraid of taking risks or of being criticized.* An anonymous sage said, "If you don't want to be criticized don't say anything, do anything, or be anything." Don't be afraid of failing. It's the way

ST. GEORGE, MARTYR, PROTECTOR OF THE KINGDOM OF ENGLAND

April 23

Patron Saint of Aragon; Genoa; Portugal; Boy Scouts; Knighthood; Soldiers

THROUGHOUT EUROPE in the later middle ages the story of St. George was best known in the form in which it was presented in the *Legenda Aurea* of Bd. James de Voragine. William Caxton translated the work and printed it. Therein we are told that St. George was a Christian knight and that he was born in Cappadocia. It chanced, however, that he was riding one day in the province of Lybia, and there he came upon a city called Sylene, near which was a marshy swamp. In this lived a dragon "which envenomed all the country." The people had mustered together to attack and kill it, but its breath was so terrible that all had fled. To prevent its coming nearer they supplied it every day with two sheep, but when the sheep grew scarce, a human victim had to be substituted. This victim was selected by lot, and the lot just then had fallen on the king's own daughter. No one was willing to take her place, and the maiden had gone forth dressed as a bride to meet her doom. Then St. George, coming upon the scene, attacked the dragon and transfixed it with his lance. Further, he borrowed the maiden's girdle, fastened it round the dragon's neck, and with this aid she led the monster captive into the city. "It followed her as if it had been a meek beast and debonair." The people in mortal terror were about to take to flight, but St. George told them to have no fear. If only they would believe in Jesus Christ and be baptized, he would slay the dragon. The king and all his subjects gladly assented. The dragon was killed and four ox-carts were needed to carry the carcass to a safe distance. "Then were there well XV thousand men baptized without women and children." The king offered St. George great treasures, but he bade them be given to the poor instead. Before taking his leave the good knight left behind four behests: that the king should maintain churches, that he should honor priests, that he should himself diligently attend religious services, and that he should show compassion to the poor.

At this period under the Emperors Diocletian and Maximian (A.D. 303) a great persecution began against the Christians. George, seeing that some were terrified into apostasy, in order to set a good example went boldly into a public place and cried out, "All the gods of the paynims and gentiles are devils. My God made the heavens and is very God." Datianus the "provost" arrested him and failing to move him by cajolery had him strung up and beaten with clubs and then tortured with red-hot irons. Our Savior, however, came in the night to restore him to health. Next a magician was brought to prepare a potion for George with deadly poison, but the draught took no effect and the magician, being converted, himself died a martyr. Then followed an attempt to crush the saint between two spiked wheels, and after that to boil him to death in a cauldron of molten lead; but without any result. So Datianus once more had recourse to promises and soft words, and George, pretending to be shaken, let them think that he was willing to offer sacrifice. All the

ST. GEORGE
Raphael. *St. George and the Dragon*, c. 1506. National Gallery of Art, Washington, D.C.

82

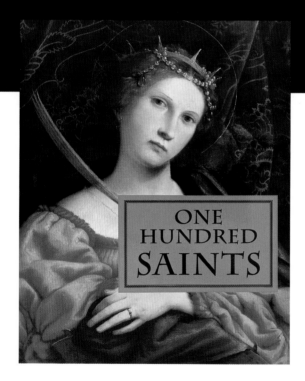

ONE HUNDRED SAINTS

Title *One Hundred Saints*

Art Director/Designer Susan Marsh

Design Firm Susan Marsh Design, Holden, MA

Client/Publisher Bulfinch Press/Little, Brown and Company

Typographer Susan Marsh/Dix Type

Printer Amilcare Pizzi

Paper Gardamatt Brilliante

Title *American Paintings and Sculpture to 1945 in the Carnegie Museum of Art*

Art Director *Paul Anbinder*

Designer *Betty Binns*

Design Firm *Binns & Lubin*

Client/Publisher *Hudson Hills Press/The Carnegie Museum of Art*

Typographer *Brad Walrod/High Text Graphics*

Printer *Toppan Printing Company*

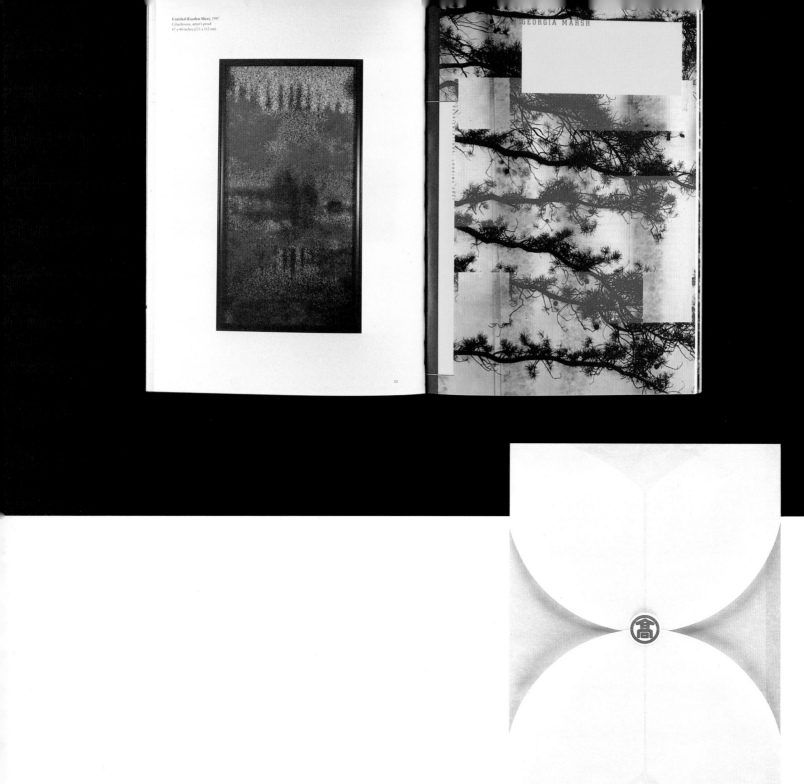

Title *Reorientations: Looking East*
Art Director/Designer *Takaaki Matsumoto*
Photographers *Various*
Design Firm *M Plus M Incorporated, New York, NY*
Client/Publisher *The Gallery at Takashimaya*
Printer *The Stinehour Press*
Paper *Mohawk Poseidon, French Dur-o-tone*

Title *Plain Wrapper Press, 1966–1988*
Designer *Bradley Hutchinson*
Photographer *Carrington Weems III*
Client/Publisher *W. Thomas Taylor, Inc.*
Typographer *Michael and Winifred Bixler*
Printer *Bradley Hutchinson, W. Thomas Taylor, Inc.*
Paper *Mohawk Superfine*

ITEM SEVENTEEN

Geographie du Regard

LAURE VERNIÈRE | Géographie du Regard | PLAIN WRAPPER PRESS

Six poems in French and three in English by Laure Vernière. Afterword in English by Richard-Gabriel Rummonds. With a two-color wood engraving by Jacques Vernière. 47, [1] pages. 19.5 x 29 cm. 71 press-numbered copies signed in ink by the author and the artist. Many copies also press-inscribed to standing-order patrons. Press Book Series. April 1976.

[1] series title: "Plain Wrapper Poets: One"; [3] title; [4] copyright; [5] "Contents"; [7] half title: "Géographie du Regard" with wood engraving; 9–11 "Nuit"; 13–15 "L'intime"; 17–19 "Affaissement"; 21–23 "Ruptures"; 25–29 "But Never Satisfied"; 31–33 "Bric-a-Brac"; 35–37 "Peur de la Peur"; 39–40 "Strike"; 41–43 "Stop Motion"; 45–47 "Afterword"; [48] colophon: "Plain Wrapper Poets: One."

Handset Berthold Post Mediaeval with Post Mediaeval display; text in 16D. Cream Richard de Bas handmade wove paper printed damp on a Washington handpress in black and brown; wood engraving printed in black and brown. Bound by Mario Rigoldi; unbleached vellum spine; boards covered with Rouille (rust) Canson Mi-Teintes machine-made wove paper marbled by Bonnie Walker in colors ranging from burnt sienna to black; "GÉO-GRAPHIE DU REGARD" gilt-stamped on spine reading top to bottom; single vertical rule gilt-stamped on vellum on front and back covers; pressmark no. 2 gilt-stamped on vellum on front cover; Pompeiana (red) Ventura Affresco machine-made laid endpapers; two blank leaves of text paper at beginning and end; handsewn linen head and tailbands. Slipcase covered with matching Affresco paper.

Notes: "Copyright © 1976 by Plain Wrapper Press." The illustration, printed in brown and black, "was originally cut on two end grain blocks. During the proofing the brown block was damaged and so a linecut was substituted for it; however, the black was still printed from the original block"—from the Afterword.

Top left: item 1, *Eight Parting Poems*; below, item 2, *1945–1965: An Evaluation of Two Decades of Self-Deception*. Right, item 3, *The Dog Bite: A Dream Narrative*.

Top left: item 9, *Didascalie*, binding; Top right, item 4, *Images and Fantasye*; Below, item 6, *Le Streghette*, binding with page spread.

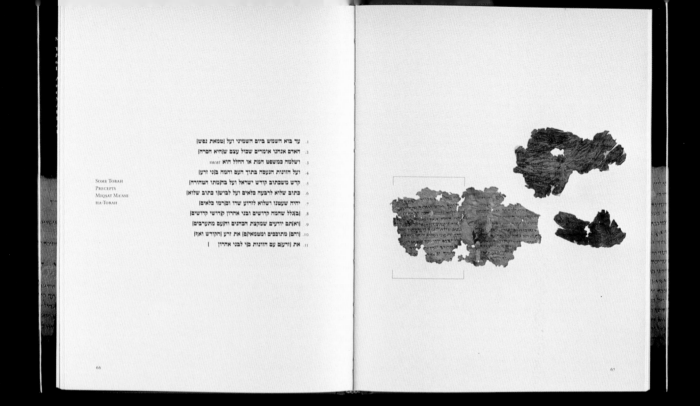

Title *Scrolls from the Dead Sea*

Art Director/Designer Robert Wiser

Design Firm *Meadows & Wiser, Washington, D.C.*

Client/Publisher *Archetype Press/George Braziller/Library of Congress*

Printer *Progress Printing Co.*

Title *The Pennsylvania Council on the Arts 1991–1992 Crafts,*
Visual Arts and Art Criticism Fellowship Recipients
Art Director *Rick Landesberg*
Designer *Mike Savitski*
Illustrator *Michael D. Rowe (cover)*
Design Firm *Landesberg Design Associates, Pittsburgh, PA*
Client/Publisher *The Society for Contemporary Crafts*
Printer *Friesen Printers*
Paper *Warren Lustro Dull, Cornwall Coated Cover*

THE PENNSYLVANIA COUNCIL ON THE ARTS 1991-1992 CRAFTS, VISUAL ARTS AND ART CRITICISM FELLOWSHIP RECIPIENTS

16 JACK TROY

CRAFTS

Born: Towanda,
Pennsylvania, 1938

Education: Haystack
School of Crafts, Deer
Isle, Maine, 1969;
Kent State University,
Kent, Ohio, 1965-67,
M.A.; West Chester
State College, West
Chester, Pennsylvania,
1957-61, B.S.

Current Residence:
Huntingdon,
Pennsylvania

**SELECTED
EXHIBITIONS**

1993
Functional Ceramics,
College of Wooster,
Wooster, Ohio

Wood-Fired
Invitational, Joanne
Rapp Gallery, The
Hand & The Spirit,
Scottsdale, Arizona

1992
National Ceramic
Invitational, West
Chester University,
West Chester,
Pennsylvania

Solo Exhibition, The
Clay Place, Pittsburgh,
Pennsylvania

1991
Solo Exhibition, The
Farrell Collection,
Washington, District of
Columbia

Tea: Origins and
Inspirations, Pittsburgh
Center for the Arts,
Pittsburgh,
Pennsylvania

1990
National Teapot
Invitational, Moira
James Gallery, Las
Vegas, Nevada

Platters, Pro Art,
St. Louis, Missouri

**SELECTED GRANTS
AND AWARDS**

1991
Fellowship,
Huntingdon County
Arts Council

1981
Fellowship,
Pennsylvania Council
on the Arts

PICTURED

Stoneware Pot, 1988
Wheel-thrown
stoneware, wood-fired,
natural ash glaze
32"x 20" diameter

ALLISON ANN ZITO 17

CRAFTS

Born: Elizabeth,
New Jersey, 1960

Education: Philadelphia
College of Art,
Philadelphia,
Pennsylvania, 1981-
1984, B.F.A.; Moore
College of Art and
Design, Philadelphia,
Pennsylvania, 1978-80

Current Residence:
Philadelphia,
Pennsylvania

**SELECTED
EXHIBITIONS**

1993
Contemporary Artists
Series, The State
Museum of Pennsylvania,
Harrisburg, Pennsylvania

1992
Contemporary
Artifacts, National
Museum of American
Jewish History,
Philadelphia,
Pennsylvania

1991
Westmoreland Arts
National, Westmoreland
County Community
College, Youngwood,
Pennsylvania

1990
Contemporary
Philadelphia Artists,
Philadelphia Museum
of Art, Philadelphia,
Pennsylvania

Handmade for the 90's,
The Berkshire Museum,
Pittsfield, Massachusetts

1989
Artist Invitational, Mill
Brook Art Gallery,
Brownsville, Vermont

Biennial '89, Delaware
Art Museum,
Wilmington, Delaware

PICTURED

Shifting Sands, 1991
Handwoven cotton
thread, acrylic, clay,
gold leaf on wood
20"x 22"x 2"

Eugenia Place

Eugenia Place

La mémoire est éphémère, elle se manifeste sous forme de reflets fugitifs que rendent invisibles les puissants faisceaux lumineux de la vie moderne. Pourquoi en est-il ainsi ? Pourquoi cette hâte ? Cela peut-il être changé ?
Richard Henriquez, 1990

Donnant sur Beach Avenue à l'extrémité ouest de Vancouver, la propriété fait face à l'English Bay et, à deux rues de Stanley Park, elle est voisine du Sylvia Hotel, un immeuble de huit étages couvert de lierre, construit en 1912. Situé dans un zonage résidentiel à densité élevée, l'emplacement offre une vue de l'océan, des îles du détroit de Georgia et du reste de la ville.

Toutes les tours reproduisent un plan identique à chacun des étages qu'elles empilent les uns sur les autres. L'Eugenia exprime ce déplacement au moyen d'une vis symbolique, sur la façade sud (Beach Avenue), qui figure aussi l'ancrage du bâtiment dans son site. Sur les autres façades, le quadrillage en béton dessine des modules de deux étages, une échelle intermédiaire entre celle de la tour et celle des étages isolés.

Le bâtiment est une tour en béton, semblable par sa hauteur, son matériau et son orientation aux immeubles voisins, mais il évoque certains aspects de l'histoire du site, notamment le grand chêne planté sur le toit, qui semble avoir été élevé jusque-là par la vis. La hauteur qu'il a atteint désormais correspond à la ligne de faîte de la forêt originelle sur le site – une façon de « boucler la boucle ». L'aménagement paysager au niveau de la rue, les souches sculptées et les espèces plantées évoquent cette première forêt, tandis qu'en plan l'aménagement paysager et le rez-de-chaussée de l'immeuble portent l'empreinte d'interventions humaines antérieures, notamment de l'immeuble d'habitation néo-Tudor des années 1940 que remplace l'Eugenia, des premières cabanes construites sur le site et de la forêt d'origine.

Memory is ephemeral, it is seen in fleeting glimpses which are rendered invisible by the glaring search lights of modern life. Why is this so? What is the rush? Can it be altered?
Richard Henriquez, 1990

Located on Beach Avenue in Vancouver's west end, the property is across the street from English Bay, two blocks from Stanley Park and neighbour to the Sylvia Hotel, an eight-storey, ivy-covered building of 1912. The site is zoned high density residential, and enjoys an unobstructed view of the ocean, the Gulf Islands, and the rest of the city.

Every high rise replicates a plan and piles the resulting floors one on top of another. The Eugenia expresses this displacement by means of a symbolic screw on the south façade (Beach Avenue), which also anchors the building to its site. Through a shift in scale, the concrete grid of the other façades delineates a two-storey module mediating the scale of the building to a single-storey suite.

The result is a concrete tower, similar to nearby buildings in height, material, and orientation, but which recalls specific details of the site's history. Predominant is the maturing single pin oak tree planted in the penthouse garden and carried by the screw. This tree matches the elevation of the towering first-growth forest, a "closing of the loop." The street-level landscaping, sculpted tree stumps, and planting recall the original forest, while the landscaping and ground-floor plan reflect the footprints of former man-made development, including references to the 1940s' mock-Tudor apartment building that the Eugenia replaces, the first cabins on the site, and beyond, to first-growth forest.

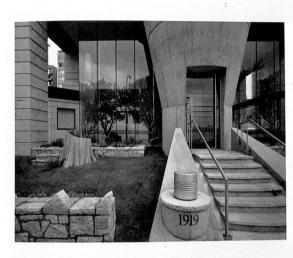

Richard Henriquez et le Théâtre de la mémoire

Richard Henriquez: Memory Theatre

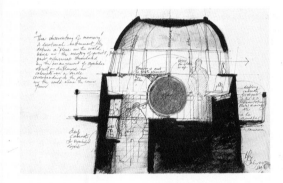

Centre Canadien d'Architecture/Canadian Centre for Architecture
Vancouver Art Gallery/Musée des beaux-arts de Vancouver

Title *Richard Henriquez: Memory Theater*
Designer *Glenn Goluska*
Photographer *CCA Photographic Services, Trevor Mills, and Geoffrey James*
Client/Publisher *Canadia Centre for Architecture/Vancouver Art Gallery*
Printer *Litho Acme, Inc.*
Paper *Monadnock Dulcet Text*

Title *Exploring Rome: Piranesi and His Contemporaries*
Designer *Jerry Kelly*
Design Firm *The Stinehour Press, Lunenburg, VT*
Client/Publisher *The Pierpont Morgan Library/Canadian Centre for Architecture*
Printer *The Stinehour Press*
Paper *Mohawk Superfine Softwhite (text) and Strathmore Pastelle (endleaves)*

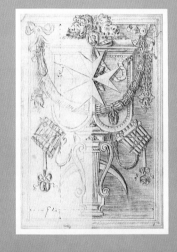

Exploring Rome: Piranesi and His Contemporaries

point. There is a much more expansive sense of space and sharper contrast between the dark shadows in the foreground and the brilliant light in the background. Like Giuseppe Vasi in his view of St. Peter's, plate 41 in volume III of *Delle Magnificenze* (1753) (fig. 1), Piranesi was influenced by the composition of Giovanni Paolo Pannini's 1741 painting of the Piazza of St. Peter's (Arisi 1986, p. 385, no. 308). Piranesi reused this same composition for his view of St. Peter's in several editions of the *catalogo inciso* (1761–75) (Mayer-Haunton in Bettagno 1978, pp. 10–11, nos. 1–6, repr. nos. 1–6) and in his second view of the Piazza of St. Peter's in the *Vedute di Roma*, which can be dated with a *terminus ante quem* of 1761, when it appeared for the first time in the first edition of the *catalogo inciso* of that year in the Accademia di San Luca (Hind 1922, p. 66, no. 101; Focillon 1964, p. 51, no. 721; Wilton-Ely 1978 [1988], pl. 101; Mayer-Haunton in Bettagno 1978, p. 16, no. 1, repr. no. 1). The other *vedute*– *Santa Croce in Gerusalemme*, the *Trevi Fountain*, and *Santa Maria Maggiore*–are all very similar to the plates in the *Vedute di Roma*: they are all shown from a similar asymmetrical viewpoint (Hind 1922, p. 40, no. 9, p. 41, no. 11, p. 66, no. 104; Wilton-Ely 1978 [1988], pls. 41, 104, 7). Robison has dated the view of Santa Maria Maggiore between 1745 and 1748. It appears in the earliest volume at Chatsworth of the *Vedute di Roma* and thus must have been designed at the same time as the small view at the bottom of Nolli's 1748 *Map of Rome* (Robison in Bettagno 1983, pp. 18–21). The view of Santa Croce in Gerusalemme has been dated by Robison between 1757 and 1758. It appears in a volume of the *Vedute di Roma* in Geneva dated in those years (Robison in Bettagno 1983, pp. 29–30). The view of the Trevi Fountain, which resembles the one at the bottom of the Nolli map, can be dated to 1760, when it was mentioned for the first time in the *catalogo inciso* of that year in the Accademia di San Luca (Mayer-Haunton in Bettagno 1978, p. 10, no. 1, repr. no. 1). Thus the compositions of the *vedute* etched by Piranesi at the bottom of Nolli's small 1748 *Map of Rome* were reused throughout his career.

GIOVANNI BATTISTA PIRANESI
Mogliano Veneto 1720–Rome 1778

53. *The Arch of Constantine*

in ANTICHITÀ ROMANE DE' TEMPI DELLA REPUBBLICA,/E DE' PRIMI IMPERATORI,/ DISEGNATE, ED INCISE DA GIAMBATTISTA PIRANESI/ ARCHITETTO VENEZIANO,/E DALLO STESSO DEDICATE/ ALL'ILLMO E REVMO SIG. MONSIG. GIOVANNI BOTTARI,/CAPPELLANO SEGRETO DI N.S. BENEDETTO XIV/UNO DE CUSTODI DELLA BIBLIOTECA VATICANA,/E CANONICO DI S. MARIA IN TRASTEVERE., *Rome, [The Author], 1748*

[Date of the binding of the etchings in this volume, late 1750s.] Etching on laid paper (pl. 9). Platemark: 5¹¹⁄₁₆ x 10⅛ inches (129 x 258 mm); paper: 13⅜ x 17¹¹⁄₁₆ inches (341 x 442 mm). Watermark: left of center, fleur-de-lis in a single circle surmounted by the letters CB.

Inscribed inside platemark, upper left, *Tav. 9*; lower left, *PIRANESI f.*; lower right, *ARCO DI COSTANTINO IN ROMA*.

DATE: execution of this etching, 1748.

PROVENANCE: family of the princes of Radali after 1842 (their coat of arms on the bookplate inside the front cover); Artemis Fine Arts, Ltd., London.

BIBLIOGRAPHY (for this plate but not for the CCA's version): Chamberlain 1937, repr. p. 62; Focillon 1964, p. 15, no. 50; Focillon (Calvesi/Monferini) 1967, p. 289, no. 50; Millon in Brunel 1978, p. 350, note 22.

EXHIBITION: London 1982.

Montréal, Centre Canadien d'Architecture/Canadian Centre for Architecture DR1986:0192:009

The CCA's copy of *Antichità Romane de' Tempi della Repubblica* is in an eighteenth-century binding made of pulp boards covered with orange paper stamped in gold. Two pieces of this paper were used to cover each board. There is a vellum spine with *PIRANESI/ ANTIC/ ROMAN* embossed in gold, as well as vellum edges on the boards. This type of stamped paper, known as *Doré d'Allemagne*, originated in Augsburg, Germany, but became widely used all over Europe during the eighteenth century; it was imported into

England and France. Several German printers also established presses in Italy–at Bassano, Rome, and Florence. This type of paper is often designed with Chinese motifs as shown here (fig. 1) (Doizy and Ipert 1985, pp. 72–73, repr. p. 74). A set of fifteen early plates of the *Vedute di Roma* executed in the 1740s, bound in paper boards covered with *Doré d'Allemagne* paper, was sold in London in 1982 (London 1982, pp. 62–63, no. 31, repr.). The watermark in the illustrations and text pages is the same as in the etchings of a dedication copy of this work found by Robison in the Gabinetto Nazionale delle Stampe, Rome, and printed in 1748 (Robison 1986, p. 26, no. 3). An eighteenth-century watermark, a fleur-de-lis in a single circle with an L below and S above, is also found in the endpapers and plain sheets, which

are interspersed with the etchings in the CCA's copy. It is the same watermark that Robison found in the endpapers of a 1757 dedication copy of the *Antichità Romane* in the Biblioteca Nacional, Madrid (Robison 1986, p. 218, no. 13). The CCA's copy of the *Antichità Romane de' Tempi della Repubblica* has the two frontispieces (Bettagno 1978, the first, fig. 94), the dedication to Giovanni Gaetano Bottari (1689–1775) inscribed lower left, *Roma 20 Luglio 1748* (Bettagno 1978, fig. 96), two plates of inscriptions, and twenty-three of the twenty-five illustrations included in the first edition (Focillon 1964, pp. 14–15, nos. 41–70). Although the 1792 sales catalogue of Piranesi's work lists a date of 1741 for this volume, most scholars accept 1748, on the dedication page, as the correct date for the printing of the first edition of this work (Hind

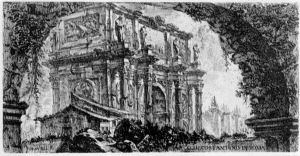

NO. 53

FIGURE 1 Giuseppe Vasi, *Basilica of St. Peter's*, in *Delle Magnificenze di Roma*, vol. III, pl. 41. Canadian Centre for Architecture, Montréal, w7358 CAGR.

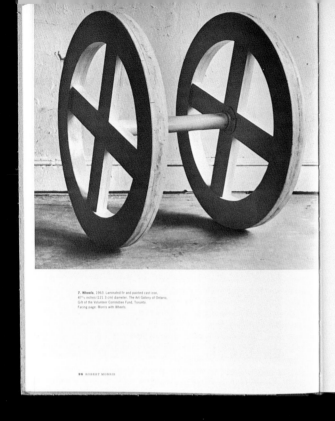

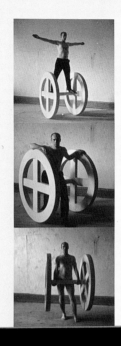

7. **Wheels.** 1963. Laminated fir and painted cast iron,
47¾ inches (121.3 cm) diameter. The Art Gallery of Ontario.
Gift of the Volunteer Committee Fund, Toronto.
Facing page: Morris with Wheels.

Title *Robert Morris: The Mind/Body Problem*
Designers *J. Abbott Miller and David Williams*
Photographers *Various*
Design Firm *Design Writing Research, New York, NY*
Client/Publisher *Guggenheim Museum*
Printer *Hull Printing*
Paper *Monadnock Dulcet Text*

Title *The Hat Book*
Art Director *Leslie Smolan*
Designers *Leslie Smolan and Jennifer Domer*
Photographer *Rodney Smith*
Design Firm *Carbone Smolan Associates, New York, NY*
Client/Publisher *Nan A. Talese/Doubleday*
Printer *Jarmon Downs, Heritage Press*
Paper *Mohawk White Superfine Smooth*

Title *ABC: International Constructivist Architecture, 1922–1939*

Art Director *Yasuyo Iguchi*

Designer *Jeannet Leendertse*

Photographer *Walter Mair*

Design Firm *The MIT Press, Cambridge, MA*

Typographer *DEKR Corporation*

Client/Publisher *The MIT Press*

Printer *NEBC, Inc. (jacket) and Arcata Graphics/Kingsport (text)*

Title *Structure in Sculpture*
Art Director *Yasuyo Iguchi*
Designer *Jeannet Leendertse*
Design Firm *The MIT Press, Cambridge, MA*
Client/Publisher *The MIT Press*
Printer *NEBC, Inc. (jacket) and Arcata Graphics/Kingsport (text)*

Structure in Sculpture

Daniel L. Schodek

10.0
Christo, *Valley Curtain*.

10 Curved Members: Arches and Cables

Suspended Cables

Shapes

Curved members are widely used in sculptural applications, though most uses function compositionally rather than structurally. When used structurally, curved members have special characteristics that distinguish them from their linear counterparts. This chapter reviews the simple suspended cable and the arch.

A simple draped cable is beautifully illustrative of a curved member in tension. Examples of the draped cable as a structural device abound in many fields—witness the many suspension bridges throughout the world—but are curiously infrequent in sculptural applications. Christo's *Valley Curtain* (1971–1972), which spanned an entire valley in Rifle, Colorado, provides a dramatic exception (fig. 10.1). The work stretched 1,250 feet and was 185 to 365 feet in height. The curtain used 200,000 square feet of nylon polymide and 110,000 pounds of steel cables. The enormous thrusts developed at either end were carried by foundations tied into the surrounding bedrock. The curtain was periodically tied into concrete foundations placed along the bottom of the curtain.

Cable structures are by definition flexible. This means that the geometry of the structure is directly dependent on the type of load present and shapes itself to it. If the loading condition changes, so does the shape of the structure. This characteristic stands in marked contrast to the rigid elements largely discussed thus far, which do not exhibit large changes in the geometry of the structure as a consequence of the loading present.

The specific shape of the curve assumed by a simple cable or chain suspended between two points is responsive to the weight of the chain itself, which is uniformly distributed along its length. The resulting curve—called a catenary—is not circular in shape but parabolic. If an extremely heavy point load is applied to the same cable structure at its midpoint, the cable dramatically changes shape into a V as a consequence of the new loading. Adding another load would cause a new shape change.

CARLETON EUGENE WATKINS, photographer
b. Oneonta, N.Y., 1829; d. Napa, Calif., 1916

28. *Residence of Mrs. Hopkins, California St. Hill., S.F.*
Albumen silver print, mounted on grey card
1878 or later (negative exposed)
11.1 x 17.7 cm (image, top domed); 11.0 x 10.7 cm
(sheet); 13.8 x 21.5 cm (mount)
Inscriptions: imprinted on mount c., B114
RESIDENCE OF MRS. HOPKINS, CALIFORNIA
ST. HILL, S.F. / WATKINS' NEW BOUDOIR SERIES
YO SEMITE AND PACIFIC COAST, 427 Montgomery
Street, San Francisco
Coll. James P. Crain

MARK HOPKINS, the former Sacramento hardware
dealer whose investment in the fledgling Central
Pacific Railroad made him one of America's wealthiest
men by the early 1870s, acquired the western portion
of the block between California, Pine, Mason, and
Powell streets from his partner Leland Stanford for
a reputed $50,000. His palatial house was designed
by the firm of Wright and Sanders, applying a loosely
Tudor motif to a rambling composition of turrets,
gables, and bays that made Stanford's ornamented
palazzo seem austere in comparison.

Hopkins never lived to see the building finished;
he died in March 1878 before its completion. The
house was only briefly occupied; after the death
of her husband Mary Hopkins moved east, and visited
San Francisco only occasionally. After her death in
1891 the house and property were bequeathed to her
second husband, Edward T. Searles, who in 1893 gave
the house to the San Francisco Art Association as the
Mark Hopkins Institute of Art (an affiliated college
of the University of California). It was destroyed in
the great fire of April 1906.

References: Lewis; Belt.

CARLETON EUGENE WATKINS, photographer
b. Oneonta, N.Y., 1829; d. Napa, Calif., 1916

29. *View of the Baldwin Hotel and Theatre, at the
Corner of Market and Powell Streets, San Francisco*
Unmounted albumen silver print from a wet-
collodion, glass-plate negative
1878 (negative exposed)
8.7 x 14.6 cm (image, top domed); 9.1 x 15.1 cm
(sheet)
Inscriptions: inscribed verso in pencil, Baldwin Hotel /
SF / WATKINS' "NEW SERIES" 115
Canadian Centre for Architecture, Montreal,
1985:0305

CARLETON EUGENE WATKINS, photographer
b. Oneonta, N.Y., 1829; d. Napa, Calif., 1916

30. *View of Nob Hill from Russian Hill, San Francisco*
Unmounted albumen silver print from a wet-
collodion, glass-plate negative
After 1878 (negative exposed)
11.8 x 19.8 cm (image and sheet)
Inscriptions: inscribed verso in pencil u.c., James St.,
California to Jackson; inscribed verso in pencil l.c.,
North Side, Cal. St., Hill S.F. / "WATKINS' New Series
B212
California Historical Society, San Francisco

THE VIEW FROM THE CORNER OF Powell and Market
streets, which shows the Hopkins residence under
construction (cat. no. 29), and this view of Nob Hill
(cat. no. 30) reveal the prominent place that the
Hopkins and Stanford houses occupied on the San
Francisco skyline, indicating how such houses became
important features and points of orientation in the
daily life of the city. Other monumental buildings in
San Francisco made a visual impression through their
sheer bulk (for example the Appraisers' Building and
the Baldwin Hotel, both completed in 1877), but until
the advent of downtown skyscraper construction in
the 1880s none had either sufficient height or a dis-
tinctive enough silhouette to create the impression
that these private homes at the crest of Nob Hill made
upon the urban landscape.

Eadweard Muybridge and the Photographic Panorama of San Francisco, 1850–1880

Title *Eadweard Muybridge and the Photographic Panorama
of San Francisco, 1850–1880*
Designer Glenn Goluska
Photographer CCA Photographic Service and Various
Client Canadian Centre for Architecture, Montréal, Québec
Printer The Stinehour Press
Paper Monadnock Dulcet Text

Title *The Strathmore Century*
Art Director/Designer *Janet Odgis*
Design Firm *Janet Odgis & Co. Inc., New York, NY*
Client/Publisher *International Paper Company*
Printer *The Stinehour Press*
Paper *100% Rag Anniversary Text*

Postage stamp issued in 1984, honoring H.A. Moses as founder of Junior Achievement. That organization was perhaps the most notable nationwide in the long list of civic, church and business organizations Mr. Moses either founded or served in a leading capacity. Among them were: the 4-H movement, the Eastern States Exposition, Deerfield Academy, Boston and Wesleyan universities, Green Mountain Junior College, Trinity Methodist Church and a number of banks and corporations. He was particularly devoted to activities serving young people and farmers; he helped form the Eastern States Farmers Exchange, a buying cooperative that was the forerunner of today's Agway. The record of his accomplishments was published in 1956 by the Foundation that bore his name, in a volume entitled *Achievement is My Goal*.

Recalling the obstacles he had encountered in his early years, in 1919, together with other business leaders, he founded Junior Achievement, an organization committed to teaching the values of entrepreneurship to young Americans. The organization rapidly attained nationwide stature and substantial influence, and Mr. Moses won recognition as its founder in 1924, at a special luncheon given in his honor by President Calvin Coolidge at the White House, and again in 1984, when a new U.S. postage stamp bearing his likeness was issued.

In 1920, another laboratory was established, in Woronoco, and a step was taken whose extraordinary outcome could not then be anticipated. A new correspondence paper, Strathmore Writing, was introduced. Offered in four colors – white, gray, ivory and blue – it started life quietly and modestly, giving no hint of its future as America's leading 25 percent cotton fiber letterhead paper.

The Village of Woronoco was growing, reaching toward the peak population of about 700 it would attain within the decade. To meet the burgeoning community's social needs, ground was broken for the Strathmore Community Building on the north side of the Westfield River. And to add living space as well as accommodation for visitors, the old Boarding House across the river, where single employees had stayed, was renovated and expanded to become the Strathmore Inn.

The new Inn incorporated the renovated boarding house, as a wing which now housed not only single employees working in the Woronoco mills, but also married employees and their families. For six dollars a week, a single resident received a furnished private room and three meals a day, including lunch brought to him at the mill. A married employee and his family could rent a three-room apartment with cooking facilities for $3.50 a week.

The Inn also accommodated and served meals to

The Strathmore Inn was a highly regarded hostelry, accommodating Company visitors and other travelers, and incorporated a wing where Strathmore workers and their families lived.

visitors. These included people coming to Strathmore on business, as well as visitors headed for the Berkshire resort areas – including celebrities such as movie star Bette Davis – who were attracted by its culinary reputation, endorsed by the coveted Duncan Hines recommendation.

Construction of individual employee houses in Woronoco continued as well. Nine were built in 1918, bringing the total to 25. Rents for these were comparable to those for apartments at the Inn. Charles Benoit, who retired in 1979 as Vice President-Operations, recalls renting one of the houses for four dollars a week in 1936 when he first came to work at Strathmore.

"The rent went up to $4.20," he recalls, "because we ordered four storm windows. At five cents a week apiece we soon figured out that that would add up to the cost of the windows in no time."

Construction in Woronoco in the same period also

included the Strathmore Community Building, built at a cost of $170,000, and the 80-acre Strathmore Park. These became social centers, not only for the Village of Woronoco, but for the entire Strathmore community, although many recreational and sports programs were also conducted at the West Springfield YMCA. Activities extended from religious services, held in the Community Building's non-denominational chapel, to athletic events in the gymnasium, dances, indoor and outdoor concerts and theatrical performances.

In the same period, Strathmore instituted other employee benefits, including medical stations staffed by nurses and visiting physicians in both Woronoco and West Springfield. Strathmore was among the first U.S. companies to provide not only in-plant medical facilities to deal with accidents but free health service to employees and their families. It was also among the first to offer group life insurance to all employees, and became a charter member of

Field day activities in Strathmore Park.

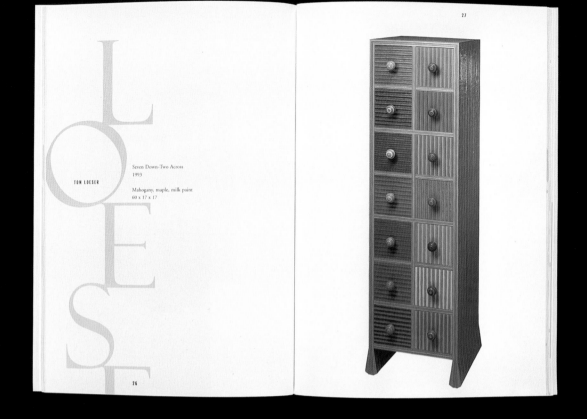

TOM LOESER

Seven Down-Two Across
1993

Mahogany, maple, milk paint
60 x 17 x 17

26

27

Title *Masterworks Two*
Art Director *Michael Bierut*
Designers *Michael Bierut and Esther Bridavsky*
Photographers *Various*
Design Firm *Pentagram Design, New York, NY*
Client/Publisher *Peter Joseph Gallery*
Printer *Becotte & Gershwin*

Title *Thoreau on Birds*
Art Director *Lori Foley*
Text and Jacket Designer *Janis Owens*
Illustrator *Louis Agassiz Fuertes*
Design Firm *Beacon Press, Boston, MA*
Client/Publisher *Beacon Press*
Typographer *Wilsted & Taylor*
Printer *Phoenix Color Corporation (jacket) and Maple-Vail (text)*

HENRY DAVID THOREAU

Thoreau

ON BIRDS

Introduction by John Hay

ILLUSTRATIONS BY LOUIS AGASSIZ FUERTES

∾ *Eleven*

GOATSUCKERS
SWIFTS
HUMMINGBIRDS

WHIP-POOR-WILL

June 11, 1851 The whip-poor-will suggests how wide asunder are the woods and the town. Its note is very rarely heard by those who live on the street, and then it is thought to be of ill omen. Only the dwellers on the outskirts of the village hear it occasionally. It sometimes comes into their yards. But go into the woods in a warm night at this season, and it is the prevailing sound. I hear now five or six at once. It is no more of ill omen therefore here than the night and the moonlight are. It is a bird not only of the woods, but of the night side of the woods.

New beings have usurped the air we breathe, rounding Nature, filling her crevices with sound. To sleep where you may hear the whip-poor-will in your dreams!

* * *

I hear some whip-poor-wills on hills, others in thick wooded vales, which ring hollow and cavernous, like an apartment or cellar, with their note. As when I hear the working of some artisan from within an apartment.

June 13, 1851 It is not nightfall till the whip-poor-wills begin to sing.

June 14, 1851 From Conant's summit I hear as many as fifteen whip-poor-wills—or whip-or-I-wills—at once, the succeed-

The following is a reproduction of a book spread shown on the page:

HENRI & ROBERT ESTIENNE

value for these prices in terms of modern money and prices. According to Renouard one denier may be taken as equal to two centimes, and one sol equal to twenty centimes. But in order to allow for the change in the value of money these prices must be multiplied by a figure varying from four to eight, according to different authorities. Even taking the highest figure, 8, the 8vo "Virgil" at 8 times 100 centimes, or 8 francs, is certainly not dear; at the same figure his largest editions would cost the equivalent of 48 francs in the money of circa 1900.

ESTIENNE'S Biblical editions made him, although he was not an avowed Protestant, suspect in the eyes of the Sorbonne, the theological faculty in France which corresponded to the Inquisition in Spain. During the lifetime of King Francis I, the printer received adequate protection against their interference, but after the death of that monarch the position became so dangerous that in 1551 Robert withdrew to Geneva. The Paris house continued under the management of Robert II, a son who remained a Catholic. The Geneva branch, after Robert's death in 1557, was controlled by another son, Henri, who maintained the high standard of his father both as printer and scholar.

Perhaps the most interesting part of Estienne's career as a printer was his dealings with the famous type-founder Claude Garamond. Through Estienne's press the Garamond roman became the standard type of all French printers, and it was

18. Henri & Robert Estienne. Linotype, 1929.
Linotype Estienne designed by George W. Jones, with typography by him.

20. The American Chap-Book.
American Type Founders, 1904.
Typography by Will Bradley.

The American Chap-Book
By Will Bradley
NOVEMBER, 1904
Published by American Type Founders Co.
Jersey City, U.S.A.

BOOKLET

The Art
of the
Type
Specimen
in the
Twentieth
Century

Title *The Art of the Type Specimen in the Twentieth Century*

Art Director/Designer *Jerry Kelly*

Client/Publisher *International Typeface Corporation*

Typographer *The Stinehour Press*

Printer *The Stinehour Press*

Paper *Mohawk Superfine (text) and Mohawk Ticonderoga (jacket)*

Title *Inside/Outside: From the Basics to the Practice of Design*
Art Director/Designer *Malcolm Grear*
Photographers *Ira Garber and Various*
Design Firm *Malcolm Grear Designers, Providence, RI*
Client/Publisher *Van Nostrand Reinhold*
Typographer *Sarabande*
Printer *Kingsport Press*
Paper *Mohawk Poseidon Perfect White*

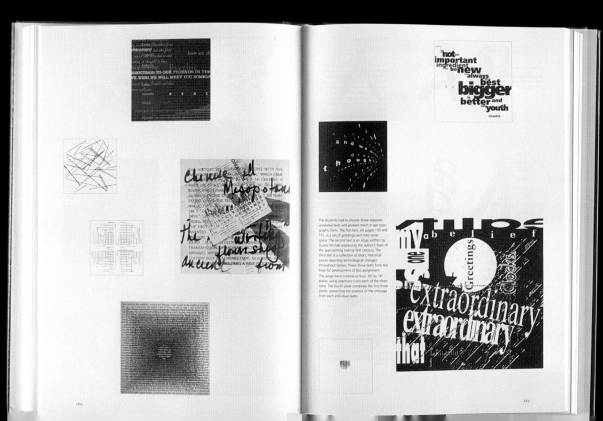

TERRARVM naturam, quas non lethiferi, sed salutares fucci imbiberint, ac earumdem, præpotentes facultates, qui exactè cognouiſſe ſapit, ſuimetipſius tutiſſimum propugnaculum aduerſus morborum incurſiones hoſtiles dicineritò poterit : mente namque percipere illi dabitur, quanti valeant ad corporis humani ſanitatem cuſtodien-

Fig.v: a) initial T and long-tailed 'm' and 'e' in reprinted gathering P of
the 1622 *Musaeum*, Trinity College, Cambridge, Q.11.97, p.109
(reproduced by permission of the Master and Fellows)

TROIAE ſive Trojanus Ludus in Circo agi ſolitus Equeſtris, & puerilis, fuit ab Ænea in Sicilia ad filii Iuli Aſcanii, & cæterorum puerorum exercitationem primum inſtitutus. Ab Aſcanio verò in Latium portatus. Is in Circo edebatur à pueris majoribus & minoribus Equeſtribus turmatim diſcurrentibus, & congredientibus, quibus is qui præſidebat, princeps juventutis vocabatur, atque ex numero filiorum primi nominis Senatorum, Auguſtorumvè legebatur, quemad-

ſtinum exercitibus captis pulchriores, & elegantiores, vaſtioreque, & proceriote corpote ſelecti fuerant, atque ad triumphum exornandum reſervati. Ferebantur etjam aureç coronç, quibus Imperatorem ipſum virtota ergo Vrbes in libertatem vindicatç, ſeu ſociæ civitates donaverant. Sequebatur deinceps Dux ipſe,ſeu populi Romani Imperator ,aurato curru à quattuor albis equis vectus, toga purpurea triũphali auro intertexta amictus, in capite lauream, ſeu auream lapilis, gemmiſque ornatam coronam geſtans, dextera Lauram, ſiniſtra verò eburneum ſceptrum tenens. Imperatoriis currũ ſi Prætor, vel pro Prætore fuiſſet, VI.ſi Conſul , vel pro Conſule, XII. ſi dictator, vel Auguſtus XXIV.Lictores cum faſcibus,& ſecuribus Laureatis, purpureis veſtibus amicti præcedebant. Circum currum verò citharedorum, & tibicinum.

b) initial T and long-tailed 'm' and 'e' in O. Panvini, *De ludis
circensibus*, Padua, Paolo Frambotto, 1642, University Library,
Cambridge, M*.1.26 (A), pp.106, 56 (reproduced by permission of
the Syndics of the University Library)

Fig.iv: first titlepage of the 1622 *Musaeum*, Warburg Institute, London, CGI 778
(copyright Warburg Institute)

Title *Printing a Book at Verona in 1622*
Designer *Roderick Stinehour*
Design Firm *The Stinehour Press, Lunenburg, VT*
Client/Publisher *Fondation Custodia*
Typographer *George Mackie*
Printer *The Stinehour Press*
Paper *Mohawk Superfine High Finish Softwhite*

Title *On Typography*

Art Director *Vance Studley*

Designers *Students in the Advanced Typographic Studies Workshop*

Design Firm *Archetype Press, Pasadena, CA*

Client/Publisher *Archetype Press/Art Center College of Design*

Printer *Students in the Advanced Typographic Studies Workshop, Using Movable Foundry Type on Vandercook Proof Presses*

Binder *Alice Vaughn*

Paper *Mohawk Superfine Letterpress*

By jickity

I'd like to make a type

that fitted 1935 all right enough,

but I'd like to make it *warm* –

so full of blood and *personality*

that it would *jump*

jump

jump

jump at you!

william addison dwiggins

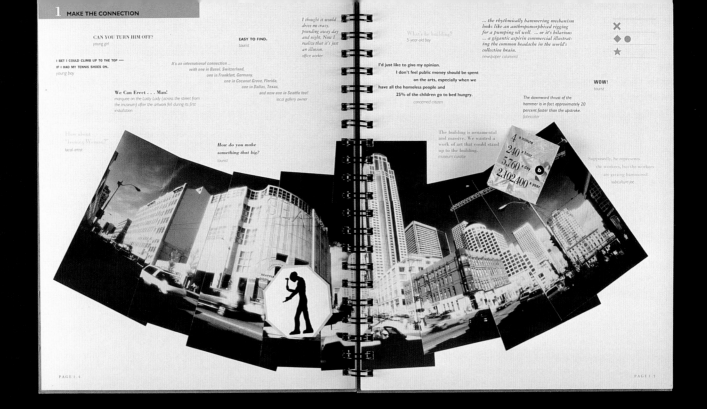

CAN YOU TURN HIM OFF?
young girl

EASY TO FIND.
tourist

I thought it would drive me crazy, pounding away day and night. Now I realize that it's just an illusion.
office worker

What's he building?
5-year-old boy

... the rhythmically hammering mechanism looks like an anthropomorphized rigging for a pumping oil well. ... or it's hilarious ... a gigantic aspirin commercial illustrating the common headache in the world's collective brain.
newspaper columnist

I BET I COULD CLIMB UP TO THE TOP —
IF I HAD MY TENNIS SHOES ON.
young boy

It's an international connection ... with one in Basel, Switzerland, one in Frankfurt, Germany, one in Coconut Grove, Florida, one in Dallas, Texas, and now one in Seattle too!
local gallery owner

I'd just like to give my opinion. I don't feel public money should be spent on the arts, especially when we have all the homeless people and 25% of the children go to bed hungry.
concerned citizen

WOW!
tourist

We Can Erect . . . Man!
marquee on the Lusty Lady (across the street from the museum) after the artwork fell during its first installation

The downward thrust of the hammer is in fact approximately 20 percent faster than the upstroke.
fabricator

How about "Ironing Woman"?
local artist

How do you make something that big?
tourist

The building is ornamental and massive. We wanted a work of art that could stand up to the building.
museum curator

4 = minute
240 = hour
5,760 = day
2,102,400 = year

Supposedly, he represents the workers, but the workers are getting hammered!
subculture joe

PAGE 1.4

PAGE 1.5

In *Sight*
The Seattle Public Art Puzzle Book
An interactive book with written and visual clues to help you connect public art with people and place.

Title *In Sight: The Seattle Public Art Puzzle Book*

Designers *Judy Anderson and Claudia Meyer-Newman*

Illustrator *Judy Anderson*

Photographer *Claudia Meyer-Newman*

Design Firm *Anderson & Helms Cook, Seattle, WA*

Client/Publisher *Seattle Arts Commission*

Printer *Printery Communications*

Title *Planetarium: The 100 Show*
Art Director *Michael Bierut*
Designers *Michael Bierut and Emily Hayes*
Photographers *François Robert and Brett Kramer*
Design Firm *Pentagram Design, New York, NY*
Client/Publisher *American Center for Design*
Printer *Burton & Meyer, Inc.*
Paper *S. D. Warren Cameo Dull*

Title *Do It! Series of Guidebooks*
Art Director *Michael Bierut*
Designers *Michael Bierut and Agnethe Glatved*
Illustrator *Nicholas Fasciano*
Photographer *John Paul Endress*
Design Firm *Pentagram Design, New York, NY*
Client/Publisher *Chronicle Books*

Title *Aerobics Instructor Manual*
Art Director *John Ball*
Designers *John Ball and Gale Spitzley*
Illustrator *James Staunton*
Photographer *John Johnson*
Design Firm *Mires Design, Inc., San Diego, CA*
Client/Publisher *Amerian Council on Exercise, Reebok University Press*
Printer *Malloy Lithographing, Inc.*

*Aerobics
Instructor
Manual*

AMERICAN
COUNCIL ON
EXERCISE

Chapter 7

Components
of an Aerobics Class

By Karen Clippinger-Robertson

n aerobics class is intended to enhance physical capacity so that overall health and quality of life improve. But to realize the potential gains from an exercise class, which include improved cardiovascular endurance, body composition, flexibility, muscular endurance and muscular strength, it is essential to design the class appropriately. Class design is probably the single most challenging task for the instructor. The challenge is to apply the scientific principles and exercise techniques presented elsewhere in this manual in a manner that will produce an effective, relatively

Karen Clippinger-Robertson, M.S.P.E., is a kinesiologist and a director of Seattle Sports Medicine Seminars and of Pacific Northwest Ballet's Conditioning and Therapy Center. She has conducted fitness-instructor training programs for more than 15 years and has consulted for the U.S. Weight Lifting Federation, the U.S. Race Walking Team, and various dance companies, sports medicine clinics and fitness centers.

One day while checking my traps, I see a strange glow on the horizon.

I think I have found gold, so I go eagerly toward it.

Then, all of a sudden, I am flying.

I end up stuck fast to the mountain with my sled, my traps, and all my belongings. Only now do I remember the stories about a magnetic stone said to be some sort of meteorite. You have to heat it with a bonfire to break its magnetic power. But I am alone, hanging head down, under my traps and gun, getting colder and colder.

A great drowsiness comes over me.

Title *A Small Tall Tale from the Far Far North*
Art Director *Denise Cronin*
Designer *Edward Miller*
Illustrator *Peter Sis*
Design Firm/Client *Alfred A. Knopf Books for Young Readers*
Printer *Horowitz Rae*
Paper *Mountie Matte*

Title *The Sonnets of Shakespeare, This Heritage Remembered V*
Art Directors *Woody Pirtle and John Klotnia*
Designers *John Klotnia and Ivette Montes de Oca*
Illustrator *Anthony Russo*
Design Firm *Pentagram Design, New York, NY*
Client/Publisher *Heritage Press*
Typographer *Typography Plus*
Printer *Heritage Press*
Paper *Fox River Confetti, Mohawk Superfine*

8
0

O how I faint when I of you do write,
Knowing a better ſpirit doth vſe your name,
And in the praiſe thereof ſpends all his might,
To make me toung-tide, ſpeaking of your fame.
But ſince your worth (wide as the Ocean is)
The humble as the proudeſt ſaile doth beare,
My ſawſie barke (inferior farre to his)
On your broad maine doth wilfully appeare.
Your ſhalloweſt helpe will hold me vp afloate,
Whilſt he vpon your ſoundleſſe deepe doth ride,
Or (being wrackt) I am a worthleſſe bote,
He of tall building, and of goodly pride.
 Then if he thriue and I be caſt away,
 The worſt was this, my loue was my decay.

85

Tuesday nite Jan 4

Back home from work at 3:00—slept, Peter came
about 7:00 after dark, no money, I had let land-
lady in downstairs, then she he, and some conver-
sation about library (he was to return my books)
but he had no money, wanted to study—I again
more alive, less plaguey than night before—no
attempts to grab hands—Sally then came in
interrupting, & chattered on, everything lucid I
was expounding (Spengler at this point) turning
to curious Sally—vague excitements of mind
wonder, contradictions, another ego in the room
beside mine—was he bored?—till I wished she'd
let me do the talking here—but I kept resolving
this sort of thing was inevitable anyway—then
Peter out to get $ from Robert, then Sally telling
me she'd spent 3 hrs. bullshitting him about
Proust & Balzac reading yesterday before he'd
seen me, and afterward said "You seem sad—did
Allen make you sad?" and he sd. yes to her, which
I'd meant to do. Then I resolved to stay night here,
though with money might have gone to 755 Pine,
but this way Peter returned alone later, another
moment with him alone—I'm getting screwy
with this plot now—Robert according to Sally is
coming off it, talks of me & Religion (his lack)

Title *Honorable Courtship*

Designer *Allan Kornblum*

Illustrator *Dean Bornstein*

Client/Publisher *Espresso Editions, Coffee House Press*

Printer *Leslie Ross*

Binder *Jill Jevne*

Paper *Fabriano Umbria*

Title *Herbarium Verbarium: The Discourse of Flowers*
Art Director/Designer *Richard Eckersley*
Client/Publisher *The University of Nebraska Press*
Typographer *Keystone Typesetting, Inc.*
Printer *BookCrafters*
Paper *Glatfelter*

que de refaire avec des paroles la rose
ou d'imiter de la pomme la belle prose!
Quelle universelle complicité!
(sw II:735, originally published in French)

*Will attain paradise, those who praise things
indeed, what felicitous examination it is
to remake with words the rose
or to imitate of the apple the beautiful prose!
What universal complicity.*

This praise is thus the only way the male artist has of making the world closer to himself, of being an accomplice to it, rather than its spectator or destroyer. It is only when the natural world ceases to be the object of observation, but becomes associated with its roots in the underworld that some kind of fertilizing encounter is possible. This descent into the underworld – to which the flower always seems to lead – uncovers an unknown world of strange metamorphoses repressed by a mimetic horizontal model which always has a tendency to come back to the same, to the father. As such, whether in Rilke or Proust, the descent into the nocturnal world points to the fact that neither the flower, nor language, nor art in general has ever been comfortable in the realm of reasoned vision, the one, the singular, but has always sprung from the interstices of their monuments and laws.

The Manufacture of the Meadow

Francis Ponge

How can a man have a sense of a thing if he does not have its germ in himself? What I ought to understand must evolve organically within me, and what I seem to learn is nothing but nourishment – stimulation of the organism. – Novalis, Pollen

Since it is difficult to remain underground for very long – unless one is called Eurydice or Persephone – I propose that we come back to the surface, to the meadow. As Ponge's work *La Fabrique du pré* (1971) shows, the meadow (*le pré*) is at the same time our end and our beginning; it is where we begin and where we end.[1] Most of the myths I have alluded to in the previous chapters start in a meadow: it is the site where Persephone was playing with her friends before being abducted by Pluto; it is where Eurydice was gathering flowers before being bitten by a serpent, it is the place where Alice falls asleep before undertaking her adventures. As a 'garden,' it is the place where Eve picked the fruit that caused the Fall. As such the meadow seems to be a dangerous place, a place where seduction occurs.

Like Ponge, one should perhaps first ask the question, what is a meadow? What is a *pré*? If we begin with the dictionary, we soon realize that the meadow is, by defini-

77. *Call Me Mister* (1951). "Japanese Girl Love American Boy": One can easily imagine how this concept might have been spectacularized in Berkeleyesque terms. Instead, as in nearly all the film's numbers, spectacle is deferred in favor of star performance.

78. *Two Tickets to Broadway* (1951). "Manhattan": Tony Martin and Janet Leigh enact a vest-pocket equivalent of "Lullaby of Broadway." This little-known musical is one of the few Berkeley films to realize its limitations well.

79. *Two Tickets to Broadway* (1951). "Are You a Beautiful Dream?": In the film's final number, Janet Leigh inhabits the type of abstract dreamspace conducive to Berkeley-esque fantasy.

Title *Showstoppers: Busby Berkeley and the Tradition of Spectacle*
Art Director/Designer *Teresa Bonner*
Client/Publisher *Columbia University Press*
Typographer *Impressions, a division of Edwards Brothers*
Printer *Edwards Brothers*
Paper *Arbor Standard, Sterling Litho Gloss*

Title *Industrial Park*
Art Director/Designer *Richard Eckersley*
Client/Publisher *University of Nebraska Press*
Typographer *Kim Essman*
Printer *Cushing-Malloy, Inc.*
Paper *Husky*

PATRÍCIA GALVÃO

TRANSLATED BY ELIZABETH & K. DAVID JACKSON

INDUSTRIAL PARK

He follows her from a distance. He manages to catch the same streetcar. They get off on Silva Teles Street. Braz's morning is in motion. The vegetable lady can't manage the weight of her basket. The banana woman groans her lazy call.

Matilde disappears through the wide doorway of the tenement. Alfredo hurries. He finds her in sobs clinging to a barefoot young girl. He remembers. It's the apprentice seamstress with whom he had spoken at the Esplanada.

—Did you come with him? Did he do something to you?
—No! It wasn't him! Talk to him!
—Not I!
Otavia leaves her, exclaiming:
—He'll be ashamed to talk to my bare feet. . .
Alfredo comes closer. . .
—Don't go to see Eleonora any more, Matilde. . .
—I won't. . .
—Does that girl live here?
—She lives with another girl in number 10.
A bleached blonde appears, in a flowered shift, calling. . .
—Come in, *Seu* Alfredo. Come have coffee. . .
It's Matilde's mother.

DIVID-
ING WALLS

Automobile Club. Inside flies. The high-class Club asks for relief through the decadent pens of its press flunkies. Now it wants to dupe City Hall, selling it the building that the Club couldn't finish. It's the crisis. São Paulo's nascent capitalism turns its feudal and hairy belly up.

Surplus value decreases, torn away by half a dozen fat money grubbers, from the whole population of State workers, through a suction house called the Industrial Park in

From end to end of the inquiry no cop had sense enough to ask Wright for his draft registration card. If it had been demanded he'd have been in serious trouble indeed, for he had none, though he was but thirty-four years old at the time. It is possible that he had been refused registration because of his addiction to morphine, but this is rather improbable, and he always represented to me that he had simply failed to register. Perhaps the cops were diverted by his florid beard, which made him look at least 40; perhaps they simply missed a bet. Whatever the reason, they did not ask for his card, and so far as I know he remained unregistered until the end of the war. Once he got out of their clutches he sent me a long letter of explanation, but it was full of the maunderings of a man who was plainly not himself, and I did not make any reply to it. I had by this time, in fact, become fed up with Wright. I had got used to his frequent borrowings of money and to all his other failings, but I found it impossible to carry on friendly relations with a drug addict.

A little while after the uproar ceased he parted from Claire and returned to the Pacific Coast, where he presently got a job on the San Francisco *Bulletin*. There he remained for several years, struggling to cure himself of the morphine habit, though of this I knew nothing, for I had no communication with him, and did not hear from him again, in fact, until 1928. Apparently he was successful, for after 1922 he began to do some magazine work and in 1923 he published another book, *The Future of Painting*. In 1926 he followed it with *Modern Literature*, and during the same year, under the pseudonym of S. S. Van Dine, he published *The Benson Murder Case*, the first of a series of detective novels that were an enormous success and made him rich.

In November, 1934, he appealed to me for aid for his second wife, who needed gynecological attention, and I invited him to bring her down to Baltimore to consult Dr. Edward H. Richardson. He came to Baltimore with her on November 18 and they had dinner in Cathedral Street. I received him politely but suspiciously, for I was already convinced that he had had something to do with the libels upon me lately launched by Burton Rascoe. He invited me to visit him in New York, but I never did so. He died of a heart attack on April 11, 1939.

CHAPTER XIII

MY RELATIONS with Dreiser continued friendly in 1917 and most of 1918, but I saw rather less of him than in the past, and for three principal reasons. The first was that I disapproved of the method he had chosen to try to force Jones to release *The "Genius"*. I believed that it would fail, and found it impossible to discuss the case with him without quarrelling. The second was that he had begun to surround himself, despite his denials and disclaimers, with a frowsy bunch of advanced thinkers of one sort or another, most of them plain frauds and all of them seeking to get publicity for themselves out of his troubles. The third was that, following the departure of Kirah Markham, he was shopping around for another girl, and most of the candidates for the situation that I encountered at his place in 10th Street, or heard of from other explorers, seemed to me to be either harpies or fools.

It was almost impossible, in those days, to offer him anything resembling rational advice, for he was always ready to listen to and follow the prehensile messiahs and designing females who swarmed about him. He was in really serious difficulties, for the suppression of *The "Genius"* had cut off the income on which he had planned to live while writing a successor to *The Financier* and *The Titan* and the three volumes of his autobiography, and his income from magazine stories was irregular, uncertain and usually short of adequate. He was hard up and in a very low state of mind. To be sure, he occasionally sold a story and in December he also got some money out of a more or less arty production of *The Girl in the Coffin*, but these revenues were delayed until the end of the year, and in its earlier months he encountered mainly disappointments.

PRINTED IN U.S.A. © 1993 ALFRED A. KNOPF, INC.

H. L. MENCKEN

MY LIFE AS AUTHOR AND EDITOR

Edited and with an Introduction by Jonathan Yardley

Title *H. L. Mencken: My Life as Author and Editor*
Art Director *Virginia Tan*
Designer *Peter A. Andersen*
Illustrator *David Low*
Client/Publisher *Alfred A. Knopf*
Typographer *Creative Graphics*
Printer *R. R. Donnelley & Sons*
Paper *S.D. Warren Sebago*

Title *The History of the Ginger Man*
Designer *Robert Overholtzer*
Jacket Designer *Louise Fili*
Client/Publisher *Houghton Mifflin/Seymour Lawrence*
Typographer *Dix Typesetting*
Printer *R. R. Donnelley & Sons (text) and John P. Pow Company (jacket)*
Paper *Finch Vanilla*

The History of
The Ginger Man

The dramatic story behind

a contemporary classic by

the man who wrote it and

who fought for its life.

J. P. Donleavy

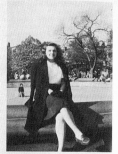

Ann Henry in New York's Washington Square Park. Such lady whose gurgling laughter and warm charm set one's anticipations and expectations high, but her allurements were only very rarely encountered again in other women one met later in life.

and made our way walking nearly an hour, I to Manhattan Prep and she to travel another mile and a half all the way to the banks of the Hudson to the college of Mount St. Vincent, for she was in college and I was still in high school. But in this dawn after this night and the premonitions it now brought, all the world seemed such a bowl of tears. In the squawking bluejay silence of these woods, where I hunted and played and walked and talked and held hands with the girls I loved. Each step I now took in the deepening snow, my confidence slowly draining away. And so began my gradual demise into despair from which I was never again to recover in America. Gainor's words echoing in one's mind.

Mike there is
For us pure of heart
No end of
Malice
No end of
Scorn

23

I HAD PREVIOUSLY WRITTEN to Valerie that from what I could gather of the publishing world, it was booming, and the sale of cheap reprints was skyrocketing. I was beginning to imagine *S.D.* selling seven thousand copies and the royalties that one might make amounting to four hundred pounds yearly. Enough in Ireland to survive on. But now with no book to write nor pictures to paint, the wait to hear no word from Scribner's and energy sapped, my decline into full-blown despair was accelerating. Gainor still advising me:

"Mike, according to John Preston, one of their authors, you're getting the recognition and respect of one of America's best editors, who has almost complete power at Scribner's. You must continue to be patient."

But with nothing left to fight, as each afternoon wore on, the greater the gloom became. I was already thinking I was wrong to resubmit the book to Scribner's and was now wishing they had rejected it outright when it had first been submitted. I again recalled my first visit there seeing Wheelock, and he had a sheaf of authors' royalty checks handed him and these were waving in front of me. And then, just as I was slowly feeling some physical recovery from my drunken night with Gainor, through the letter slot of the front door of the sun porch, the fatal news came.

CHARLES SCRIBNER'S SONS
PUBLISHERS
597 FIFTH AVENUE, NEW YORK 17, N.Y.

Mr. J. P. Donleavy, December 18, 1952
233 East 238th Street, New York City.

Dear Mr. Donleavy,
 At last we have had a chance, two of us, to read in its entirety this

and opportunities of thoughtful participation, the beneficia-
ries of today may themselves prove worthy, in turn, of the
thanks of their successors.

Examination of the political science of Plato and of his
follower Fārābi may disclose it to be more finely attuned to
the nuances of statesmanship than is its avowedly more
realistic contemporary replacement. Likewise, examination
of the manner in which Burke, Lincoln, and Tocqueville
retell the stories of their national revolutions may give added
impetus to our looking beyond our now conventional cate-
gories. In each case the statesman begins by seeking to settle
his public's mind about some distressing issue of the day. To
do so he makes use of an old art at once poetic and philo-
sophic, seductive and hectoring, adroit and naive. His de-
fense of his regime is designed to stiffen the unsteady, rouse
the drowsy, and meet the enemy on his own ground. Like the
dialectical theology described by Fārābi, this political *kalām*
is no shy and timid voice.

5

Burke's Muffled Oars

From first to last in his long career as a public man,
Edmund Burke insists on a self-conscious scrutiny of one's
stance when approaching questions of public policy. Igno-
rance, inexperience, myopia, closed-mindedness (whether
prompted by self-satisfaction, indifference, or sloth): each
rules out the chance that sound policy might be found and
followed. As surely as "a great empire and little minds go ill
together," so too might it be said more generally that the
conduct of the public's business demands enlarged views
both from the few charged with that business and from the
many empowered to select them (C 1:509).[1] An electorate

[1] There is as yet no complete edition of Burke's writings that
meets present-day critical standards, but one is under way. All
volume and page citations given here parenthetically are to *The*

《 66 》 *'Re-visioning "Our Revolution"*

Two Faces of the Politics of Enlightenment

REVOLUTIONS
Revisited
RALPH LERNER

Title *Revolutions Revisited*

Art Director/Designer *Richard Hendel*

Jacket Illustrator *Michael McCurdy*

Client/Publisher *University of North Carolina Press*

Typographer *Keystone Typesetting*

Printer *Thomson Shore*

Paper *Uncoated Natural White*

Title *Torn Out by the Roots*
Art Director/Designer *Richard Eckersley*
Jacket Illustrator *Unknown Russian Artist*
Client/Publisher *University of Nebraska Press*
Typographer *Tseng Information Systems*
Printer *Edwards Brothers, Inc.*
Paper *Glatfelter Natural*

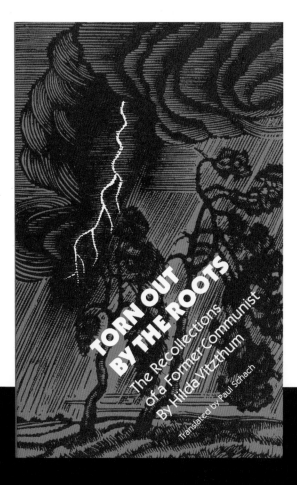

Finally the time came for us to depart as well. Our destination was the camp at Sukhobezvodnoye, situated 200 kilometers beyond Gor'kiy.

Our barge had moored at the bank opposite the city near the confluence of the Volga and the Oka. It was the end of September; already the days were occasionally quite cold, and sleeping on the deck became uncomfortable, yet I preferred this place to one in a camp barracks. Of Gor'kiy itself we got to see nothing but the contours of the city and the depressing suburb that lay adjacent to where we were moored. The confluence of the Volga and the Oka, however, had afforded us an impressive drama of nature.

We were transported from Gor'kiy in trucks. Since I was the last one to climb on after everything else had been stowed away, I could only squat there, hemmed in between crates and mothers. Tired, thoroughly shaken, and hungry, we reached our goal after a ride lasting for hours. I was directed to the central hospital of the camp, which also included a nursery. The individual divisions of the hospital consisted of rather well-built barracks. Sukho-

bezvodnoye was one of the oldest camps, and thus it was also relatively well organized and equipped.

Toward the end of our voyage, several infants had also become ill; now they were brought into the nursery, to which I was assigned. Strange to say, there were already sulfa drugs here for the children, which I had never even heard of. Now I saw how the children could be cured of diarrhea within a few days. If only we had had this medication during our trip! Then probably most of the patients who died would still have been alive.

Soon after our arrival, Lydia Ivanovna, who was so highly esteemed by everyone, again took charge of the nursery.

The director of the children's sanitarium was a splendid woman, a Georgian teacher. When she was arrested, her husband, who retained his freedom, had repudiated her. We two occupied a cubicle in the sanitarium barracks. The doctors and nurses with whom I had come from Kem also remained in this hospital. After a short while the children's sanitarium was transferred to an especially constructed building that lay near the camp entrance but outside the enclosure. With the help of the director we had everything organized and were cooperating well. But nothing in a camp is permanent.

The personnel who now worked with the children were less well trained, because we needed all the qualified personnel in the hospital: conditions in the camps had deteriorated greatly since the outbreak of the war, and the number of patients had increased. I too had to leave the children and was transferred to one of the wards for general medicine. In addition to the seriously ill from the camp, we constantly received new arrivals from the prisons and war areas. If conditions in the camps had deteriorated significantly, they were even worse in the prisons. Among the new prisoners were some who had come directly from the front or from places that the Soviet armies had reconquered from the Germans. Apparently, contingencies of the war did not per-

Over the river and through the wood,
Trot fast, my dapple-gray!

*Over the River
and Through the Wood*

A Thanksgiving Poem by Lydia Maria Child
ILLUSTRATED WITH WOODCUTS BY
Christopher Manson

Title *Over the River and Through the Wood*
Art Director/Designer *Marc Cheshire*
Illustrator *Christopher Manson*
Client/Publisher *North-South Books*
Printer *Proost*
Paper *Hanno Art, Acid- and Chlorine-Free*

Title *All the Places to Love*
Art Director/Designer *Al Cetta*
Illustrator *Mike Wimmer*
Design Firm *HarperCollins, New York, NY*
Client/Publisher *HarperCollins*
Printer *Worzalla*
Paper *S.D. Warren Patina Matte*

Someday I might live in the city.

Someday I might live by the sea.

But soon I will carry Sylvie on my shoulders
 through the fields;

I will send her messages downriver in small boats;

And I will watch her at the top of the hill,

Trying to touch the sky.

I will show her my favorite place, the marsh,

Where ducklings follow their mother

Like tiny tumbles of leaves.

Now the fox,
And the dog,
And the hunter,
And the boy named Will,
Are sitting on the sled,
Sliding swiftly down the hill.
Down the hill they swiftly sped,
Till they ran into a hare.

The Story of a Boy Named
Will,

Title *The Story of a Boy Named Will, Who Went Sledding Down the Hill*

Art Director *Marc Cheshire*

Designer/Illustrator *Vladimir Radunsky*

Client/Publisher *North-South Books Inc.*

Printer *Proost*

Paper *Hanno Art (Acid- and Chlorine-Free)*

Title *Nuts to You!*
Art Director *Michael Farmer*
Designer *Lydia D'moch*
Illustrator *Lois Ehlert*
Design Firm *Kirchoff/Wohlberg, Inc., New York, NY*
Client/Publisher *Harcourt Brace Jovanovich*
Printer *Tien Wah Press*

In t[...]
one [...]
is a [...]
sea[...]
for [...]
to [...]
bef[...]

Tr[...]
Ev[...]
W[...]
pa[...]
inf[...]

Red fox, hungry fox,
Listening to hear
The scrabble scrabble scrabble
Of a white-tailed deer,
The rustle of the cranes
As they lift into the sky,
The sad, lonely echo
Of a last loon's cry.

RED FOX
RUNNING
by Eve Bunting
Paintings by Wendell Minor

Title *Red Fox Running*
Art Director *Anne Diebel*
Designer/Illustrator *Wendell Minor*
Client/Publisher *Clarion Books/Houghton Mifflin Company*
Printer *Horowitz Rae*
Paper *Glatco Matte C-16*

Title *Journey*
Art Director/Designer *Rita Marshall*
Illustrator *Guy Billout*
Design Firm *Delessert & Marshall, Lakeville, CT*
Client/Publisher *Creative Education*
Printer *Mondadori*
Paper *Gardamatt Brillante*

Sunday afternoon in September.

Then things changed and became different. They found out that if any man took a penny, covered it with whag and then put one drop of slutch on it, the penny had power. Just a copper penny fixed with a little whag and one drop of slutch was stronger than a thousand men. If one penny with a whag cover and a spot of slutch on it was laid on the front doorstep of a house, two minutes afterward the house and the family and everything in the house went straight up overhead, so far in the sky that it was six weeks coming back, six weeks floating down from the sky in fine dust.

This was the same time a long-nose man met a short-nose man one afternoon on the main street. And when they met they bumped against each other not looking, bumping the same as people bump when they bump in an accident.

"You dirty long-nose," said the short-nose man.
"You dirty short-nose," said the long-nose man.
"You long-nose people don't belong," snorted one.
"You short-nose people don't belong," snorted the other.
"Neither do you long-nose people," came back.

Then all the long-nose people and all the short-nose people took pennies and fixed them with whag and slutch. They put these pennies on each other's front doorsteps. And the houses went up in the air overhead, straight into the sky,

and took six weeks to come back, floating down in fine dust. And so after a while all the long-nose families and all the short-nose families were gone from the Village of Pick Ups. Nobody was left who had either a long nose or a short nose. Only people with middle noses, noses not long and not short, were living in the houses that were left.

Then one day two men met on the main street with different ears sticking out from their heads. One had ears far out, the other had ears close up. Their ears didn't match. And each was proud of his ears. And when they met they bumped against each other not looking, bumping the same as people bump when they bump in an accident.

53

Title *More Rootabagas*

Art Director *Mina Greenstein*

Designers *Paul O. Zelinsky and Mina Greenstein*

Illustrator *Paul O. Zelinsky*

Client/Publisher *Alfred A. Knopf Books for Young Readers*

Typographer *Mara Sachs*

Printer *Arcata Graphics*

Paper *P + S Offset Smooth*

Title *Cotton Mill Town*
Art Director/Designer *Sara Reynolds*
Illustrator *Jeanette Winter*
Client/Publisher *Dutton Children's Books/Penguin USA*
Printer *South China Press*
Paper *Japanese Matte*

Cotton Mill
·Town·

by Kathleen Hershey
illustrated by Jeanette Winter

The dirt is black and full of earthworms.

Grandmama fills a can with dirt and worms for times when
we go fishing.

Mean old Mother Goose

Lions on the loose

They don't frighten me at all

Dragons breathing flame

On my counterpane

That doesn't frighten me at all.

LIFE Doesn't Frighten ME

Poem by Maya Angelou

Paintings by Jean-Michel Basquiat

Publishers Weekly Best Book of 1993

Title *Life Doesn't Frighten Me*
Art Director *James Wageman*
Designer *Paul Zakris*
Illustrator *Jean-Michel Basquiat*
Client/Publisher *Stewart, Tabori & Chang*
Printer *Tien Wah Press, Ltd. Lithographers*
Paper *Mitsubishi Matte Stock*

Title *John Jeremy Colton*
Designers/Illustrators *Byron Glaser and Sandra Higashi*
Design Firm *Higashi Glaser Design, New York, NY*
Client/Publisher *Hyperion Books for Children*
Typographers *Trufont Typographers*
Printer *South China Printing Co.*
Paper *Espel Matte Art*

INDEX